The History of

Basque Music Series, No. 1

# The History of Basque Music

Edited by
Josu Okiñena

Center for Basque Studies
University of Nevada, Reno
2019

# Table of Contents

This book was published with generous financial support from the Basque Government and Musikene.

The History of Basque Music
Basque Music Series No. 1
Series editor: Xabier Irujo

Center for Basque Studies
University of Nevada, Reno
1664 North Virginia St.
Reno NV 89577-2322 USA

http://basque.unr.edu
Editor: Josu Okiñena

Library of Congress Cataloging-in-Publication Data forthcoming

Names: Okiñena, Josu, 1971- editor.
Title: The history of Basque music / edited by Josu Okiñena.
Description: Reno : Center for Basque Studies Press, 2019. | Series: Basque music series; 1 | Includes bibliographical references. | Summary: "The history of Basque music from prehistory to modern day, looking at various political issues and types of music"--provided by publisher.
Identifiers: LCCN 2019023626 | ISBN 9781949805123 (paperback)
Subjects: LCSH: Basques--Music--History and criticism. |
   Music--Spain--País Vasco--History and criticism. |
   Music--Spain--Navarre--History and criticism. | Music--France--Pays Basque--History and criticism.
Classification: LCC ML315.P35 H57 2019 | DDC 780.89/9992--dc23
LC record available at https://lccn.loc.gov/2019023626

# Introduction

Josu Okiñena

In this introduction I intend to provide an account of the gestation and development of the present study. Which grew out of the agreement concluded between the Center for Basque Studies at the University of Nevada, Reno, in the United States of America, and Musikene, the Higher School of Music in the Basque Country. Musikene was created in the 2001–2002 academic year by the Basque government. It is a center committed to providing quality instruction in fields associated with direction, and research. This book is a product of this research.

The initial event that gave rise to this study was my first tour through the United States; I held a recital at Nightingale Hall at the University of Nevada, Reno, performing, among other works, pieces by Basque composers. When the recital was over, in a conversation with Xabier Irujo, Director of the Center for Basque Studies at that university, we exchanged opinions noting the low diffusion that Basque music has experienced internationally, and specifically in the United States, where, although there are some instances of Basque music, mainly folk music, the great Basque composers and their works were and continue to be largely unknown.

For this reason, we decided that it was indispensable to present English-speaking readers with a history of our music, since sources for music history in the English language were almost completely absent.

When examining more closely the idea of undertaking this project, it seemed necessary to track sources on Basque music history and, reviewing the available materials, I noted that more

than thirty years had passed since José Antonio Arana Martija—a musicologist and member of Euskaltzaindia, the Academy of the Basque Language—published his work on the history of Basque music. I therefore considered it indispensable to propose this work. This book tracks the different elements that contribute to the creation of Basque music, and this task requires determining their geographic breadth and search for contributions to their study. In this regard, the work undertaken by Musikene provides a panoramic vision of Basque music.

"Basque music" refers to the music that is created or experienced where Basque culture has been established or is practiced: mainly, in the present-day Euskal Herria (Basque Country), but also outside of its borders. Establishing geographical limits for these territories is complex due to the different modifications that have arisen over the course of history and due to administrative questions related with France and Spain. Three of these territories, Araba (Álava), Bizkaia (Vizcaya), and Gipuzkoa (Guipúzcoa), make up the political administrative unit of the Autonomous Community of the Basque Country, which, together with Nafarroa (Navarra), the current Autonomous Community of Navarre, are parts of the Spanish state. The three historical territories of Lapurdi (Labourd), Nafarroa Beherea (Bassse Navarre, Lower Navarre), and Zuberoa (Soule), which are situated in France, belong to the *département* of the Atlantic Pyrenees, in the region New Aquitaine, in France. We also include in this work the music created by Basques outside of these Basque territories, which is known as the Basque diaspora or the eighth Basque province.

Although in recent years research has been conducted on Basque music and Basque musicians, and there have been limited overviews of territories such as Araba or Navarre, and genres such as opera or liturgical monody, until now there has been no

panoramic view of Basque music that also includes other topics such as jazz or urban music.

This work is divided into ten chapters. The first seven present a chronological view of academic music of the mainly written tradition, and the three remaining chapters focus on specific topics to which I will refer later. Chapter 1 deals with music in Prehistory, Antiquity, and the Middle Ages in the current Euskal Herria. Chapter 2 focuses on Basque music in the Renaissance and the Baroque era, including the most important musical events between the late fifteenth century and the first half of the eighteenth century. Music in Euskal Herria during the Enlightenment is treated in the chapter 3, and chapter 4 is dedicated to the reality of events in Basque music over the course of the nineteenth century. Musical nationalism and the reform of liturgical music are presented in chapter 5, and chapter 6 focuses on musical events during the Spanish Civil War and Franco's dictatorship. Chapter 7 begins in the Spanish Transition and concludes with the most recent trends in composition. Lastly, chapters 8, 9, and 10 handle the following topics: women and Basque music, a brief history of jazz, and popular music revisited.

The bibliography at the end includes a selection of the most relevant sources, and the volume concludes with a phonography listing the most representative audio files from the different eras of Basque music.

Each author is responsible for the focus of his thinking, and this introduction merely serves to present the reader with the motives and contents of the work and to demonstrate satisfactorily the need for this synthesis of the history of Basque music, while accepting that it is not definitive. We are aware that there are topics and authors that have not been included, mainly due to lack of sufficient sources or previous studies.

# The Prehistory, Antiquity, and Middle Ages of Music in Today's Euskal Herria

Elixabete Etxebeste

## Euskal Herria in Prehistoric Europe: Unknown Music

Throughout history, human groups create, maintain, and modify elements of their musical culture, but little is known of their origins. Through objects and discovered sites, the study of prehistory tries to reconstruct the human past from its origin, from two or three million years ago to 4,000 years ago, when the written record changes the quality of the received information, and beliefs, sentiments, opinions, descriptions, and successes can be transformed into material for memory. With the passage of the time we can count on more and better sources, and although there is not always agreement as to its interpretation, this is a moment that is studied with special zeal because it reveals information on how we become who we are. Although information on basic questions of music is slim, the finding of a flute gives us facts about the needed mobility of the phalange in the development of human mobility. To date, the possible beginnings of instrumental music with a system of sounds more or less previously determined assumes placing a date on a state of evolution capable of creating it. And in the same breath that we describe the amazing undertaking of the reconstruction of the millenary history of our culture, let us recall Basque anthropologists like José Miguel de Barandiarán,[1] a leader in research of his time, who warns against a reconstruction based on slim facts.

---

[1] José Miguel de Barandiarán (1889–1991), a Basque anthropologist, ethnologist, and folklorist disciple of Telesforo Aranzadi and one of the

In the study of music in various cultures we should keep in mind the fact that the use of sound does not imply musical practice, since organized sound cannot be considered music either intentionally in the act or conscious of the result. As in all cultures, so in Basque culture one would hope that through the sound of the voice, the whistle, the rhythm with the body or with objects, and with work or musical instruments, certain prehistoric musical activities would accompany daily life in diverse ways and functions: to aspire to calm or valor, to unite the group, to be the sonorous part of dance, or to mark a presence in the valley. Its potential as a sign and symbol in the realm of communication associated with the advantages and benefits of musical execution and listening transform it into a sonorous expression of survival, protection, celebration, communication, and playfulness.

To sing and create rhythms with one's own body are considered original forms of making music, since they do not require any type of instrument. In order to intone and repeat melodies or consciously alter them, as well as to play musical instruments, a certain cerebral structure and an anatomy that allows dexterity dependent on fine motor skills is required. The level of complex movements of the fingers and the control over the airflow in the mouth cavity has evolved with time. Song and percussion, together with instruments of undetermined sound-

---

fundamental figures in the study of Basque culture. Together with Aranzadi and Enrique de Eguren, in 1917 he began a team active for nearby two decades, and his research makes up the mass of received documents of the first Basque archaeological studies. He belonged to the Junta Permanente de la Sociedad de Estudios Vascos from its beginning in 1918 and under his direction, a little later in 1921, the Anuario *de Eusko-Folklore* was published. The beginning of the war in 1936 caused the cessation of activities of the Sociedad de Estudios Vascos until 1978 and also the interruption until 1955 of the publication of the *Anuario de Eusko-Folklore*, although this did not impede the journal from becoming a reference point for Basque ethnology. Barandiarán lived in exile in Sara (Lapurdi) from 1936 until 1953.

clashing objects, may be the most spontaneous of musical expressions and can accompany activities of work, ritual, or pleasure. The use of taut membranes requires a process of previous elaboration, even if only a basic drum and the simplest aerophones as well as string instruments require a certain skill and planning in their manufacture.

The appropriate activities of musical archaeology are to discover and reconstruct tools of sound, to study rock paintings in as much as they represent instruments or dances, and to examine cave acoustics. In view of the lack of other sources, finding musical instruments becomes the most tangible evidence; however, the consideration of an object as a musical instrument is sometimes doubtful. Bones, shells, stones, and surrounding or useful objects for daily use have been conserved for millennia, but these improvised instruments cannot be recognized as such. In order to be considered musical instruments, along with rigorous dating, it is essential that they show characteristics of an artifact made for such a purpose.

Given that various animals can be responsible for marks and perforations on bones and horns, attention to holes, parallel cuts, straight or curved marks, and other details must be made to ensure the unquestionable human elaboration of the object. Although many cases have been considered and discussed in Europe, Euskal Herria (the Basque Counrtry) offers two significant finds: a flute in Isturitz[2] and a horn in Atxeta.

## Isturitz, One of the Oldest Aerophones in Europe

The aerophone of Isturitz is the most important find in Basque prehistory and also one of the oldest in European musical

---

[2] Although Euskaltzaindia (the Basque Language Academy) recommends the use of toponyms like Izturitze or Isturits, following the use of available sources, here we will use Isturitz when writing about the flute.

archaeology. The Laminazilo de Isturitz cave in the North Pyrenees is located in Donamartire (Saint-Martin-d'Arbéroue, Lower Navarre). Already in 1895 it sparked archaeological interest when, during excavations for phosphates, workers found numerous primitive objects in the cave, which was then systematically studied from 1912 on by the archaeologist Emmanuel Passemard.[3] In 1923 he published his find of the fragment of a flute made from the bone of a bird without epiphysis, which at that moment was the oldest known. Diverse later excavations allowed for a more precise stratigraphy as well as the unearthing of more than twenty aerophones.[4] Toward the end of the twentieth century, Dominique Buisson[5] completed an individual detailed study of the finds, and despite doubts, attributes only the first flute to the Auriñaciense period (between 32,000 and 28,000 years ago), while the other finds come from later cultures.

On the other hand, while the aerophone of Isturitz was the oldest of its kind found in Europe, it also inspired some narrative exaggerations, like imagining that this *txistu* (Basque three-holed pipe) was the first instrument of humankind.[6] However, research by later authors like Karlos Sánchez Ekiza and José Ignacio Ansorena Miner displayed the necessary rigor needed to address the study of the *txistu* and its history. Concerning the aerophones of Isturitz, the experiments carried out by

---

[3] See Emmanuel Passemard, "Une flûte Aurignacienne d'Isturitz." in *Congrès de l'Association Française pour l'Avancement des Sciences 46e session* (Montpellier: 1923), 474–76.

[4] Like those carried out by the couple René and Suzanne de Saint-Périer over a period of three decades.

[5] Dominique Buisson, "Les flûtes paléolithiques d'Isturitz (Pyrénées-Atlantiques)." *Bulletin de la Société préhistorique française* 87, nos. 10–12 (1990), 422.

[6] See Hilario Olazarán de Estella, "El txistu. ¿Primer instrumento de la humanidad?" in *La Gran Enciclopedia Vasca*, vol. 1 (Bilbao: La Gran Enciclopedia Vasca, 1966), 157–62.

archaeologists Carlos Mazo Pérez, Carlos García Benito, and Marta Alcolea Gracia[7] are of interest. They reproduce one of the found pieces in order to study three options of how the objects could produce music: one as a bezel terminal (oblique flute), another as a reed instrument (clarinet), and a third as instrument with mouthpiece/lips (trumpet). According to the authors, the three options offer interesting timbres and scales, but the first and third option offer great difficulties in execution, and the second requires the making of reeds. Basically, no option can be ruled out, and the three options require certain technical control to be interpreted. However, the first option, as a flute, offers the most sonorous possibilities.

## The Adarra of Atxeta and Other Finds

Between 1959 and 1960 Barandiarán carried out excavations in a deposit that he discovered in the cave of Atxeta in Forua, Bizkaia. There, he found a three-ponited deer's horn identifiable as a sonorous instrument, known as the *adarra* ("horn" in Basque) of Atxeta. The peculiar stratigraphy of the cave complicated dating the aerophone, at first placing it in the Bronze Age between 2000 and 1000 B.C. and later in the Aziliense between 9000 and 8000 B.C. In later revisions, experts like Pilar Utrilla Miranda,[8] remark on the difficulty in assigning an exact date to the cave finding with any definite conclusions.

Problems of dating and identification can also be seen in other finds that, despite difficulties in functional interpretation, are objects of interest. Among those that can be mentioned

---

[7] Carlos Mazo Pérez, Carlos García Benito, and Marta Alcolea Gracia, "Un caso de Arqueología Experimental aplicado a la Arqueología Musical," *SALDVIE* 15 (2015), 65–91.

[8] Pilar Utrilla Miranda, "El Magdaleniense inicial en el País Vasco peninsular," *Munibe* 28, no. 4 (1976), 245.

are the stone whistles found in the dolmens of Aizibita in Zirauki (Cirauqui, Navarre), Faulo (Biotzari-Bigüézal, Navarre), and Ereñuko-Arizti (Ereño, Bizkaia). Utrilla, Carlos Mazo, and José Ignacio Lorenzo[9] mention a skull found in the cave of Abauntz (Navarre), which contained in its right eye socket a jet necklace with a T-like perforation resembling a whistle, identical to that found in the cave of Ereñuko-Arizti. Both were found mixed with material from the Late Roman Empire. They also note that Mª Amor Begulristáin Gúrpide and David Velaz[10] date five similar but larger whistles from the Calcolithic period, which were found in the Navarrese dolmen of Aizibita.

## Music between Battles: Complicated Times and Lack of Information

When we speak about the music of a nation, certain features stand out, yet musical cultures change and the repertory becomes modified—more so in the oral tradition—because the understanding of organized sound, scales, intervals, timbres, and rhythms are the result of cultural agreements that evolve. Transformation is characteristic of every culture, and traditions are immersed in a continuous process of encounter, loss, assimilation, and evolution. Moreover, complex geographic and social relationships characterize these first centuries of history, of which we have only scarce and imprecise references, at times adorned with ingredients of little rigor coming from ideologies or

---

[9] Pilar Utrilla, Carlos Mazo, and José Ignacio Lorenzo, "Rituales funerarios en el calcolítico de Abauntz. Un ejemplo de lesión con supervivencia," *SALDVIE* nos. 13–14 (2014), 304.

[10] See Mª Amor Begulristáin Gúrpide and David Vélaz, "Objetos de adorno personal en el dolmen de Aizibita (Ciaruqui, Navarra)," *Cuadernos de Arqueología Universidad de Navarra* 6 (1998), 7–31.

fantasies, such that very often the problem is to discern and reveal that which is the most likely.

Thus, for a description of musical activities in Euskal Herria in Antiquity and the Middle Ages, we must consider different dating processes and perspectives.

The possibility of writing initiated the Classical Age, which ended with the fall of Roman Empire in the fifth century, the moment in which traditionally the beginning of the Middle Ages is placed. It lasted a millennium, up to the capture of Constantinople by the Ottoman Turks in 1453. The remoteness of the fall of Byzantium prompts some authors to revise the political and social situation of Euskal Herria by connecting the date of the end of the Middle Ages with the submission of Navarre to peninsular union in 1512. Nevertheless, in the domain of musical activity, Maricarmen Gómez Muntané[11] considers that the date of the marriage between Isabel of Castile and Fernando of Aragón (1464) could very well indicate the end of the Medieval music and the beginning of Renaissance music in the peninsula. José Antonio Arana Martija,[12] on the other hand, argues on a local level and considers 1450 a key date in the independence of polyphonic vocal music in Euskal Herria. During the second half of the fifteenth century, the musical Renaissance would begin with the influence of the Franco-Flemish school, and the Modern Age would begin. At the end of the fifteenth century, Euskal Herria took to ships and discovered a new course on the American continent.

We must understand that, in trying to reconstruct Basque music from Antiquity and the Middle Ages, territorial and

---

[11] Maricarmen Gómez Muntané, *Historia de la música en España e hispano América*, vol. 1, *De los orígenes hasta c. 1470* (Madrid: Fondo de Cultura Económica, 2009), 16.

[12] José Antonio Arana Martija, *Música vasca* (Bilbao: Caja de Ahorros Vizcaína, 1987), 39.

geographic questions are as decisive as they are confusing. On the one hand, population nuclei were beginning to appear and with them, social, economic, and religious differences between rural and urban areas, and at the same time similarities and union like language, folklore, crafts, games, and food. On the other hand, we must bear in mind that the territories that comprise Euskal Herria were not connected to each other in the same way during the Roman period as in subsequent centuries. The artificial fixed borders that we are able to consider after both victories and defeats are themselves the result of historical dynamics starting from the Middle Ages.

Although the average altitude of the Iberian Peninsula is one of the highest in Europe, and the roads that crossed the mountains of Euskal Herria were few and tortuous and often impracticable because of wind, rain, and snow, due to its location, people could not live in isolation. The Atlantic coast as a limit and an extension, and mountains and valleys serving as open land toward the peninsula and the heart of Europe, demarcate and identify the Basque-speaking country. The Cantabrian Sea was used for food and was progressively better navigated. The Pyrenees were both a border and protection, and their passes arteries of communication. Aquitanians, Basques, Varduli, Caristii, and Autrigones populated the area. Barandiarán[13] remarks that, despite Basque domination, the Celts passed through Roncesvalles (Orreaga) in about the seventh century B.C. and occupied a few locations of strategic interest and villages in Navarre, Araba (Álava), and La Rioja. The Roman presence was evident already from the second century B.C. and would be

---

[13] José Miguel de Barandiarán, *El hombre primitivo en el País Vasco* (Zarauz: Itxaropena, 1934), 99.

strengthened by the founding of urban nuclei[14] both north and south of the Pyrenees along with the corresponding means of communication. In order to imagine these populations in the Roman period, Barandiarán[15] describes how the population organized itself by concentrating or dispersing according to geoeconomic factors. Thus, the important populations in the area of the Rioja part of Araba and the Ribera region of Navarre show a predominance of the population concentrated in nuclei distant from each other, unlike the planes of Araba, where density and distance were less, while in other areas organization was more dispersed and dependent both on the coast and on villages as centers of agricultural and livestock rearing, as these were situated near rivers and means of communication between valleys.

## Musical Activities

The Basque repertory that we preserve in museums and in the streets constitutes a special patrimony characterized by unique elements. But to speak of specificities and characteristics at the dawn of history is very complicated because the study of music in Antiquity and a large part of the Middle Ages, not only in Euskal Herria but also in Europe, confronts a scarce or nonexistent record of musical accomplishments. Non-written musical notations were dominant until the ninth century, the moment at which, by consensus, the presence of a system of musical notation dominant in Europe can be dated. Although earlier systems of notation are believed to exist, the lack of evidence makes it

[14] Such as *Pompaelo* (Pamplona-Iruña, Navarre), *Oiasso* (Irun, Gipuzkoa), and *Imus Pyrenaeus* (Saint-Jean-Pied-de-Port-Donibane Garazi) and *Beneharnum* (Lescar), both in Aquitaine.

[15] José Miguel de Barandiarán, "Breve historia del hombre primitivo," *Anuario de Eusko-Folklore* XI, 1931; reprint, in *Obras completas*, vol. 10 (Bilbao: La gran enciclopedia vasca, 1976), 394–96.

difficult to imagine aspects of musical activity in Euskal Herria, detracting from the rigor of its reconstruction and transform into fanciful thinking the concept of music as developing and continuing from Antiquity to our present.

Thus, instruments, iconographic documents, and written sources that mention musical activities became silent informants that allow us to imagine music played in remote periods of time. In broad outlines, we presuppose the use of precompositional patterns and other common general characteristics of western music, like the use of metric feet and the development of melody in a reduced range of the usual spectrum of musical forms. Common popular music remains in the hands of oral tradition associated with musical use and dominated by spontaneous creation, improvisation, variety, and memory in a repertory of songs and ritual dances, songs of love and games, lullabies, and songs related to work that accompanied rural labor, rhythmically controlling movements and making the task easier.

The Roman presence in Euskal Herria would leave its mark, although it remains largely unrecognized in musical life. Despite the beauty of finds like the fourth-century octagonal Roman mosaic in Arellano (Navarre), also known as the Villa of Muses, which shows a muse strumming a lyre and a musician playing a flute, there are no dates. Also, carnivals have been connected to Roman Saturnalia between the fifth century B.C. and the fifth century A.D. Yet despite indicating links between Greek mythology and Basque mythology—for example, between the Greek Polyphemus and Basque Tartalo, which can be explained by cultural exchange[16]—there remains no evidence to prove this relationship. Suppressed and proclaimed throughout history, the various theories about the origin of these festivals have gained and lost credit. The panorama invites us to consider the notion that

---

[16] Ibid., 406.

ancestral rituals and celebrations made expressive use of mime, masks, and ruckus accompanied by music and dance. And because they coexisted, pastorals and carnivals offered a sort of counterweight to each other in which the explanatory, exemplary, and reflexive character of the pastorals contrasted with the lively, spontaneous, and energetic character of the carnivals. What is sure is that slowly and until the fifteenth century, pagan myths and rituals were mixed with an increasingly prominent Christian Church and that Christian criteria catechized and converted pagan rites into heresy and cleansed society according to its values.

## From Writing to the Fifth Century: Basques, Romans, and Others

We find the first written record of Basque music in Strabo's *Geography*, a huge work written around the first century. Although the great geographer and historian never visited the territory, his documentation is considered relevant for the study of Basque Antiquity. Thus, Barandiarán[17] evaluates the ancient descriptions from an anthropological viewpoint when he analyzes initiative and liberty as the origin of differences between people. Strabo (7 B.C.–19 A.D.)[18] writes about mountain dwellers, including the people of Euskal Herria, referring generally to the people of the north, and stating that there were "Callaicans, Asturians, and Cantabrians as far as the Basques and the Pyrenees," and others like the Pleutaurans, Bardyetans, and the Allotrigans, who all have a similar life style. About their habits he says they normally drink water, sleep on the ground, wear their hear long "like women," although when they go to war, they tie it in front with a strip. They make offerings of meat, captives, and horses to the god of war

[17] Ibid., 391.

[18] See Estrabón, *Geografía*, book 3, chap. 3, no. 7, trans., intro., and notes by Mª J. Meana and F. Piñero (Madrid: Gredos, 1992), 85–87.

and participate in sports and gymnastic competitions related to combat. A good part of their diet is made up of bread made from the wheat of acorns. He makes no reference to fish but does mention goat meat. Neither does he mention cider and says they normally drink water, but they are familiar with beer and wine, although the latter they seemingly drink quickly at banquets with their relatives. They use butter, not oil. They eat sitting on benches against a wall arranged by age and rank, and when it comes time for drinking, they dance in a circle to the sound of a flute and trumpet.

A certain pleasure in imagining a contemporary instrument placed in musical settings of antiquity, or the value that something spreads through history as an instrument of culture, has led such diverse authors as José Antonio Arana Martija and Jorge Oteiza to wonder if today's *txalaparta* (an instrument consisting of wooden blocks) could be part of that history. Indeed, its traditional construction does not require any special tools or knowledge of musical organology; it is made of one or two planks on supports and four *makilas* or drumsticks, for which reason it is probable it was a combination similar to a percussion instrument. It is the same story with the *tobera* and the *kirikoketa*, which are derived from work tools: an iron rod for the *tobera* and striking tools or harvest cutting tools for the *kirikoketa*. Moreover, documentation about the Romans mentions the ringing of the crowbars that may be similar to the ringing of the *toberas*. But documentation directly related to *toberas* and *txalapartas* dates from the seventeenth and nineteenth centuries, respectively. Antxon Aguirre Sorondo gives two documented testimonies in Gipuzkoa:[19] one about the permit for the sale of cider in Arrasate-

---

[19] Antxon Aguirre Sorondo, "Sidra," *Enciclopedia Auñamendi*. In his article, the author refers to Gonzalo Martínez Díez, et al. *Colección de Documentos Medievales de las villas guipuzcoanas (1200–1369)* (San Sebastián: Diputación Foral de

Mondragón in 1342 and the other about the importance of the production and sale of cider in the Municipal Ordinances of Segura, approved in 1348.

## From the Fifth to Ninth Century: The Fight for Religious and Territorial Power

After the fall of the Roman Empire in the West in 476, power in Europe rested in the hands or feudal governors and in the church. The unity of the Basques to the north and south of the Pyrenees, flanked by Visigoths to the south and Franks to the north, created one of the areas of passage from Gaul into Hispania; the Basques also faced attacks from Barbarian tribes.

Between the fifth and eighth century, the territory was involved in numerous internal and border wars and innumerable clashes and alliances between Basques, Franks, and Visigoths. For this reason, the warriors on whose battles the new kingdom depended enjoyed great power in an archaic society with diverse cultural influences.

In its mission of integration, the church introduced religious festivals that coincided with cosmic cycles related to the calendar for sowing and harvesting, becoming celebrations that replaced the worship of pagan gods with those of the saints, and promoting the creation of its own repertory for its churches. Thus, and keeping in mind the importance of the church in questions of medieval music, Arana Martija divides the Middle Ages into two periods:[20] the first, lasting from the sixth to the thirteenth century, in which the Gregorian chant dominated; and the second, in which the *organum* appeared, which set the stage for modern polyphony. But we should not think of this medieval

---

Gipuzkoa, 1991), at: http://aunamendi.eusko-ikaskuntza.eus/es/sidra/ar-109880/ (last accessed December 9, 2017).

[20] Arana Martija, *Música vasca*, 39.

ecclesiastical repertory as being definite, homogeneous, and uniformly established. It was not that way, even if the intention was so. The initial liturgical repertory was the monodic chant in Latin used in the offices and in mass, a heterogeneous group of works that evolved both as regards texts as well as music and the diversity of which did not favor ecclesiastical unity.

The Christian rite included Greek practices altered by Ambrose of Milan, Pope Gregory I, and Charlemagne, and from the sixth century on, the Gregorian chant would gradually dominate vocal music. The importance of Navarre was unquestionable in this environment, and the founding of the diocese of Pamplona in 589, and on record since the third council of Toledo, brought along changes in the repertory by introducing a new repertory and prohibiting existing ones considered inappropriate.[21] And in the homeland, while from the south the Visigoths tried to conquer territory from the Basques, in the north the Basques allied themselves with the Aquitanians in order to defeat the Franks. In the seventh century, Liuvigild, the Visigoth king, and Chilperic, the Frankish king, negotiated the borders of the Duchy of Vasconia.[22] The development of territorial fighting and advance of Christian expansion continued up until the beginning of the eighth century.

Arab expansion arrived in the north after conquering a great part of the Iberian Peninsula while the Visigoth Kingdom became fragmented as the Frankish Kingdom became stronger. At this moment, as Iñaki García Camino notes,[23] unity among the

---

[21] María Gembero-Ustárroz, *Navarra. Música* (Pamplona: Gobierno de Navarra, 2016), 16. The author quotes this fact based on the research of Higinio Anglés and José Goñi Gaztambide.

[22] Arana Martija, *Música vasca*, 40.

[23] Iñaki García Camino, "Historia del País Vasco. Edad Media," *Enciclopedia Auñamendi*, at: http://aunamendi.eusko-ikaskuntza.eus/es/historia-del-pais-vasco-edad-media/ar-154220/.

Basques shattered: some participated in the creation of the Kingdom of Pamplona, or in the Kingdom of Asturias, while some converted to the Muslim faith and governed the upper borders of Al-Andalus, and others joined the Franks of the Carolingian Empire.

The Muslim presence did not leave a specific trace of the popular music of Euskal Herria. Although it is tempting to posit a relationship of the *alboka* (hornpipe) with Arab instruments similar in name and construction,[24] there is no proof of this; still, comparisons can be made between various reed wind instruments that use a horn for amplification and for an air chamber in order to make the reed vibrate. These instruments are very widespread on the European continent and innumerable variants are found in the Mediterranean basin. According to Jose Antonio Donostia,[25] the first data collected about the *alboka* go back to 1443 and Esteban de Garibay y Zamalloa, a sixteenth-century historian and royal chronicler who published his *Compendio Historial* in 1571, supports the data. In this work he mentions that the *alboka* was used along with the small drum and tambourine in dances and songs in Arrasate-Mondragón (Gipuzkoa). Similarly, on the main façade of the Romanesque parish church of Santa María Magdalena in Tutera (Tudela), Navarre, we find carved a wind instrument very similar to the *alboka*. This would place this family of instruments in the twelfth century.

Another fact connects Basque music with the Muslim world in the person of a slave called Kalam from the court of Abderraman II during the first half of the ninth

---

[24] Such studies go back to the first decades of the twentieth century, as in the case of Telesforo de Aranzadi, "Alboka y albogues. Dos piezas para un banco musical-transfilológico," *Euskal-Erria* 74 (1916), 152–58.

[25] José Antonio de Donostia, *Obras completas,* vol. 2, articles 58–78 (Bilbao: La gran enciclopedia vasca, 1983), 280.

century. Arana Martija[26] cites the report that historian Carmelo de Echegaray (1865–1925) takes from the Arab writer Al-Makari, who writes of the slave's perfect singing, his exquisite elegance, urbanity, and culture. María Gembero-Ustárroz[27] notes that there is no specific research on the musical activities of the Muslim or Jewish communities, although she cites Hebrew poets from Tutera in the eleventh and twelfth centuries, in Hebrew and in the Romance languages probably were sung with music. She also cites Jewish minstrels active in the court of Carlos II of Navarre.

## Court and Religious Music. From the Ninth to the Eleventh Century: The First Musical Texts

At the end of the eighth century, the Kingdom of Navarre, with Iñigo Arista or Eneko Aritza as first monarch, was developing. The Crown of Navarre remained the only independent territory until 1512, but during the early years of the monarchy, political and cultural relations maintained with Muslims, other Christian kingdoms on the peninsula, and the French regions nearby—which would be of great importance in musical life—favored the necessary hybridization and mixing to establish the foundation for the Renaissance in the area.

The oldest source of court music preserved is the epithalamium of Leodegundia. This deals with a literary composition in honor of the daughter of King Ordoño I of Asturias, who, in the mid-ninth century, married the King Fortún Garcés of Pamplona. We have a copy (in Visigoth neumes that cannot be transcribed) dating from the late tenth century or early eleventh century. Written in Latin, it consists of twenty-nine

---

[26] Arana Martija, *Música vasca*, 44.

[27] Gembero-Ustárroz *Navarra. Música*, 44.

stanzas in three non-rhyming verses. Only the first stanza includes musical text, which might indicate that the same melody was used throughout. Arana Martija includes some references about music and instruments of the time that are in the text itself:[28] arpeggios for flute, clapping of hands, sweet praises, a harmonious chorus, pleasant harmonies, zither players who use plectrums, mellow tibia, resonant lyres, and gentle pipes.

The influence of an established court and religious society was felt in the popular repertory, and the wandering lifestyle of many professions brought foreign repertories to the municipalities. But the information we can glean from those centuries is scarce and also contradictory not only for music, but also for territorial themes. Two documents now considered apocryphal offer an example:[29] a letter dating from 980, and attributed to the bishop of Baiona (Bayonne, Lapurdi), Arsius (Arsivus Racha), who documents under his jurisdiction various valleys among which we find Oiartzun (Gipuzkoa); and a diploma dating from 1027 relating to the reconstruction of the cathedral of Pamplona, which includes Oiartzun in its diocese.

In regard to the language that prevailed over the popular and secular repertory, we understand it to be Basque, but the diffuse territorial borders allowed for trade and other influences. Besides, in the ninth century an important growth in demographics and settlements took place. The languages that surrounded the Basque territory were Romance languages, and in urban centers Euskara (Basque) coexisted with languages and dialects spoken by people who arrived in the territory, attracted by

---

[28] Arana Martija, *Música vasca*, 43. See also José Antonio Arana Martija, "Historia de la Música en Euskal Herria," *Enciclopedia Auñamendi*, at: http://aunamendi.eusko-ikaskuntza.eus/es/historia-de-la-musica-en-euskal-herria/ar-79408/.

[29] Sagrario Arrizabalaga Marín and Lourdes Oyarbide Odriozola, *Historia de Irún* (Irún: Ayuntamiento de Irún, 2014), 46.

the Camino de Santiago de Compostela or for political reasons: Occitan, Romance, Navarrese, Hebrew, and Arabic as well as Castilian and French would coexist through the centuries around the Basque language.[30]

## Christianization and Repertory

Without a doubt, religious music provides the most information on musical life in the Middle Ages. During the early centuries, there were diverse liturgical variants in Europe with their corresponding types of monodic chant in Latin. Starting in the eighth century, the Roman rite prevailed, driven by Charlemagne with the idea of unifying all rituals, and extended with this melodic Gregorian chant system, would influence secular compositions as well.

Despite the various theories about the chronology and extent of Christianization in the Basque territory, it is possible that the process of Christianization took place unevenly. Carmen Rodríguez Suso notes, furthermore, the necessity to distinguish between organized ecclesiastical life and the diffusion of Christianity.[31] This is because, besides the possible existence of Christian centers without any established public, the documentation of the bishoprics does not show that the bishops were successful in calling the scattered Basque population to the rite. Most probably, there was no mass conversion, and in mountainous and rural areas religion was much more diffuse than in the urban municipalities.

---

[30] Using a non-standardized language rich in oral tradition, Bernart Etxepare is considered the first Basque writer to publish in Euskara. His *Linguae Vasconium Primitivae* (1545) included the famous the phrase "Euskara, jalgi hadi mundura" (Euskera, show yourself to the world).

[31] Carmen Rodríguez Suso, *La monodía litúgica en el País Vasco*, vol. 1 (Bilbao: Bilbao Bizkaia Kutxa, 1993), 10–14.

Records from the end of the ninth century, indicate that there was an early bishop of Araba who was from Castile,[32] and there were at least two more in Navarre. The bishoprics orchestrated a growing religious organization, to which we should add the increase of monasteries from the tenth century on. From the ninth century onward, the religious life of Basque Christians remains documented, although their moderation and paganism would cause the inhabitants of the area to be labeled "impious" in the twelfth-century *Liber Sancti Jacobi* (Book of Saint James).[33]

The Hispano-Visigoth rite started to disappear with the implantation of the Roman-French rite decreed by the Council of Burgos in 1081, and during the next one hundred years a complete change of the liturgy would take place. The Basque territory found itself under Gallic, Iberian, and Navarrese influence, and the latter was one of the last kingdoms on the peninsula to give up the Visigoth rite. This prohibition involved the invalidation of deep-seated ritual customs and the disqualification of its gestures and expressions of communication. The role of the Cluniac monastic order was very important in spreading the Roman cult, not because of its innovative tendencies in liturgical matters, but because the order formed relationships with social powers as it thought convenient. Founded in the tenth century, the order stood out for its ties to the court and maintained contact with Sancho the Great, King of Navarre, between 1004 and 1035, a relationship that later would lead to the appointment of French monks to bishoprics in Navarre.

In disagreement with the suppression of the Hispano-Visigoth rite, in 1072 the episcopate sent four of its own liturgical books, from monasteries in the surrounding area, to Pope

---

[32] Arana Martija, *Música vasca*, 46.

[33] Rodríguez Suso, *La monodía litúgica en el País Vasco*, vol. 1, 14.

Alexander II: *Liber Ordinum, Missarum y Oratorium*, and an Antiphonarium. The books were analyzed and considered Catholic and free from heresy; however, in the following year Alexander II died and was succeeded by Gregory VII, who would decide to abolish the Hispano-Visigoth rite in 1078.[34] The centralization of ecclesiastical power in Rome would be the main mission of the new pope, and his objective the standardization of the repertory. In the late eleventh century, the principal religious centers of Navarre had already adopted the Roman rite, although this would not happen in Araba until the mid-thirteenth century. The Roman rite spread to the north in the fourteenth century, and another half century was needed for it to be established definitely in Bizkaia. We need to look for the reason for this in the relationship between the clergy and the Basque nobility, in which the tithe given to the clergy did not come from the faithful but from the nobles, as well as in the persistence of jurisdictional systems that prohibited the entry of bishops and priests into the territory.[35]

## The Development of Music and Musical Instruments. Eleventh–Thirteenth Centuries: The Evolution of Repertories and Notation

In order to understand the subsequent evolution of musical practice in Euskal Herria, it is important to keep in mind the presence of the Gregorian repertory since the twelfth century and with it the theory and modal practice of composition. As Rodriguez Suso suggests,[36] the intersection between Roman

---

[34] Arana Martija, *Música vasca*, 46.

[35] Rodríguez Suso, *La monodía litúgica en el País Vasco*, vol. 1, 21.

[36] Carmen Rodríguez Suso, "El canto litúrgico romano y la música vasca. Una intersección decisiva en la historia de nuestro lenguaje musical," *Nuevas*

liturgical chants and Basque music is decisively connected, in the post-medieval era, to the polyphony of Juan de Anchieta (1462–1523). As the Middle Ages advanced, so court music became favored because of economic prosperity and the relations established by the governors in order to strengthen their power in the territory. At the same time, religious music spread as the church expanded its presence by constructing monasteries and churches.

Despite the mystery surrounding the beginnings and the process of normalization of the use of musical notation, manuscripts found from the eleventh century demonstrate the evolution of musical writing. To interpret the compositions, besides connecting notation and text in form and content, we must keep in mind other factors like the type of ritual, the location, and the function of the composition. Hispano-Visigoth notation is neumatic, and the graphic marks are written above the literary text adiastematically, that is, without lines referring to height. Each neume can represent one or more sounds and also has innumerable variants, so the interpretation of the piece depends on training and memory, and actual understanding of it turns out to be more improbable than in the case of more advanced notations. Increasingly more precise forms included Aquitanian, gothic, and squared notations, which provided for the use of one or various lines to represent the relative height of the notes.

Some of the best-known manuscripts dating from the late twelfth and early thirteenth centuries that display Aquitanian notation include the *Libro de la Jura*, the *Evangeliario de Roncesvalles*, the *Sacramentero de Fitero*, and the *Breviario de Irache* (the latter thought to date from the fourteenth century), but there are countless more. It is interesting to note that

---

*formulaciones culturales: Euskal Herria y Europa. XI Congreso de Estudios Vascos* (Donostia-San Sebastián: Eusko Ikaskuntza, 1992).

Rodríguez Suso, in her detailed study of liturgical monody in the Basque Country, provides 865 fragments of texts—some dating from later—of which 472 are in Aquitanian notation, one in gothic (from the fifteenth century), 385 in squared, and seven in measured notation. [37]

For an in-depth study of medieval manuscripts, the research of the Catalan musicologist Higinio Anglés (1888–1969) continuously offers indispensable information.[38] Also worthy of note are the studies of Mª Concepción Peñas García in Navarre (2004) and Maider Valdivielso Zubiria in Araba (2007).[39]

## From the Thirteenth to the Fifteenth Century: Polyphony and Instrumental Richness

From the second half of the thirteenth century on there is evidence in Navarre of sacred polyphony under the influence of the Nôtre Dame school of polyphony. This is not surprising considering the French influence in the territories of the Pyrenees and France's direct presence though French dynasties occupying the throne of Navarre. Although there is also information on sacred polyphony in Araba and Baiona, Navarre stands out above the rest because of its contribution of the minima note, a shorter measure than the existing ones (*maximum, long, brief,* and *semibrief*); the necessity of new notes indicates innovative

---

[37] Rodríguez Suso, *La monodía litúgica en el País Vasco*, vol. 2, 474.

[38] See for example Higinio Anglés, *Historia de la música medieval en Navarra,* Publicaciones de la Institución Príncipe de Viana 37 (Pamplona: Diputación Foral de Navarra, 1970).

[39] Mª Carmen Peñas García, *Fondos musicales históricos de Navarra. Siglos XII– XVI* (Pamplona: Universidad Pública de Navarra, 2004); Maider Valdivielso Zubiria, *Inventario de libros manuscritos de música sacra existentes en el Territorio Histórico de Álava* (Vitoria-Gasteiz: Arabako Foru Aldundia, 2007).

ideas. Navarre could also boast of a significant presence of musicians at the court.[40] The compositions of one of the most important musicians in the Middle Ages and a representative of the French *Ars Nova*, Guillaume de Machaut, were collected at the court of Charles II of Navarre (1349–1387). This monarch stands out for his interest in the music of the day and for hiring and exchanging musicians whom the documentation locates in French, Spanish, German, and English territory. His attitude would set a trend, and his successor, Charles III, would also be conscious of the importance of music as an element in portraying power accompanying the king in his official trips with colorful uniforms. Pamplona, the standard bearer of musical culture of the time, would have wide-ranging influence.

The importance that music would acquire for religious authority is reflected both in the attention to musical life in churches, monasteries, and cathedrals and in the iconography adorning the buildings. The very post of chanter or master cantor, created to carry out duties in the musical domain in important religious centers, testifies to the interest in taking care of and directing the repertory. The iconography present in religious architecture is furthermore an important source for the study of musical instruments, not only in the religious domain but also in the courtly and popular spheres. In the case of Navarre, we should keep in mind the many churches and monasteries, such as the monastery of Santa María la Real de la Oliva or the very Cathedral of Pamplona, to name but two. The systematic study of its iconography, driven by its Capilla de Música, reveals more than a hundred medieval instruments that adorn the cathedral of the capital of Navarre, which was constructed in the early twelfth century. The Cathedral of Baiona, constructed between the late

---

[40] See Hygini [Higinio] Anglés, *Studia musicologica III* (Roma: Edizioni di storia e letteratura, 1976), 1145–1146, 1323–1324. See also Johann Nikolaus Forkel, *Allgemeine Geschichte der Musik*, vol. 2 (Leipzig: Schwickert, 1801), 418.

thirteenth and early fourteenth centuries, also offers an interesting iconography, which was studied by Thierry Trufaut in the late 1980s. Innumerable other churches would enlarge the list like those of Santa María la Real in Guardia (Laguardia, Araba), Santa Maria in Lekeitio (Bizkaia), the old Cathedral of Vitoria-Gasteiz, the parish of Deba (Gipuzkoa), and the church of Santa Grazi-Urdatx (Sainte-Engrâce) in Zuberoa, among many others. The instruments represented are numerous: from the moveable organ to the many string instruments like pyriform guitars, zithers, and harps; bowed instruments like the violin, oval viola, and rebec; and others, like the turning instruments that remind us of the contemporary hurdy-gurdy, as well as struck instruments like the *ttun-ttun* or string drum. The wind instruments also offer a wide range among them: horns, trumpets, simple and double flutes, reed instruments with conical tubes, utricular bagpipes, and the *txistu* and small drum duo.

Toward the mid-thirteenth century, the Riojan poet Gonzalo de Berceo, in his verses to the Virgin, mentions some musical instruments:

Nunquo udieron omes órganos más temprados,

Nin que formar pudiessen sones más acordados.

Unos tenien la quinta, è las otras doblaban,

Otras tenien el punto, errar non las dexaban,

Al posar, al mover todas se esperaban,

Aves torpes nin roncas hy non se acostaban.

Non serie organista nin serie violero,

Nin giga nin salterio, nin manoderotero,

Nin estrument nin, lengua, nin tan claro vocero,

Cuyo canto valiesse con esto un dinero.[41]

---

[41] Gonzalo de Berceo, stanzas 7, 8, and 9 of those dedicated to "Milagros de Nuestra Sennora," in Tomás Antonio Sánchez, *Coleccion de poesias castellanas*

The text makes reference to the organ, which was present in the musical life of that time, and to possible instruments constructed by a viola maker, a prestigious profession on the Iberian Peninsula, dedicated to the manufacture of string instruments. Berceo goes on to mention the gig (a bowed string instrument) and the psaltery (a string instrument like the zither and associated with minstrels). It is not clear whether the *manoderotero* is an instrument—such as a hurdy-gurdy, or perhaps a type of aerophone—or refers to the interpreter or to the hand of the director. But as Felipe Pedrell observes, Berceo not only offer, an enumeration of instruments, but also mentions a sample of the art of making polyphony.[42]

## Troubadours, Minstrels, Poets, and Singers

Written and oral literature that acts as a support for sung music would prevail up until the development and expansion of written music. At the same time, lyrics often become the sole witness to songs, popular songs, ballades, and improvisation. The presence of troubadours in Euskal Herria followed the trend in Europe, although the first news of such figures dates from much later. Donostia mentions some of the numerous troubadours who, from the late twelfth century on, visited castles and palaces,[43] a presence that would become more prominent around nobles and lords. Among the most legendary troubadours we find a king of Navarre, a descendant of the French counts of Champagne and Brie; Theobald I, the son of Blanche of Navarre and Count

---

anteriores al siglo XV. Ilustradas con algunas notas e índice de voces antiquadas, vol. 2 (Madrid: Antonio de Sancha, 1780), 286.

[42] Felipe Pedrell, *Organografía musical antigua española* (Barcelona: Juan Gili, 1901), 121.

[43] Donostia, *Obras completas*, 7. The author cites as a reference the work by Joseph Anglade, *Les troubadours provençaux en Biscaye* (1928).

Theobald of Champagne. He governed from 1234 to 1253, and from the beginning had a special interest in the areas of Araba and Gipuzkoa. As a troubadour, he left a religious and amorous repertoire that included jongleur-like activity and strengthened the French influence. As king, he supported the presence of troubadours at his court, who in turn would take the king's compositions and interpretations to other palaces. He was succeeded by his son, Theobald II (1253–1270), another poet king and troubadour of carnal love and religious devotion, but he would not equal the stature of his father.

The oldest poems from the oral tradition that have been preserved date back to the fourteenth century, and the vast majority are epic songs that relate, in poetic fashion, war events and exploits of heroes and characters considered admirable. The first reference work to study them was that of Esteban de Garibay (1571). More recently, in the 1980s there was renewed interest in Basque ballades and songs, with several anthologies and studies published, such as "Euskal lirika gortesauari buruzko oharrak" (1980) by Ion Kortazar, *Ahozko Euskal Literatura* (1982) by Juan Mari Lekuona, and *Euskal baladaren azterketa eta antologia* (1983) by Joseba Lakarra, Koldo Biguri, and Blanca Urgell.[44] The most quoted examples are the ballad of *La Batalla de Beotibar* (1321), *La Batalla de Acondia* (1390), *La batalla de Urrejola* (1388–1401), *Sandailia* (fourteenth–fifteenth centuries), *Alostorrea* (early fifteenth century), *El cantar de Aramaio* (1388–1401), *La Quema de Mondragón* (1448), *Olaso* (1450), and a few others from the fifteenth century.

The ballad of Bereteretxe—*Bereterretxen khantoria*—is an example of Zuberoan poetry dating from between 1434 and 1449

---

[44] Ion Kortazar, "Euskal lirika gortesauari buruzko oharrak," *Jakin* 16 (1980): 76–90; Juan Mari Lekuona, *Ahozko Euskal Literatura* (Donostia: Erein, 1982); Joseba Lakarra, Koldo Biguri, and Blanca Urgell, *Euskal baladaren azterketa eta antologia* (Donostia: Hordago, 1983).

and published for the first time in a compilation work titled *Chants populaires du Pays Basque* (1870) by the Zuberoan folklorist Jean Dominique Julian Sallaberry.[45] The poem tells of the death of a knight from Bereteretxe in the civil war between the Agramonteses and the Beaumonteses in the lands of Lower Navarre and Zuberoa. Angel Goicoetxea Marcaida notes the uniqueness of the metaphors in the first stanza that express a person's moral character:[46]

Halzak eztu bihotzik
Ez gaztanberak ezurrik
Enian uste erraiten ziela
Aitunen semek gesurrik

The alder tree has no marrow
Nor cottage cheese bones
I never imagined
that those well born could lie.

The improvised ballad of the Basques, *bertsolaritza* maintains its ancestral flavor, but at present reveal an enormous and complex variety of formulas in its creation. If we reduce the definition of *bertsolaritza* to improvisation of verses at a particular place and for a changing public, the tradition of the *bertsolaris* (the verse improvisers) dates from before the fifteenth century, the moment when improvisation should have been sufficiently established to encounter references with pretensions of control and prohibition in the old fuero (legal code) of Bizkaia (1452). Although written reports are very old, there is

---

[45] Jean Dominique Julian Sallaberry, *Chants populaires du Pays Basque* (1870; Nîmes: C. Lacour, 1992).

[46] Ángel Goicoetxea Marcaida, "Medicina y música popular vasca," *Munibe Antropologia – Arkeologia* 42 (1990), 444.

no evidence of the improvised texts themselves, but there is mention of two types of women improvisers: *erostagileak* ("whiners") and *profazadak* (satirists). Xabier Paya notes how Koldo Mitxelena cites the fifteenth-century improvising women, mentioned by Esteban de Garibay in the sixteenth century.[47] As regards Manuel Lekuona Etxebeguren, he alludes in his article on *bertsolaritza* to the "boastful" lady Usoa de Alós in Deba and, the lady of Lastur emphasizing that none of the women improvisers should be of a lower class.[48] The course of *bertsolaritza* would be entangled among improvised, written, and learned-by-heart songs, and one would have to wait until the nineteenth century to have more information, until the twentieth century to ponder the wisdom of the great *bertsolaris*, and until almost the end of the twentieth century to return to having women's names among the most distinguished protagonists.

## Bibliography

Aguirre Sorondo, Antxon. "Sidra." *Enciclopedia Auñamendi*. At: http://aunamendi.eusko-ikaskuntza.eus/es/sidra/ar-109880/ (last accessed December 27, 2017).

Anglés, Higinio. *Historia de la música medieval en Navarra*. Publicaciones de la Institución Príncipe de Viana 37. Pamplona: Diputación Foral de Navarra, 1970.

———. *Scripta musicologica*. 3 volumes. Roma: Edizioni di Storia e Letterature, 1976.

Arana Martija, José Antonio. *Música vasca*. Biblioteca Musical del País Vasco. Bilbao: Caja de Ahorros Vizcaína, 1987.

---

[47] Xabier Paya, *Antología de Literatura Oral Vasca* (Donostia: Instituto Etxepare, 2013), 192.

[48] Manuel Lekuona Etxabeguren, "Bertsolarismo," *Enciclopedia Auñamendi*, at: http://aunamendi.eusko-ikaskuntza.eus/es/bertsolarismo/ar-13609/ (last accessed April 4, 2018).

————. "Historia de la Música en Euskal Herria." *Enciclopedia Auñamendi.* At: http://aunamendi.eusko-ikaskuntza.eus/es/historia-de-la-musica-en-euskal-herria/ar-79408/ (last accessed January 20, 2018).

Aranzadi, Telesforo de. "Alboka y albogues. Dos piezas para un banco musical-transfilológico." *Euskal-Erria* 74 (1916): 152–58.

Arrizabalaga Marín, Sagrario, and Lourdes Oyarbide Odriozola, Lourdes. *Historia de Irún.* Irún: Ayuntamiento de Irún, 2014.

Aulestia, Gorka. *Escritores vascos.* Vitoria-Gasteiz: Fundación Caja Vital Kutxa, 1996.

Barandiarán, José Miguel de. *El hombre primitivo en el País Vasco.* Zarauz: Itxaropena, 1934.

————. "Breve historia del hombre primitivo." Originally published in *Anuario de Eusko-Folklore* 11 (1931). In *Obras completas.* Volume 10. Bilbao: La gran enciclopedia vasca, 1976.

————. "Excavaciones en Atxeta (Forua, 1960)." In *Obras completas.* Volume 14. Bilbao: La gran enciclopedia vasca, 1980.

Bazán, Iñaki. "La civilización vasca medieval: Vida(s) cotidiana(s), mentalidad(es) y cultura(s)." *Revista internacional de estudios vascos* 46, no. 1 (2001): 105–201. At: https://addi.ehu.es/bitstream/handle/10810/7991/BAZAN%20Vida%20cotidiana%20RIEV.pdf?sequence=1&isAllowed=y.

Beguiristáin Gúrpide, Mª Amor, Mª Luisa García García, Jesús Sesma Sesma, Jesús García Gazólaz, and Mariano Sinués Del Val. "Excavaciones en el dolmen de Aizibita (Cirauqui, Navarra). Campañas de 1991-1992-1993." *Trabajos de arqueología Navarra* 11 (1993): 265–69. At: http://www.navarra.es/NR/rdonlyres/55F48739-E0A8-4347-854A-310429766E4B/325609/16_beguiristain.pdf.

Begulristáin Gúrpide, Mª Amor, and David Vélaz. "Objetos De Adorno Personal en el Dolmen De Aizibita (Cirauqui, Navarra)." *Cuadernos de Arqueología. Universidad de Navarra* 6 (1998): 7–31. At: http://dadun.unav.edu/bitstream/10171/8236/1/CA_0 6_01.pdf.

Beltran, Juan Mari. *Txalaparta*. Donostia: Nerea, 2009.

Berceo, Gonzalo de. "Estrofas dedicadas a los 'Milagros de Nuestra Sennora'." In Tomás Antonio Sánchez. *Coleccion de poesias castellanas anteriores al siglo XV. Ilustradas con algunas notas e índice de voces antiquadas.* Volume 2. Madrid: Antonio de Sancha, 1780.

Buisson, Dominique. "Les flûtes paléolithiques d'Isturitz (Pyrénées-Atlantiques)." *Bulletin de la Société préhistorique française* 87, nos. 10–12 (1990): 420–33. At: http://www.persee.fr/web/revues/home/prescript/arti cle/bspf_0249-7638_1990_hos_87_10_9925.

Departamento de Cultura y Política Lingüística del Gobierno Vasco. *El euskera, en la Edad Media. Corpus Euskera. Euskera, la lengua de los vascos.* Volume 4. At http://www.euskara.euskadi.eus/contenidos/informacio n/argitalpenak/es_6092/adjuntos/EEH/GAZTELAN/ EEH4_CAS.PDF (last accessed January 14, 2018).

Donostia, José Antonio de. *Obras completas.* Volume 2. Articles 58–78. Bilbao: La gran enciclopedia vasca, 1983.

Durán, Rosalía. *La Casa Rural Romana. El Mosaico De Las Musas. Pieza Del Mes, Ciclo 1998.* Madrid: Museo Arqueológico Nacional, 1998. At: http://www.man.es/man/dms/man/actividades/pieza-del-mes/historico/1998-de-la-cueva-al-palacio/6-junio/MAN-Pieza-mes-1998-06-Mosaico-musas.pdf.

Estrabón. *Geografía.* Books 3–4, translated, introduced, and notes by Mª J. Meana and F. Piñero. Madrid: Gredos, 1992.

Forkel, Johann Nikolaus. *Allgemeine Geschichte der Musik.* Vilume 2. Leipzig: Schwickert, 1801. At: https://play.google.com/store/books/details?id=0yWlH Y6GZDQC&hl=es.

García Camino, Iñaki. "Historia del País Vasco. Edad Media." *Enciclopedia Auñamendi.* http://aunamendi.eusko-ikaskuntza.eus/es/historia-del-pais-vasco-edad-media/ar-154220/ (last accessed December 7, 2017).

Gembero-Ustárroz, María. *Navarra. Música.* Pamplona: Gobierno de Navarra, 2016.

Goicoetxea Marcaida, Angel. "Medicina y música popular vasca." *Munibe Antropologia – Arkeologia* 42 (1990): 441–48. At: http://www.aranzadi.eus/fileadmin/docs/Munibe/1990 441448AA.pdf.

Gómez Muntané, Maricarmen. *Historia de la música en España e hispano América.* Volume 1. *De los orígenes hasta c. 1470.* Madrid: Fondo de Cultura Económica, 2009.

Haritschelhar, Jean. "La Soule dans la littérature basque." In *Le Pays de Soule*, edited by Pierre Bidart. Baigorri: Izpegi, 1994. At: https://artxiker.ccsd.cnrs.fr/artxibo-00109630.

Iriarte, María José. "La Prehistoria en el País Vasco." Hiru-euz. Portal de Aprendizaje Permanente del Gobierno Vasco. At http://www.hiru.eus/es/arte/la-prehistoria-en-el-pais-vasco (last accessed January 12, 2018).

Kortazar, Ion. "Euskal lirika gortesauari buruzko oharrak." *Jakin* 16 (1980): 76–90.

Lakarra, Joseba, Koldo Biguri, and Blanca Urgell. *Euskal baladaren azterketa eta antologia.* Donostia: Hordago, 1983.

Landa El Busto, Luis. *Historia de Navarra. Una identidad forjada a través de los siglos.* Pamplona: Gobierno de Navarra, 1999.

Lekuona, Juan Mari. *Ahozko Euskal Literatura.* Donostia: Erein, 1982.

Lekuona Etxabeguren, Manuel, et al. "Bertsolarismo." *Enciclopedia Auñamendi.* At: http://aunamendi.eusko-ikaskuntza.eus/es/bertsolarismo/ar-13609/ (last accessed April 4, 2018).

Martínez Díez, Gonzalo, et al. *Colección de Documentos Medievales de las villas guipuzcoanas (1200–1369).* San Sebastián: Diputación Foral de Gipuzkoa, 1991.

Mazo Pérez, Carlos, Carlos García Benito, and Marta Alcolea Gracia. "Un caso de Arqueología Experimental aplicado a la Arqueología Musical." *SALDVIE* 15 (2015): 65–91. At: http://salduie.unizar.es/sites/default/files/Saldvie_15_ Mazo_Garc%C3%ADa_Alcolea.pdf.

Mezquíriz Irujo, María Ángeles, Luis Francisco Labé Valenzuela, Mikel Ramos Aguirre, Ana Carmen Sánchez Delgado, and José Antonio Sanz Mosquera. "La villa de las musas. Estudio previo." *Trabajos de arqueología Navarra* 11 (1993): 55–100.                                    At: http://www.navarra.es/NR/rdonlyres/55F48739-E0A8-4347-854A-310429766E4B/325597/5_mezquiriz.pdf.

Olazarán de Estella, Hilario. "El txistu. ¿Primer instrumento de la humanidad?" In *La Gran Enciclopedia Vasca*. Volume 1. Bilbao: La Gran Enciclopedia Vasca, 1966.

Ortigosa, José Luis. *La cuestión vasca: desde la prehistoria hasta la muerte de Sabino Arana*. Madrid: Vision Libros, 2013.

Passemard, Emmanuel. "Une flûte Aurignacienne d'Isturitz." In *Congrès de l'Association Française pour l'Avancement des Sciences 46e session*. Montpellier: N.p., 1923.

Paya, Xabier. *Antología de Literatura Oral Vasca*. Donostia: Instituto Etxepare, 2013.

Pedrell, Felipe. *Organografía musical antigua española*. Barcelona: Juan Gili, 1901.

Peñas García, Mª Carmen. *Fondos musicales históricos de Navarra. Siglos XII–XVI*. Pamplona: Universidad Pública de Navarra, 2004.

Rodríguez Suso, Carmen. "El canto litúrgico romano y la música vasca. Una intersección decisiva en la historia de nuestro lenguaje musical." *Nuevas formulaciones culturales: Euskal Herria y Europa. XI Congreso de Estudios Vascos*. Donostia-San Sebastián: Eusko Ikaskuntza, 1992. At: http://www.eusko-ikaskuntza.eus/es/publicaciones/el-canto-liturgico-romano-y-la-musica-vasca-una-interseccion-decisiva-en-la-historia-de-nuestro-lenguaje-musical/art-8575/.

———. *La monodía litúrgica en el País Vasco*. 3 Volumes. Bilbao: Bilbao Bizkaia Kutxa, 1993.

————. "Canto Gregoriano." *Enciclopedia Auñamendi*. At: http://aunamendi.eusko-ikaskuntza.eus/es/canto-gregoriano/ar-78225/ (last accessed February 2, 2018).

Sallaberry, Jean Dominique Julian. *Chants populaires du Pays Basque*. 1870; Nîmes: C. Lacour, 1992.

Sánchez Ekiza, Karlos. *Euskal musika klasikoa. Música clásica vasca. Basque Classical Music*. Donostia: Etxepare Euskal Institutua, 2012. At https://www.etxepare.eus/media/uploads/publicaciones/euskal_musika_klasikoa.pdf.

Truffaut, Thierry. "Les instruments de musique utilisés dans le Labourd à travers les textes anciens et l'iconographie." *Cuadernos de etnología y etnografía de Navarra* 52 (1988): 403–14.

Utrilla Miranda, Pilar. "El Magdaleniense inicial en el País Vasco peninsular." *Munibe* 28, no. 4 (1976): 245–75. At: http://www.euskomedia.org/PDFAnlt/munibe/1976245275.pdf.

Utrilla Miranda, Pilar. "El yacimiento de la cueva de Abauntz (Araiz, Navarra)." *Trabajos de arqueología Navarra* 2 (1982): 203–345. At: https://www.navarra.es/NR/rdonlyres/6C7A64CF-DCB0-4893-B2A8-C2B3F7B7816A/225252/Utrilla.pdf.

Utrilla, Pilar, Carlos Mazo, and José Ignacio Lorenzo. "Rituales funerarios en el calcolítico de Abauntz. Un ejemplo de lesión con supervivencia." *SALDVIE* nos. 13–14 (2014): 297–314. At: http://salduie.unizar.es/sites/default/files/Saldvie_13_14_Utrilla_Mazo_Lorenzo.pdf.

Valdivielso Zubiria, Maider. *Inventario de libros manuscritos de música sacra existentes en el Territorio Histórico de Álava*. Vitoria-Gasteiz: Arabako Foru Aldundia, 2007.

## Websites, Archives, and Academic Repositories

Aranzadi Society of Sciencies: http://www.aranzadi.eus

*Auñamendi Eusko Entziklopedia*: http://aunamendi.eusko-ikaskuntza.eus/es/

Eresbil Basque Archives of Music: http://www.eresbil.com

Eusko Ikaskuntza – Society of Basque Studies: http://www.eusko-ikaskuntza.eus/es/

Euskaltzindia – Royal Academy of the Basque Language: http://www.euskaltzaindia.eus/index.php?lang=es

The musical catalogue of the Cathedral of Pamplona: http://www.archivomusica-catedralpamplona.org

# Renaissance and Baroque: Between Tradition and Change

Sergio Barcellona

In the following pages, I summarize some of the most relevant aspects of the diverse musical activities of the Basque Country and Navarre from the end of the fifteenth century to the first half of the eighteenth century.

As we know, during these three centuries certain changes of extraordinary importance took place in western music at a formal and productive level. On the one hand, we see the diffusion of the polyphonic-modal style, the later establishment of tonal harmony, and the adoption of accompanying melody. On the other, there was a consolidation of a more efficient institutionalized productive system—through both ecclesiastic and civil chapels—that remained practically unaltered up until the end of the modern era and that bestowed a certain homogeneity to the diverse types in the use and consumption of music, despite the variety of styles and genres that can be seen throughout this extensive period.

Studies on music in the modern era regarding the Basque Country and Navarre are not very numerous. Besides the contributions of general character carried out by Father Donostia and José Antonio Arana Martija,[49] there are more specific studies

---

[49] I am referring to the chapters dedicated to the Renaissance and Baroque in José G. Z. Donostia, *Música y músicos en el País Vasco* (San Sebastián: Biblioteca Vascongada de los Amigos del País, 1951), reprint in *Obras completas del P. Donostia*, vol. 2 (Bilbao: La Gran Enciclopedia Vasca, 1983), 5–112; and in José Antonio Arana Martija, *Música vasca* (Bilbao: Diputación Foral de Bizkaia, 1989). See also by the latter author "Euskal Musikuak Ameriketan," *Cuadernos de Sección Música* 6 (1993), 85–103.

(on composers, institutions, and organ builders, for example) that, along with the catalogs of some archives and practice editions of scores, have contributed in extending our knowledge of this period, permitting us in some cases to recuperate a forgotten musical repertory.

The recent publication of an extensive study of the music of Navarre by María Gembero Ustárroz constitutes an important effort to collect, in one complete and rigorous text, the current state of knowledge concerning musical activities of this region, its composers and institutions, from prehistory up to today.[50] The relative scarcity of musical sources from the Basque Country prior to the contemporary era is, however, a factor limiting the quantity of bibliography on the musical past of this territory in regard to that which is centered on the former Kingdom of Navarre.[51]

## The Historical-Social Context

The progressive unification of the three Spanish kingdoms (Aragon, Castile, and Navarre), made possible by the matrimony of the Catholic monarchs (1469), widened considerably the international horizons of the Iberian Peninsula. The transfer of the Aragonese court to Naples (conquered by Alfonso the Magnanimous in 1443), the capture of Granada (1492), the discovery of the Americas, and the inclusion of Portugal

---

[50] María Gembero Ustárroz, *Navarra. Música* (Pamplona: Gobierno de Navarra, 2016).

[51] Among the contributions of a general nature on the history of music in Basque Country, see Sabin Salaberri Urzelay and Sagastume Mendialdúa Errarte, "Renacimiento y Barroco," in *La música en Álava*, ed. Sabin Salaberri (Vitoria-Gasteiz: Fundación Caja Vital Kutxa, 1997); and Carmen Rodríguez Suso, "Viejas voces de Bilbao. La música en la Villa durante los siglos XVIII y XIX," in *Bilbo, arte eta historia. Bilbao, arte e historia* (Bilbao: Diputación Foral Bizkaia, Bilbao, 1990), 227–51. Among the specific studies, I will discuss below the study on Basque organ making.

in the Catholic monarchy (1581) completed the extension of a culturally very diverse empire. Its principal mark of identity was a militant Catholicism, which "permitted all artistic manifestations and among them, music, because of its tie to the divine cult," [52] and that was spread and strengthened by a capillary administrative-ecclesiastic control (the dioceses) and a fierce system of repression of heretical and moral deviations (the Tribune of the Inquisition, established in 1478).

During the modern age all the small local communities (towns, villages, estates) that today constitute the provinces of Bizkaia, Gipuzkoa, and Araba were part of the Kingdom of Castile. The former Kingdom of Navarre, once it was "annexed" by Fernando the Catholic (1512), was divided between Upper Navarre (whose geographic boundaries correspond more or less to those of today's autonomous community) and Lower Navarre (beyond the mountain passes), incorporated into the French crown in 1589.

All these territories, whose administrative organization was coordinated and complex as well as a source of frequent litigation and conflict, also demonstrated a certain diversity from a socioeconomic viewpoint. Population density, reflecting uneven economic activity, was particularly high in the Basque territories— there were 30 inhabitants per square kilometer in sixteenth-century Bizkaia, compared with an average of 20 in the rest of the peninsula—and this population was predominantly rural. The agricultural economy of Basque farmhouses, based on the productive principles of maximum self-sufficiency with minimal economic contact with the exterior, was supplemented thanks to earnings from the commerce of products deriving from secondary activities such as mineral extraction and iron production. But the

---

[52] Maricarmen Gómez Muntané, ed., *Historia de la música en España e Hispanoamérica*, vol. 2, *De los Reyes Católicos a Felipe II* (Madrid: Fondo de Cultura Económica de España, 2012), 18.

most active economic sector was that of the middle class, dedicated to commerce, which was especially strong in Bizkaia and Gipuzkoa. Moreover, the growth of wool exports helped to continue to foster and consolidate the axis of transportation routes between Burgos and the Atlantic coast, along which during the thirteenth century many towns had been established. Nevertheless, despite the growth of urban areas that was already being experienced in the sixteenth century, seventeenth- and eighteenth-century urban centers remained small conglomerations (in the sixteenth century Bilbao only had five thousand inhabitants).[53] Imports were concentrated in the ports of Pasaia (Pasajes), Donostia-San Sebastián, and Lekeitio, while metallurgical activities tied to mining were especially numerous in Eibar, Arrasate-Mondragón, and Bergara, which led Europe in this sector.

However, the seventeenth-century decline in wool exports resulting from wars in northern Europe entailed a gradual impoverishment of the coastal population. Population levels there were only maintained, with great difficulty, thanks to the cultivation of recently imported American products (corn and potatoes), although farmers in the plains of Araba, who were especially tied to the cultivation of grains, were less lucky. By the end of the century, the decline of military orders had a negative effect on the arms industry, while agriculture recovered due to population growth. Bilbao, therefore, progressively became one of the principle commercial centers of the north, giving rise to a phase of prosperity that would continue throughout the eighteenth century.

---

[53] Fernando García de Cortázar and José M.ª Lorenzo Espinosa, *Historia del País Vasco* (San Sebastián: Txertoa, 2011), 52.

## A Social Status about to Change

The expansion of imperial territory, the burden of Catholicism on public and private life (transformed by the Inquisition into an instrument of social control of its subjects through the selection of bishops by monarchs), and the needs of a propagandistic representation of the arts (a symbolic extoling of power) were factors that broadened the professional opportunities of practical musicians in the modern era in contrast to their medieval predecessors, on whom clearly ancient social stigma weighed heavily. The minstrels, heirs to the medieval jongleurs, devoted themselves to the trade of paid musical interpretation in the service of the court, church, or town hall. Normally, they came from the lower social classes, but during the Renaissance their progressive economic recognition, especially if working for a royal court, could be comparable to that obtained by singer-composers.[54]

Above these two categories of "practical" musicians (minstrels and singers) were the "theoretical" musicians (*musici*) who were devoted to the scientific study of music understood as abstract art. However, thanks to the diffusion of musical practice among the upper classes (the effect of humanist currents that had begun to penetrate the peninsula from the end of the fifteenth century on), such separation by status began to be a lot less rigid or effective.

The effects of this change can be seen as well in some of the most emblematic musicians of this European region: the theorists Gonzalo Martínez de Bizcargui and Martín de Azpilcueta; the singer and composer Juan de Anchieta; and even humble minstrels, ever more needed in the chapels of religious

---

[54] Salva Astruells Moreno, "Los ministriles altos en la corte de los Austrias mayores," *Brocar. Cuadernos de Investigación Histórica* 29 (2005), 27–52.

music, who began to see their profession recognized socially. Only *tamborileros*[55] in this last category, would have to wait until the nineteenth century to see their reputation improve and were thus able to escape their outcast status as itinerant musicians.

We know very little about the life of Gonzalo Martínez de Bizcargui (Azkoitia, c. 1460–1528).[56] The author of treatises and a chaplain and organist in the church of the Visitation in Burgos, from what remains of his work, he seems more an heir of the old medieval concept of the *musicus*. Of his work as a composer we only have a *Salve Regina* for four voices kept in the cathedral of this Castilian city, but he was better known for two musical treatises. Nevertheless, both in his *Arte de canto llano y contrapunto y canto de órgano* (published in at least eleven editions, between 1508 and 1550, in Zaragoza and Burgos) and in his *Intonationes según el uso de los modernos* (the oldest edition is from 1515), it is evident how much Bizcargui's position differed from that of his predecessors devoted to theory, whose approach was still in force in the most conservative treatises of the time. The interest in this musician lies "in his didactic attitude—common among other treatise writers of the moment—and, above all, in the quiet indifference to philosophical speculation to which he never turns."[57] Instead of writing his treatises in Latin (still being used in works of this kind, although this would suggest access to a few scholars), he wrote in

---

[55] This expression meant literally "drummers," but in this era it referred to the *txistu* and *tamboril* players.

[56] On Bizcargui, see José López Calo, "Martínez de Bizcargui, Gonzalo," in *Diccionario de la Música Española e Hispanoamericana* (hereafter *DMEH*), ed. Emilio Casares, vol. 7 (Madrid: Sociedad General de Autores y Editores, 2000), 275–79; Carmen Rodríguez Suso, "Gonzalo Martínez de Bizcargui y la música práctica," *Cuadernos de Sección Música* 6 (1993), 43–57; and Enrique Jordá, "Gonzalo Martínez de Bizcargui y la teoría musical de su tiempo," in *De canciones danzas y músicos del País Vasco* (Bilbao: Editorial La Gran Enciclopedia Vasca, 1978), 179–210.

[57] Rodríguez Suso, "Gonzalo Martínez de Bizcargui y la música práctica," 39.

Castilian; and instead of turning for support to the *autoritas* of Boethius or Saint Augustine, he limited himself to proposing rules aimed at solving technical-interpretative problems for musicians of the moment. He proposed, for example, the adoption of a writing system "modernized" in five lines (necessary to make the readings of the church and parish cantors easier, since still at that time they were anchored to the old Aquitanian notation on one line because of the expense of "new" codices). His didactic approach, use of simple language, and, above all, his most debated proposal for solving the theoretical problem of the tonal subdivision in two unequal semitones, based on hearing and instrumental practice rather than on a medieval system of tuning, made him the target of many conservative critics who denounced the "thousands of lies" in his insignificant treatises and harshly admonished him: "quiet, quiet already and be ashamed Gonzalo Martinez de Bizcargui . . . and stop your barbarous and venomous tongue in persisting and writing down heresies in the shape of music, contradicting Boecio . . . wishing to trust exclusively one's ear."[58]

But what pushed Bizcargui to adopt new approaches were his objectives, since his work was aimed at a new typology of practical musicians that were largely made up of

> a group of clergy dispersed in a diocese of great territorial extensions . . . belonging to different linguistic and cultural communities, having a liturgy still not normalized, with old books written in a notation system which could not be deciphered, and without money to buy new ones . . . with a deficient level of education which in some cases rose to

---

[58] Joannes de Espinosa, *Tractado de Principios de Música Práctica et Teórica, sin dejar cosa atrás* (Toledo, 1520), cited in ibid., 40.

illiteracy and in others to not knowing from memory the words of the mass.[59]

Through his treatises, Bizcargui attempted to answer these contingent necessities. His approach is perhaps limited, but yet modern, and a reflection of the profound transformations happening in all fields of music in the early sixteenth century.

The Navarrese Martín de Azpilicueta (Barasoain, Navarre, 1492–Rome, 1586), known as "Doctor Navarre," a moralist and counselor of canonical law at the court of Philip II, cannot fully be considered a musician. Nonetheless, driven in part by his direct relation with the practical role (he was also *cantor* in the cathedral of Coimbra), he edited and published three treatises concerning liturgical music, which had widespread diffusion.[60] His position on the use of music in religious ritual was not technical, but rather moral: although he accepted the use of polyphony and instruments in liturgical music, he thought that only plainsong was appropriate for worship. More than a thousand years after the *Confessions*, in which Saint Augustine confessed himself "guilty" of enjoying with aural pleasure liturgical music, Doctor Navarre insisted on the "moral" danger that the use of polyphony involved, in that it was capable of diverting the devotion of the

---

[59] Ibid., 42.

[60] These were *Commento en romance a manera de repetición latina*[y scholastica] *de iuristas* (Coimbra, 1545); later published in Latin as *Manual de confessores y penitentes* (Coimbra, 1553); and *Commentarius de silentio in divinis officiis* (Roma, 1580). On Martín de Azpilcueta's musical contribution, see Leocadio Hernández Ascunce, "La personalidad musical del doctor Navarro," *Tesoro sacro musical* (1951), 22–23 and 33–35; Enrique Jordá, "Las ideas musicales del doctor Martín de Azpilcueta," *Musiker. Cuadernos de música* 9 (1997), 84–87; and Bonnie J. Blackburn, "How to Sin in Music: Doctor Navarrus and Sixteenth-Century Singers," in *Music as Social and Cutural Practice. Essays in Honour of Reinhard Strohm*, ed. Melania Bucciarelli and Berta Joncus (Woodbridge: The Boydell Press, 2007), 86–102.

faithful through seduction more by the combination of sounds than by the message of the religious texts.

The professional career of the person considered one of the greatest exponents of the music of the period, Juan de Anchieta (Azpeitia, c. 1462–1523), represents perfectly how, in the modern era, the social and economic recognition of a practical musician had changed, especially when in the service of the elites.[61]

"I will not be satisfied with our gentleman unless he is a musician and knows how to play various instruments," the Italian Castiglione had stated in his *Il Cortegiano* (1528, *The Book of the Courtier*, published in English in 1561), referring to "making" music as an indispensable aspect in the education of a noble. The work, translated into Spanish as *El Cortesano* by Juan Boscán, was published in 1534. Anchieta had died more than a decade earlier, after having carried out his entire professional career in the service precisely of the court of the Catholic monarchs. He had begun as "chaplain and cantor" in the chapel of Queen Isabel (a title somewhat more distinguished than that of a simple choirmaster), but he was also put in charge of the musical education of the monarchs' son, Prince Juan, who was considered "obstinate in singing."[62] After the death of the prince in 1497, he returned to work in the music chapel of Queen Isabel, which numbered about

[61] On Anchieta and his work , see Robert Stevenson, "Anchieta, Juan de," *Grove Music Online: Oxford Music Online*, at:
http://www.oxfordmusiconline.com/grovemusic (last accessed April 9, 2018); Albert Cohen, "The Vocal Polyphonic Style of Juan de Anchieta," PhD diss., New York University, 1953; Enrique Jordá, "Vida y obra de Johannes de Anchieta," in *De canciones danzas y músicos del País Vasco*, 127–78; Imanol Elias Odriozola, *Juan de Anchieta: apuntes históricos* (San Sebastián: Caja de Ahorros Provincial, 1981); and Pedro Aizpurua, "Presentación de las *Pasiones* y biografía musical," in *Juan de Anchieta: Cuatro pasiones polifónicas*, ed. Dionisio Preciado (Madrid: Sociedad Española de Musicología, 1995), 15–25.
[62] Cited in Gómez Muntané, ed., *Historia de la música en España*, 24.

thirty members between cantors, young boys, and instruments. At the death of the queen, Anchieta entered into the service of Juana the Mad (1504) who took him on her trips to Flanders and England, permitting him thus to enter into direct contact with the musicians of the Burgundian chapel of Felipe the Fair, exponents of the musical vanguard in Europe at that time (such as Pierre de la Rue and Alexander Agricola, among others). From 1509 on he was a teacher to Queen Juana's children, among whom was the future King Carlos I, and from 1512 until the death of Fernando in 1516 he remained in service to the court as cantor. Although the consideration in which he was held as a *maestro,* composer, and singer was most likely no different from that of any other servant of the court, his recognition was confirmed on multiple occasions by various privileges bestowed by the monarchs. Although excused from service in 1519 because of his advanced age, the monarch kept his salary at 45,000 *maravedies* (more than double what he received when he began his professional career in the service of Isabel): a decent salary, yet similar to that of any other musician of the royal chapel. He was able then to retire and live out his later years in his native city, where he had a luxurious palace built with the income from the privileges received years earlier from Queen Isabel. With a part of the accumulated capital during his lifetime, he also contributed to the foundation of the convent of the Franciscan Sisters, and in his will he also left an income of 400 gold *ducados* to his son Juan, the issue of an illegitimate relationship with María Ezquerrategui, a resident of his home town.

   Not many of Anchieta's works remain, and some are of dubious attribution according to the various musicologists who have edited or analyzed them like Aita Donostia (1932), Albert Cohen (1953), Robert Stevenson (1960), and Samuel Rubio (1980), who edited Ancheita's *Opera Omnia.* In any case, it is the sacred works that are predominant (three *Misas,* two *Magníficats,*

four Passions, and some dozen motets), with musical characteristics that correspond only in part to the style adopted at this time by the Franco-Flemish Polyphonists (with whom Anchieta associated himself). His liturgical compositions show a certain predilection for homophonic textures that facilitate the comprehensibility of the texts: a characteristic shared with sixteenth-century Hispanic composers.

On the other hand, there are some scholars who insist on the influence of the Basque oral tradition on Anchieta.[63] Because the use of popular melodies in some of his Masses (for example, in the well-known song "L'homme armé," which appears as *cantus firmus* in the *Agnus* of his *Missa quarti toni*) was a common recourse among the composers of liturgical music of the Renaissance, the four secular compositions of Anchieta left to us give witness of the typology of repertory destined for the amusement of the royal court. In the *Cancionero de Palacio* we find one of the principal sources of court music of Renaissance Spain. Both Aita Donostia and Arana Martija show how two of them (the carols "Dos ánades" and "Con amores, mi madre") are in a five-beat rhythm, which is not at all normal in written sources of the time and that could be due to the influence of the Basque oral tradition on music in Gipuzkoa.

From the progressive process of "nobilizing" practical musicians, a dynamic aided especially by authors who cultivated good relations with the classes in possession of what Peter Burke calls the "great" tradition,[64] representatives of the "small" tradition, that of the uneducated, remain excluded: for example, the Basque *tamborileros,* today known as

---

[63] Arana Martija, for example, identifies the beginning of one of Anchieta's secular songs with the beginning of a traditional melody collected by Aita Donostia four centuries later. See Arana Martija, *Música vasca*, 78.

[64] Peter Burke, *Popular Culture in Early Modern Europe* (Aldershot: Scolar Press, 1994).

txistularis. Because of their condition as illiterate drifters, these musicians were even excluded from the noble status that other inhabitants of Bizkaia dominion enjoyed, although their services were needed to enliven all the communal activities in rural and urban areas.[65]

The use of the flute and drum, widely documented before the eighteenth century, appears exclusively tied to music destined to accompany dance. This entertainment at the time was surrounded by negative moral connotations, independent of the context in which it was produced: whether as regarded dances organized on festive days in village squares or with dances associated with the obscure rituals of the *akelarres* (covens) in the rural areas of northern Navarre, Lapurdi, and Gipuzkoa.[66] In the sixteenth and seventeenth centuries especially, witch hunts were particularly intense and aggressive in these areas. Accounts of the Inquisition frequently describe dances in which "warlocks and witches dance in chorus, hands clasped to the sound of the drum, small drum and flute, hoarse and out-of-tune."[67]

*Tamborileros* were indispensable actors in the musical animation of rituals whose participants committed, according to the confessions of the witnesses subject to torture, every kind of

---

[65] On *txistularis* and their history, see two works by Karlos Sánchez Ekiza: "Del tamborilero al txistulari; la influencia de la música culta en la música popular de txistu," *Cuadernos de etnología y etnografía de Navarra* 52 (1988), 327–42 and *Del dambolin al silbo* (Pamplona: Euskal Herriko Txistularien Elkartea, 1999).

[66] Sánchez Ekiza, *Del dambolin al silbo*, 12–15.

[67] *Relación de lo sucedido en el Auto da Fe que se celebró en Logroño el 7 de noviembre de 1610*, in Eloísa Navajas Twose and José Antonio Sáinz Varela, "Una relación inquisitorial sobre la brujería Navarra," *Huarte de San Juan. Geografía e Historia* 17 (2010), 363. The scope of this chapter does not allow for further discussion of this matter. Its general aspects are widely discussed by Julio Caro Baroja, *Las brujas y su mundo. Un estudio antropológico de la sociedad en una época oscura* (Madrid: Alianza, 1961). For the anthropological and musical implications, see Karlos Sánchez Ekiza, *Txuntxuneroak. Narrativas, identidades e ideologías en la historia de los txistularis* (Pamplona: Ataffaylla, 2005), 79–89.

aberration.[68] But it was not only the "obscene satanic dances" accompanied in the *akelarres* by village drummers that received the foreseeable condemnation of the church: following the Counter Reformation, especially, various bishoprics pronounced, although without much success, prohibitions and limitations (even beyond Lent) to eliminate every kind of dance, even popular dances that took place in front of the churches on festive days or during patron saints' days, labeling them as "immoral."[69] Faced with such difficulties, most drummers saw it necessary to find other work (usually as shoemakers) and kept on the move in order to survive from village to village according to the festive calendar or sometimes without a fixed date, playing in inns and other places of collective entertainment. Despite all this, the presence of "whistle and drum" musicians was a constant in the Basque urban soundscape. However, the changes in other musical professions did nothing to influence their status: the social contempt that surrounded them was not dissimilar to that suffered by the minstrels of the Middle Ages.

In the case of many religious centers in the Basque Country, organs and the documentation surrounding them are often the most important testimonies that remain of the existence

---

[68] Juan de Mongastón, *Relación de las personas que salieron al Auto de Fe ...* (Logroño, 1611), Bibl. nacional de Madrid, V/Ca 248, n. 71, cited in Caro Baroja, *Las brujas y su mundo*, 219–39: "they dare to commit all sorts of evil, and amuse and entertain themselves by dancing to the sound of small drum and flute, which in the Zugarramurdi's coven (of which almost all the aforementioned were witches) was played by one called Joanes de Goyburu, and to the sound of the drum, which was played by another called Juan de Sansin, both cousins, who were brought to the proceedings, and were acquitted for having been good informers; and they still attend the aforementioned dances, celebrating the devil (who is watching them), until the cockerel crows."
[69] See Carmen Rodríguez Suso, *Los txistularis de la villa de Bilbao* (Bibao: Caja de Ahorros Vizcaína, 2000), 27–28.

and the activity of their choirs.[70] The accomplishments and innovations of the organ makers' workshops in the Basque Country and Navarre were particularly decisive in the development of this instrument.

From the sixteenth century on, the Castilian organ (more austere and economical than those used in the former kingdoms of the Aragonese crown) began to prevail, spreading throughout the peninsula, and in this process, organ makers from the Basque Country and Navarre played a key role. The principal technical innovations adopted for the Iberian organ (the divided register and, from the late seventeenth century, the horizontal trumpet and echo registers) originated precisely in the territory under study.[71] In 1675 Juan de Anchieta and Félix de Yoldi (Lerín, Navarre) were commissioned to construct a new organ for the Royal Palace in Madrid, and their disciples continued their activity in the Royal Chapel, working for numerous churches in Castile (among them, the Cathedral of El Burgo de Osma, together with the disciple of José de Echevarría), from the late seventeenth century until 1735. Brother José de Echevarría, born in Eibar

---

[70] For a brief summary of the main active organ makers in the Basque Country and Navarre, I rely here on Arana Martija's text and the bibliography he uses, especially Claudio Zudaire Huarte, "Organerías. Notas sobre órganos y organistas de Guipúzcoa en el siglo XVII," *Cuadernos de Sección Música* 2 (1985), 79–101 and Aurelio Sagaseta and Luis Taberna, *Órganos de Navarra* (Pamplona: Gobierno de Navarra, 1985). Among the more specific bibliography, published after the work of the aforementioned Basque musicologist, one should note, among others, Rafael Mendialdúa Errarte, *Maestros de Capilla y Organistas de la Colegiata y Catedral de Santa María de Vitoria-Gasteiz.* ([Vitoria-Gasteiz]: Real Sociedad Bascongada de los Amigos del País, Comisión de Álava, 1988); Carmen Rodríguez Suso, "Notas sobre la organería en Vizcaya durante el siglo XVIII," *Recerca Musicològica* 5 (1983), 137–72; Sergio del Campo Olaso, *El Órgano de la villa de Ochandiano* ([Donostia]: Eusko Ikaskuntza, 2000); and Miguel Salaberría, *Órganos de Bizkaia* (Bilbao: Diputación Foral de Bizkaia, 1992).

[71] See Louis Jambou, "El órgano en la Península Ibérica entre los siglos XVI y XVIII. Historia y Estética," *Revista de Musicología* 2, no.1 (1979), 43.

(Gipuzkoa) made such emblematic instruments as that of the convent of San Diego (Alcalá de Henares, 1670). Regarded as the inventor of the horizontal trumpet registers, he also finished the new organ for the Cathedral of Santo Domingo de la Calzada (1662–1664), and made the organ of the convent of San Francisco (Vitoria-Gasteiz, 1665) as well as those of the churches of Eibar (1667), Arrasate (1677), Otxandio (1680), and the Cathedral of Palencia (1690). His homonymous disciple participated in the construction of the organ of the collegiate church of Cenarruza (1686) and in various organ restorations in cathedrals in cities such as Seville (1697), Sigüenza, Cuenca (1699), and Burgos (1706).

## Church Choirs

Church choirs, made up of cantors and instrumentalists, had as their main function the execution of chants associated with liturgical rituals. Practically all the salaried composers and instrumentalists of this period were attached to one of these institutions, which were transformed into the principal centers of musical education and production.

After the establishment of the Roman rite in the eleventh century, local particularities gave way progressively to more standard forms of liturgical practice and associated chants. Following the Council of Trent (1545–1563), and thanks also to the recent invention of printed music, the publication of official liturgical texts was promoted (the first musical document to be printed in the region under study was the *Missale mixtum pampilonensis*, published by Guillem de Brocar in Pamplona-Iruñea, between 1490 and 1501), but only with the 1614 edition of the

*Gradual* was a musical model adopted that would be a valid reference work for all religious centers.[72]

The plainsong, monodic and in Latin, could be heard daily in churches and monasteries, independent of their locations, importance, and economic resources. This was a collectively sung chant, with or without organ accompaniment, by clerics who read directly from manuscript their books (or *cantorales*): today, eight hundred are kept in Navarre, and three hundred remain in Gipuzkoa, Bizkaia, and Araba.[73] The large size of the choir books is due to the shared need of their simultaneous use by the clerics who placed them on *facistoles* (four-sided lecterns) located in the center of those spaces appointed for the choir (normally next to the organ, an instrument that almost all the churches had at this time).

Learning the monodic repertory was the main difficulty in the first formative stages of the common clergy, taught and directed by the sub-cantor who responsible for the vocal ensemble. But the interpretation of polyphonic music, which began to spread throughout the peninsula in the late fifteenth century, necessitated a more specialized musical education of the choir members. The difficulty in interpreting polyphonic songs, which in the liturgical ceremonies on festive days were interwoven with plainsong, posed a challenge for the new chapels of church music.

---

[72] Ismael Fernández de la Cuesta, "Libros de música litúrgica impresos en España antes de 1900 (II). Siglos XV y XVI," *Música. Revista del real conservatorio de Madrid* 3, (1996), 11–29.

[73] The estimates are those of Gembero Ustárroz, *Navarra. Música*, 51 and Carmen Rodríguez Suso, *La monodia litúrgica en el País Vasco. Fragmentos con notación musical de los siglos XII al XVIII*, vol. 1 (Bilbao: Bilbao Bizkaia Kutxa, 1993), 28, respectively.

The organizational structure of a choir was identical in all ecclesiastic centers. The choirmaster, almost always recruited through a tough selection process from among the best available professionals, took care of composing the constantly changing polyphonic repertory that was intended for divine services during the main festivities of the liturgical calendar. His work also oversaw the organizing and directing of the group of musicians and the pedagogic instruction of the choir (Latin, reading and writing music, and plainsong). Young boys sang the high registers (soprano and contralto) of the polyphonic scores, reinforced by some adult clergy (singing falsetto), while the others covered the parts for tenor and bass in their natural register.[74] Regardless of their financial means, all the choirs also had at least one organist. His main function was to accompany the plainsong, but in the parishes of small towns, he also had to fulfill the work of schoolteacher. To the choir and organist one could add more instrumentalists, whose number depended on the resources of the institution and of the time.[75]

From the sixteenth century on, these institutions became consolidated and organized, growing in size in accordance with their needs and available resources. The cathedrals (Pamplona-Iruñea being one of them) whose cathedral chapter could count on income from the diocese—to which could be added the resources of the bishop, royal contributions, and donations from the faithful—did not skimp on measures to maintain their

---

[74] In the seventeenth and eighteenth centuries, despite the opposition of the church (at least officially), the practice of using castrated men ("capons," as they were pejoratively called in the peninsula) was widespread. This would end in 1769, when Pope Clement XIV allowed the participation of women in choirs.

[75] During the Renaissance and Baroque periods, for example, a harpist or player of the dulcian or curtal (a predecessor of the bassoon) could be added, but stylistic changes entailed, from the seventeenth century on, a progressive substitution and expansion of the instrument used.

musical training. Substantially more modest were the financial means of the numerous parish choirs, which in many urban centers (Bilbao and Vitoria-Gasteiz for example) needed the support of the civil authorities to survive.

The chapel of the Cathedral of Pamplona-Iruñea is one of the oldest in the peninsula. There are records of a *chantre* (the person who preceded the choirmaster) dating back to the early thirteenth century, and we know that in 1436 the Navarrese José Anchorena was the "main maestro of the lesser cantors." [76] Its first recorded choirmaster was Juan Úriz in 1516, under whose leadership there were six cantors and two reed pipe players, plus the organist.[77]

Pamplona-Iruñea was not the only center that enjoyed a musical structure of certain importance. The Royal Collegiate Church of Orreaga-Roncesvalles, for example, already in 1531 counted on a more modest chapel, while in the seventeenth century it could boast of a group composed of twelve cantors, an organist, and a bassoonist, despite its reduced polyphonic

---

[76] For this musical institution, see José Goñi Gaztambide, "La Capilla Musical de la Catedral de Pamplona en el siglo XVII," *Música en la Catedral de Pamplona* 5 (1986), 3–97; Aurelio Sagaseta Aríztegui and María Gembero Ustárroz, "La música en la Catedral," in *La Catedral de Pamplona*, ed. Carmen Jusué Simonena, vol. 2 (Pamplona: Caja de Ahorros de Navarra y Gobierno de Navarra, 1994), 165–83; and three works by Leocadio Hernández Ascunce: "El archivo Musical de la Catedral de Pamplona," *Tesoro sacro musical* (1940), 9–10, 23–24, 34–36, and 42–43; "Música y músicos de la Catedral de Pamplona [I]," *Anuario Musical* 22 (1969), 209–46; and "Música y músicos en la Catedral de Pamplona [II]. Documentos inéditos," *Anuario musical* 23 (1970), 231–46. The musical catalogue of the chapel archive has been published by Aurelio Sagaseta Aríztegui, *Catálogo del Archivo de Música. Catedral de Pamplona*, vol. 1, *Fondos históricos desde los orígenes hasta 1962* (Pamplona: Analecta, 2015).

[77] The organs of this cathedral are documented since 1461. In the late seventeenth century the cathedral had one large and two small organs that were used when the chapel was moved.

repertory.[78] Besides the collegiate church of Tutera (Tudela), which probably had a choir of cantors and instrumentalists since 1534 and is documented since the seveneteenth century, in Navarre at least another dozen music groups existed with similar characteristics, spread throughout the parishes in the jurisdiction of Olite (Tafalla, Faltzes-Falces, Larraga, and Uxue-Ujue), Lizarra-Estella (Los Arcos and Viana), Zangoza-Sangüesa, and Tutera (Corella).[79]

The musical scene in what is today the Basque Country was significantly more modest. From 1581 there was only one choir in Bilbao that had to serve the four united parishes of the city (the mother church of Santiago, alongside Santos Juanes, San Antonio, and San Nicolas). When necessary, it could be reinforced by the choir of the convent of San Francisco (whose documentation was lost in repeated fires that affected the building).[80]

The situation in Vitoria-Gasteiz was similar: one of its two music choirs was assigned exclusively to the collegiate church of Santa Maria—documented from the early sixteenth century—while the other, the "Chapel of the University of Parishes," looked after the needs of liturgical music in the other churches of the city (San Pedro, Mother Church, San Miguel, San Vincente, and San Idelfonso). In both cases their resources were rather limited. Because of this, in regard to their income, Joaquín de Landázuri

---

[78] Of the forty music books preserved in its archive, only five contain polyphonic works. The Archive of the Collegiate Church of Orreaga-Roncesvalles has been catalogued by María C. Peñas García, *Catálogo de los fondos musicales de la Real Colegiata de Roncesvalles* (Pamplona: Gobierno de Navarra, 1995).

[79] See Gembero Ustárroz, *Navarra. Música*, 67–77.

[80] Rodríguez Suso, "Viejas voces de Bilbao," 227–28. On the situation in Bilbao see as well Carmen Rodríguez Suso, "La capilla musical de Santiago de Bilbao. Una institución peculiar," in *La Catedral de Santiago* (Bilbao: Obispado de Bilbao, 2000), 174–75.

comments that "[i]n view of the frequent special functions that took place in the village and adding a few mishaps, they collect enough for the maintenance of the chapels and for their relatives."[81]

A different and particularly outstanding case was the sanctuary of Arantzazu in Gipuzkoa. [82] Its Franciscan community, established in 1514, became in just a few decades a reference point for musical production and education. The documentation that has been preserved (despite devastating fires in 1553, 1622, and 1834) attests to an intense musical activity, and not only related to worship:

> This severity, and rigor of penitence, is tempered and softened by sweet music, which in Basque is heard at certain hours of night, its harmonies composed by different choirs, numbering eight or ten people each, by alternating voices and hymns, devoutly entertain the spirits, so that they might rest a bit from such austerities.[83]

The documentation of the musical activities of the convent in the seventeenth century is fragmentary but significant. Although it does not allow us to know exactly when or how the convent choir was established, it does inform us of its nature. Already in 1644, for example, besides a group of adult cantors, the convent numbered ten boy cantors (the *donados*, who dedicated themselves to the study of an instrument as well) as well as an organist and other instrumentalists, judging from the list of instruments the convent had some years later (clavichord, harp,

---

[81] Cited in Salaberri Urzelay and Mendialdúa Errarte, "Renacimiento y Barroco," 59.

[82] See Jon Bagüés, *Catalogo del Antiguo Archivo Musical del Santuario de Aránzazu* ([San Sebastián]: Caja de Ahorros provincial de Guipuzcoa, 1979).

[83] Cited in ibid., 25.

guitar, reed pipe, spinet, harpsichord, bassoon, small bassoon, and cornet).[84] Many of the *donados*, who entered Arantzazu at the age of six or seven, would end up as choirmasters in the same sanctuary (this was the case, for example, of Francisco de Valderrain, Francisco de Ibarzábal, and Fernando de Eguiguren). The prestige that this center enjoyed also attracted musicians from other localities seeking a technical-instrumental education, which was evermore necessary, to complement the teaching of plainsong, whose study was obligatory for the *donados* (about an hour daily). In 1646, for example, the chaplain Eugui from the Collegiate Church of Orreaga-Roncesvalles was sent to receive bassoon lessons there.[85]

The intense musical activity inside Arantzazu was complemented by the production of materials in response to a demand from the exterior market: not only had the monastery been converted into a reference workshop for the making of choir books, but its prestigious choir was also frequently invited to religious and civil celebrations held in various places in Gipuzkoa, such as Deba, Azpeitia, Ordizia (Villafranca), Donostia-San Sebastián, and Bergara, as well as in Vitoria-Gasteiz (on at least seven occasions between 1640 and 1730) and even in Valladolid (1740), where its members played together with the choir of the Convent of San Francisco in Bilbao. But without a doubt one of the most exceptional aspects of the repertory still preserved in the archive of Aranzazu is the presence of a great quantity of secular vocal and instrumental music sources, which were probably intended for the musical entertainment of its guests. Unfortunately, due to recurring fires in the monastery, only the repertory of the second half of the eighteenth century has been preserved. Arias by Gluck and Italian opera composers like

---

[84] Ibid., 35.

[85] Donostia, *Música y músicos en el País Vasco*, 38.

Galuppi (dated 1756), Traetta, Piccinni, Anfossi, Jommelli, Paisiello, Leo, Auletta, and Hasse, together with concert music by Handel (concerts "for the harpsichord or Organ," 1758), instrumental works by Haydn (late eighteenth- and early nineteenth century-transcriptions), and dances by Mozart, Nebra, and Scarlatti bear witness to first-rate musical activity, with a repertory that reflects the musical trends of the most important European centers, whose research requires a study exceeding the scope of this chapter.

Church choirs accompanied the most important ceremonies in the liturgical calendar: especially lavish were those involving the religious and civil strata like Corpus Christi, which implied parades and processions with music. In the festivities of the Corpus in 1609, in Pamplona-Iruñea, among works "whose music would make Morales, Guerrero, and Palestrina envious," an auto sacramental was performed with music and dance; and even a poetry competition was organized with prizes reserved for works written in Euskara (Basque), the "mother language of the kingdom," among performances that included "songs, motets, romances, Latin, Basque, Portuguese, Guinean carols in incredible abundance." The admiration at seeing such pomp was such that an Italian choirmaster passing through the city commented that not even in Rome were festivities made "with greater skill and grandeur." [86]

As we have seen in the case of the choir of Arantzazu, the associations of the most prestigious centers of church choirs were also required to accompany special civil celebrations, such as paying homage to royal visits. The Navarrese choir, for example, took part in the celebrations surrounding Carlos I's visit to Pamplona-Iruñea in 1523 and Philip IV's visit to Santo Domingo

---

[86] See Gembero Ustárroz, *Navarra. Música*, 59 and Goñi Gatzambide, "La Capilla Musical de la Catedral de Pamplona en el siglo XVII," 6–9.

de la Calzada in 1646. It also accompanied the royal entourage to Donostia-San Sebastián and Donibane Lohizune (Saint-Jean-de-Luz) and was performed on the occasion of the royal wedding between Louis XIV of France and Maria Teresa of Spain in 1660. Furthermore, in order to give "pomp and solemnity" to the funeral of Carlos II in 1700, the *villa* of Bilbao called on its choir to celebrate with a *Te Deum* the coronation of Felipe IV in 1701.[87] And the two choirs of Vitoria-Gasteiz joined together to pay him homage during his passage through the city that same year.[88] Such choirs were also required to be present during royal visits, such as those to Pamplona-Iruñea of Isabel de Farnesio in 1714, Princess Mariana Victoria de Borbón in 1725, and Princess Louise Elizabeth of France in 1739, and to Vitoria-Gasteiz of Maria Teresa de Borbón in 1745; and the most outstanding members of these musical groups were often required to perform abroad. For example, one of the tenors in the Pamplona-Iruñea choir, Joaquin de Redone, performed at the court of Maria Anna of Neuburg, the widow of Carlos II.[89] Unfortunately, we do not know what music was composed on these occasions.

The repertory composed by the masters or by the organists of the choirs was based on two types of composition differentiated both by the language used (Latin or common), and by form and style. Latin, although forgotten by the majority of the faithful, was used in practically all the liturgical music. However, the choirmaster also composed carols based on religious texts written in the vernacular, designed to be performed during Christmas and Easter as well as on patron saints' feast days.

There is also evidence of some traffic of liturgical music: among the polyphonic books preserved in the cathedral archive of Pamplona-Iruñea, for example, we find works by Francisco

---

[87] Rodríguez Suso, "Viejas voces de Bilbao," 231.
[88] Salaberri Urzelay and Mendialdúa Errarte. "Renacimiento y Barroco," 69.
[89] Ibid.

Guerrero (1528–1599), Sebastián Aguilera de Heredia (1561–1627), and Giovanni Pierluigi da Palestrina (1525–1594), of whom two works preserved are found only in this Cathedral.[90] But most often, each choir would perform polyphonic works composed by its own masters.

Few works by Renaissance authors remain. The best example of this style can be found in the first polyphonic repertory published in the early seventeenth century in Navarre and composed by Miguel de Echarren y Nabarro (c. 1563–1627) from Pamplona-Iruñea, under the name Michael Navarrus.[91]

Navarrus had worked as choirmaster in the Cathedral of Pamplona-Iruñea at two different times (between 1585 and 1591 and from 1608 until his death) and had occupied the same post in the Cathedral of Calahorra between 1591 and 1600. After various years dedicated to a hermitic life in the outskirts of the village of Turruncún (La Rioja), between 1600 and 1608, Navarrus was again named choirmaster of the Cathedral of Pamplona-Iruñea; at the same time, he was chosen as prior of the hermits of Navarre. His remaining works that we have are: a few motets and a Mass of four voices in two manuscripts preserved in the Cathedral of Pamplona-Iruñea, and some other polyphonic pieces contained in two miscellaneous volumes preserved in the Royal Collegiate Church of Orreaga-Roncesvalles. Thanks to his sound financial position (he came from a moneyed family), he could pay for the publication of at least two books of his polyphonic works: the

---

[90] These are the *Missa Sexti toni* and the *Missa Assumpta est Maria*. See Sagaseta Aríztegui, *Catálogo del Archivo de Música. Catedral de Pamplona*, vol. 1, *Fondos históricos desde los orígenes hasta 1962*, 27–45.

[91] On this author, see Aurelio Sagaseta Aríztegui, *El polifonista Michael Navarrus (ca. 1563–1627)* (Pamplona: Capilla de Música de la Catedral de Pamplona, 1983). The work of Navarrus has been published by the same author in *Miguel Navarro (ca. 1563–1627). Opera Omnia* (Pamplona: Capilla de Música de la Catedral, 2006).

*Liber magnificarum* for four voices (published in Pamplona-Iruñea, 1614) and another *Liber magnificarum* (undated and preserved in Zaragoza).

This was indeed exceptional, considering the almost inexistent musical publishing activity both in the Basque Country and in Navarre during the modern age (as we have seen, the two treatises by Gonzalo Martinez de Bizcargui were published in Burgos and Zaragoza, and not even Johannes de Anchieta had managed to publish his compositions).[92] The work of Navarrus reflects the composing style in use at that time, but at certain moments also offers "advanced harmonic characteristics," especially when he exhibits his mastery of the contrapuntal technique, which can be seen even in the short sections of the Mass or in the verses of the *Magnificat*.[93]

From the seventeenth century on, the uniformity of the "old" style adopted by liturgical polyphony began to incorporate some of the novelties of the incipient Baroque, manifested not only by adopting the continuo—used in all musical genres of the time—but also by the use of polycorality. This style of composition, which demands two or more vocal and instrumental groups placed in different locations of the liturgical space, was quickly taken up by the most progressive choirmasters and would remain in force up until the first half of the eighteenth century. The "modern" style—understood as composing for one or two voices with accompaniment, of a more solo aspect, which could

---

[92] Despite the existence, since the first half of the sixteenth century, of various music publishers in the main centers (Pamplona-Iruñea, Tutera, Bilbao, Vitoria-Gasteiz, Donostia-San Sebastián, and Baiona) there are hardly any references to documents published through the nineteenth century. All the liturgical production of the local choirs was transmitted in manuscript form. See *Editoriales musicales de Euskal Herria (s. XV–1950)*, at

http://www.eresbil.com/web/tema-editpartituras/Pagina.aspx?moduleID=1390&lang=es.

[93] Sagaseta Aríztegui, *Miguel Navarro*, 23–24.

be accompanied by harmonizing instruments, with an abundance of rhetoric-expressive resources—began to be used toward the mid-seventeenth century in carols (especially those meant for festivities outside the liturgy on Christmas day or for the Easter holiday), the texts of which, often of little poetic quality, were almost always written in Spanish. There are very few carols in Basque that have been preserved with music: one of the oldest, of which we only know the beginning lines (*"Nay duen esquero sein ederrac"*) dates from 1755 and was composed by Martin de Oarabeitia, the organist of the convent of Saint Francis in Bilbao.

We find in the carols of the Baroque era, more easily than in the contemporaneous liturgical works in Latin, elements that reflect musical styles present in the secular music of the time. Due to their playful-festive function, popular elements were often incorporated that come to the surface both in linguistic and musical aspects. The carols of the Navarrese Urbán de Vargas (1606–1656), for example, are particularly emblematic in this regard. This composer uses with great agility the handling of different compositional styles: he adopts a counterpoint to the old style or polycorality in works composed in Latin (managing to compose for up to sixteen voices), but he uses a homophonic writing, constructed on energetic popular rhythms like *jácaras* and *seguidillas* when he puts music to playful and even ironic texts in his Christmas carols.

## The Diaspora of Musicians in the Seventeenth and Eighteenth Centuries

The choirs, both educational and productive centers, provided an occupation for musically trained clergy that they could combine with their pastoral mission. But only the religious centers with

more financial means could offer the best opportunities for composers, organists, and other professional instrumentalists.[94]

The professional possibilities for musicians born and educated in this region were often limited to working as an organist in a modest local parish choir or in some collegiate church, since at this time in history only Pamplona-Iruñea and Baiona (Bayonne) held the category of cathedral in the area under consideration.[95] The search for better employment was, then, the principal motive for the dispersion of musicians from this region to music institutions throughout the peninsula and including the New World.[96] Such "diasporic" movement, especially during the Baroque period, was common and most typical in the cases of choirmasters, but it also involved organists, cantors, and instrumentalists. The examples cited hereafter, referring to the movements of Navarrese musicians, can serve in understanding the scope of this phenomenon.

---

[94] On this general subject, see Juan José Carreras and José Máximo Leza Cruz, eds., *La circulación de música y músicos en la Europa Mediterránea (ss. XVI–XVIII)* (Zaragoza: Universidad de Zaragoza, 1997).

[95] Tutera (Navarre) became a cathedral in 1783, while the old Collegiate Church of Santa María in Vitoria-Gasteiz became one only in 1949. Ecclesiastic institutions in the Basque Country were organized into four dioceses: the largest was in Pamplona-Iruñea, which included part of the contemporary provinces of Gipuzkoa and Zaragoza; next came Baiona, which included the parishes of Lapurdi and those located in the Baztan Valley of Navarre (these were integrated into the diocese of Pamplona-Iruñea in 1567); the diocese of Calahorra in La Rioja included, from the eleventh century on, Araba and an extensive area comprising what is today La Rioja, Bizkaia, and parts of the provinces of Burgos and Soria, as well as the Viana (Navarre) district and the towns of the Deba Valley in Gipuzkoa; and, to the south, the diocese of Tarazona (Aragón), which included Tutera.

[96] See Javier Marín López, "Música y músicos navarros en el Nuevo Mundo: algunos ejemplos mexicanos (ss. XVII–XIX)", *Príncipe de Viana* 238 (2006), 425–57.

Emblematic of this development was the *cursus honorum* of the Navarrese Bernardo de Peralta (Falces, Navarre, ?–1617). After working as an organist in his native town, he was appointed a choirmaster in, successively, Viana (Navarre), the collegiate church of Alfaro (La Rioja), and the Cathedral of Santo Domingo de la Calzada (La Rioja). He was then transferred to La Seo in Zaragoza and then to Burgos, where he died in 1617.[97] His works today are preserved in Zaragoza, but his fame reached New Spain: indeed, his *Magnificat* in the first tone was "one of the earliest polycoral works preserved in the former Vice Regency of New Spain, now preserved in the cathedral of Puebla."[98]

Francisco Garro (Alfaro, La Rioja, 1539–Lisbon, 1623) worked in the cathedrals of Logroño, Valladolid, and Sigüenza, as well as the royal court in Lisbon, where he published two collections of polyphonic music in 1609.[99]

The course of the aforementioned Urbán de Vargas or Bargas (Falces, Navarre, 1606–Valencia, 1656) was still more complicated: educated in Burgos, he was a choirmaster in the cathedrals and collegiate churches of Huesca, Pamplona-Iruñea, Daroca (Aragón), El Burgo de Osma (Soria), Zaragoza (in the Pilar), Burgos, and Valencia.[100] Such movement was perhaps the result as well of his combative attitude toward the local authorities. In Pamplona-Iruñea, for example, he was involved in legal proceedings for having defended two young cantors of the cathedral, who, against their will but with the support of the cathedral chapter, should have been sent to Madrid as cantors by

---

[97] See Antonio Ezquerro Esteban, "Peralta Escudero, Bernardo [de]," in *DMEH*, vol. 8 (2001), 601–2.

[98] Marín López, "Música y músicos navarros en el Nuevo Mundo."

[99] See José López-Calo, "Garro [y de Yanguas], Francisco," in *DMEH*, vol. 5 (1999), 528–29.

[100] See Antonio Ezquerro Esteban, "Vargas [Bargas], Urbán de," in *DMEH*, vol. 10 (2002), 738–44.

order of the Count of Castrillo (councilor of the state, in the chamber of Castile), probably to be castrated and turned into *capons*.

Miguel de Irízar (Artaxoa-Artajona, Navarre, 1635–Segovia, c. 1684) followed a course that took him from Léon and Toledo (where he was a choirboy) to occupying a position in the choir of the collegiate church of Vitoria-Gasteiz and in the Cathedral of Segovia (which preserves the majority of his 1,200 compositions, all of which are religious). The lively correspondence he had with musicians from diverse cathedral choirs, asking him to exchange compositions, is of enormous importance in knowing the musical tastes prevailing in his lifetime.[101]

Juan de Durango (Falces, 1632–San Lorenzo del Escorial, 1696), left home at age eighteen to enter the monastery of the Escorial (Madrid) as a harpist, where he spent the rest of his life also working as choirmaster.[102] His brother, Matías de Durango (Falces, Navarre, 1636–Santo Domingo de la Calzada, 1698), coincided in León and Toledo with Irízar during his formative years. He held different posts (choirmaster, tenor, and harpist) in Logroño, Viana, Palencia, and Santo Domingo de la Calzada.[103]

---

[101] See Matilde Olarte, *Miguel de Irízar y Domenzáin, (1635–1684?). Biografía, epistolario y estudio de sus lamentaciones* (Valladolid: Servicio de publicaciones de la Universidad, 1996); Matilde Olarte, "Irizar Domenzáin, Miguel de," in *DMEH*, vol. 6 (2000), 480–83. On the epistolary of Irízar, see José López Calo, "Corresponsales de Miguel de Irízar. I," *Anuario Musical* 18 (1963), 197–222 and "Corresponsales de Miguel de Irízar. II," *Anuario Musical* 20 (1965), 209–33; and Matilde Olarte, "Aportaciones de la correspondencia epistolar de Miguel de Irízar sobre música y músicos españoles durante el siglo XVII," *Cuadernos de arte de la Universidad de Granada* 26 (1995), 83–96.

[102] See José López Calo, "Durango, Juan", in *DMEH*, vol. 4 (1999), 570–71.

[103] See José López Calo, "Durango, Matías," in ibid., 571–72; Raúl Angulo Díaz, ed., *Matías Durango: Villancicos con instrumentos* (Santo Domingo de la Calzada: Fundación Gustavo Bueno, 2012).

Both display a rich body of work including works in Spanish (carols and, in the case of Juan, thirty-five songs for four voices with accompaniment) that are preserved not only in the cathedral archives in which they worked, but also in several cities in Latin America.

Between the mid-seventeenth and mid-eighteenth centuries, the diaspora of composers, and especially those from Navarre, continued.

Pedro Ardanaz (Tafalla, Navarre, 1638–Toledo, Castile, 1706), was a choirmaster in Pamplona-Iruñea, and spent almost half his life in Toledo.[104] Fray Jose de Vaquedano (Gares-Puente la Reina, Navarre, 1642–Santiago de Compostela, Galicia, 1711) finished his education in Madrid (where he studied composition) and ended up being appointed a choirmaster in Santiago de Compostela, Galicia;[105] Manuel de Egüés (Egues, Navarre 1654–1729) held the same post in the collegiate church of Vitoria-Gasteiz, and later in the cathedrals of Lleida (in Catalonia) and Burgos (in Castile), where he remained for more than forty years;[106] Francisco Zubieta (c. 1657–1718), who was probably of Navarrese origin, was educated in Madrid and was a choirmaster in Palencia and Salamanca (in Castile).[107]

---

[104] Aurelio Sagaseta Aríztegui, "Ardanaz Valencia, Pedro de," in *DMEH*, vol. 1 (1999), 614–15.

[105] On this author, see José López Calo, "Fray José de Vaquedano, sumo representante de Barroco musical español," *Cuadernos de Sección Música* 1 (1983), 59–70, and by the same author, "Nuevas aportaciones a su biografía y al estudio de su obra," *Cuadernos de Sección Música* 2 (1985), 103–15.

[106] Antonio Ezquerro Esteban, "Egüés, Manuel [Miguel Conejos] de," in *DMEH*, vol. 4 (1999), 571–72.

[107] María Gembero Ustárroz, "Zubieta, Francisco," in *DMEH*, vol. 10 (2002), 1204; Aurelio Sagaseta Aríztegui, "Zubieta, Francisco," in *Gran enciclopedia navarra*, vol. 11 (Pamplona: Caja de Ahorros de Navarra, 1990).

Simón de Araya Andía (Azkoien-Peralta, Navarre, 1676–1738) was a choirmaster in Medina del Campo and León (Castile), where he held this post for almost a quarter of a century.[108]

Among the eighteenth-century choirmasters, one of the most significant composers of the Hispanic Baroque stands out: Juan Francés de Iribarren (Zangoza-Sangüesa, Navarre, 1699–Malaga, 1767), whose enormous productivity (more than nine hundred compositions) is dispersed among Spanish and Latin American archives.[109] After studying for a period in Madrid, he was an organist in Salamanca, but spent half his professional life in Malaga as a choirmaster. His compositional versatility allowed him to go from the most archaic style (used in some motets) to the polycoral style and to the most typical resources of Baroque vocalism in the Italianate tradition, as seen in his six hundred cantatas, a genre in which Iribarren was one of the most fertile Hispanic composers. His vocal and instrumental writing (often virtuosic) and skill in handling rhetoric-musical resources, which Iribarren showed especially in this genre and in his carols, was complemented by the adoption of popular dance themes, which at times seem to be explicitly composed.[110]

A transition to the graceful style became evident in the later compositions of one of the few composers of the time who executed his whole carrier in his place of origin: Andrés Escaregui (Eibar, Gipuzkoa, 1711–Fitero, Navarre, 1773). In the Cathedral of Pamplona-Iruñea he held the posts of choirboy, then harpist,

---

[108] Emilio Casares Rodicio, "Araya Andía, Simón de," in *DMEH*, vol. 1 (1999), 631–32.

[109] Luis Naranjo, "Francés de Iribarren Echevarría, Juan," in *DMEH*, vol. 5 (1999), 235–41.

[110] One could cite, as an example, his well-known Christmas carol for five voices "Jácara de fandanguillo" (c. 1733). On this author's cantata production, see Miguel Querol Gavaldá, "El cultivo de la cantada en España y la producción musical de Juan Francés de Iribarren (1698–1767)," *Cuadernos de Sección Música* 1 (1982), 117–28.

and, from 1738 until his death, that of choirmaster.[111] All his compositions, which are dispersed throughout various national archives, remain within the preclassical graceful esthetic, with no great harmonic-contrapuntal complexities. In tune with the new style, Escaregui gives more importance to melodic development structured through a very regular phrasing with frequent cadences.[112]

In order to end this brief *excursus* (study) of the mobility of Basque musicians, one should cite two eighteenth-century composers whose work was not religious, and because of this who constitute an exception to the musical panorama of the period.

Sebastián de Albero y Araños (Erronkari-Roncal, Navarre, 1722–Madrid, 1756) is probably one of the most interesting contributors to the instrumental music of the Spanish Baroque. His first musical education was as a choirboy in the Cathedral of Pamplona-Iruñea. He later held the post of organist in the Royal Chapel of Fernando VI in Madrid, where he coincided with Alessandro Scarlatti and Joaquin Oxinaga.[113] His two manuscript collections of music for clavichord (*Works for clavichord and pianoforte* and *Thirty sonatas for clavichord*) furthermore display anomalous characteristics in the repertory of this century. The first collection contains six compositions, organized in three very different sections therein: *ricercata*, in improvised style; followed by a fugue of great length and by a sonata, which is monothematic and bipartite in the style of Scarlatti. The second collection, preserved in Venice, contains sonatas of only one movement:

---

[111] María Gembero Ustárroz, "Escaregui Mendiola, Andrés de," in *DMEH*, vol. 4 (1999), 705–8.

[112] Gembero Ustárroz, *La música en la Catedral de Pamplona*, vol. 2, 334.

[113] María Gembero Ustárroz, "Albero Francés José de," in *DMEH*, vol. 1 (1999), 204–6. On this author, see the most complete study existing at present: Carlos Andrés Sánchez Baranguá, "Sebastián Ramón de Albero y Añanos (1722–1756)," PhD diss., Universidad Pública de Navarra, 2016.

because of their tonal connections and contrasting tempos, almost all of them seem composed to be played in groups of two. For some musicologists, this is a question of very innovative compositions since they display advance stylistic changes that came about in the second half of the century (and titled the *Empfindsamer* style). His musical writing precedes, in some cases, the pianistic language adopted by many composers from the second half of the eighteenth century.[114]

In the same Royal Chapel, Albero coincided with Joaquín de Oxinaga (Bilbao, 1719–Toledo, 1789), who, after having held the post of first organist in the convent of the Encarnación in Madrid, entered the Royal Chapel as second organist and, in 1750, prebendal organist in the Cathedral of Toledo. Oxinaga also stood out in terms of his compositional originality: his output for organ abandons the style based on the *tiento* that had prevailed up to that time in the writing for this instrument and frequently uses thematic development as its principal system of composition.

The Navarrese Albero and the Bilbao native Oxinaga helped spread the new style from Madrid. Other Basque keyboard players of the same generation did the same from Gipuzkoa. Both Manuel de Gamarra (Lekeitio, Bizkaia, 1723–Bilbao 1791) and Joseph de Larrañaga (Azkoitia, Gipuzkoa, 1728–Oñati, Gipuzkoa, 1806), along with Oxinaga, had been taught by the eclectic choirmaster Joseph de Zailorda (Bilbao, 1688–1779), and can be included in this new generation of "restless" composers to whom is owed the transition "in our country from a baroque style to one fully of the eighteenth century."[115]

---

[114] Ibid., 335.

[115] Carmen Rodríguez Suso, "Sobre la formación de un grupo de músicos ilustrados en el País Vasco," *Revista de musicología* 6, nos. 1–2 (1983), 478. The study of the new generation of these composers for keyboard exceeds the chronological limits of this article. On Gamarra and Larrañaga, see Mario Lerena Gutiérrez, "Gamarra Licona, Manuel de," in *Enciclopedia Auñamendi*

## Conclusion

Obviously this region did not remain apart from the socio-musical changes that took place during these three centuries. Undoubtedly in this period the secular output of this region cannot be compared, at least from the quantitative viewpoint, with that of the rest of Europe. But on the other hand, we cannot deny that the individual contributions of composers like Anchieta, Navarrus, Iribarren, and Sebastián de Albero, the technological innovations driven by the workshops of local organ makers, and the considerable and widespread liturgical output of composers in the Basque Country made this European region an important center of cultural diffusion from the very beginnings of the modern age.

## Bibliography

Aizpurua, Pedro. "Presentación de las Pasiones y biografía musical." In *Juan de Anchieta: Cuatro pasiones polifónicas*, edited by Dionisio Preciado. Madrid: Sociedad Española de Musicología, 1995.

Angulo Díaz, Raúl, ed. *Matías Durango: Villancicos con instrumentos*. Santo Domingo de la Calzada: Fundación Gustavo Bueno, 2012.

Arana Martija, José Antonio. *Música vasca*. Bilbao: Diputación Foral de Bizkaia, 1989.

―――. "Euskal Musikuak Ameriketan." *Cuadernos de Sección Música* 6 (1993): 85–103.

(online) at http://aunamendi.eusko-ikaskuntza.eus/es/gamarra-licona-manuel-de/ar-60317/ (last accessed May 26, 2018) and, by the same author, "Larrañaga, Fr. Joseph," in *Enciclopedia Auñamendi* (online), at http://aunamendi.eusko-ikaskuntza.eus/es/larranaga-fr-joseph/ar-86003/ (last accessed May 26, 2018).

Astruells Moreno, Salva. "Los ministriles altos en la corte de los Austrias mayors." *Brocar. Cuadernos de Investigación Histórica* 29 (2005): 27–52.

Bagüés, Jon. *Catálogo del Antiguo Archivo Musical del Santuario de Aránzazu.* [San Sebastián]: Caja de Ahorros provincial de Guipuzcoa, 1979.

Blackburn, Bonnie J. "How to Sin in Music: Doctor Navarrus and Sixteenth-Century Singers." In *Music as Social and Cultural Practice: Essays in Honour of Reinhard Strohm,* edited by Melania Bucciarelli and Berta Joncus. Woodbridge: The Boydell Press, 2007.

Burke, Peter. *Popular Culture in Early Modern Europe.* Aldershot: Scolar Press, 1994.

Campo Olaso, Sergio del. *El Órgano de la villa de Ochandiano.* [Donostia]: Eusko Ikaskuntza, 2000.

Caro Baroja, Julio. *Las brujas y su mundo. Un estudio antropológico de la sociedad en una época oscura.* Madrid: Alianza, 1961.

Carreras, Juan José, and José Máximo Leza Cruz, eds. *La circulación de música y músicos en la Europa Mediterránea (ss. XVI–XVIII).* Zaragoza: Universidad de Zaragoza, 1997.

Casares Rodicio, Emilio. "Araya Andía, Simón de." In *Diccionario de la Música Española e Hispanoamericana,* edited by Emilio Casares. Volume 1. Madrid: Sociedad General de Autores y Editores, 1999.

Cohen, Albert. "The Vocal Polyphonic Style of Juan de Anchieta." PhD dissertation, New York University, 1953.

Donostia, José G. Z. *Música y músicos en el País Vasco.* San Sebastián: Biblioteca Vascongada de los Amigos del País, 1951; reprint, in *Obras completas del P. Donostia.* Volume 2. Bilbao: La Gran Enciclopedia Vasca, 1983.

Ezquerro Esteban, Antonio. "Egüés, Manuel [Miguel Conejos] de." In *Diccionario de la Música Española e Hispanoamericana*, edited by Emilio Casares. Volume 4. Madrid: Sociedad General de Autores y Editores, 1999.

———. "Peralta Escudero, Bernardo [de]." In *Diccionario de la Música Española e Hispanoamericana*, edited by Emilio Casares. Volume 8. Madrid: Sociedad General de Autores y Editores, 2001.

———. "Vargas [Bargas], Urbán de." In *Diccionario de la Música Española e Hispanoamericana*, edited by Emilio Casares. Volume 10. Madrid: Sociedad General de Autores y Editores, 2002.

Fernández de la Cuesta, Ismael. "Libros de música litúrgica impresos en España antes de 1900 (II). Siglos XV y XVI." *Música. Revista del real conservatorio de Madrid* 3 (1996): 11–29.

García de Cortázar, Fernando, and José M.ª Lorenzo Espinosa. *Historia del País Vasco*. San Sebastián: Txertoa, 2011.

Gembero Ustárroz, María. *La música en la catedral de Pamplona en el Siglo XVIII*. 2 volumes. Pamplona: Gobierno de Navarra, 1995.

———. "Albero Francés José de." In *Diccionario de la Música Española e Hispanoamericana*, edited by Emilio Casares. Volume 1. Madrid: Sociedad General de Autores y Editores, 1999.

———. "Escaregui Mendiola, Andrés de." In *Diccionario de la Música Española e Hispanoamericana*, edited by Emilio Casares. Volume 4. Madrid: Sociedad General de Autores y Editores, 1999.

———. "Zubieta, Francisco." In *Diccionario de la Música Española e Hispanoamericana*, edited by Emilio Casares. Volume 10. Madrid: Sociedad General de Autores y Editores, 2002.

————. *Navarra. Música.* Pamplona: Gobierno de Navarra, 2016.

Gómez Muntané, Maricarmen, ed. *Historia de la música en España e Hispanoamérica.* Volume 2. *De los Reyes Católicos a Felipe II.* Madrid: Fondo de Cultura Económica de España, 2012.

Goñi Gaztambide, José. "La Capilla Musical de la Catedral de Pamplona en el siglo XVII." *Música en la Catedral de Pamplona* 5 (1986): 3–97.

Hernández Ascunce, Leocadio. "El archivo Musical de la Catedral de Pamplona." *Tesoro sacro musical* (1940): 9–10, 23–24, 34–36, and 42–43.

————. "La personalidad musical del doctor Navarro." *Tesoro sacro musical* (1951): 22–23 and 33–35.

————. "Música y músicos de la Catedral de Pamplona [I]." *Anuario Musical* 22 (1969): 209–46.

————. "Música y músicos en la Catedral de Pamplona [II]. Documentos inéditos." *Anuario musical* 23 (1970): 231–46.

Jambou, Louis. "El órgano en la Península Ibérica entre los siglos XVI y XVIII. Historia y Estética." *Revista de Musicología* 2, no.1 (1979): 19–46.

Jordá, Enrique. "Vida y obra de Johannes de Anchieta." In *De canciones danzas y músicos del País Vasco.* Bilbao: Editorial La Gran Enciclopedia Vasca, 1978.

————. "Gonzalo Martínez de Bizcargui y la teoría musical de su tiempo." In *De canciones danzas y músicos del País Vasco.* Bilbao: Editorial La Gran Enciclopedia Vasca, 1978.

————. "Las ideas musicales del doctor Martín de Azpilcueta." *Musiker. Cuadernos de música* 9 (1997): 84–87.

López Calo, José. "Corresponsales de Miguel de Irízar. I." *Anuario Musical* 18 (1963): 197–222.

————. "Corresponsales de Miguel de Irízar. II." *Anuario Musical* 20 (1965): 209–33.

————. "Fray José de Vaquedano, sumo representante de Barroco musical español." *Cuadernos de Sección Música* 1 (1983): 59–70.

————. "Nuevas aportaciones a su biografía y al estudio de su obra." *Cuadernos de Sección Música* 2 (1985): 103–15.

————. "Durango, Juan." In *Diccionario de la Música Española e Hispanoamericana*, edited by Emilio Casares. Volume 4. Madrid: Sociedad General de Autores y Editores, 1999.

————. "Durango, Matías." In *Diccionario de la Música Española e Hispanoamericana*, edited by Emilio Casares. Volume 4. Madrid: Sociedad General de Autores y Editores, 1999.

————. "Garro [y de Yanguas], Francisco." In *Diccionario de la Música Española e Hispanoamericana*, edited by Emilio Casares. Volume 5. Madrid: Sociedad General de Autores y Editores, 1999.

————. "Martínez de Bizcargui, Gonzalo." In *Diccionario de la Música Española e Hispanoamericana*, edited by Emilio Casares. Volume 7. Madrid: Sociedad General de Autores y Editores, 2000.

Marín López, Javier. "Música y músicos navarros en el Nuevo Mundo: algunos ejemplos mexicanos (ss. XVII–XIX)." *Príncipe de Viana* 238 (2006): 425–57.

Mendialdúa Errarte, Rafael. *Maestros de Capilla y Organistas de la Colegiata y Catedral de Santa María de Vitoria-Gasteiz.* [Vitoria-Gasteiz]: Real Sociedad Bascongada de los Amigos del País, Comisión de Álava, 1988.

Naranjo, Luis. "Francés de Iribarren Echevarría, Juan." In *Diccionario de la Música Española e Hispanoamericana*, edited by Emilio Casares. Volume 5. Madrid: Sociedad General de Autores y Editores, 1999.

Navajas Twose, Eloísa, and José Antonio Sáinz Varela. "Una relación inquisitorial sobre la brujería Navarra." *Huarte de San Juan. Geografía e Historia* 17 (2010): 347–72.

Odriozola, Imanol Elias. *Juan de Anchieta: apuntes históricos*. San Sebastián: Caja de Ahorros Provincial, 1981.

Olarte, Matilde. "Aportaciones de la correspondencia epistolar de Miguel de Irízar sobre música y músicos españoles durante el siglo XVII." *Cuadernos de arte de la Universidad de Granada* 26 (1995): 83–96.

———. *Miguel de Irízar y Domenzáin, (1635–1684?). Biografía, epistolario y estudio de sus lamentaciones*. Valladolid: Servicio de publicaciones de la Universidad, 1996.

———. "Irizar Domenzáin, Miguel de." In *Diccionario de la Música Española e Hispanoamericana*, edited by Emilio Casares. Volume 6. Madrid: Sociedad General de Autores y Editores, 2000.

Peñas García, María C. *Catálogo de los fondos musicales de la Real Colegiata de Roncesvalles*. Pamplona: Gobierno de Navarra, 1995.

Querol Gavaldá, Miguel. "El cultivo de la cantada en España y la producción musical de Juan Francés de Iribarren (1698–1767)." *Cuadernos de Sección Música* 1 (1982): 117–28.

Rodríguez Suso, Carmen. "Notas sobre la organería en Vizcaya durante el siglo XVIII." *Recerca Musicològica* 5 (1983): 137–72.

———. "Sobre la formación de un grupo de músicos ilustrados en el País Vasco." *Revista de musicología* 6, nos. 1–2 (1983): 457–90.

———. "Viejas voces de Bilbao. La música en la Villa durante los siglos XVIII y XIX." In *Bilbo, arte eta historia. Bilbao, arte e historia*. Bilbao: Diputación Foral de Bizkaia, 1990.

———. *La monodia litúrgica en el País Vasco. Fragmentos con notación musical de los siglos XII al XVIII*. Volume 1. Bilbao: Bilbao Bizkaia Kutxa, 1993.

———. "Gonzalo Martínez de Bizcargui y la música práctica." *Cuadernos de Sección Música* 6 (1993): 43–57.

————. *Los txistularis de la villa de Bilbao.* Bibao: Caja de Ahorros Vizcaína, 2000.

————. "La capilla musical de Santiago de Bilbao. Una institución peculiar." In *La Catedral de Santiago.* Bilbao: Obispado de Bilbao, 2000.

Rubio, Samuel. *Juan de Anchieta. Opera Omnia.* [San Sebastián]: Caja de Ahorros Provincial de Guipúzcoa, 1980.

Sagaseta Aríztegui, Aurelio. "Zubieta, Francisco." In *Gran enciclopedia Navarra.* Volume 11. Pamplona: Caja de Ahorros de Navarra, 1990.

————. "Ardanaz Valencia, Pedro de." In *Diccionario de la Música Española e Hispanoamericana,* edited by Emilio Casares. Volume 1. Madrid: Sociedad General de Autores y Editores, 1999.

————. *Catálogo del Archivo de Música Catedral de Pamplona.* Volume 1. *Fondos históricos desde los orígenes hasta 1962.* Pamplona: Analecta, 2015.

————. *El polifonista Michael Navarrus (ca. 1563–1627).* Pamplona: Capilla de Música de la Catedral de Pamplona, 1983.

————. *Miguel Navarro (ca. 1563–1627). Opera Omnia.* Pamplona: Capilla de Música de la Catedral, 2006.

Sagaseta Aríztegui, Aurelio, and María Gembero Ustárroz. "La música en la Catedral." In *La Catedral de Pamplona,* edited by Carmen Jusué Simonena. Volume 2. Pamplona: Caja de Ahorros de Navarra y Gobierno de Navarra, 1994.

Sagaseta, Aurelio, and Luis Taberna. *Órganos de Navarra.* Pamplona: Gobierno de Navarra, 1985.

Salaberri Urzelay, Sabin, and Sagastume Mendialdúa Errarte. "Renacimiento y Barroco." In *La música en Álava,* edited by Sabin Salaberri. Vitoria-Gasteiz: Fundación Caja Vital Kutxa, 1997.

Salaberría, Miguel. *Órganos de Bizkaia.* Bilbao: Diputación Foral de Bizkaia, 1992.

Sánchez Baranguá, Carlos Andrés. "Sebastián Ramón de Albero y Añanos (1722–1756)." PhD Dissertation. Universidad Pública de Navarra, 2016.

Sánchez Ekiza, Karlos. "Del tamborilero al txistulari; la influencia de la música culta en la música popular de txistu." *Cuadernos de etnología y etnografía de Navarra* 52 (1988): 327–42.

———. *Del dambolin al silbo.* Pamplona: Euskal Herriko Txistularien Elkartea, 1999.

———. *Txuntxuneroak. Narrativas, identidades e ideologías en la historia de los txistularis.* Pamplona: Ataffaylla, 2005.

Stevenson, Robert. "Anchieta, Juan de." *Grove Music Online.* At: http://www.oxfordmusiconline.com/grovemusic (last accessed April 9, 2018).

Zudaire Huarte, Claudio. "Organerías. Notas sobre órganos y organistas de Guipúzcoa en el siglo XVII." *Cuadernos de Sección Música* 2 (1985): 79–101.

**Encyclopedias**

*Enciclopedia Auñamendi.* Eusko-Ikaskuntza: http://aunamendi.euskoikaskuntza.eus/

Casares, Emilio, et al., eds. *Diccionario de la Música Española e Hispanoamericana.* Madrid: Sociedad General de Autores y Editores, 2002.

*Grove Music Online: Oxford Music Online*: http://www.oxfordmusiconline.com.

Sadie, Stanley, ed. *The New Grove Dictionary of Music and Musicians.* London: Macmillan Publishers; Washington, D.C.: Grove's Dictionaries of Music, 1980.

# Music in Euskal Herria in the Enlightenment: The Real Sociedad Bascongada de los Amigos del País

Jon Bagüés

Half a century passed between 1764, the year the Real Sociedad Bascongada de los Amigos del País (Royal Basque Society of the Friends of the Country, RSBAP or Bascongada hereafter) was founded, and 1808, a crucial date for the Napoleonic invasions that also entailed the de facto paralyzing of RSBAP activity. The present chapter will focus on the musical efforts developed by this Enlightenment society that extended its activity to the provinces of Araba, Bizkaia, and Gipuzkoa.

## Influences on Music before the Founding of the RSBAP

In chapter 2 of this book the preeminence of church as the principal protagonist in developing music in the Basque Country is clearly shown. The religious music chapels were practically the only means of professional development for musicians throughout the entire Old Regime.

In these three provinces we do not find, in practically the whole eighteenth century, theaters where dramatic plays could be staged or concerts held, nor did the Basque Country have important educational centers. Children from well-off families had to leave Basque Country to be educated.

It is in this context and by these musical standards that we must place the musical activities of the circle of people promoted by Manuel Ignacio Altuna, Marquis of Narros and Count of Peñaflorida, in the 1740s in Azkoitia, Gipuzkoa. The proven

musical enthusiasm of the entire group and its contacts and social ties assured in the circle around Azkoitia an awareness of the musical reality of the Spanish court, of new French esthetic movements, and of the revolutionary Italian musical intermezzi. And we cannot forget the importance of the relationship between Altuna and Rousseau, precisely during the latter's Italian years, during which the philosopher was primarily busy with his musical labors, both theoretical and practical.

In 1764, these intellectually restless gentlemen used the fiestas in honor of San Martin de la Ascensión in Bergara, Gipuzkoa, to propose to a wider circle of friends the founding of an academy to promote the social, cultural, and economic progress of the Basque Country. The new soundscape proposed at these fiestas stands out, since it involved the new genres that the friends were going to practice in their soirées once the RSBAP was established. For the first time in Basque Country operas were heard: *el borracho burlado*, the first opera with lyrics in Euskara (the Basque language); and *le maréchal ferrant*, a French comic opera translated into Spanish, to which was almost entirely added the music from *la serva padrona* by Pergolesi. Orchestral music was also played during these fiestas, which was very rare in the Basque Country.

The display of music in the months preceding the founding of the RSBAP, given the proven musical enthusiasm of its promoters, still showed a bias of public posturing by certain sectors that were apparently not very useful to society, in contrast to the statues of those sectors tied clearly to the economy, according to the plan of the *sociedad economica*, which a good number of the same people had presented a year before but that was limited to Gipuzkoa and received a reply from the business class. Perhaps they were using music and theater as a strategy in the service of social development, which was their principal objective.

## Musicians Connected to the RSBAP

Without a doubt, much of the achievement resulting from the RSBAP's musical activity was due to most of its founding members' musical preparation and proven love of music. Their resolute support of the use of music allowed them to spread the reach of their activities with the cooperation of professional musicians. Among the initial group of supporters of the newly found society, the Count of Peñaflorida took an outstanding leadership role as a true promoter and driving force of the RSBAP's musical dimension.

Born in 1729 in the Gipuzkoan town of Azkoitia, he began his studies in a Jesuit school there, furthering his studies between 1740 and 1746 in another Jesuit school in the French town of Toulouse. During these years he learned to play the violin and the viola and most likely trained in the basics of composition. Learning to play the viola is not a minor detail, as it was not frequently in use in the religious music chapels and it was a necessary instrument for the interpretation of all the instrumental repertory of the classical age.

Appointed the general delegate of the province on numerous occasions, he held other public posts as well, which strengthened the scope of his political and social ties in the Basque Country and at court. In terms of music, Peñaflorida was a constant presence in all soundscapes, from religious settings, both in Azkoitia as in Arantzazu, to public squares, in instructing drummers.[116] In addition, he left samples of

---

[116] As indicated by Josep Pla's *Stabat Mater* score that is preserved in the Arantzazu monastery, in 1756 "it was sung by Mr. Count of Peñaflorida at Madre de Dios de Aranzazu, with the entire community listening with great pleasure." See Jon Bagüés, *Catálogo del antiguo archivo musical del Santuario de Aránzazu* (San Sebastián: Caja de Ahorros Provincial de Guipúzcoa, 1979), 161. He is also attributed with being the author of the text in Basque for the carol

domestic music he composed himself, from the *zortziko Adiyo Probintziya*[117] to the *tonadillas* composed in 1762 for the festivities on the occasion of his friend Pedro Valentín de Mugártegui's wedding.[118]

The Count of Peñaflorida was responsible for some firsts when it came to the relationship between music and Euskara. In 1762 he composed three carols, or *Gavon–sariak*, with the entire text in Euskara, to be sung in Azkoitia. The music has not survived to this day, but fortunately the text has been preserved, having been published.[119] The enlightened ideals of the author shine through in these words. And two years later, in 1764, he composed the aforementioned opera *el borracho burlado*, of which only the text has been preserved and the melody of the beginning *canzonetta*.

In 1767 the Count of Peñaflorida moved to Bergara to follow more closely the development of the institution that would have the widest social reach of the RSBAP, the Real Seminario Patriótico Bascongado (Royal Basque Patriotic Seminary). The count composed various stage pieces for students in the institution, like the operas *El Amo querido* and *La paz* as well as the comedy *Los pedants*; these last two works were left unfinished at his death in 1785.

---

"Euquicic echean bear dezun arguia" put to music by Fr. Agustin de Echeverria in 1779 and also preserved in Arantzazu.

117 Published by Narcisse Paz in Paris on as distant a date as c. 1815 in a collection titled *Deuxième collection d'airs espagnols avec accomp. de piano et guitarre* (Paris: Mme. Benoist, c. 1815), which went on to enjoy some distribution, including manuscript copies overseas.

118 Jon Bagüés, *Ilustración musical en el País Vasco*, vol. 1, *La música en la Real Sociedad Bascongada de los Amigos del País* (Donostia-San Sebastián: Real Sociedad Bascongada de los Amigos del País, 1990), 99.

119 Xavier de Munibe, Conde de Peñaflorida, *Gabonsariak; El borracho burlado*, ed. Xabier Altzibar (Vitoria-Gasteiz: Eusko Legebiltzarra/Parlamento Vasco, 1991).

The count's family and friends, who were inspired to become member of the new association, formed the initial nucleus for the musical groups that Peñaflorida required to put on his musical soirées. Indeed, these family members included his son Ramón Mª, a cellist, who died prematurely in 1774 due to a wound incurred in a four-year trip around Europe, and his son Antonio Mª, a violinist. His great nephew, Felix María Samaniego, is known in history as the author of the *Fabulas*, which were, indeed, written as didactic pieces at the educational center established for the Bascongada in Bergara. But it was mainly his French education in the Jesuit school in Baiona (Bayonne) that allowed him to learn the violin and vihuela. Later on he would master the double bass as well, and in 1777 he learned "a new musical instrument, the clavichord." [120] Samaniego, a member of the RSBAP, left his musical footprint not only in his home town of Laguardia, Araba, but also in Tolosa, Gipuzkoa, where he was mayor for one year, promoting, among other things, an improvement in church music.

Pedro Valentin de Mugartegui, born in Bilbao in 1732 and who lived in Markina (Marquina), Bizkaia, was counted as a full member in 1765, among the first list of members of the Bascongada. I mentioned above the two *tonadillas* that the Count of Peñaflorida composed in 1762 to celebrate the marriage of Mugartegui to Javiera de Elio in Pamplona-Iruñea. Mugartegui participated in Bergara in 1764, both in theater and opera, and we find his name mentioned in various commissions once the RSBAP started functioning.

Roque Xabier de Moyua, the Marquis of Rocaverde, was another founding member who also stood out as violinist. In the early intellectually restless days of the group, which sought to

---

[120] Emilio Palacios Fernández, *Vida y Obra de Samaniego* (Vitoria: Institución "Sancho el Sabio", 1975), 47.

promote education, prior to founding the seminary, its members established a private school in Bergara with seven of their own children as students and the members themselves acting as teachers. The Marquis of Rocaverde was responsible for music instruction through the teaching of the violin. He also organized outstanding music concerts at his home in Donostia-San Sebastián, in the only street that survived the fire of 1813, the present August 31 Street.

Another family whose members stand out in the practice of music in the Bascongada is the Mazarredo family of Bilbao. Juan Rafael de Mazarredo was one of the members in the orchestra for the festivities of Bergara in 1764. Mª Antonia de Moyua y Mazarredo also stands out in this family. The daughter of the Marquis of Rocaverde, she was born in Bergara in 1757 and married José de Mazarredo (Juan Rafael's brother), an outstanding soldier and also a member of the RSBAP. She developed a great love of music and as a child in 1764 participated as a singer in the opera *El borracho burlado*. Moreover, in a 1783 letter from the Count of Peñaflorida to P.J. de Álava, the count says of Mª Antonia that, "I will soon have her piano-forte." [121] In such musical surroundings, it is not surprising that Mª Antonia's daughter, Juana Mazarredo, was also a great lover of music. In the same aforementioned Parisian publication in which the Count of Peñaflorida's *zortziko* appears, there is likewise a "Zortziko, Song and Dance of Vizcaya composed by Mme. Mazarredo." It could be a question of one of the two women mentioned, the mother or the daughter, but I lean toward the mother because she was a

---

[121] *La Ilustración Vasca: Cartas de Xabier de Munibe, Conde de Peñaflorida, a Pedro Jacinto de Alava*, ed., intro., notes, and indexes by J. Ignacio Tellechea Idígoras (Vitoria-Gasteiz: Eusko Legebiltzarra/Parlamento Vasco, D.L., 1987), 682.

devotee of the *zortziko* of Peñaflorida, who died in 1785 and with whom Mª Antonia was very connected.[122]

Because music practice was important in the private realm as has been mentioned, the true social reach of the RSBAP, as a result of its diffusion and development of music, resides in the collaboration and interconnection it achieved with prominent professional people in the Basque Country in the second half of the eighteenth century.

I will now list the professional musicians in order of their admission to the Bascongada, beginning and ending with the two musicians who held the post of chapel master of the RSBAP. This post appears specified in the statutes of 1765: "The society shall have a chapel master with the title of aggregate member, who will present at all the board meetings, compose whatever music for the society he is charged with, review and correct all music given to him for his examination by the society, and prepare and preside over the orchestra of the academies of music."[123]

Manuel Gamarra was born in Lekeitio, Bizkaia, in 1723 and entered the Music Chapel of Bilbao as a boy soprano in 1734, directed at that time by Jose de Zailorda; there he coincided for a while with Joaquin Oxinaga, the nephew of the titular organist

---

[122] See Jon Bagüés, "Dos mujeres compositoras en la Bizkaia ilustrada y romántica," *El Boletín de la Sociedad Filarmónica de Bilbao* 6 (2008), 4–7. One should also emphasize that "Mme. Mazarredo" is not the only case of a female composer linked to the Royal Basque Society of Friends of the Country. In 2006, Eresbil received a set of musical documents from the Mugartegui palace in Markina. It included several pieces composed by the Countess of Peñaflorida, whom we identified as Epifanía de Munibe y Argaiz, the eleventh Countess of Peñaflorida, who was born in Donostia-San Sebastián in 1812. Her father, Xavier Mª de Argaiz (discussed below) had studied at the Royal Basque Patriotic Seminary in Bergara.

[123] *Estatutos de la Sociedad Bascongada de los Amigos del País, según el Acuerdo de sus Juntas de Vitoria por Abril de 1765* (San Sebastián: En la Oficina de Lorenzo Joseph de Riesgo, Impresor de esta Sociedad, [1766]), 24–25.

Juan Bautista de Inurreta. In 1741 he was organist of Eibar, Gipuzkoa, taking on the post of chapel master coadjutant of the town of Bilbao, and involved as much with the organ as with the training of the boy sopranos, of which the choir had two or three. It is likely that part of the unease Gamarra developed in the heart of the Bascongada was due to the Chapel Master Zailorda. He was a true *novatore* who, besides being a musician, was also a construction manager and architect who designed, for example, the façade of the Pamplona-Iruñea city hall that still exists today.[124] Gamarra's professional music activities took place in Bilbao, where he was also an examiner for various posts for organists. Gamarra was admitted into the RSBAP as its first member in the "aggregate" category, and included as the "Chapel Master of Santiago of Bilbao, and of the Society" in the first catalog of Bascongada members dated 1766 and published with the first statutes of 1765. He kept his position as chapel master until his death in 1791.

Normally, music members belonged to the second commission of practical arts and sciences. Gamarra, however, belonged to the first, which was dedicated to the study of "agriculture and rural economics," at which he submitted various reports and contributed as an invention various machines related to hygiene. With respect to music, besides fulfilling his statutory obligations, he contributed other works: from esthetic ones, such as a discourse on poetry dedicated to music, to technical contributions, such as a summary on composition presented in 1772 (unfortunately lost), and pedagogical offerings such as a "geography pack" to teach the description of Spain to young people. Of the compositions he wrote for the Bascongada only

---

[124] Carmen Rodríguez Suso, "El Patronato Municipal de la Música en Bilbao durante el Antiguo Régimen," spec. issue "III Symposium 'Bilbo, Musika-Hiria/Bilbao, una ciudad musical'," *Bidebarrieta* 3 (1998), 57.

*Juego de versos* has come down to us.[125] But we have evidence that he composed the opera *El médico avariento*, as shown in the 1772 catalog of works of the Bascongada, and moreover in 1784 he presented *24 pieces for harpsichord and organ*, written for use by students at the royal seminary in Bergara.

Brother José de Larrañaga also appears on the first list of RSBAP members in 1766 as a "Religious Franciscan and Choirmaster of Aranzazu." He was born, according to records, in Azkoitia, Gipuzkoa, in 1728 and appeared as early as 1747 as "master" on one of his compositions preserved in the Arantzazu Archive.[126] His musical path, lasting until his death in 1806 in Arantzazu, coincides with one of the most splendid musical periods of the Franciscan monastery. The musical ascent of Larrañaga goes beyond the summits of the monastery, to display his activity both as specialist in the approval of new organs (in Ataun, 1762; Bergara, 1774; Etxarri-Aranatz [Echarri-Aranaz], 1779; Durango, 1781; Zegama [Cegama], 1788/1790; Tolosa, 1789; and Legazpi, 1791), and by taking part in examining tribunals for positions for organists (in Bilbao, 1779; Ondarroa, 1782; Legazpi, 1786; and Zegama, 1789).

Most probably, his reasons for entering the RSBAP were based on the mutual personal acquaintance and musical appreciation with the Count of Peñaflorida. Brother José de Larrañaga's activity at the heart of the Bascongada testifies to his presence on the councils of the second commission between 1767 and 1781, offering to the society a work titled "Information on the Musical Code of Mr. Rameau," presented in 1766, about the *Code de Musique Pratique* method of musical training published in Paris in 1760 by J.Ph. Rameau.

---

[125] Manuel de Gamarra, *Juego de versos y Sonatas* (San Sebastián: Eusko Ikaskuntza, 1986).

[126] Bagüés, *Catálogo del antiguo archivo musical del Santuario de Aránzazu*, 143.

Juan Andrés Lombide is another of the professional musician members of the RSBAP. In 1772, as a piece to enter the society, he offered a collection of six sonatas for harpsichord and violin, unfortunately lost today. The professional activity of Lombide, born in Elgeta, Gipuzkoa, in 1745, began in 1765 when he attained the position of organist in the Music Chapel of Bilbao, replacing Manuel Gamarra. He remained there until 1778 when, after having auditioned for more important musical posts like that at the Royal Chapel in 1768 and the Cathedral of Calahorra in 1771, he obtained the position of organist at the Cathedral of Oviedo in 1778. In 1786 he obtained via competitive exams the post of organist in the Real Convento de la Encarnación in Madrid, remaining there until his death in 1811. Lombide's professional path is perhaps that desired by a large number of Old Regime professional musicians: the gradual attainment of positions in places with better economic possibilities, eventually obtaining a position in one belonging to the Royal Chapel.

Lombide's membership in the RSBAP was not limited to his initial presentation of the aforementioned sonatas, but was also supported by his presence in various seminary councils. But above all his importance is due to the appearance in 1733 of a treatise titled *El arte del Organista* or *Tratado del arte y método de aprender con facilidad el órgano o clavicembalo, y acompañar sobre él*, which he introduced complete in three parts in 1775, and of which only the resume of the contents has come down to us. It is important to point out that he wrote this didactic work during his Bilbao period, strengthening the practical will of the efforts of the RSBAP in music as well. Lombide's music still held up in the mid-nineteenth century, as seen in an 1855 article in the *Gaceta de Madrid* mentioning him as an "organist of very good reputation."

José Ferrer was admitted to the RSBAP as a member professor in 1782, and a prominent as "Organist of the Cathedral of Pamplona." He was born in Mequinenza, Zaragoza, about 1745.

He was organist in Tremp, Lleida (Lérida), before assuming the post of organist in the cathedral of Pamplona-Iruñea in 1777, a position he would keep until 1786 when he obtained the position of organist in the Cathedral of Oviedo, where he died in 1815. In his Oviedo period, he maintained a close friendship with the enlightened Gaspar Melchor de Jovellanos.

As far as we know, Ferrer did not submit musical compositions or scholarly works to the Bascongada, although he did participate in the general board meetings of 1784, held in Bilbao. But it should be pointed out that, precisely during his Bilbao period, advertisements appear in the *Gaceta de Madrid* in 1780 and 1781 about his *Six Sonatas for Pianoforte or also Clavicord*, as well as for his *Three Sonatas for Harpsichord and Pianoforte with Violin Accompaniment*. Brother Martin de Crucelaegui was nominated in 1784 to be accepted as a "music teacher," pointing out the merits "he showed in his travels through the Americas great Fervor for the advancement of the society." He was born in Elgoibar, Gipuzkoa, in 1742. We know nothing about his education, but we find him as examinant, and as a choirmaster in the Franciscan monastery in Bilbao in 1767, before taking part in a missionary expedition in 1770. Brother Pablo de Murgategui, the brother of the aforementioned member of the Bascongada Pablo Valentin de Mugartegui, was also in the same expedition. The Franciscan historian Ignacio Omaechevarría attributes to Crucelaegui the composing of the *Missa Viscaína*, which spread throughout the Californian missions.[127] This could very well be, since Brother Martin de Crucelaegui was the choir priest in the Missionary

---

[127] Fr. Ignacio Omaechevarria, "Los Amigos del País y los Frailes de Aránzazu," *Misiones Franciscanas* 429 (1964), 278–79. See also William J. Summers, "The MISA VISCAINA: An Eighteenth-Century Musical Odyssey to Alta California," in *Encomium Musicae: Essays in Memory of Robert J. Snow*, ed. David Crawford and G. Grayson Wagstaff (Hillsdale, NY: Pendragon Press, 2002), 127–42.

School of San Fernando in Mexico, to which staff the Californian missionaries belonged.[128] Recent cataloging of the musical archives in Mexico is providing new scores by Crucelaegui in addition to those already known.[129]

Joaquín Montero is listed in the membership catalog of the RSBAP in 1791 as "Organist of S. Pedro el Real, in Seville." The only connection we could find between this organist and composer with the Bascongada is a dedicatory that he includes in the printed edition of his *Six Sonatas for Harpsichord and Pianoforte*, op. 1, thanking "the protection that you very wisely have offered to the sciences." These were printed in Madrid in 1790. Joaquin Montero was born in about 1740 in Seville, and from 1780 on was substitute organist in the Cathedral of Seville, the city in which he died in 1815. He was also the author of two treatises, a *compendio harmonico* (Madrid, 1790) and a *Theoretical-practical treatise on counterpoint* (Seville, 1815).

Pedro de Landazuri was, as far as we know, the second and last choirmaster of the society in its first stage, although it is certain that various years had passed since Manuel de Gamarra's death in 1791. We do not know if the society at that time took on such a responsibility, although, given the unstable years that followed, especially with the French invasion of 1794, it seems that music did not have the same status as it had in its first twenty-five years. In any case, his presence at the Bascongada's concerts, in addition to being chaplain to the Marquis of Montehermoso in

---

[128] See Idoia Arrieta Elizalde, *Ilustración y Utopía: Los frailes vascos y la RSBAP en California (1769–1834)* (Donostia-San Sebastián: RSBAP, 2004), 177–84; Craig H. Russell, *From Serra to Sancho: Music and Pageantry in the California Missions* (New York: Oxford University Press, 2009).

[129] Lidia Guerberof Hahn, *Archivo Musical. Catálogo. Insigne y Nacional Basílica de Santa María de Guadalupe* (Mexico D.F.: Insigne y Nacional Basílica de Guadalupe, 2006); Lidia Guerberof Hahn, "El archivo musical del convento franciscano de Celaya (México)," *Anuario Musical* 65 (2010), 251–68. The music archive of Guadalupe conserves twenty-one works by Crucelaegui.

Vitoria-Gasteiz (who was appointed director of the RSBAP in 1785), were sufficient reasons for his nomination. Pedro Antonio Ortiz de Landazuri was born in Larrinbe (Larrimbe), Araba, about 1747. He was appointed choirmaster at the Colegiata of Vitoria-Gasteiz in 1770, occupying the post until his retirement in 1815, and died two years later in 1817.[130]

Pedro de Landazuri was admitted to the RSBAP in 1786 as a member professor, "in view of the consistency in which he always attended the concerts of the society." Certainly, there was consistency in his attendance at least from 1771, not only for the concerts of the general board that took place in Vitoria-Gasteiz, but also those that took place in Bilbao in 1793. Besides his specific work as music director, he submitted in 1801, on request of the general board, a study about the report presented by Vicente Garviso concerning a new method of printing music.

## Education

One of the principal achievements of the RSBAP, if not the most visible, but certainly of great perspicacity, was the establishment of the Real Seminario Patriótico Bascongado de Bergara, an educational institution that opened its doors in 1776, once the educational program was approved. It remained in operation in its first period until 1794, when it was forced to close because of the War of the Convention. Its year of maximum splendor was 1787, when it had 132 students and 25 professors. The origin of the students was very mixed; not only did they come from various places in the Basque Country, but also from distant areas like Galicia and Andalusia, and they included children of Basque emigrants from various American countries such as Argentina,

---

[130] Rafael Mendialdua, "Músicos alaveses en la Colegiata de Santa María," in *Coral Manuel Iradier. Argentina. 1987* (Vitoria-Gasteiz: Coral Manuel Iradier, 1987).

Colombia, Cuba, Guatemala, Mexico, and Venezuela, and indeed the Philippines. In the aforementioned year of 1787 the institution obtained a royal certificate by which the courses were made valid for the secondary school degree and access to the larger university faculties.

The educational program consisted of two parts: general education and a specialized education that included subjects like commerce, chemistry, mineralogy, metallurgy, civil agriculture, agriculture, and politics. The students had an opportunity to receive training, upon payment, in what at that time was termed "skills": music, dance, and foil or fencing.

In the teaching of music, the contents and professors varied. Until 1786 there was one specific music teacher, but from thereafter the number of professors increased to up to four or five. Everything seems to indicate that professors from elsewhere were enlisted. The first name listed as the violin teacher is that of Juan Bautista de Lascorret (1779–1794), to which is added that of Francisco Enero (1783–1784). Jose Roig signed a contract in 1786 as a professor in the seminary, going with his family to Bergara so that two of his sons also gave music lessons: Fernando Roig in wind instruments and violin and Juan Roig as assistant in violin classes. Also in 1786 we find Vicente Quintana as professor of music for singing and harpsichord. In this case, the rectors of the seminary engaged the person who had held the post of organist since 1766 in the town of Bergara. At times we also find Vicente Quintana's brother José Quintana. Everything seems to indicate that after the reopening of the seminary after the close of the war, the origin of the professional staff was Basque, so that in 1801 we find Bartolomé Jauregui as professor of violin, José de Soto as professor of vocal music and piano, and Joaquin Quintana, professor of vocal music. In 1802 Domingo Barrera joined the institution as first

master of violin, and later on introduced himself as "first professor of music and orchestra conductor."

In the case of Xavier Mª Argaiz, we are lucky enough to know more directly the type of music practiced by the students after their apprenticeship. He was married to a granddaughter of the Count of Peñaflorida and former student of the seminary from 1793 to 1794, the year in which all the personnel were evacuated because of the eminent invasion of the French troops. He died in 1815, and in the inventory of his possession of his house in Pamplona-Iruñea we find, on one hand, "a viola in its case" and, on the other, the specific contents of the "library," in which are found among others a "collection of all Haydn's quartets," the "complete collection of Mozart's quartets, quintets, and trios," "a concerto of Dussek with orchestral accompaniment," and "three of Georxe Onslora's quintets."

In a cultural environment in which it was not easy to obtain printed music, an aspect that one should consider when studying the spread of music in the classical period is the custom of copying music scores. In the conserved records conserved of the seminary's accounts we find receipts for copies of "music papers" for the students of the institution. Although not very specific, they still seem to indicate an author, "two quartets by Pleyel," and more frequently the genres or forms like "duets," "rondos," "contra dances," "a symphony," "seven duets for violin," "six quartets for violin," "four duets and a trio," "a notebook of minuets and contra dances," and "music for flute and violin." The students to whom the copies were to be sent came from peninsular locations like Zaragoza, Arahal (Seville), Toranzo (Santander), Donostia-San Sebastián, Labastida, and El Ferrol, but we also find some from more far afield places like Ciudad de la Paz and Trujillo in Peru, Chile, Havana, Onda in Nueva Granada, Veracruz, and Buenos Aires. It is not easy to know the level of such diffusion or the impact these musical practices had, but traces of these

transatlantic musical voyages are not lacking as, for example, copies have been found in Argentina.[131]

As regards the teaching of the dance, the faculty came from outside the Basque territory, reinforcing the tendency noted in the music faculty: Italy and France seem to be, at the beginning, the countries from which the faculty was drawn; later, the teachers would come from the Mediterranean area. Thus, after an initial professor to teach dance and fencing, named as Mr. Dubois, Reinero Gabrieli was contracted in 1778 to teach dance exclusively. The negotiation took place in Barcelona, and he was appointed the theater-dance instructor. He remained there until 1780, when they tried to hire Jaime Ferrer, a "dance master from Barcelona," to replace him, but without success because of his demands. The search for a "French-style dance master" came to an end with the contracting of José León, a native of Valencia, of whom it was noted that he was "twelve years a dance master in the Seminary of Nobles of Calatayud. He knows how to play the cello, double bass, and violin." His stay at the seminary extended to 1785, when again they looked for his successor in Barcelona, in the end contracting Antonio Furtó. In 1790 we find a new professor in the person of Segismundo Torrents: his son Antonio Torrents was his assistant for a year. Torrents (the father) remained there until the closing of the seminary in 1794. After its reopening in 1798 the tendency to obtain the dance faculty from around the Mediterranean changed to searching in Madrid. Thus from 1798 to 1811, Juan Antonio Lorenzo de Castro held the post of dance professor at the seminary.

---

[131] Although not directly related to the seminary, Maria Antonia Palacios' *Libro Sesto*, which includes two sonatas by the RSBAP member, Juan Antonio Lombide, is from that period and could be referred to. See Guillermo Marchant, "El Libro Sesto de Maria Antonia Palacios, c. 1790. Un manuscrito musical chileno," *Revista Musical Chilena* 192 (1999), 27–46.

Do we know anything about the content of dance education? What did "French-style dance" mean? In a request proposed by the dance master at the seminary in 1791, concerning the suitability of teaching new styles of dance, we learn that the classic French school, on which traditionally the apprenticeship of dance was based, included basically the Minuet and the Passepied, and that the dances in fashion at the time were the English Gigue, the Allemande, and the French and English contra dances. Also at the end of the century, an apprenticeship of the Spanish school of dance was required, most probably the bolero school.

Concerning the venues for music, in 1783, seven years after the opening of the seminary, 3,173 reals were authorized to upgrade the music room there; one item included the building of five lecterns, most probably straight benches with lecterns. This is where the usual concerts were performed, to which the masters of vocal and instrumental music at the seminary were required to attend along with those students given permission by the orchestra masters or conductor. A document titled "Regulation that should be observed in the concerts of the royal seminary of Bergara" and dictated in sixteen points by the seminary director, Miguel de Lardizabal, in 1804, has been conserved he specifies that "the first violin will be tuned from the key of the trumpet or traverse flute, all other instruments kept quiet until one of the masters comes by to give them the key individually."[132]

In terms of the repertory played in the seminary, we have two documentary sources: one from 1787, in which the music teacher asks for duos, trios, quartets, concertos, and symphonies, in a receipt from Mme. V. Baillon of Paris specifying the works desired; and also an "Inventory of the music papers of the

---

[132] José Ignacio Tellechea Idígoras, "El Real Seminario de Vergara y su Director Lardizabal (1801–1804)," in *Los Antiguos Centros Docentes Españoles* (San Sebastián: Patronato "José María Quadrado" [CSIC], 1975), 43–88.

seminary," signed by the professor Domingo Barrera in 1817, in which are specified all such papers available at the seminary at that time. From the general count made, we have recorded a total of 204 instrumental works that were part of the music archive at the Bergara seminary in its first 40 years of existence (1776–1817); prominent by genre were 104 symphonies, 25 concertos, 30 quartets, and 14 duets. Among the composers that stand out are Haydn, Bréval, Cambini, Fodor, Clementi, Pleyel, Stamitz, and Sterckel, with the 1817 list also revealing composers like Davaux, Giroverz, Hoffmeister, Mozart, Pichl, and Wranitzky.

There was an attempt, probably promoted by the Count of Peñaflorida. to create a "music school" to link the musical activity of the seminary with that of the RSBAP (indicating that "the chapel master would be the same as the one of the RSBAP"), and noting that the concerts would be held on Sundays and last one hour and a half. This was not an educational but rather a diffusion project with the aim of transcending the educational work undertaken by the seminary into something like a society of concerts, as a clear antecedent to the philharmonic societies that would emerge in the next century.

## Theater Music Relating to the RSBAP

It was not until the end of the eighteenth century that Bilbao would see the construction of a building dedicated specifically to theater performances, and Donostia-San Sebastián would have to wait until 1802. Only Pamplona-Iruñea, with its Casa de Comedias theater, offered performances throughout the eighteenth century (with some breaks), including opera companies. It was precisely the performance of one of the Italian opera companies, that of Nicolas Setaro, that gave rise to a regrettable situation showing us

the difficulties of developing a musical theater in the Basque Country—in other words, due to the opposition of the clergy.[133]

And yet, it was probably the very same Jesuit education of the Count of Peñaflorida, first in his native town of Azkoitia and later in the French city of Toulouse, that imbued him with the school motto "instruct pleasantly," based on the Horatian maxim. The comic opera was the preferred genre of RSBAP members for lyrical performances. Two operas, *el mariscal en su fragua* and *el borracho burlado*, had already been performed in the festivities celebrated in Bergara in 1764 and that gave rise to the later birth of the RSBAP. The first was a translation of the French opera *le maréchal ferrant*, written by François-André Danican Philidor and premiered in Paris in 1761, to which was added fragments of *la serva padrona* by Giovanni Battista Pergolesi. *El borracho burlado* was an opera written by the selfsame Count of Peñaflorida, today lost, and notable for being the first opera to use the Basque language in the lyrics.

The initial proposal of the RSBAP promoters to use their free time to stage theater works, both dramatic and lyric, was met with opposition in Gipuzkoa, but because these were private performances, this had no impact. Perhaps this opposition caused the practice of music at the society to be centered more on instrumental music. Nevertheless, among the items of the society inventoried in 1771, we find works by the Italian composers Nicola Conforto, Egidio Romualdo Duni, and G.B. Pergolesi; by the Frenchman Pierre-Alexandre Monsigny; and by the Belgian Modest Grétry; as well as the aforementioned work of the Count of Peñaflorida; and of Manuel de Gamarra, lost today, entitled *El médico avariento*. Except for the work of Conforto, all the others belong to the genre of comic opera.

---

[133] Carmen Rodríguez Suso, "El empresario Nicola Setaro y la ópera italiana en España: La trastienda de la Ilustración," *Il Saggiatore Musicale* 5, no. 2 (1998), 247–70.

True to the initial ideals of the count, once the seminary was founded, the practice of musical theater was turned to the service of the students. Thus we have reports of two other titles composed by the Count of Peñaflorida, both lost today, which were intended to be interpreted by the students: *El amo querido* (1781) and *La Paz* (a posthumous work of 1785).

## Concerts and Instrumental Music in the RSBAP

It was perhaps through the concerts organized on the occasion of the annual RSBAP general board meetings that the network of musical contacts uniting members' amateur practice with the participation of instrumentalists could be established, permeating the genres and esthetics of classicism. So-called music academies were found in the statues of the Bascongada as the only diversion for attendants to the annual board meetings, noting that one should try between the professional musicians and the amateurs to have a concert.

More than 170 concerts were held between 1765 and 1793. In 1794, the general board met, but due to the exceptional political circumstances, no concerts were advisable. The general board meetings were held in a rotating manner among the localities of Bilbao (Bizkaia), Vitoria-Gasteiz (Araba), and Bergara (Gipuzkoa). In 1767 they were held in the Markina, Bizkaia.

Members had to confront the problem of concert venues on more than one occasion. Keep in mind that none of the three provinces had in those years a building expressly dedicated to concerts or a theater, as has been mentioned. This meant that, for a performance space, concerts had to be held at both public and private places. In Bergara concerts took place either in the home of Roque Xabier de Moyua, the Marquis of Rocaverde, or in the home of Peñaflorida and occasionally at the city hall. In Bilbao they were held either on the premises of the Bilbao

Consulate, in the home of Pablo de Epalza, or in the home of Manuel de Salcedo. And in Vitoria-Gasteiz they were probably held in the home of the Marquis of Montehermoso.

This rotation of the Bascongada concerts gave the organization greater reach for activities relating to the participation of professional musicians. Based on the data I obtained, I believe the totality of musicians belonging to orchestras can be estimated to be around twenty. How many of these were professional? On average, the number of musicians contracted every year varies between four and eight, although the number is higher in some years; thus in 1771 there were eleven musicians contracted, and in 1780 twelve. Logically, the venue of the concerts would vary the number of musicians contracted, so that when concerts were held in Vitoria-Gasteiz, the two chapel masters of the city were included; one of them, Pedro de Landazuri, was chapel master of the selfsame society following Manuel de Gamarra, and with them buglers and Manteli horns were hired, as well as the bassoonist Francisco de Quintana, who came from Laguardia (Araba) and also played the "violone," and a tenor singer from the same locality was also contracted.

On occasion, the first violinist of the Cathedral of Burgos, Gaspar de Mainarte, was also present. In Bilbao, besides the obligatory presence of Manuel de Gamarra, the two buglers of the chapel of the city, Juan Jorge Muncig and Francisco Müller, were hired, as well as Antonio Soidel, a violinist and Francisco Serrano, a contralto, but hired to play the clavichord. On more than one occasion the flutist of the Cathedral of Santander, Juan Pamphille, joined the orchestra. In Bergara, a smaller locality relying on the nearby Sanctuary of Arantzazu, could count on the participation of musicians from its music chapel. In Bergara, likewise, we note the participation of musicians from Donostia-San Sebastian ("two Catalan musicians," without specification, in 1773) and Ramon Antonio de Elormendi and Domingo de

Ichaso, from Tolosa, in 1776. Bergara and the RSBAP itself counted on the possibility, from 1776, of incorporating into the general board concerts the musicians of the patriotic seminary, as we see in 1780 with the assistance at the concerts in Vitoria-Gasteiz of the seminary's violin teacher, Juan Bautista Lascorret, as well as the dance teacher with an instrument, the double bass, which seemingly was not very frequent in the orchestras of the Bascongada. A little later it was the students themselves who joined the concerts of the councils, as happened in Vitoria-Gasteiz in 1783 and 1786.

Along with the hiring of professional musicians, we find on occasion the hiring of instrumental soloists: thus, in 1770 the hiring of "a famous German oboist" for the meetings in Bergara; in 1773, and also in Bergara, "a musician of [musical] glasses"; and in 1780, a "boy of fourteen amazing at the clavichord" (probably Joseph Andes), for whom a pianoforte was provided.

It is no easy matter to detail the repertory used in concerts organized by the RSBAP. I indicated above the theater pieces for the theater that the RSBAP had in its first years of activity. The same "list of properties held by the society as gifts," dated 1771, details likewise in the section specifically dedicated to music the instrumental genres it had at its disposal in fourteen titles grouped in three parts that added up to 54 instrumental pieces: 38 symphonies, 7 quartets, and 9 trios, representing a good summary of contemporary European music: the Manheim School stands out in its two generations: Johamn Stamitz and Anton Filtz, in the first, and Carl Joseph Toeschi and Franz Beck in the second; Carl Ditters von Dittersdorf represents the Viennese school; Pierre van Maldere carried out his work in Belgium; Italy is represented by Stefano Galeotti, who carried out his work in Holland, as well as by Luigi Bocherini who worked principally in Spain; England is represented by the native German Charles Barbandt, and France

is represented by the greatest personage of the moment, François-Joseph Gossec.

Logically, this early relation with works of music, including chamber music and orchestral music, and with woodwind and brass sections, would have to be expanded in later years to that which we have pointed out previously tied to the seminary, in which the style was expanded to become the symphony concertante.

## Music in the Continental Basque Country

The lack of records and detailed studies of music in the French Basque Country in the eighteenth century hinders us from having a precise idea of the impact of music during the Enlightenment. Natalie Morel[134] points out this difficulty in her work dealing with the beginnings of lyrical theater in Baiona, given the proven enthusiasm of the people of Baiona for all types of performances. This included dance, an art form to which the people of Baiona contributed a special dance, the *Pamperruque*, a nocturnal ball danced to the sound of the drum up until the early nineteenth century. It is difficult to record opinions like those of Paul Lafond when, in order to document the great love of the people of Baiona for music, he writes that there were few families in which at least one member did not play the violin, the double bass ("de la base"), the viola, and above all the guitar, the preferred instrument of the country. Lafond discusses this in his biography of the famous singer Pierre Garat,[135] who was born and educated musically in Bordeaux, although in his youth he would spend time in his family's ancestral territory of the Basque Country. His artistic importance as a singer was notable, including his position

---

134 Natalie Morel, "La música en Bayona," in *Bayona: Vida, Paisajes, Símbolos*, ed. Enrique Ayerbe Echebarria (Oiartzun: Sendoa, 1994), 288-307
135 Paul Lafond, *Garat: 1762–1823* (Paris: Calman Lévy, 1900).

as singer to Queen Marie Antoinette, and has left us some thirty songs and romances as the output of his compositions. Our knowledge of the instruments and their teaching as part of the educational program is confirmed in the case of the fabulist Samaniego, a RSBAP member who in the six years he spent at the Jesuit School of Baiona learned to dance, play the violin, and the vihuela.[136]

What remains beyond doubt is the strategic position of Baiona in commerce. The selection of French novelties in books for the Count of Peñaflorida was made through Baiona merchants such as Eydelin and Monix. The seminary of Bergara also received through Baiona scores published in Paris. In 1787 the music teacher put in an important order for scores, and in February of 1789 the receipt was issued for eleven of Pleyel's symphonies, just months before the outbreak of the French Revolution, a revolutionary movement that among other effects immediately produced a *cordon sanitarie* encircling everything concerning the diffusion of French publications, with the corresponding cultural isolation of the peninsular Basque Country.

## The Musical Enlightenment in Navarre

In the 1770s numerous economic societies were founded in all over Spain and had to follow an order by the statesman Count of Campomanes to take as a model the Madrid Society. As one might expect, at no moment does it mention music in its statues, taking into account the development of music in the capital of the kingdom. Thus, the option of including music as one of its engagements was closed. The same happens in most of these societies, as well as in the Real Sociedad Económica Tudelana de

---

[136] Emilio Palacios Fernández, *Vida y obra de Samaniego* (Vitoria: Institución "Sancho el Sabio," 1975), 26

los Deseosos del Bien Público, created in 1778, despite the fact that its first director was himself a member of the RSBAP. It seems that music had no place in the labors of this society. However, María Gembero-Ustárroz, in her latest and complete overview of the development of music in Navarre,[137] provides us with precise data concerning musical patronage of the Navarrese nobility. The Marquis of San Adrián had as music teacher for his children in Tutera (Tudela) Jose Castel, also from Tutera, who would publish two collections of chamber music in Paris. The Marquis of Castelfuerte, also a member of the Society of Tutera, had as musicians Nicolás Sertori (around 1758–60), the author of the *Divertimenti Musicali per camera*, and Bilbao native Juan Antonio Múgica, who composed in 1762 a *Drama para música*.

We should not overlook the fact that the situation of the musical development of Navarre was of a different caliber if we compare it with the territory of the Bascongada. The fact of having two cathedrals, Pamplona-Iruñea and Tutera, implied having important musical resources. The capital, Pamplona-Iruñea, besides having a historic established episcopal see with a vigorous music chapel, also had a theater house that hosted theater and opera performances, including both serious operas and opera buffa, zarzuelas, *tonadillas*, and dance.

To that can be added not only the houses of the nobility, but a large well-to-do segment of society that, besides status, enjoyed developing domestic music. I mentioned above Xavier Maria de Argaiz, who would practice the music he learned in the seminary of Bergara in his homes in Azkoien-Peralta and Pamplona-Iruñea.

---

[137] María Gembero-Ustárroz, *Navarra: Música* (Iruña-Pamplona: Nafarroako Gobernua/Gobierno de Navarra, 2016).

Another place that contains musical traces of the period is the Casa Navascués, whose music archive has recently been catalogued.[138]

## The Square, the *Txistu*, and the Dance: Iztueta.

In a stratified society like that of the eighteenth century, one tends to think that, as regards amusement, there was no contact between commoners and elites. However, we have data in regard to the Basque Country that connect Bascongada members with popular music and dance. This helps explain the importance of music, and the very RSBAP, in reorienting the wealth of popular music, not only in the domain of the figure par excellence of popular Basque music, the drummer (presently called *txistulari*, the *txistu* interpreter), but also in the domain of dance. Thus, although no scores have come down to us today, we have heard of the Count of Peñaflorida instructing the drummer of Azkoitia, having him play *zortzikos* and contradanses composed by him. And among his family, thanks to his preserved correspondence, we hear that "he made [two of the sons of Peñaflorida in 1763] dance the *carrica* with its *chilibitus*" and in 1785 made his son Antonio Mª, accompanied by twelve friends, dance an *ezpata-dantza* in the streets of Arrasate-Mondragón (Gipuzkoa).

In the preface to his celebrated collection of Gipuzkoan dances, Juan Ignacio de Iztueta points out his debt to the RSBAP and to Enlightenment thought.[139] Karlos Sanchez Ekiza studies

---

[138] María Álvarez-Villamil and Ignacio Menéndez Pidal, "El fondo musical de la Casa de Navascués. El testimonio de una práctica musical en el entorno privado de una familia hidalga de Navarra," *Príncipe de Viana* 262 (2015), 941–54.

[139] Juan Ignacio de Iztueta, *Euscaldun anciña ancinaco ta are lendabicico etorquien dantza on iritci pozcarri gaitzic gabecoen soñu gogoangarriac beren itz neurtu edo versoaquin* (Donostia: Ignacio Ramon Barojaren moldizteguian, 1826).

the transition of the *txistu* and Basque dance during the Enlightenment, coming to the conclusion that, "Iztueta tried to combine the ideas of the Enlightenment with Basque defensiveness, and carried out in Gipuzkoan dance a process of invention in a typically folkloric tradition, but tremendously precocious for the time."[140] And he values as principal technical changes in the drum's very representation as a predominant instrument, a change in the study of the instrument, changes in musical forms, and in the very melodies of the new repertory, as well as in the expansion of the instrumental family and the orchestral structure.

A last detail that links the Bascongada with the domain of traditional music is the fact that Wilhem von Humboldt, in his trips through the Basque Country, would have extensive meetings with people associated with the RSBAP acting as informants on traditional music.[141]

## The RSBAP, a Failed Project?

Several observers declare that the reformist project of the RSBAP was a failure. I believe that, insofar as music is concerned, one could not explain the Basque nineteenth century without its direct influence. It is true that in the creative domain the scores they composed have not been preserved, but this can be explained by the lack of development in music printing along with historical circumstance and, I might add, by the negligence of conserving libraries and documented sources.

---

[140] Karlos Sánchez Ekiza, *Del danbolin al silbo: Txistu, tamboril y danza vasca en la época de la Ilustración* (Pamplona: Karlos Sánchez Ekiza, 1999).

[141] The Basque folklore materials collected by Humboldt are published in P. Donostia, *Cancionero Vasco. III. Canciones. Papeles de Humboldt* (Donostia: Eusko Ikaskuntza, 1994), 1527–91.

Perhaps we should recall the words of José Ignacio Tellechea Idígoras in the introduction to the correspondence between the Count of Peñaflorida and Pedro Jacinto de Álava, words that can be applied to the efforts of all the RSBAP: "He dreamed, in the vocabulary of his time, not that of the nineteenth century, to transform and better society."[142] Nevertheless, when analyzing the historical consequences of the RSBAP relating to music, it would probably be more correct to label it as a work of fertilization undertaken in an environment such as the Basque Country, not familiar with types of music beyond its reach. The Bascongada left its trace in technical advances and various social aspects. It drove the development of printing, both general and musical, as is reflected in the printed editions of chamber music made outside the Basque Country by musicians of the Bascongada like José Ferrer and Joaquin Montero. It supported women's education in publishing in 1785 a "Plan and rules for a seminary" or school for ladies in Vitoria-Gasteiz, a project that did not see the light of day. Included in the project as skills was the teaching of the clavichord or pianoforte. It is no surprise that it was in the environment of the Bascongada that we see the names of women composers. And I must point out the support of members of the society for the development of Euskara.

Javier Esteban Ochoa de Eribe's recent essay on "Authors, Readers, and Reading of Texts in Euskara" devotes a section to the Bascongada and theater reform as part of its civilizing project, presenting its members as promoters of secular Basque literature and of the civilized discourse of the Enlightenment.[143]

---

[142] *Ilustración Vasca: Cartas de Xabier de Munibe, Conde de Peñaflorida, a Pedro Jacinto de Álava.* Editing, introduction, notes and indexes by J. Ignacio Tellechea Idígoras (Vitoria-Gasteiz: Eusko Legebiltzarra/Parlamento Vasco, 1987), 19.

[143] Javier Esteban Ochoa de Eribe, *Discursos civilizadores: Escritores. Lectores y lecturas de textos en euskera (c. 1767 c. 1833)* (Madrid: Silex, 2018), 165–206.

These are the aspects that contributed to a rather direct influence of the RSBAP on various musical personalities who all had in common belonging to a new merchant class and developing its work in the first third of the nineteenth century. Baltasar Manteli is a curious personality who has already been studied in relation to music.[144] He appears on numerous occasions related to the Bascongada, as a musician and bookseller. The society helped him establish himself as a printer in 1786. But the relationship that most interests me is his participation as a clarinetist and horn player in the general board concerts. We have records of this from 1771 and beyond. Thus, Baltasar Manteli figures as the center of musical activity in Vitoria-Gasteiz (Araba) in the first third of the nineteenth century. He organized an orchestra with members of his own family, managing to play the Beethoven symphonies.

Among other, Mateo Pérez de Albéniz, the father of Pedro Albéniz, collaborated with Manteli. These two musicians worked for years in the parish of Santa María in Donostia-San Sebastián, the latter becoming an important personality as a concert musician and piano teacher at the Royal Conservatory of Music in Madrid.[145] He studied in the Paris Conservatory, where he met Juan Crisóstomo Arriaga, the unsuccessful musician from Bilbao. At the time of Arriaga's death, Manteli wrote a letter from Donostia-San Sebastián to Arriaga's father in which he mentioned the Mazarredo ladies.

This is not the only relationship established between Arriaga and the RSBAP. On two occasions, in 1792 and 1793, the RSBAP awarded Juan Simon de Arriaga, Juan Crisóstomo's

---

[144] Paula Garaicoechea Sagasti, "Los Manteli, una saga de clarines durante el siglo XVIII," *Cuadernos de Sección. Música* 7 (1994), 127–43.

[145] In 1802 Mateo Pérez de Albéniz published in Donostia the method *Instrucción metódica, especulativa y práctica, para enseñar a cantar y tañer la música moderna y antigua* (San Sebastián: En la Imprenta de Antonio Undiano, año 1802).

father, first prize for literacy in Bizkaia in recognition of his work as a schoolteacher in Gernika. Otherwise, besides the Mazarredo ladies, mother and daughter, there was another woman closely linked to the RSBAP's Bizkaian circle in the person of the Countess of Echauz, who maintained connections with Arriaga. From one of the letters preserved in the Arriaga Museum, we learn that she was interested in the young musician, through a professor from the Paris Conservatory, and shared the answer with Juanita Mazarredo. Another musical personality born in Bilbao at this time but habitually ignored because practically his whole professional career was carried out in England is Rufino Lacy, a precocious child who gave his first concert in Bilbao in 1801.

The musicians mentioned above were not members of the RSBAP. Some, like Arriaga and Lacy, would not have managed to know about it. Besides, they belonged to a new emerging society based on commercial and mercantile activity. Nevertheless, they are part of a finely wrought musical mesh, which, I believe, is tied by subtle threads to the RSBAP. It is not by chance that these composers and performers stood out principally in chamber music (Arriaga, Lacy), theater music (Arriaga), teaching (Albéniz), or that they would cultivate symphonic music (Arriaga in composition and Manteli in performance). These are precisely the genres and subjects that the RSBAP would cultivate for the first time in the Basque Country.

## Bibliography

Álvarez-Villamil, María, and Ignacio Menéndez Pidal. "El fondo musical de la Casa de Navascués. El testimonio de una práctica musical en el entorno privado de una familia hidalga de Navarra." *Príncipe de Viana* 262 (2015): 941–54.

Arrieta Elizalde, Idoia. *Ilustración y Utopía: Los frailes vascos y la RSBAP en California (1769–1834)*. Donostia-San Sebastián: RSBAP, 2004.

Bagüés, Jon. *Catálogo del antiguo archivo musical del Santuario de Aránzazu*. San Sebastián: Caja de Ahorros Provincial de Guipúzcoa, 1979.

————. *Ilustración musical en el País Vasco*. Volume 1. *La música en la Real Sociedad Bascongada de los Amigos del País*. Donostia-San Sebastián: Real Sociedad Bascongada de los Amigos del País, 1990.

————. *El Real Seminario Patriótico Bascongado de Vergara*. Volume 2 of *Ilustración musical en el País Vasco*. Donostia-San Sebastián: Real Sociedad Bascongada de los Amigos del País, 1991.

————. "Dos mujeres compositoras en la Bizkaia ilustrada y romántica." *El Boletín de la Sociedad Filarmónica de Bilbao* 6 (2008): 4–7.

D'Ors, Miguel. "Representaciones dramáticas en la Pamplona del siglo XVIII." *Príncipe de Viana* 134–135 (1974): 281–315.

Donostia, Padre. *Cancionero Vasco. III. Canciones. Papeles de Humboldt*. Donostia: Eusko Ikaskuntza, 1994.

*Estatutos de la Sociedad Bascongada de los Amigos del País, según el Acuerdo de sus Juntas de Vitoria por Abril de 1765*. San Sebastián: En la Oficina de Lorenzo Joseph de Riesgo, Impresor de esta Sociedad, [1766].

Gamarra, Manuel de. *Juego de versos y Sonatas*. San Sebastián: Eusko Ikaskuntza, 1986.

Garaicoechea Sagasti, Paula. "Los Manteli, una saga de clarines durante el siglo XVIII." *Cuadernos de Sección. Música* 7 (1994): 127–43.

Gembero-Ustárroz, María. *Navarra: Música*. Iruña-Pamplona: Nafarroako Gobernua / Gobierno de Navarra, 2016.

Guerberof Hahn, Lidia. *Archivo Musical. Catálogo. Insigne y Nacional Basílica de Santa María de Guadalupe.* Mexico D.F.: Insigne y Nacional Basílica de Guadalupe, 2006.

————. "El archivo musical del convento franciscano de Celaya (México)." *Anuario Musical* 65 (2010): 251—68.

*La Ilustración Vasca: Cartas de Xabier de Munibe, Conde de Peñaflorida, a Pedro Jacinto de Alava,* edited, introduced, notes, and indexes by J. Ignacio Tellechea Idígoras. Vitoria-Gasteiz: Eusko Legebiltzarra/Parlamento Vasco, D.L. 1987.

Iztueta, Juan Ignacio de. *Euscaldun anciña ancinaco ta are lendabicico etorquien dantza on iritci pozcarri gaitzic gabecoen soñu gogoangarriac beren itz neurtu edo versoaquin.* Donostia: Ignacio Ramon Barojaren moldizteguian, 1826.

Lafond, Paul. *Garat: 1762–1823.* Paris: Calman Lévy, 1900.

Marchant, Guillermo. "El Libro Sesto de Maria Antonia Palacios, c. 1790. Un manuscrito musical chileno." *Revista Musical Chilena* 192 (1999): 27–46.

Mendialdua, Rafael. "Músicos alaveses en la Colegiata de Santa María." In *Coral Manuel Iradier. Argentina. 1987.* Vitoria-Gasteiz: Coral Manuel Iradier, 1987.

Morel, Natalie. "La música en Bayona." In *Bayona: Vida, Paisajes, Símbolos,* edited by Enrique Ayerbe Echebarria. Oiartzun: Sendoa, 1994.

Munibe, Xavier de, Conde de Peñaflorida. *Gabonsariak; El borracho burlado,* edited by Xabier Altzibar. Vitoria-Gasteiz: Eusko Legebiltzarra/Parlamento Vasco, 1991.

Ochoa de Eribe, Javier Esteban. *Discursos civilizadores: Escritores. Lectores y lecturas de textos en euskera (c. 1767 c. 1833).* Madrid: Silex, 2018.

Omaechevarria, Fr. Ignacio. "Los Amigos del País y los Frailes de Aránzazu." *Misiones Franciscanas* 429 (1964): 278–79.

Palacios Fernández, Emilio. *Vida y Obra de Samaniego.* Vitoria: Institución "Sancho el Sabio," 1975.

Rodríguez Suso, Carmen. "El Patronato de la Música en el País Vasco durante el Antiguo Régimen." Special issue, "III Symposium 'Bilbo, Musika-Hiria/Bilbao, una ciudad musical'," *Bidebarrieta* 3 (1998): 41–76.

———. "El empresario Nicola Setaro y la ópera italiana en España: La trastienda de la Ilustración." *Il Saggiatore Musicale* 5, no. 2 (1998): 247–70.

Russell, Craig H. *From Serra to Sancho: Music and Pageantry in the California Missions.* New York: Oxford University Press, 2009.

Sagastume. Manuel. "La Ilustración Musical. Música y músicos en el País Vasco del siglo XVIII." In *La Real Sociedad Bascongada de los Amigos del País en la Ilustración.* Vitoria-Gasteiz: Real Sociedad Bascongada de los Amigos del País, 1999.

Sánchez Ekiza, Karlos. *Del danbolin al silbo: Txistu, tamboril y danza vasca en la época de la Ilustración.* Pamplona: Karlos Sánchez Ekiza, 1999.

Summers, William J. "The MISA VISCAINA: An Eighteenth-Century Musical Odyssey to Alta California." In *Encomium Musicae: Essays in Memory of Robert J. Snow,* edited by David Crawford and G. Grayson Wagstaff. Hillsdale, NY: Pendragron Press, 2002.

Tellechea Idígoras, José Ignacio. "El Real Seminario de Vergara y su Director Lardizabal (1801–1804)." In *Los Antiguos Centros Docentes Españoles.* San Sebastián: Patronato "José María Quadrado" (CSIC), 1975.

# Music in the Nineteenth Century

Isabel Díaz Morlán

Throughout the nineteenth century, several historical events that indirectly or directly affected music took place in the Basque Country. After the Napoleonic invasion, the uprising of the population in the so-called War of Independence (also known as the Peninsular War, 1808–14) was a rehearsal for the confrontation between liberals and absolutists that was to be perpetuated in the Basque Country and Navarre in the three Carlist Wars that took place at different times between 1833 and 1876.[146] When peace was reached in 1876, the Basque *fueros* or charters (the Basque local laws and customs) were abolished, which meant, among other things, the free working of mining resources and the transfer of customs to the coast, that is, the inclusion of the Basque provinces in a single internal market, a permanent aspiration of the Bizkaia and Gipuzkoa bourgeoisie.[147] From that moment on, there were rapid demographic, urban development, and customs changes[148] that transformed the region forever. But above all there was enormous economic growth,

---

[146] Jon Juaristi, *Historia mínima del País Vasco* (Madrid: Turner, 2013), 233.

[147] Fernando García de Cortázar and José María Lorenzo Espinosa, *Historia del País Vasco. De los orígenes a nuestros días* (San Sebastián: Txertoa, 1997), 108–9; Juaristi, *Historia mínima del País Vasco*, 250–52.

[148] The direct relationship between the increase in population and musical consumption is pointed out by Carmen Rodríguez, "La leyenda de Arriaga," in Juan de Eresalde, *Resurgimiento de las obras de Arriaga*, facs. ed. (Bilbao: Diputación Foral de Bizkaia, 2006), 11. It was only in Bilbao that the population went from 18,000 to 80,000 in the thirty-year period from 1870 to 1900. In the mining area, the increase in that same time was from 25,000 to 230,000.

especially in Bizkaia, as a result of the mining, steel, and shipping industries.[149] The consequent enrichment of the bourgeoisie encouraged the consumption and practice of music, both in the private and public spheres. Meanwhile, in neighboring France, the centralization of political power that came about as a result of the revolution of 1789 did not prevent the barely industrialized French Basque Country from retaining its essentially rural customs and landscapes. This explains why it was precisely there where the pioneers in the recovery and dissemination of Basque musical folklore emerged, before being imitated by their Spanish counterparts.

Finally, and to complete the panorama, the forced expropriations of ecclesiastical assets carried out by successive Spanish governments between 1808 and 1856, the disentailments, were settled on the one hand with the abandonment of monasteries and convents, and their musical activities, and in most cases the loss of their archives and instruments as well; and on the other, with the general decrease in rental income, which affected the endowment of the surviving music chapels. In short, and as a consequence of these events, the Old Regime institutions that up to that point had sustained music were transformed, directly eliminated, or replaced by new initiatives, until finally a modern, although unequally distributed, musical fabric was developed.

In order to provide an account of the musical events of that complex century, the content of this chapter has been

---

[149] See in particular the reference works of Emiliano Fernández de Pinedo and José Luis Hernández Marco, eds., *La industrialización del norte de España. Estado de la cuestión* (Barcelona: Crítica, 1988); Jesús María Valdaliso, *Los navieros vascos y la marina mercante en España, 1860-1935. Una historia económica* (Bilbao: IVAP, 1991); and Emiliano Fernández de Pinedo, "De la primera industrialización a la reconversión industrial: la economía vasca entre 1841 y 1990," in *Historia económica regional de España, siglos XIX y XX*, ed. Luis Gonzalo Germán *et al.* (Barcelona: Crítica, 2001).

organized on the basis of themes rather than chronology. The objective is to detect in isolation the musical aspects that most intensely developed in the Basque Country during the nineteenth century and also to establish relationships between them. These themes are the ecclesiastical music chapels, the contrast between the world of guilds and that of amateurs, musical education, the founding of bands, choral societies and choirs, the creation of orchestras, companies and theaters, the musical market of scores and instruments, and the promotion of virtuosos of singing, the violin, and keyboard.

## Music Chapels

The most constant and richest musical institution inherited from the eighteenth century was the ecclesiastical music chapel. In many European cities, the existence of a chapel was, until the mid-nineteenth century, the only support for musical production; apart from ensuring stable teaching, the chapel musicians provided not only religious but often also civil and even theatrical music. The oldest and also the most powerful of the music chapels with influence in the Basque Country was that of Pamplona-Iruñea Cathedral, which had medieval origins was founded as a chapel in the sixteenth century and has continued its trajectory until today.[150] During the nineteenth century, and despite the fact that the number of permanent musicians was reduced, the activity

---

[150] María Gembero-Ustárroz, *La música en la Catedral de Pamplona durante el siglo XVIII* (Pamplona: Gobierno de Navarra; Institución "Príncipe de Viana," 1995); Aurelio Sagaseta, "Música en la Catedral de Pamplona (siglo XIX)," *Ars Sacra 7* (1998), 112–21; María Gembero-Ustárroz, ed., *Estudios sobre música y Músicos de Navarra. Conmemoración del VIII Centenario de la Chantría de la Catedral de Pamplona como dignidad eclesiástica (1206–2006)* (Pamplona: Gobierno de Navarra, 2006); María Gembero-Ustárroz, *Navarra. Música* (Pamplona: Gobierno de Navarra. Departamento de Cultura, Deporte y Juventud, 2016).

of the Pamplona-Iruñea chapel was not interrupted, and it even collaborated with the new civil musical institutions that were going to emerge in the city. This cooperation was becoming more and more of a necessity for the musicians, who, in order to subsist, had to supplement their earnings with private classes and collaborations in bands and music orchestras, although this moonlighting generated a network of connections in the main Basque cities, as will be discussed below. Among the musicians who passed through the Pamplona-Iruñea chapel at this time was Hilarión Eslava (1807–78), who, after training as a choirboy and chaplain musician, played the double bass and violin and was an organist, tenor, and composer in the chapel, before embarking on his brilliant national career.[151]

The degree of the Pamplona-Iruñea chapel's provision cannot be compared to that of the Basque music chapels, not having had episcopal see for much of the nineteenth century, specifically until 1862, when the diocese of Vitoria-Gasteiz was instituted and the collegiate church of Santa María in Vitoria-Gasteiz became a cathedral. However, Bizkaia and Gipuzkoa, had had for considerable time different chapels that allowed a network of personal relationships and musical activities to be formed that impelled the development that was going to occur in the second half of the nineteenth century. In Bilbao there were two music chapels: San Francisco, which after more than three hundred years of activity disappeared in 1851 after the church burned down;[152] and especially the church of Nuestro Señor Santiago, which had been operating under municipal patronage since the sixteenth century.[153] It declined in the first half

---

[151] Gembero-Ustárroz, *Navarra. Música*, 141, 143, 149.

[152] Carmen Rodríguez, "Bilbao," in Grove Music Online, at http://www.oxfordmusiconline.com (last accessed February 20, 2018).

[153] Carmen Rodríguez, "La capilla musical de Bilbao: una institución peculiar," in *La Catedral de Santiago de Bilbao* (Bilbao: Obispado de Bilbao, 2000), 167–95.

of the nineteenth century through problems of discipline among its members and a gradual loss of interest on the part of the inhabitants of Bilbao. However, it was precisely then, in 1830, when Nicolás Ledesma (1791–1883) entered the church as an organist to restore lost quality to the chapel and maintained this for another half century. The chapel was finally dissolved in 1877 by the city hall, which could not maintain it after the abolition of the *fueros* in 1876, and its musicians were relocated to a municipal academy of music. Not much of the music performed in this chapel has survived, although we do know about the activity of its musicians, especially the chapel masters. As already noted regarding Pamplona-Iruñea, in the Basque Country as well after centuries of unquestioned identity, these musicians had to endure the decline of their profession in the nineteenth century, and many were able to do so with great success, accepting all kinds of works inside and outside the chapel, and serving as a channel for a renewal of musical styles.[154]

Two particularly interesting cases of chapel musicians "reconverted" into modern musicians are, in Bizkaia, the aforementioned Nicolás Ledesma, and in Gipuzkoa, José Juan Santesteban (1809–84). Ledesma, Aragonese by birth but settled in Bilbao, was appointed chapel master in 1832, played in public for twenty-seven years (the organ in the church and the piano in theaters and salons), composed all kinds of both religious and popular secular works, trained musicians inside and outside the chapel, and was apparently responsible for creating a philharmonic society in 1852.[155] The dissolution of the chapel and the consequent transformation of its musicians into teachers at the new municipal academy "left Nicolás Ledesma unprotected, and, at ninety years of age, he had to play the Santiago organ again

---

[154] Ibid., 192–94.

[155] Antonio Ezquerro, *Música en imágenes. El maestro Nicolás Ledesma (1791–1883). Un músico en la España del siglo XIX* (Madrid: Alpuerto, 2015), 218.

to earn a living," although finally he was given a pension.[156] Among Ledesma's outstanding students in the chapel, for example, was José Aranguren (1821–1902), a teacher at the Royal Madrid Conservatory, author of a piano method that was declared an official textbook, and grandfather of Jesús Guridi (1886–1961), one of the best Spanish musicians of the twentieth century. Ledesma's students also included Valentín Mª de Zubiaurre (1837–1914), likewise a teacher at the Royal Conservatory and chapel master of the Royal Palace, and Manuel Villar (1849–1902), born in Tutera (Tudela, Navarre) and an adopted citizen of Bilbao, a singer in Santiago at eighteen and known in Bilbao, especially for his great pedagogical vocation.

The other very similar case is that of José Juan Santesteban, an organist and teacher at the Santa María chapel in Donostia-San Sebastián, where he had succeeded Mateo Pérez de Albéniz (1755–1831) and his son Pedro Pérez de Albéniz (1795–1855). We know that in the mid-nineteenth century the chapel acted in the main parish of Santa María del Coro, but also in the parish of San Vicente, located in the same street of Donostia-San Sebastián's old quarter. At that time the city hall only considered the existence of one chapel, which was basically that of Santa María, and among the musicians of both parishes there was close collaboration that was very regulated.[157] Santesteban received his first serious music classes from Mateo Pérez de Albéniz and founded a philharmonic society in Donostia-San Sebastian as early as 1839.[158] He moved to Madrid in 1840, and four years later to Paris and various Italian cities to further his musical studies. That same year, on his return to Donostia-San Sebastián, he took up

---

[156] Rodríguez, "La Capilla musical de Bilbao," 195.

[157] *Reglamento para el Régimen de la Capilla Música de esta M.N.y M.L. ciudad de San Sebastián* (San Sebastián: Imprenta de Ignacio Ramón Baroja, 1848).

[158] José Antonio Arana, *Música vasca* (Bilbao: Caja de Ahorros Vizcaína, 1987), 171.

the position of organist and teacher at the chapel of Santa María. From that moment on he displayed incredible musical activity, not only as organist in the chapel's activities but also as a composer, editor, director, ensemble creator, and teacher. His students included his own son, José Antonio Santesteban (1835–1906), and Raimundo Sarriegui (1838–1913), who, among other things, became very popular as a music composer for the Donostia-San Sebastian carnival.

Gipuzkoa also had other important chapels, especially the Franciscan Monastery of Nuestra Señora de Aránzazu, the Santa María monastery in Tolosa, and the Santa María del Juncal monastery in Irun. The monk-musicians of the Aránzazu chapel produced, especially in the eighteenth century, a large amount of music for singing and organ and abundant repertoire for harpsichord, before its activity came to an end at the beginning of the nineteenth century, when the Franciscan community was expelled and the convent burned down several times, the last time in 1834.[159] The Santa María chapel in Tolosa, whose patronage corresponded to the city hall—which paid for the organ and the organist, cantor, and singers—underwent a very intense period in the second half of the nineteenth century, when Felipe Gorriti (1839–96) was appointed chapel master in 1867, the year in which the patronage passed to the crown.[160] In addition to acquiring a new organ, playing regularly on it, and directing the musical group of the chapel, Gorriti composed more than two hundred works for it and created a music school from which excellent artists emerged. The Tolosa music chapel is still active today and comprises an organ, string, and wind orchestra, and a

[159] Jon Bagüés, *Catálogo del Antiguo Archivo Musical del Santuario de Aránzazu* (San Sebastián: Caja de Ahorros Provincial de Gipuzkoa, 1979).
[160] Berta Moreno, *Felipe Gorriti. Compositor, maestro de capilla y organista* (Pamplona: Fondo de Publicaciones de Gobierno de Navarra, 2011).

mixed-voice choir, an exceptional body in that era.[161] Finally, the chapel of the parish church of Santa María del Juncal in Irun, which also received municipal patronage, was very active during the nineteenth century, and not only in the area of ecclesiastical and civil performance, but also in the area of teaching. As was the case in other Basque towns, the chapel's musicians were those that provided the opportunity to receive musical training to the children and young people in the area for decades.[162]

In Araba, almost all the important towns had at least one organist who accompanied services and instructed the children musically in the mid-nineteenth century, and many had a church choir.[163] Some, such as Agurain (Salvatierra) and Guardia (Laguardia), had more means, and the case of Sebastián Iradier (1809–1865), who was an organist in the parish of San Juan in Agurain from 1827, when he was awarded the position at the age of eighteen, is well known. However, among music chapels, that of the collegiate church of Santa María in Vitoria-Gasteiz stands out. It was already mentioned in documents in 1544, and there is record of activities of the chapel throughout the nineteenth century. From 1862 on, when Vitoria-Gasteiz became a diocese and therefore the collegiate church became a cathedral, the chapel increased its influence in the city, subduing the other chapel that existed in the Parish of San Pedro.

---

[161] See http://www.tolosasantamariakapera.eu/ (last accessed February 20, 2018).

[162] Paulino Capdepón, *La música en Irún en el siglo XIX: La capilla de música de la Iglesia de Santa María del Juncal* (Irún: Ayuntamiento de Irún, 2011).

[163] Sabin Salaberri et al., *La música en Álava* (Vitoria-Gasteiz: Fundación Caja Vital Kutxa, 1997), 96; Rafael Mendialdua, *Maestros de Capilla y Organistas de la Colegiata y Catedral de Santa María de Vitoria-Gasteiz* (Vitoria-Gasteiz: Real Sociedad Bascongada de los Amigos del País, 1988); Eduardo Moreno, *La música en Laguardia: del siglo XII a la actualidad* (Logroño: Piedra de rayo, 2014).

Finally, in relation to this world of the ecclesiastical chapels, the activity of organ making should be highlighted. Despite the progressive decline of the chapels during the nineteenth century, in its closing decades many of the old organs of the Basque and Navarrese churches were replaced by new and expensive ones from the French firms Cavaillé-Coll, Merklin, Stoltz Frères, and Puget, or Basque organ makers were commissioned. María Gembero-Ustárroz documents at least forty-two new organs "installed in churches in Navarre throughout the nineteenth century."[164] Among the local organ makers, the workshop of the Navarrese Pedro Roqués, and especially that of the Gipuzkoan Aquilino de Amezua (1847–1912) stand out. Amezua, after training in France, Germany, and England, introduced into Spain the romantic-symphonic organ, and built numerous instruments in the Basque Country and Navarre, such as the spectacular organ of Bera (Vera de Bidasoa) in 1895.[165] In short, and as a result of this intense period of construction, today we have a rich heritage of romantic organs, many of them restored or in the process of restoration.

## Contrasts: Buglers and Drummers, and Amateurs Looking to Europe

Another type of professional musician very different from those of the chapel, but who were also dependent on city hall (at least in the case of Bilbao), were the buglers and the drummers.[166]

---

[164] Gembero-Ustárroz, *Navarra. Música*, 148, 150.

[165] Sergio Del Campo and Berta Moreno, "El órgano de San Esteban de Bera: un modelo experimental de Aquilino Amezua," *Musiker* 19 (2012), 175–278.

[166] Carmen Rodríguez, *Los txistularis de la Villa de Bilbao* (Bilbao: BBK-Bilbao Bizkaia Kutxa, 1999). As far as is known, there is no systematic study of this type on the *txistularis* or flute players in Donostia-San Sebastián, where the activity of drummers has been documented since 1824, according to Iztueta's

The latter played the whistle (*txistu*, in Basque) and the drum in the official acts of the municipal corporation, as well as in local festivals and pilgrimages. On the other hand, drummers and buglers often collaborated with the musicians of the two Bilbao chapels on special occasions. These musicians were also united by a similar fate: it seems that as the nineteenth century advanced, the music of the drummers was being displaced by military bands at official events; and several festive occasions for which the city hall paid orchestras to entertain the dances, thereby dispensing with their traditional musicians, have been documented. All this is another manifestation of the cultural changes that were happening as the institutions born in the Old Regime were losing prominence. According to Carmen Rodríguez, of the three types of professional musicians that the city had in the first half of the nineteenth century (chapel musicians, buglers, and drummers), the latter could not adapt to the changes that were taking place and were relegated to public dances, parades, and accompanying the authorities, while the other two (chapel musicians and buglers), who were better trained, joined new musical institutions such as bands, orchestras, and music academies that were to be formed throughout the second half of the century.[167]

An early example, of a very different type, of that transition to the non-guild world is that of Juan Crisóstomo de Arriaga (1806–1826), who represents the access of amateurs to the professional playing of music. He did not study at the chapel of Santiago nor later enter it, but he did train with José de Sobejano (1791–1857), the organist of Santiago in 1815 and friend of the Arriaga family, and received violin lessons from Fausto

---

testimony. The same could be said of Vitoria-Gasteiz, which in the mid-nineteenth century had a *txistulari* service that ended up being part of the municipal band that would be created at the end of the century. See Salaberri et al., *La música en Álava*, 103.

[167] Rodríguez, *Los txistularis*, 39, 47–49.

Sanz (?–1863), a tenor and violinist in the chapel.[168] When he was sixteen, he traveled to Paris, where he studied at the conservatory, became a professor there, published three quartets and a *Romanza* for piano, and wrote more music that he would never see published. He died in Paris at a very young age, without having been able to order and review his papers, which were kept in a trunk from which they did not emerge for decades. When finally at the end of the century someone showed an interest in recovering his production, distance, confusion regarding sources (signed manuscripts with the handwriting of different people, and various arrangements), and even personal interests (such as those of Emiliano de Arriaga, his "discoverer") caused historical truth to blend with myth. However, since the late twentieth century, serious studies have been published on the figure of Arriaga, a catalogue has been properly prepared, and his complete works have been published. We therefore now have a more complete idea of the figure and creations of this composer.[169] The value of Arriaga for musical history in the Basque Country, apart from the undoubted impulse of the later "Arriaga effect,"[170] lies above all in his quality as a modern musician, a young member of the bourgeoisie with talent who embarked on a professional career, mirroring the changes that were approaching. After him, other Bilbao musicians such as Enrique de

---

[168] Ramón Rodamilans, *En busca de Arriaga* (Bilbao: Mínima, 2006), 38.

[169] Carmen Rodríguez, "La leyenda de Arriaga"; Willem De Waal, "Arriaga (y Balzola), Juan Crisóstomo (Jacobo Antonio) de," in *Grove Music Online*, at http://www.oxfordmusiconline.com (last accessed February 21, 2018); Rodamilans, *En busca de Arriaga*; Barbara Rosen, *Arriaga, the Forgotten Genius: The Short Life of a Basque Composer* (Reno: Basque Studies Program, University of Nevada, Reno, 1988); Judith Ortega and Christophe Rousset, *Juan Crisóstomo de Arriaga. Obra Completa* (Madrid: Instituto Complutense de Ciencias Musicales, 2006).

[170] This "Arriaga effect" that introduced "the name of the composer in all the new icons that the city was generating in its growth" has been well studied by Rodríguez in "La leyenda de Arriaga," 16.

Aldana (1829–1856), a violinist, who, like Arriaga, went to Paris in 1847, would follow a similar path.

## Musical Education

The teaching of music in Bilbao during most of the nineteenth century was undertaken by the musicians of the two chapels and also private teachers who had learned and practiced as musicians in them, especially in that of Santiago.[171] In addition to the cases of Sobejano and Sanz, who were Arriaga's teachers, and of course the case of Ledesma, there is Manuel Villar, who, after practicing as a singer in the chapel of Santiago, was a music teacher in the municipal schools of Bilbao. He created a private school of music in 1875 and another music school in 1882, and composed many school pieces, as well as hymns and popular *zortzikos* that are still remembered today.[172] On the other hand, the municipal academy of music, founded in 1878 "for teachers and children who lost their jobs because of the dissolution of the old chapel," was directed by Manuel Figuerido (1851–90) and Enrique de Diego (1844–?), and the aforementioned Manuel Villar and Lope Alaña (1850–1926) taught there until 1882, the year in which the academy closed.[173] It was not until the twentieth century that a stable musical education institution appeared, when the new philharmonic society founded the Vizcaína academy of music in

---

[171] Rodríguez, "Bilbao," at http://www.oxfordmusiconline.com (last accessed February 20, 2018).

[172] María Nagore, "Villar Jiménez, Manuel," in *Diccionario de la Música Española e Hispanoamericana*, ed. Emilio Casares (Madrid: Sociedad General de Autores y Editores, 1999).

[173] Carmen Rodríguez, *La Banda Municipal de Música de Bilbao: al servicio de la villa del Nervión* (Bilbao: Área de Cultura y Euskera del Ayuntamiento de Bilbao, 2006), 21.

1903, the predecessor of the current "Juan Crisóstomo de Arriaga" professional conservatory.

It seems clear that during the second half of the nineteenth century, and in parallel with the European tendency toward bands and choral societies, in Bilbao there was a substitution of the musical education of the chapels for secular musical teaching in academies. In both cases, however, the administration was municipal. As Rodríguez states, after the abolition of the *fueros* in 1876, "Bilbao city hall maintained its connection with the various musical groups of the previous era because it could thus implicitly claim its traditional powers. For this reason[...] it continued to maintain what today we would call 'a municipal music service'."[174] That is, at least two aspects are perceived in the teaching of music: the municipal, first through the chapel and then the bands and choral societies; and the other private, whether through personal initiatives such as those of the aforementioned Villar, or through the philharmonic societies and concerts promoted by the local bourgeoisie, which will be discussed presently.

In Donostia-San Sebastián, musical education throughout much of the nineteenth century was undertaken by the organists of Santa María and San Vicente, and probably by private teachers, until the city hall created a municipal academy of music in 1879. It therefore met the insistent request of the person who would be its director, the violinist Fermín Barech (1840–91), to endow the city with a breeding ground for future musicians for the groups whose work duplicated during the summer months.[175] A similar situation had occurred shortly before in Baiona (Bayonne), where in 1876 the city hall had created, on the advice of Jean-Delphin Alard (1815–88), a municipal school of music to produce musicians for the theater orchestra. It should be borne in

---

[174] Ibid., 15.

[175] José Ignacio Tellechea, *Orígenes de la Academia municipal de música de San Sebastián* (Donostia-San Sebastián: Fundación Kutxa, 1992).

mind that these coastal cities received thousands of wealthy tourists in the summer season who hoped to find, in addition to the recommendable "bathing in the sea," musical entertainment. In the case of Donostia-San Sebastián, from 1887 on the royal family spent the summer vacation in the city, and with it many members of the court and tourists who came from all over Spain.[176] The efforts of this city to improve its leisure and cultural profile were not only made on the part of Donostia-San Sebastián city hall, but also, and especially in the last decade of the nineteenth century, by illustrious citizens, many of them amateur musicians, like Leonardo Moyúa Alzaga, the Marquis of Rocaverde (1856–1920): a politician, cultural manager, and pianist under the pseudonym of Leo de Silka, whose life reflects the enthusiasm of those like him and their vocation of service to the city.[177] The truth is that they were involved in multiple projects in cultural societies that would result in the construction of a fine arts theater, a regular concert season, the creation of exhibitions and consequent museums, and the founding of a music academy in 1897, which replaced the municipal one for some years. This impulse lasted until the first decade of the twentieth century, and a symptom of the decline of private initiative was the sale of the fine arts theater in 1912 to an entrepreneur who turned it into a cinema.[178]

---

[176] Just as Napoleon III and his wife Eugenia de Montijo had built a seaside palace in neighboring Biarritz in 1854, Queen Maria Cristina demonstrated her attraction to the city by building her own palace in 1894, the Real Casa de Campo de Miramar. See Fernando Díaz Plaja, *La vida cotidiana de los Borbones* (Madrid: Espasa Calpe, 1988) and Mª de los Santos García Felguera, "Entre la terapia y el deporte. Los veraneos reales: de Isabel II a Alfonso XIII," *Reales Sitios. Revista del Patrimonio Nacional* 136 (1998), 3–11.

[177] Isabel Díaz, "Leonardo Moyúa Alzaga, "Leo de Silka" (1856–1920), el ilustre aficionado," unpublished ms., n.d.

[178] José María Aycart, *La música en la "Real Sociedad Bascongada de los Amigos del País"* (Donostia-San Sebastián: Real Sociedad Bascongada de Amigos del País, 2010); Díaz, "Leonardo Moyúa Alzaga."

In Araba, as in Bizkaia and Gipuzkoa, music was taught by parish organists and musicians during a good part of the nineteenth century, highlighting the work of the chapel of the collegiate church of Santa María in Vitoria-Gasteiz. To this must be added, also in Vitoria-Gasteiz, the action of the city hall, which in the mid-nineteenth century maintained a municipal school of music, until in 1882 it was abolished to establish compulsory music education in public schools in the city.[179] For its part, in Navarre there was also this process of transferring musicians from the chapels to the municipal academies and the private teaching of music. In Pamplona-Iruñea, for example, the municipal school of music was founded in 1858, which for a century was the guarantor of the musical education of the children of the old kingdom.[180]

## Bands, Choral Societies, and Choirs

Rodríguez explores in detail the steps prior to the creation of the municipal band of Bilbao in 1894, revealing that throughout the nineteenth century up to five ensembles were founded in the city and comprising musicians of humble status and without training, as well as professional musicians who came from the chapel of Santiago.[181] In all these initiatives, the names of certain key characters in the musical life of that time appeared, from the aforementioned Fausto Sanz to Juan R. Amann (1830–1890), and especially Ledesma, who was involved in one way or another in each one of the musical projects. As would happen with choirs and choral societies, one of the objectives of the creation of these bands was to offer the working class an occupation, if not a professional outlet, while entertaining citizens outdoors.

---

[179] Salaberri et al., *La música en Álava*, 97.

[180] Gembero-Ustárroz, *Navarra. Música*, 158.

[181] Rodríguez, *La Banda Municipal de Música de Bilbao*, 16.

Rodríguez and María Nagore[182] offer a convincing explanation that enables an understanding of the proliferation of bands and choruses within a broader movement of music popularization that was taking place then in Europe. To this movement should be added in parallel that of private concert societies, which reflected a very different trend: a certain musical elitism more favorable to the European repertoire of sonatas and string quartets, which continued in a certain way the paths taken by the Real Sociedad Bascongada de Amigos del País (RSBAP; The Royal Basque Society of Friends of the Country) in the eighteenth century. Both movements had many contacts between them, as well as coincidental objectives (such as the creation of music schools), but the latter in particular tried to influence or control the first, as shown by the interesting data offered by Rodriguez: when in 1894 the municipal band of Bilbao was finally founded, the panel that had to decide the purchase of instruments, and even approve the repertoire and concert schedule, was formed by Juan Carlos de Gortazar (1864–1926), Javier Arisqueta (?–1949), and Lope Alaña, three well-known promoters of the "philharmonic" private movement, but who were also very well connected to the city hall.[183]

The city of Donostia-San Sebastián was equipped with a band of its own in 1887, thus alleviating the inconvenience of having to resort to bands and diverse military groups every time the official occasion required it or whenever they wanted to offer outdoor music to citizens and the numerous visitors of the summer vacation city. However, in 1905 city hall decided to disband it due to economic problems, even dismissing the offer of the musicians to play for free on Sundays and holidays on the boulevard, one of the city's main thoroughfares. In 1906, the

---

[182] María Nagore, *La revolución coral: estudio sobre la Sociedad Coral de Bilbao y el movimiento coral europeo (1800–1936)* (Madrid: ICCMU, 2001).

[183] Rodríguez, *La Banda Municipal de Música de Bilbao*, 29.

matter was raised again, as is recorded in the minutes of the municipal plenary sessions, and the decision was made to reconstitute the band and even, in 1907, to build a new music kiosk.[184]

The case of Vitoria-Gasteiz is somewhat similar, at least concerning its beginnings. After two attempts, in 1866 and 1888, the municipal band was finally created in 1894, with a total of forty-eight musicians. However, eleven years later it was disbanded, probably due to the recurring economic problems of these types of groups, which needed to buy uniforms (both summer and winter), scores, and especially good instruments, in addition to paying wages and travel to the events. It reformed in 1916 and has remained active until today.[185] Regarding Navarre, the municipal band of Pamplona-Iruñea (La Pamplonesa) was not formed until 1919, although ephemeral municipal groups existed throughout the nineteenth century.[186]

The trend to establish choirs and choral societies that occurred in the Basque Country in the late nineteenth and early twentieth centuries was the result of what Nagore terms the "choral revolution." Until 1910, up to forty choral societies were created in this region and in Navarre, the most important of which, in terms of quality and durability, were the Bilbao Choral Society (1886), the Pamplona-Iruñea Choral Society (1891), and the Orfeón Donostiarra (1897). Meanwhile, in neighboring

---

[184] Municipal Archive of Donostia-San Sebastián, minutes of the plenary sessions of Donostia-San Sebastián city hall from 1905 to 1909 (Signatures H-00484-L to H-00490-L). With the outbreak of the Spanish Civil War in 1936, the band disappeared again and never reformed. Nowadays, Donostia-San Sebastián is the only Basque capital that does not have a municipal band, although it does have an active *txistulari* (Basque flute) band.

[185] *La Banda Municipal de Música de Vitoria-Gasteiz. Un siglo de trabajo ininterrumpido,* at http://www.vitoria-gasteiz.org (last accessed February 22, 2018); Salaberri et al., *La música en Álava,* 103.

[186] Gembero-Ustárroz, *Navarra. Música,* 163.

France, various choral groups had been operating for years, such as the Baiona Choral Society (1877),[187] which regularly participated in competitions. The first international choral society competition was inaugurated in 1886 in Donostia-San Sebastián precisely in imitation of these contests, and many more would follow. Among the reasons for this "revolution," on the one hand, is the influence of the European and Spanish choral movement, driven by the popularization of music and the rise of the working class, and on the other hand what Nagore calls "the competitive spirit," that is, the desire of large cities and towns to compete in competitions with their own groups that would represent them, and that would allow them to equal or outdo others.[188]

The later life of these choirs and choral societies, in the twentieth century, had much influence on two aspects that will be discussed in the respective chapters in this book: the definitive establishment of opera and the reassessment of folk music by musical nationalism.

## Orchestras, Societies, and Theaters

Regarding orchestras in the Basque Country, their true history began in the twentieth century, although the existence of sporadic formations in the previous century can be traced, such as the theater orchestras and the ephemeral instrumental ensembles that emerged during the process of creating the municipal bands.

In the midst of this changing landscape, as has been seen, the private initiatives of the various musical societies are of note. These tried to form orchestras to provide music for the avid

---

[187] Natalie Morel, "La música en Bayona. Perfiles relevantes de una historia," in *Bayona. Vida, Paisajes, Símbolos*, ed. Enrique Ayerbe Echebarria (Oiartzun, Gipuzkoa: Sendoa, 1994), 292.

[188] Nagore, *La revolución coral*, 82, 83, 89.

public of a more cultured repertoire and different from the traditional offerings of lyrical theater, varietés, popular music, and ecclesiastical music.

For this reason, any discussion of the background to the foundation of orchestras in the Basque Country throughout the nineteenth century must go hand in hand with that of societies, which were very active above all in Bilbao and Donostia-San Sebastián.[189]

It is known that a philharmonic society was created in Bilbao in 1852 and that it had an orchestra for its concerts. Its teachers were the same as those of the theater orchestra, the only one in the town at that time, and teachers from the chapel of Santiago also took part in it. That is, there were not enough musicians in the city to maintain two different orchestral groups. In the 1880s, a Santa Cecilia Society of Friends offered concerts with orchestral works of the classical and romantic repertoire at the Vizcaíno Institute for several years, but when it was disbanded, it left a void that ended up being filled by a private initiative.

Following the discovery of the Paris edition of the Arriaga quartets by Emiliano de Arriaga, a quartet society was founded in Bilbao (1884), dedicated to the interpretation of string quartets and eventually performing public concerts.[190] It was based at the Teatro Viejo or Old Theater and in the Vizcaíno Institute assembly hall, and later at the Bilbaina Society. The same musicians who had promoted the academy of music in 1878, such as Figuerido and Alaña, played there. This quartet society had

---

[189] María Nagore, "Sociedades filarmónicas y de conciertos en el Bilbao del siglo XIX," *Cuadernos de arte* 26 (1995), 195–206; María Nagore, "La Orquesta Sinfónica de Bilbao: origen, fundación, y primera etapa," in *Bilbao Orkestra Sinfonikoa-Orquesta Sinfónica de Bilbao. Ochenta años de música urbana*, ed. Carmen Rodríguez (Bilbao: Fundación Bilbao Bizkaia Kutxa, 2003), 99–150.
[190] Rodríguez, "La leyenda de Arriaga," 15.

emerged out of the musical meetings of a curious initiative known as El Cuartito, in which Gortázar, Arisqueta, and Alaña[191] were active, among others. In a few years, these and other illustrious citizens of Bilbao would go on to launch four more institutions, which today continue to be the pillars of its culture: the philharmonic society (1896), the Vizcaína academy of music (1903), the museum of fine arts (1908), and the symphony orchestra (1922).[192]

The other way of establishing instrumental groups was through theaters and venues.[193] The first theater in Bilbao, El Coliseo (The coliseum), was built in 1799 and burned down in 1816. Another provisional brick building without foundations was soon constructed, until the Teatro de la Villa (City Theater) was built in 1834. It was later named Teatro Viejo (old theater) and demolished in 1886, making way for the definitive Teatro Nuevo (or new theater, today the Arriaga Theater) in 1890. That is to say, over the course of almost a century, several different buildings followed one another in the same area of the city with the same purpose: to have a place for dramatic and lyrical-dramatic activity. The public demand was not dissatisfied even during the four years that passed between the demolition of the old theater and the inauguration of the new theater, because in that time period three

[191] Idoia Estornés and Patricia Sojo, "Kurding Club," in *Enciclopedia Auñamendi/Auñamendi Eusko Entziklopedia*, at http://aunamendi.eusko-ikaskuntza.eus (last accessed February 22, 2018); María Nagore, "Sociedades filarmónicas y de conciertos."

[192] Sociedad Filarmónica de Bilbao, "Historia," at https://www.filarmonica.org (last accessed February 22, 2018); Ramón Rodamilans, *La Sociedad Filarmónica de Bilbao. Memoria de un Centenario* (Bilbao: Fundación Bilbao Bizkaia Kutxa, 1998).

[193] Mikel Bilbao, "Arquitectura teatral en Bilbao durante los siglos XIX y XX. De los lugares para la memoria a los espacios recuperados," *Bidebarrieta, Revista de humanidades y ciencias sociales de Bilbao* 23 (2012), 38–52; Alberto López, *Bilbao, cine y cinematógrafos* (Bilbao: Fundación Bilbao 700, 2000).

venues were opened (the Teatro Gayarre, Teatro Circo on the Gran Vía, and Teatro Romea). In 1895, another Teatro Circo was opened, called Del Ensanche, which came to replace that of the Gran Vía, which had closed the previous year. Finally, in 1896, the philharmonic society was founded, which offered its first concerts in the auditorium of the Vizcaíno Institute, until it inaugurated its famous concert hall on Marqués del Puerto Street in 1904. By then a new theater, the Champs-Élysées (1901), had opened in the Abando neighborhood, which still exists.

What can be concluded from all this data is that in the late nineteenth century Bilbao required, and in parallel to its economic upturn and increase in population, a varied range of entertainment, from popular dances, band music, cinema, lyrical theater, and varietés to symphonic and chamber music, and that such a demand can be observed in the history of its premises. To the opening and demolition of the various buildings and places that overlapped or substituted each other, and venues that were enabled for chamber music and orchestra, other spaces in which music was also played may be added: cafés that offered live music,[194] open and popular venues, and private meeting rooms. The latter had been a reality in Bilbao at least in the first decades of the century, and the Mazarredo, Torres-Vildósola, and Eladio Villabaso tend to be referred to; quartets played in the latter with Arriaga as concertmaster of first chair. Although the data we have from these rooms is confusing and sometimes contradictory, partly due to the panegyric literature of Emiliano de Arriaga and Juan de Eresalde, and partly because it has never been studied in depth, chamber music was played there, and they provided artistic

---

[194] Carlos Bacigalupe, *Cafés parlantes de Bilbao. Del Romanticismo a la Belle Epoque* (Bilbao: Ediciones Eguía, 1995).

experience for young talents such as Arriaga and the violinist Rufino Lacy (1793–1847).[195]

As regards Donostia-San Sebastián, in 1839, a year before embarking on his European journey, the chapel master of Santa María, José Juan Santesteban, promoted the creation of a philharmonic society. Apparently this society offered concerts of a certain importance between 1840 and 1846.[196] And on the basis of the testimony of a contemporary, Francisco Gascue (1848–1920), we know that the concerts took place in a probably vaulted room, inside the imperial round turret of the southern façade of the wall that in those years still surrounded the city.[197] There is no evidence that this society was active in the second half of the nineteenth century. However, music may still have been played in a private room, such as that of Marquises of Rocaverde, or that of Mª Antonia Moyúa Mazarredo. On the other hand, although always complementary, we find popular festivals, especially the carnival, in Donostia-San Sebastián, only interrupted in the nineteenth century for a few years following the fire of 1813.

In terms of theaters, apparently a theater existed in Donostia-San Sebastián in 1802 and disappeared in the fire of 1813. In the middle of the century[198] the Teatro Principal or Main Theater was built. It was active until the first decades of the

---

[195] Rodríguez, "Bilbao," n.p.; José Antonio Zubikarai, *Bilbao, música y músicos* (Bilbao: Ediciones Laga, 2000), 41; Arana, *Música vasca*, 168; Rodamilans, *En busca de Arriaga*, 41–46.

[196] Arana, *Música vasca*, 171.

[197] Francisco Gaskue, "Recuerdos agradables," *Euskalerriaren Alde* 11 (1911), 341; reprint, in *La Gran Enciclopedia Vasca* (Bilbao: La Gran Enciclopedia Vasca, 1974); Juan Antonio Sáez, *Fortificaciones en Gipuzkoa, siglos XVI–XIX*, at http://bertan.gipuzkoakultura.net (last accessed February 20, 2018).

[198] In the sources consulted, several contradictory dates appear: 1843, 1846, and 1850.

twentieth century.[199] In the late nineteenth century, in 1887, the impressive Gran Casino (which currently houses the city hall) was inaugurated, whose rooms regularly offered musical shows. Donostia-San Sebastián's musical life was further improved with the inauguration in 1890 of the Díaz and Jornet Salon, in the music store of the same name. It was a room for gatherings and concerts in the style of other Spanish and European music stores, which on summer evenings offered concerts that the press announced and then reviewed.[200] In 1895, the Easo company built a palace of fine arts in which, until 1912, regular seasons of concerts were offered in which amateur members took part, such as Leo de Silka, Juan Guimón (1870–1916), and Manuel Cendoya (1851–1920), and even international artists such as the pianist Emil Sauer (1862–1942) in 1906.[201]

In the case of Vitoria-Gasteiz, the civic movement around music, with the consequent founding of societies and orchestras, was much more modest than that of the other two cities. There were at least two private salons with musical activity in the nineteenth century, that of Baltasar Manteli and of the Marquis of

---

[199] The present Teatro Principal on the high street is an heir of the one demolished in 1930 and reconstructed in 1931. See "Raimundo Sarriegui," Basque music archive, Eresbil, at http://www.eresbil.com (last accessed February 21, 2018).

[200] To find music news in the nineteenth century, the local or national press must be consulted, as well as the few national music magazines, such as the Barcelona *La Ilustración Musical Hispanoamericana* edited by Felip Pedrell. See Jacinto Torres, *Las publicaciones periódicas musicales en España (1812–1990): estudio crítico-bibliográfico, repertorio general* (Madrid: Instituto de Bibliografía Musical, 1991); Jacinto Torres, "Bilbao y la prensa musical," *Bidebarieta: Anuario de Humanidades y Ciencias Sociales de Bilbao* 3 (1998), 195–219; Arantxa Arzamendi, "Catálogo de publicaciones periódicas donostiarras: 1800–1936," *Revista Internacional de Estudios Vascos* 35, no. 1 (1990), 131–63; Javier Díaz-Noci, "Historia del periodismo vasco (1600–2010)," *Mediatika. Cuadernos de Medios de Comunicación* 13 (2012), 1–261.

[201] Aycart, *La música en la Real Sociedad Bascongada*, 25.

Montehermoso, in whose palace dances and gala concerts were held at the beginning of the century, and later some bars and cafés were opened in which enthusiasts discussed literature and painting and made music.[202] The consumption of music in the home can also be traced, with the consequent purchase of instruments and subscription to women's magazines that provided music for the women of the wealthy families.[203] As for the theaters, Vitoria-Gasteiz's Teatro Principal was not inaugurated until 1918, although on the same site there had been a Teatro Principal since 1822, and according to Sabin Salaberri there was an orchestra, founded by a "society of young people," which came to perform in the theater in the 1860s.[204]

In 1856, the New Casino or Main Casino was inaugurated in Pamplona-Iruñea, which introduced ballroom dancing into the daily life of society. By then, there had been a 1,200-seat main theater in the capital of Navarre for fifteen years, which still exists today as the Gayarre Theater, and a Teatro Circo or Circus Theater that burned down in 1915, which regularly provided the public with operas and *zarzuelas*, or light operas. According to Gembero-Ustárroz, in 1867 there were a total of seven open theaters in Navarre. On the other hand, in 1879 the violinist Pablo Sarasate (1844–1908) encouraged the creation of the Santa Cecilia Orchestra, the oldest active orchestral ensemble in Spain, based on the music association of the same name created the previous year, and overseen by him.[205] Sarasate also had a very close relationship with the French Basque Country, especially with the towns of Biarritz and Baiona. In the latter, during the first half of

---

[202] Salaberri et al., *La música en Álava*, 97, 98.

[203] Isabel Díaz, "El piano en el País Vasco entre 1830 y 1920," in *El piano en España entre 1830 y 1920*, ed. José Antonio Gómez (Madrid: Sociedad Española de Musicología, 2015), 495–528.

[204] Salaberri et al., *La música en Álava*, 98, 103.

[205] Gembero-Ustárroz, *Navarra. Música*, 156, 161, 164, 165.

the nineteenth century, there was a theater that had an orchestra, a small mixed choir, and technical staff for the staging of operas. In 1841, the new municipal theater was inaugurated. Already supplied with a stable company, which performed the main operas and operettas of the nineteenth-century repertoire, from Rossini to Verdi, its gaslit room was the admiration of locals and foreigners alike.[206] In 1844, Franz Liszt performed there, and in 1857, Sarasate, with his teacher, Delphin Alard, a native of Baiona. Sarasate returned later every summer to offer concerts, always traveling between Baiona, Donostia-San Sebastián, and Biarritz. In the latter town he finally acquired a villa, which he called Villa Navarra, where he settled once retired from the stage, until his death in 1908.[207] It is very interesting to see through the lives of musicians such as Pablo Sarasate, Isaac Albéniz (1860–1909, another regular of Basque cross-border summers), and, on a more modest level, Leonardo Moyúa from Donostia-San Sebastián, to what extent the distances between French and Spanish Basque towns shortened each year during the long summer period. The custom of the summer vacationing inaugurated by the French and Spanish monarchs during the second half of the nineteenth century allowed high society and artists to move around in a cultural and leisure circle that knew no borders and was to continue into the early decades of the twentieth century.[208]

---

[206] Morel, "La música en Bayona," 289.

[207] Ibid., 293.

[208] Édouard Labrune, *Côte Basque: Les années folles* (Urrugne: Pimientos, 2015), 6.

# The Music Market: Businesses, Publishers, and Publications[209]

The first musical publication known was a teaching method by Mateo Pérez de Albéniz, chapel master of Santa María in Donostia-San Sebastián. It was published by the Donostia-San Sebastián printing house of Antonio Undiano in 1802. Almost a quarter of a century later, the activity of a musical publisher, also from Donostia-San Sebastián, is once again detected: in 1824 and 1826 Ignacio Ramón Baroja (1797–1874) published two works on traditional Gipuzkoan dances by Juan Ignacio Iztueta (1767–1845), pioneering studies in terms of collecting folklore, and an exceptional source for knowledge of popular Basque musical practice in the first half of the nineteenth century. Somewhat more than three decades later, the Casa Baroja printed *Método teórico práctico de canto llano* (The Plainchant Practical and Theoretical Method, 1864) by the master of the Santesteban chapel. In 1854, he founded a store and music publisher in Donostia-San Sebastián, the Casa Almacen Santesteban, through which he published the opera *Pudente* (1890) and the *Colección de aires vascongados* (Collection of Basque Airs, 1862–89) by his son, José Antonio Santesteban. The *Colección de aires vascongados*, composed of easy harmonizations of folkloric melodies for voice and piano and for solo piano, pursued a double purpose: on the one hand to disseminate Basque folklore, and on the other hand to do it in a "salon" format, that is, a suitable entertainment for a musical evening. Given that the Santesteban publishing company only

---

[209] See Pello Leiñena, "Guía de editoriales musicales en Euskal Herria," *Musiker* 15 (2007), 327–72; "Editoriales musicales de Euskal Herria (s.XV–1950)," Basque music archive, Eresbil, at http://www.eresbil.com (last accessed February 21, 2018); Carlos José Gosálvez, *La edición musical española hasta 1936: guía para la datación de partituras* (Madrid: Asociación Española de Documentación Musical, 1995); Martija, *Música vasca*.

published seventeen more songs, apart from those in the *Collection*,[210] we can conclude that the business was created with the purpose of promoting his own works and selling them in the store, a natural resource in an environment that lacked a publishing infrastructure but that began to have music stores. In short, as a publishing initiative, it was a great and isolated effort that had no continuation.

Without leaving Donostia-San Sebastián, a different case was that of the Díaz y Jornet store. The publisher Ambrosio Díaz and the printer Francisco Jornet established around 1890 a business selling sheet music, pianos, and harmoniums, in which the Díaz y Jornet Salon was established. The publishing company was renamed A. Díaz y Cía., [211] a name with which it continued until its disappearance in the twentieth century. In the last decade of the nineteenth century, A. Díaz y Cía. undertook the publication of a collection of scores entitled *Ecos de Vasconia* (Echoes of Vasconia), composed of fifty songs for voice and piano from traditional or newly created Basque melodies but in a folkloric style.[212] The cover of the collection says verbatim that the *Ecos de Vasconia* have been "arranged" by José María Echeverría (1855–1946) and Juan Guimón, two well-known musicians from Donostia-San Sebastián who took part in the creation of almost all the companies mentioned here previously. This collection therefore follows the same line as that of

---

[210] See vol. 2 of Isabel Díaz, "La canción para voz y piano en el País Vasco entre 1870 y 1939. Catalogación y studio," PhD diss., University of the Basque Country (UPV-EHU), 2005. In 2013, an abbreviated version of this work was published, without the catalogue: *La canción para voz y piano en el País Vasco, 1870-1939* (Madrid: Bubok, 2013).

[211] The A. Diaz y Cía. score archive is located in the Basque music archive, Eresbil, under the symbol A88.

[212] The *Ecos de Vasconia* collection has been digitized and can be obtained at http://www.liburuklik.euskadi.eus. An original can be found in the Basque music archive, Eresbil.

Santesteban, although in the case of A. Díaz y Cía, the arrangements go a little beyond simple harmonizations, and the most original pieces contain a certain challenge for the pianist.

Another of the music stores that opened in Donostia-San Sebastián at the end of the century (in 1891) was Casa Erviti, which had been founded by the Navarrese José Erviti in Madrid fifteen years earlier, and which, once installed in the capital of Donostia-San Sebastián, has remained open until today under the same name. There are more cases of Navarrese businessmen publishers, such as Arilla y Cía., Narciso Rada, and F. Ripalda, who did not leave the area of Pamplona-Iruñea, although Bonifacio Eslava (1829–1882) stands out: he established his "piano factory and publishing house" in Madrid in 1857, a business that survived until it was absorbed by Casa Dotésio from Bilbao in 1900.[213]

Meanwhile, music stores and shops were emerging in Bilbao during the second half of the nineteenth century: Juan Reynoso (1859), Almacenes Amann (1864), José Aranguren (1881), Casa Dotésio (1885), and Aramburu y Cía., and then Casa Toña (1898), among others. They were all in Bilbao's Old Town, popularly known as "the seven streets." Of all these businesses, it would be above all that of Louis Ernest Dotésio Paynter (1855–1915) who stood out from the rest.[214] A chemist by profession, born in Paris but from an English family, at a very young age he moved to Bilbao, where in 1876 he founded a chemical analysis laboratory. In 1885, he started a sheet music publishing and musical instrument business, under the trademark "L. E. Dotesio," and created a concert promotion society, which led to,

---

[213] Gosálvez, *La Edición Musical Española*, 153–56.

[214] The main source on Dotésio is Arana, *Música vasca*. Apparently Arana was already preparing a book on the subject from 1995, but unfortunately he died in 2011 before being able to publish it. See also Gosálvez, *La edición musical española* and Leiñena, "Guía de editores musicales."

among other things, the construction of the Gayarre Theater. Of all his business adventures, the sheet music publishing was the only one that really prospered, to the point of becoming the most important publishing house in Spain through the purchase, between 1898 and 1901, of the main Spanish publishing holdings. It was established in 1900 as Casa Dotésio Publishing Company, based in Bilbao and later in Madrid and, after the compulsory resignation of its founder through debts in 1911, it became the Spanish Musical Union (Unión Musical Española, UME) in 1914. It was the Casa Dotésio that published intensively (although not exclusively) works by Basque authors, especially songs and pieces for piano.

During the nineteenth century, therefore, Basque publishing activity was mainly limited to Bilbao and Donostia-San Sebastián. Many of the publishers that we have quoted here continued to work in the twentieth century, and some with great success, such as the UME, but above all they were going to create many more, including many of a religious nature. It would be very interesting to have business-type studies of these publishing businesses, to know the sales flows and the origins of the subscribers, and to get a better idea of how intense the Basque music market was in terms of the publishing and distribution of sheet music, books, and instruments.[215]

## Virtuosity: Singers, Violinists, and Pianists

The phenomenon of musical virtuosos, which developed strongly in Europe from the eighteenth century and during the Romantic period, also reached Spain, which praised singers, violinists, and

---

[215] Between 1862 and 1939, for example, almost 1,500 scores of songs for voice and piano by Basque authors were published, most of them in publishers based in the region, which gives an idea of the strength of this sector. See vol. 2 of Díaz, "La canción para voz y piano."

pianists, many of whom came from the Basque Country and neighboring Navarre. The list of virtuosos is led by the Navarrese musicians, especially by the tenor from the Erronkari-Roncal Valley, Julián Gayarre (1844–90) and the Pamplona-Iruñea violinist, Pablo Sarasate. Gayarre's beautiful voice was apparently discovered by Hilarión Eslava, then director of the Madrid Conservatory, when he was still a child shepherd, and the enormous international fame he achieved was only matched by his compatriot, Sarasate. It is particularly interesting the way in which the latter was interested in his hometown despite his continuous trips, because apart from the founding of the Santa Cecilia Orchestra in 1879, he inaugurated in Pamplona-Iruñea the custom of staging concerts during the San Fermín festivities, to boost "young local values."[216] Among the Navarre pianists, we find Juan Mª Guelbenzu (1819–86), the most international of all, Joaquín Gaztambide (1822–70), whose name is associated with that another Navarrese musician, Emilio Arrieta (1821–94), in the composition of theatrical music,[217] Dámaso Zabalza (1835–94), Melecio Brull (1858–1923), and Joaquín Larregla (1865–1945). Hilarión Eslava, also from Navarre, was a teacher of several generations, especially of organists, of whom just among his Navarrese students we find, for example, Felipe Gorriti, Agapito Insausti (1851–1914), and Buenaventura Íñiguez (1840–1902).

As regards Basque musicians, during the nineteenth century a number of them emerged who later achieved international fame and who can be rightly called virtuosos. We find at the beginning of the century in Bilbao, in addition to the figure of Arriaga, the violinist Rufino Lacy. The son of Irish

---

[216] Gembero-Ustárroz, *Navara. Música*, 160. In her book, Gembero-Ustárroz offers, in a footnote and in the final list of references, an exhaustive review of the most relevant bibliography on these two musicians from Navarre.

[217] María Encina, *Emilio Arrieta: de la ópera a la zarzuela* (Madrid: Instituto Complutense de Ciencias Musicales, 2003).

merchants who had settled in Bilbao, after astonishing the public in the city by playing a violin concert at the age of six, he undertook an international career that was successful, especially in England and Scotland. Two other cases, also Bizkaian, and with truncated lives like Arriaga, are those of the violinist Enrique Aldana and the tenor Pedro María de Unanue (1814–46). The Bilbao native Aldana, after studying with Alard in Paris and working his way through the Madrid theaters, ended up embarking for Cuba, where he died of a fever. Unanue was born in Ondarroa, a fishing village on the Bizkaian coast. After a brief apprenticeship in neighboring Lekeitio, he moved to Santander at the age of seventeen, then to Madrid, and finally made the European leap to the theaters of Saint Petersburg and Bergamo, where he became ill and died at the age of thirty-one. Meanwhile, the compositions of Sebastián Iradier, from Araba, achieved an international reputation, especially his songs, which were known and appreciated in Europe and the Americas. A generation later, three great Basque musicians were born. They were three singers: the baritone from Gipuzkoa, Ignacio Tabuyo (1863–1947), the bass from Araba, José Mardones (1868–1932), and the tenor from Bizkaia, Florencio Constantino (1869–1919). While Mardones and Constantino built a brilliant international career, including performing in American theaters, Tabuyo remained more linked to the Spanish stages, with a constant artistic presence in the Basque Country, and also devoted himself to the teaching of singing.

And pianists and organists? The list of those born before 1870 is quite broad, and although none of the musicians present in it achieved an authentic reputation as an international virtuoso, they were nevertheless intensely active at the national, and also at the local level, creating in a special way the conditions by which the study of piano and composition in Spain would match that of other European countries. As regards the

organists, there were the chapel masters Nicolás Ledesma, the Pérez de Albéniz father and son, and the two Santestebans, key figures in Bilbao and Donostia-San Sebastián nineteenth-century musical life, to which we could add the Bizkaian Valentín Mª de Zubiaurre, and the generation of Basque organists who studied in Madrid with Hilarión Eslava, such as Avelino Aguirre (1838–1901) and Toribio Eleizgaray (1840–1910). As for the pianists, among others we should mention the Bizkaians Manuel Villar, Cleto Zavala (1847–1912), and José Aranguren; the Gipuzkoans Manuel Mendizábal (1817–96), Leonardo Moyúa, and José Echániz (1860–1926); as well as Emilio Serrano (1850–1939) and Juan Santiago Aramburu (1860–1937) from Araba. Most developed their musical career as musicians and teachers in Madrid, although some, like Villar or Moyúa, were very important in Basque musical life. A similar case is that of musicians from the French Basque Country, such as the tenor Pierre Garat (1762–1823), the violinist Delphin Alard, and the composer Adrien Barthe (1828–98), who developed their careers in the French capital, returning sporadically to their places of origin to promote projects or give concerts.

It is not possible to give an account here of the interesting lives and achievements of all these musicians, and of some more that could be discussed, but any of them deserves a particular study, and even one that would reveal reciprocal professional and friendly relationships.

## Conclusion

The history of music in the Basque Country during the nineteenth century is framed by two end-of-century processes. On the one hand, at the turn of the eighteenth and nineteenth centuries there was the transfer of the chapel and guild music to that of amateur citizens, who were taking corporate initiatives that led to the

founding of societies, theaters, orchestras, and music academies. This civic impulse, which had been occurring for decades throughout Europe and the Americas, increased in the Basque Country from 1876 on, after the end of the Carlist Wars and the abolition of the *fueros*, which produced an enrichment of the bourgeoisie through flourishing businesses (more in Bizkaia than in Gipuzkoa, and much more than in Araba). In this second hinge between two centuries, the greatest demand for live music was added to need for printed music, instruments, teaching, and music criticism, all activities that were largely developed by private initiatives. On the other hand, throughout the century we also see the ever-present role of the city and town councils, maintaining municipal bands, holding festivities, and creating academies, among other things. They thus assumed in part the role between protector and controller of musical production that for a long time had been the sole domain of ecclesiastical chapels. These two tendencies, public and private, coexisted and often collaborated throughout the century, and this did not prevent individual initiatives from contributing their essential vigor to musical life. Looking back from the vantage point of the present, this is one of the great lessons that, in my opinion, we can learn from the endeavors of our ancestors.

## Bibliography

Arana, José Antonio. *Música vasca*. Bilbao: Caja de Ahorros Vizcaína, 1987.

Arzamendi, Arantxa. "Catálogo de publicaciones periódicas donostiarras: 1800–1936." *Revista Internacional de Estudios Vascos* 35, no. 1 (1990): 131–63.

Aycart, José María. *La música en la "Real Sociedad Bascongada de los Amigos del País"*. Donostia-San Sebastián: Real Sociedad Bascongada de Amigos del País, 2010.

Bacigalupe, Carlos. *Cafés parlantes de Bilbao. Del Romanticismo a la Belle Epoque.* Bilbao: Ediciones Eguía, 1995.

Bagüés, Jon. *Catálogo del Antiguo Archivo Musical del Santuario de Aránzazu.* San Sebastián: Caja de Ahorros Provincial de Gipuzkoa, 1979.

*Bidebarrieta: Anuario de Humanidades y Ciencias Sociales de Bilbao* 3. Actas del III Symposium "Bilbao, una ciudad musical". Bilbao: Bidebarrieta Kulturgunea, 1998.

Bilbao, Mikel. "Arquitectura teatral en Bilbao durante los siglos XIX y XX. De los lugares para la memoria a los espacios recuperados." *Bidebarrieta, Revista de humanidades y ciencias sociales de Bilbao* 23 (2012): 38–52.

Capdepón, Paulino. *La música en Irún en el siglo XIX: La capilla de música de la Iglesia de Santa María del Juncal.* Irún: Ayuntamiento de Irún, 2011.

Casares, Emilio, ed. *La música española en el siglo XIX.* Oviedo: Universidad de Oviedo, Servicio de Publicaciones, 1995.

De las Cuevas, Carmen. "El Orfeón Donostiarra 1897–1997: proyección social, cultural y educativa." PhD dissertation, Universidad del País Vasco (UPV/EHU), 1999.

De Waal, Willem. "Arriaga (y Balzola), Juan Crisóstomo (Jacobo Antonio) de." In *Grove Music Online* (2001). At: http://www.oxfordmusiconline.com.

Del Campo, Sergio, and Berta Moreno. "El órgano de San Esteban de Bera: un modelo experimental de Aquilino Amezua." *Musiker* 19 (2012): 175–278. At: https://www.jsergiodelcampo.com/publicaciones.

Díaz, Isabel. "La canción para voz y piano en el País Vasco entre 1870 y 1939. Catalogación y estudio." PhD dissertation, Universidad del País Vasco (UPV/EHU), 2005.

———. *La canción para voz y piano en el País Vasco, 1870–1939.* Madrid: Bubok, 2013.

————. "El piano en el País Vasco entre 1830 y 1920." In *El piano en España entre 1830 y 1920*, edited by José Antonio Gómez. Madrid: Sociedad Española de Musicología, 2015.

————. "Leonardo Moyúa Alzaga, "Leo de Silka" (1856–1920), el ilustre aficionado." Unpublished ms. N.d.

Díaz-Noci, Javier. "Historia del periodismo vasco (1600–2010)." *Mediatika. Cuadernos de Medios de Comunicación* 13 (2012): 1–261.

Díaz Plaja, Fernando. *La vida cotidiana de los Borbones*. Madrid: Espasa Calpe, 1988.

Encina, María. *Emilio Arrieta: de la ópera a la zarzuela*. Madrid: Instituto Complutense de Ciencias Musicales, 2003.

Estornés, Idoia, and Patricia Sojo. "Kurding Club." In the *Enciclopedia Auñamendi/Auñamendi Eusko Entziklopedia*. At: http://aunamendi.eusko-ikaskuntza.eus (last accessed February 22, 2018).

Ezquerro, Antonio. *Música en imágenes. El maestro Nicolás Ledesma (1791–1883). Un músico en la España del siglo XIX*. Madrid: Alpuerto, 2015.

Fernández de Pinedo, Emiliano. "De la primera industrialización a la reconversión industrial: la economía vasca entre 1841 y 1990." In *Historia económica regional de España, siglos XIX y XX*, edited by Luis Gonzalo Germán *et al.* Barcelona: Crítica, 2001.

Fernández de Pinedo, Emiliano, and José Luis Hernández, eds. *La industrialización del norte de España. Estado de la cuestión*. Barcelona: Crítica, 1988.

García Felguera, Mª de los Santos. "Entre la terapia y el deporte. Los veraneos reales: de Isabel II a Alfonso XIII." *Reales Sitios. Revista del Patrimonio Nacional* 136 (1998): 3–11.

García de Cortázar, Fernando, and José María Lorenzo Espinosa. *Historia del País Vasco. De los orígenes a nuestros días*. San Sebastián: Txertoa, 1997.

Gaskue, Francisco. "Recuerdos agradables." *Euskalerriaren Alde* 11–12 (1911), 340–47, 363–68; reprint, in *La Gran Enciclopedia Vasca*. Bilbao: La Gran Enciclopedia Vasca, 1974.

Gembero-Ustárroz, María. *La música en la Catedral de Pamplona durante el siglo XVIII*. Pamplona: Gobierno de Navarra; Institución "Príncipe de Viana", 1995.

————, ed., *Estudios sobre música y Músicos de Navarra. Conmemoración del VIII Centenario de la Chantría de la Catedral de Pamplona como dignidad eclesiástica (1206–2006)*. Pamplona: Gobierno de Navarra, 2006.

————. *Navarra. Música*. Pamplona: Gobierno de Navarra. Departamento de Cultura, Deporte y Juventud, 2016.

Gómez, Carlos. *Historia de la música española, V: Siglo XIX*. Madrid: Alianza, 1987.

Hoke, Sharon Kay. "Juan Crisóstomo Arriaga: a Historical and Analytical Study." PhD dissertation, University of Iowa, 1984.

Juaristi, Jon. *Historia mínima del País Vasco*. Madrid: Turner, 2013.
Labrune, Édouard. *Côte Basque: Les années folles*. Urrugne: Pimientos, 2015.

Pello Leiñena, Pello. "Guía de editoriales musicales en Euskal Herria." *Musiker* 15 (2007): 327–72

López, Alberto. *Bilbao, cine y cinematógrafos*. Bilbao: Fundación Bilbao 700, 2000.

Mendialdua. Rafael. *Maestros de Capilla y Organistas de la Colegiata y Catedral de Santa María de Vitoria-Gasteiz*. Vitoria-Gasteiz: Real Sociedad Bascongada de los Amigos del País, 1988.

Morel, Natalie. "La música en Bayona. Perfiles relevantes de una historia." In *Bayona. Vida, Paisajes, Símbolos*, edited by Enrique Ayerbe Echebarria. Oiartzun, Gipuzkoa: Sendoa, 1994.

Moreno, Berta. *Felipe Gorriti. Compositor, maestro de capilla y organista.* Pamplona: Fondo de Publicaciones de Gobierno de Navarra, 2011.

Moreno, Eduardo. *La música en Laguardia: del siglo XII a la actualidad.* Logroño: Piedra de rayo, 2014

Nagore, María. "Sociedades filarmónicas y de conciertos en el Bilbao del siglo XIX." *Cuadernos de arte* 26 (1995): 195–206.

———. "Villar Jiménez, Manuel." In *Diccionario de la Música Española e Hispanoamericana*, edited by Emilio Casares. Madrid: Sociedad General de Autores y Editores, 1999.

———. *La revolución coral: estudio sobre la Sociedad Coral de Bilbao y el movimiento coral europeo (1800–1936).* Madrid: Instituto Complutense de Ciencias Musicales, 2001.

———. "La Orquesta Sinfónica de Bilbao: origen, fundación, y primera etapa." In *Bilbao Orkestra Sinfonikoa-Orquesta Sinfónica de Bilbao. Ochenta años de música urbana*, edited by Carmen Rodríguez. Bilbao: Fundación Bilbao Bizkaia Kutxa, 2003.

Ortega, Judith, and Christophe Rousset. *Juan Crisóstomo de Arriaga. Obra Completa.* Madrid: Instituto Complutense de Ciencias Musicales, 2006.

*Reglamento para el Régimen de la Capilla Música de esta M.N.y M.L. ciudad de San Sebastián.* San Sebastián: Imprenta de Ignacio Ramón Baroja, 1848.

Rodamilans, Ramón. *La Sociedad Filarmónica de Bilbao. Memoria de un Centenario.* Bilbao: Fundación Bilbao Bizkaia Kutxa, 1998.

———. *En busca de Arriaga.* Bilbao: Mínima, 2006.

Rodríguez, Carmen. "Viejas voces de Bilbao: la música en la Villa durante los siglos XVIII y XIX." In *Bilbao: arte e historia*, edited by Juan Manuel González and Arturo Rafael Ortega. [Bilbao]: Bizkaiko Foru Aldundia, Kultura

Saila/Diputación Foral de Bizkaia, Departamento de Cultura, 1990.

———. *Los txistularis de la Villa de Bilbao*. Bilbao: BBK-Bilbao Bizkaia Kutxa, 1999.

———. "La capilla musical de Bilbao: una institución peculiar." In *La Catedral de Santiago de Bilbao*. Bilbao: Obispado de Bilbao, 2000.

———. "Bilbao." In *Grove Music Online* (2001). At: http://www.oxfordmusiconline.com.

———, ed. *Bilbao Orkestra Sinfonikoa-Orquesta Sinfónica de Bilbao. Ochenta años de música urbana*. Bilbao: Fundación Bilbao Bizkaia Kutxa, 2003.

———. "La leyenda de Arriaga." In Juan de Eresalde, *Resurgimiento de las obras de Arriaga*. Facsmile edition. Bilbao: Diputación Foral de Bizkaia, 2006.

———. *La Banda Municipal de Música de Bilbao: al servicio de la villa del Nervión*. Bilbao: Área de Cultura y Euskera del Ayuntamiento de Bilbao, 2006.

Rosen, Barbara. *Arriaga, the Forgotten Genius: The Short Life of a Basque Composer*. Reno: Basque Studies Program, University of Nevada, Reno, 1988.

Sáez, Juan Antonio. *Fortificaciones en Gipuzkoa, siglos XVI–XIX*. At: http://bertan.gipuzkoakultura.net (last accessed February 20, 2018).

Sagaseta, Aurelio. "Música en la Catedral de Pamplona (siglo XIX)." *Ars Sacra* 7 (1998): 112–21.

Salaberri, Sabin, et al. *La música en Álava*. Vitoria-Gasteiz: Fundación Caja Vital Kutxa, 1997

Tellechea, José Ignacio. *Orígenes de la Academia municipal de música de San Sebastián*. Donostia-San Sebastián: Fundación Kutxa, 1992.

Torres, Jacinto. *Las publicaciones periódicas musicales en España (1812–1990): estudio crítico-bibliográfico, repertorio general.* Madrid: Instituto de Bibliografía Musical, 1991.

———. "Bilbao y la prensa musical." *Bidebarieta: Anuario de Humanidades y Ciencias Sociales de Bilbao* 3 (1998): 195–219.

Valdaliso, Jesús María. *Los navieros vascos y la marina mercante en España, 1860-1935. Una historia económica.* Bilbao: IVAP, 1991.

Zubikarai, José Antonio. *Bilbao, música y músicos.* Bilbao: Ediciones Laga, 2000.

# A Study of Basque Music: 1876–1936

Josu Okiñena Unanue

In this chapter, I will focus on the evolution of Basque music in the era comprising the period between 1876, the year of the abolition of the *fueros* in Hegoalde,[218] and 1936, the year that the Spanish Civil War broke out. This evolution is analyzed based on two variables. First, the changes occurring in Europe as a whole over the course of the nineteenth century, which had a decisive influence on Basque music; this influence gave rise to the need to seek elements of cultural identity and express them in the musical repertoire. For this reason, many authors call this era that of "Basque musical nationalism," since they consider music as the vehicle that enabled society to construct its own identity by compiling folk melodies in songbooks and songs, the development of instrumental pieces based on folk elements, and the proliferation of the lyric genre. Within this genre we can distinguish one of this historical period's most representative phenomena: Basque lyric theater, which included both operas and zarzuelas. It developed in Euskara, the Basque language, and incorporated popular Basque songs and dances. Other zarzuelas were also composed that did not include motifs from the reality of Basque society and history, but that are of great sociocultural significance. The choral genre was also significant in achieving this feature of identity; and so pieces composed for choral societies proliferated and undertook to spread Basque culture using the secular or religious repertoire.

---

[218] A Basque toponym designating the historical territories of Araba, Bizkaia, Gipuzkoa, and Nafarroa (Navarre).

The second variable important for studying the music of this era and appreciating how it was transformed is the fact that most composers were clergymen and trained in the church; hence the reform of sacred music due to the impact of *Motu Proprio* of Pius X exercised a significant influence on Basque music. This, together with the influence that the new liturgy exerted, brought about a great change, and we must add to this that a multiplication of congresses and schools served as vehicles for extending the new manner of production and extending Basque music. Both developments fostered cultural progress by way of music, as I will continue to recount in the course of this chapter.

Last, I consider it important, when describing this era of Basque music, to examine the Basque origin of Maurice Ravel (1875–1937) and his connection to this culture, which is also a significant aspect in this period of the history of Basque music.

## Basque Musical Nationalism

Nationalism can be traced back to the eighteenth century, when, as Anne-Marie Thiesse asserts, a series of actions began to be taken in Europe that enabled the construction of national identities.[219] Music served as a fundamental vehicle for the construction of that identity, and the popular melody was the element related *par excellence* to that identity. Over the course of the nineteenth century, a series of activities was carried out that lent support to Basque musical nationalism, the most noteworthy of which was the different collection of Basque songs. Historical conditions were different on each side of the Pyrenees. In Gipuzkoa, Bizkaia, Araba, and Navarre, the abolition of the Basque *fueros* in 1876 meant the loss of administrative self-

---

[219] Anne-Marie Thiesse, *La création des identités nationales: Europe, XVIIIe–XXe siècle* (Paris: Seuil, 2001).

government, which gave rise to a rebirth of the Basque people's civic conscience. Moreover, starting in 1880 the industrial development in Bizkaia favored social and cultural pluralism, which would be decisive for the creation of institutions and convocations that would foster the development of the nationalist movement.

In Iparralde,[220] the *fueros* had disappeared in 1789, and the Basques were united with the Bearnese to form a *département* administered by the French government. Yet "de-Basquization occurred more slowly, more discreetly, less visibly than in Hegoalde, and it did not leave such a drastic mark on the spirits."[221] From the cultural standpoint, in any case, the reactions were similar to those observed to the south of the Pyrenees. Among the elements significant for Basque musical nationalism, I will mention songbooks and songs, the Basque lyric theater, and other genres.

## Songbooks and Songs

During the nineteenth century, numerous collections of popular songs were compiled in Europe. One of the first of these was Juan Ignacio Iztueta's collection,[222] which dates from 1826. As Jorge de Riezu[223] indicates, "without being aware of the current that were beginning in that era, [he] had the idea of associating music and lyrics and did so in his book of Gipuzkoan Dances (1826)."[224]

---

[220] The three Basque historical territories administered by France.

[221] Natalie Morel Borotra, *La ópera vasca (1884–1937): 'y el arte vasco bajó de las montañas"* (Bilbao: Mínima, 2006), 45.

[222] Juan Ignacio de Iztueta Echevarría, *Viejas danzas de Guipúzcoa/Gipuzkoa'ko dantza gogoangarriak* (Bilbao: Editorial La Gran Enciclopedia Vasca, 1968).

[223] A musicologist born in Riezu (Yerri Valley, Navarre) on July 1, 1894. He died on March 27, 1992. He edited the *Obras Completas de Donostia*.

[224] In José Antonio de Donostia, *Obras completas del Padre Donostia*, vol. 1 (Bilbao: La Gran Enciclopedia Vasca, 1983).

Other noteworthy works are *50 chants pyrénéens* by Pascal Lamazou;[225] *Souvenir des Pyrenées*[226] by Mme. de Villéhélio;[227] *Chants populaires du Pays Basque* by Jean Sallaberry;[228] *Folklore du Pays Basque* by Julien Vinson;[229] *Cancionero Basco* by José Manterola;[230] and *Douze chansons amoureuses du Pays Basque-Français* by Charles Bordes.[231]

The lecture entitled "La música popular baskongada" (Popular Basque music) by Resurrección María de Azkue on February 15, 1901, at the "Centro Vasco" society in Bilbao offers for the first time an ethnographic study of Basque folk songs. This author continued to extend his folklore research, and finally published, between 1922 and 1925, in eleven booklets, his *Cancionero Popular Vasco* with one thousand and one melodies without accompaniment.[232]

---

[225] Pascal Lamazou, *Chants pyrénéens 36 airs béarnais, 12 airs basques, 2 airs des Pyreénées orientales, avec traduction française* (Paris: Chez P. Lamazou, En dépot chez S. Richault, 1869).

[226] Julie Adrienne Karrikaburu Roger, *Souvenir des Pyrénées 12 airs basques* (Paris: n.p., 1869).

[227] Julie Adrienne Karrikaburu, a female musicologist known as Mme. de Villéhélio.

[228] Jean Dominique Julien Sallaberry, *Chants populaires du Pays Basque. Paroles et musique originales, recueillies et publiées avec traduction française par J.D.J. Sallaberry* (Bayonne: Imprimerie de Veuve Lamaignère, 1870).

[229] Julien Vinson, *Le Folklore du Pays basque, par Julien Vinson* ([Paris]: Maisonneuve et Larose, 1883).

[230] José Manterola, *Cancionero basco: poesías en lengua euskara* (San Sebastián: Juan Osés, 1878).

[231] Charles Bordes and Paul Gravollet, *Chansons populaires: Douze chansons amoureuses du Pays Basque français* (Paris: Rouart, Lerolle & Cie, 1910).

[232] Karlos Sánchez Ekiza, "El cancionero de Azkue desde una perspectiva etnomusicológica." In Iñaki Bazán Díaz and Maite Garamendi, *Resurrección María de Azkue: euskal kulturaren erraldoia eta funtsezko zutabea* (Donostia: Eusko Ikaskuntza, 2003).

While Azkue pioneered the work of searching for, collecting, and classifying Basque folk music, it was Donostia in his different phases who undertook the most ambitious task in this field.[233] Donostia is the author of the most extensive known Basque songbook, and he could be considered one of the best specialists in folk music of the twentieth century. The first folk motifs collected by Donostia date from 1911. In each of the records of motifs collected in his songbook, we have evidence that Donostia, starting from that year, took advantage of all available occasions to collect melodies, while also noting the names of his collaborators, among whom Arrigarai, Lecumberri, and Larrainzar are most worthy of mention. From the time of the *Gure abenduaren eresiak* collection, made up of 523 melodies and presented in 1915, until the songbook entitled *Euskel-Eres-Sorta* with 393 melodies, he continued publishing melodies in the journal *Gure Herria*, based in Baiona (Bayonne) from 1926 until 1939, when this publication was paralyzed by World War II. He later produced a second edition of his songbook *Euskel-Eres-Sorta* starting from January 1955, one year before his death. The final result of his work as a collector was the publication many years after his death, in 1994, of the *Cancionero vasco-donostia*, which contains 2,142 melodies.[234]

Jesús Guridi, in turn, presented his songs on folk motifs in 1913 in the journal *Euzkadi*. These songs were published in 1915 in the booklets *Euzkal Abestijak* (1915–1917) of the Juventud Vasca in Bilbao.[235] In 1930 Guridi published the booklet

---

[233] Both authors compiled the folklore in the same period, and both entered the competition convened in 1911 by the Gipuzkoa Provincial Council to reward the best collection of unpublished Basque songs, which Azkue won with his work entitled *Cancionero Vasco*.

[234] José Luis Ansorena, *Aita Donostia: P. José Antonio de San Sebastián (José Gonzalo Zulaica Arregui)* (Donostia: Fundación Kutxa, 1999).

[235] Juventud Vasca de Bilbao (Bilbao Basque Youth) was the most important organization in the Basque nationalist community, and the main agent for the creation and promotion of the Basque nationalist imagination. See Nicolás Ruiz

*XXII canciones del folklore vasco,* on popular Basque motifs.[236] This work was praised by Donostia in the newspaper *El Día* of Donostia-San Sebastián, where he asserts that:

> Reading these songs I would say that the ancient spirit of the race is embodied and appears next to us at the piano with a continent of serenity, nobility and commendable aristocracy. Guridi, as a great artist, has framed these melodies with great simplicity. We will never be able to insist firmly enough in the need to simplify the accompaniment of popular song. A rhythm, a note that characterizes an ancient scale, a silence. . ., have a power of evocation that cannot be attained by doubling useless notes. In this booklet, Guridi gives us authentic models of the difficult simplicity that must characterize this genre of music. There is nothing more delicious than the "Jentileri un," "Ala Bai-ta," "Agustuaren amabost garren" and other numbers. They are real achievements . . . Guridi's booklet should always be kept within reach. Open the piano and take any page of this album. The freshness of the mountains, of the woods, breezes through our souls; the vision of beloved countryside restores and moves us; for one moment we have been whisked away far from the city where the daily struggle is waiting for us. [237]

---

Descamps, *Música y nacionalismo vasco: la labor musical de Juventud Vasca de Bilbao y el uso de la música como medio de propaganda política (1904-1923)* (Donostia: Eusko Ikaskuntza, 2010).

[236] Guridi would later use these songs for the composition of his famous *Diez melodías vascas* (1941) (Bilbao, 1992).

[237] Aita Donostia, cited in Jesús María de Arozamena, *Jesús Guridi: (Inventario de su vida y de su música)* (Madrid: Editora Nacional, 1967), 251–52.

In addition to the folk elements compiled by these authors, numerous songs appeared in this era that, despite not being folk songs as such, took their inspiration from Basque popular music, such as those by J.M. Iparraguirre published by José Antonio de Santesteban;[238] *Álbum de cantos vascongados* (c. 1900) by Julián Martínez Villar;[239] and the *Ecos de Vasconia* collection by José María Echeverría and by Juan Guimón (c. 1890) among others. Classifying these songs requires an in-depth study that cannot be conducted in this chapter,[240] but it is beyond dispute that the form of song for voice and piano is one of the most representative genres of this era.

Although most composers of this era wrote songs for voice and piano, Donostia was the author of the most extensive and diverse work for voice and piano. He composed 165 pieces for voice and piano, and the special feature of this corpus of songs was that to create it he drew upon folk roots that were mainly Basque, but also on motifs found in the Gascon, French, Castilian, and Sephardic cultural heritage. We also find a series of songs based on Catalan poems and a collection of vocal exercises entitled *Fanfares de Chasse envisagées comme des exercises vocaux* and *Cloches et carrillons*, which Donostia harmonized for the Armenian singer Margueritte Babaïan (1874–1968).[241]

---

[238] José Antonio de Santesteban, *Álbum Iparraguirre* (Donostia-San Sebastián: Almacén de música de Santesteban, 1889).

[239] Julián Martínez Villar, *Álbum de cantos vascongados* (Madrid: Unión Musical Española, ca. 1904).

[240] See Isabel Díaz Morlán, *La canción para voz y piano en el País Vasco, 1870–1939* (Madrid: Bubok Publishing, 2013).

[241] Marguerite Babaïan enjoyed an international career as a mezzo-soprano. With a very active presence in the most important artistic circles of her time, Ravel dedicated to her the last of his Greek songs, titled *Trypatos*. A defender of Armenian culture, this singer had a great predilection for Basque music, as can be seen in the letters she sent to Donostia. She participated in several of his talks, singing musical items, such as the one on November 12 and

## The Lyric Genre

One of the most representative art forms in the historical period under discussion here is the lyric genre. This includes numerous operas and zarzuelas, among other things, that reflected the ideology characteristic of the Basque nationalist movement as it existed in Euskal Herria (the Basque Country) in that era. For this reason, I will refer to this repertoire as Basque lyric theater. In this era, other zarzuelas were also created that were inspired by elements foreign to the social and historical reality of Basque Country, but that were of great sociocultural significance.

## Basque Lyric Theater

By "Basque lyric theater" I mean both Basque opera and Basque zarzuela, which involve, as Natalie Morel Borotra asserts, "awakening of national consciousness and crafting of a heritage of identity based on appreciation of aspects of culture such as language, customs, legends, song, dance."[242] In any case, it is impossible to limit lyric theater to a series of specific characteristics, since "it is understood that the reality delimited by the terms of Basque opera cannot be translated into a fixed and unchanging formula. Each new creation—including revivals— would contribute an aspect or lend a nuance to the definition of this concept." Most sources that I have consulted connect the origins of Basque lyric theater with the Souletin pastorals. The pastorals are a form of popular theater that emerged in the late sixteenth century, and, as Morel Borotra indicates, "has in common with Basque opera a theatrical performance of a

---

December 6, 1931 in Paris, titled *Les berceuses basques*, and that on August 9, 1935 at the Marianistas de San Sebastián School, entitled "the popular Basque song in general."

[242] Morel Borotra, *La ópera vasca*, 12.

decidedly religious nature, incorporating Basque music and dance, staged by a company of amateurs assembled for this purpose."[243]

It is important to clarify the difference between the terms "pastoral" and "opera," since some Basque operas, such as *Maitena* (1909) by Charles Colin and *Mendi-Mendiyan* (1910) by José María Usandizaga, bear the additional name of pastoral, but in this case the term pastoral does not refer to a performance in Zuberoa.

## Early Years

*Pudente* (1884) was the first work for theater, created by Santesteban (1835–1906), which is called Basque opera. To create this work, he used popular melodies that he himself collected in his *Colección de aires vascongados para canto y piano* (c. 1889), and he also imported motifs from *Cancionero basco* (1877–1880) by Manterola (1849–84).

Worthy of note in this era are the opera *Chanton Piperri* (1897) by Buenaventura Zapiráin and *Iparraguirre* (1889) by Guimón, as well as the zarzuelas *Vizcaytik Bizkaira* (1895) and *Eguskia Nora* (1896) by Azkue. The composition of works for the Basque lyric theater was intermittent until the golden era of this genre, which, just as José Antonio Arana Martija asserts, occurred between May 1909 and May 1914 with the composition of eight Basque operas by seven different composers.[244]

## The Great Repertoire 1909–20

In May 1909, the premiere of the operas *Anboto* by Zapiráin and *Maitena* by Colin prompted the Bilbao Choral Society to organize a campaign to create, produce, and popularize three Basque

---

[243] Ibid., 74.

[244] José Antonio Arana Martija, *Música vasca* (Bilbao: Caja de Ahorros Vizcaína, 1987).

operas that premiered in 1910.[245] These were *Mendi–Mendiyan* by Usandizaga, *Mirentxu* by Guridi, and *Lide eta Ixidor* by Santos de Inchausti. The author of the libretto of the first of these was José Power (1876–1964), and Alfredo de Echave (1872–1926) was the librettist of the latter two. Both were members of the management board of the Bilbao Choral Society.

This institution attempted to promote Basque lyric theater by commissioning composers to create works into which the most recent avant-garde trends of the era were incorporated. For this purpose, they requested that Usandizaga and Guridi compose their operas, *Mendi-Mendiyan* and *Mirentxu*, respectively. Both composers had trained at the *Schola Cantorum* in Paris, where they cultivated a language pertaining to the most advanced European trends, and they had resolved to break with the lyric tradition whose expression consisted exclusively of exhibiting popular songs and customs of the Basque people, quite apart from European trends in composition. Thus, in the correspondence between the two musicians there is evidence that they are familiar to a certain extent with the Basque lyric genre as composed up to that time. But both Guridi and Usandizaga found this genre lacking in artistic value and mediocre in its compositions. These ideas are confirmed in the following citation from Guridi:[246]

> They clearly have some pretty popular motifs, but as soon as they abandon the motif and do something intended as development, it becomes intolerable, and since moreover all the motifs are the same, a defect that I find in the French-Basque motifs, this leads to a monotony and a lack of contrast that really becomes unbearable. Let's not even talk about the orchestration; sometimes, maybe in the

---

[245] An association that was founded in 1886 and that from that time was linked to activities promoted by Basque nationalism.

[246] Jesús Guridi, cited in Arozamena, *Jesús Guridi*, 130.

middle of a melodrama, you hear an unpleasant trombone passage that makes even bald men's hair stand on end.

Usandizaga in turn also declares to Guridi, in a letter dating from October 30, 1909, his disapproval of the manner of composition of the first Basque lyric works. He stresses the importance of making each character interesting by assigning him a certain *leitmotiv*, and not by unstructured use of more or less attractive songs.[247]

The success of the premieres of *Mendi-Mendiyan* by Usandizaga and of *Mirentxu* by Guridi bolstered the development of a Basque lyric trend following the same precepts applied by these authors. And so, 1911 saw the premier of *Itsasondo* by Inchausti and *Ortzuri* by Azkue; the latter was the first work in this genre composed entirely in Euskara. That same year, on the occasion of the Euskara Festivals[248] celebrated in Segura, the Provincial Council of Gipuzkoa convoked a competition for the creation of new *libretti* for the Basque lyric theater.

At this time Usandizaga was engaged in creating two new works of the Basque lyric genre, which he never completed: namely, *Costa Brava* and *Alostorrea*.[249] For his part, Guridi began to compose his Basque opera entitled *Amaya*, which would premiere in 1920. The staging of Guridi's *Amaya* constituted the final push on the part of Bilbao's society to establish a Basque lyric theater. The scale of this opera is evidence of this, since it is the only work in this genre that required for its staging professional singers who

---

[247] Gillen Munguía, "El folclore en la obra para voz y piano en lengua vasca de Jesús Guridi," Master's thesis, Universidad Internacional de La Rioja, 2017. [248]

From 1853, the promoter of Basque culture, Antoine D'Abbadie, launched the first contest in the town of Urruña (Urrugne), Lapurdi. Subsequently, various towns in Euskal Herria began to celebrate these festivals in order to promote Basque culture.

[249] Morel Borotra, *La ópera vasca.*

were able to perform together with an orchestra of Wagnerian dimensions.

## Other Zarzuelas

The economic costs of producing the operas mentioned in the previous section put a stop to the staging of new works of this genre. In addition, the consequences of the audience's unenthusiastic reception for the opera *Urlo* (1914) by Azkue worsened the situation and prevented new productions such as the opera *Zara* (1913) by Eduardo Mocoroa and *Lekobide* (1911) by Andrés de Isasi (1890–1940), which were never performed. The lack of economic resources was one of the reasons that put a stop to the trend to create and produce new Basque operas. Zarzuelas, however, had a more significant social impact at a much lower production cost. Thus, as Guridi[250] explains:

> I spent ten long years composing *Amaya*, and I scarcely earned enough to buy a vest. On the contrary, I spent a few months writing *El Caserío*, and the royalties that it generated enabled me to bring up my children well and spend the vacation months in this chalet in Donostia. Fame is great, but without misery. And the Basque people, even those who seek, so to speak, their inspiration in the clouds, can thank God that they have their feet firmly planted on the ground.

In addition to the economic cost, other factors, such as the impact of World War I, which appeased nationalist spirits, influenced the new creative projects. As Morel Borotra explains,[251]

---

[250] Jesús Guridi, cited in Arozamena, *Jesús Guridi*, 219.
[251] Morel Borotra, *La ópera vasca*, 278.

"Composers prefer to devote themselves to other genres or to produce works that can no longer be circumscribed by an exclusively Basque literary landscape and soundscape."

The zarzuelas composed in this period in Hegoalde were not inspired by the ideological tenets of the Basque nationalist movement. Iparralde, however, witnessed the debuts of titles such as *Perkain* (1931) by Landagorri and *Yuana* (1933) by Laurent Bossières, which, although they used Basque settings, were written in French and are more closely akin to French operetta, which was in its heyday in this period in France.

Among the most significant works of zarzuela by Basque authors of this period are *Las Golondrinas* (1914) by Usandizaga. Guridi, in turn, premiered *El Caserío* (1926), *La Meiga* (1928), and *Mari-Eli* (1936), among others. Juan Tellería (1895–1949) composed *Los Blasones* (1930) and *El joven piloto* (1934), and the Donostia composer Pablo Sorozábal (1897–1988) deserves special mention, especially for *Katiuska* (1931), *Adiós a la Bohemia* (1933), *La del manojo de rosas* (1934), and *La tabernera del puerto* (1936).

## Other Genres

As explained in detail in chapter 4, which is dedicated to music in the nineteenth century, over the course of this century, bands, choral societies, and choruses[252] sprung up in different Basque locations. This explains how Basque musical nationalism was strengthened based on the existence of a musical infrastructure that induced composers to compose for these groups. The Euskara Festivals, noted previously, promoted Basque culture in this era, and they

---

[252] The Bilbao Choral Society was created in 1886; the Orfeón Donostiarra in 1897, and the origins of the Pamplona-Iruñea Choral Society date back to 1865.

were held fundamentally for the creation and performance of orchestral and choral works and works for bands.[253]

The choral genre is the most important in this era. Works for choral societies were numerous, both of a secular and a religious orientation. Guridi's employment as director of the Choral Society of Bilbao motivated him to compose numerous choral pieces. His secular choral works include noteworthy harmonizations of folklore motifs such as *Goiko mendijan* (1919) and *Oñazez* (1923). Guridi also published the *Cantos populares vascos* collection (1913–1923) with his own harmonizations, which he premiered with the Bilbao chorus.[254] His religious choral pieces include especially the noteworthy *Misa de Requiem* (1921) and *Misa en honor a San Ignacio de Loyola* (1922).[255]

Aita Donostia was also the author of numerous choral works for mixed voices as well as and for equal voices and children's voices. The religious works were composed for each of the different liturgical periods. Among the secular works, most are pieces with roots in Basque folklore.

In addition to this, the symphonic and symphonic-choral repertoire includes works such as *Irurak Bat* by Usandizaga, based on popular Basque songs for orchestra and band (1906). This composer also authored pieces for orchestra such as *Dans la mer* (1904), the symphony *Bidasoa* (1907), and *Aires vascos para orfeón* and *Marcha Vascongada* (1909). *Umezurtza* (1913), for soprano, tenor, mixed choir, and orchestra, based on popular Basque melodies, is Usandizaga's most significant work in this genre. Other representative works by Usandizaga are the fantastic dance entitled *Hasshan y Melihah* (1912) and the hymn for August 31,

---

[253] One notable example is Raimundo Sarriegui (1838–1913), from Donostia-San Sebastián, who was the author of numerous band compositions.

[254] Pablo Bilbao Aristegui, *Jesús Guridi* (Alava: Diputación Foral de Álava, Departamento de Cultura, 1992).

[255] Víctor Pliego de Andrés, *Jesús Guridi* (Madrid: SGAE, 1997).

1813—the day on which the centenary of the burning of the city of Donostia-San Sebastián was commemorated—which he composed for music band, trumpets, and drums.

Other significant works in this genre are *Euzko Irudiak* (1922) by Jesús Guridi and the *Basque Suite* (1923) by Pablo Sorozábal, and two works composed by Fernando Remacha (1898–1984) in his youth: the ballet *La maja vestida* (1919) and the symphonic poem *Alba* (1922).

As far as instrumental works, I consider one of the most important compositions from this era to be the *Basque Preludes— Euskal Preludioak* for piano by Aita Donostia. Composed between 1913 and 1924 and based on folk motifs, they were so successful that they were arranged for orchestra and performed in Madrid by the Pérez-Casas Philharmonic Orchestra in 1919. As for the *txistu* (Basque flute), the Capuchin friar Hilario Olazarán de Estella (1894–1973), a friend and companion of Aita Donostia, published the first method for this instrument, titled *Método para txistu y tamboril* (1927). Olazarán, moreover, was the author of pieces for three voices with *txistu* and *tamboril* (tabor), and also of numerous piano pieces, many of which are based on the folk motifs that he compiled in Navarre. In 1936, as a result of the Spanish Civil War, he was sent to Chile, where he remained until 1963.

Olazarán was not the only composer who resided in Latin America. Of all the Basque musicians who popularized Basque music in the Americas, alongside Emiliana de Zubeldia (1888–1987) and the world-famous Nicanor Zabaleta (1907–33), one of the most noteworthy was Tomás Múgica Gaztañaga (1883–1963) due to the importance that he had in the musical life of Uruguay. Born in Tolosa (Gipuzkoa), he studied with Felipe Gorriti and Eduardo Mocoroa. Afterward, he moved to Belgium to study in the Royal Conservatory of Brussels, where he met Eduardo Fabini, who mentioned to him that composition teachers were needed in Uruguay, and so in 1913 he sailed for

Montevideo. In 1931 the Sodre was created, one of the most important musical institutions in that country, was created, with Múgica as its co-founder. In addition to composing, he was appointed as orchestra conductor, and in 1933 he created a choral society with members of the Euskal Herria society. His works display a strong influence of Basque folk motifs, and in a subsequent stage incorporate traditional Uruguayan elements.[256]

## The Reform of Sacred Music in Euskal Herria

In Euskal Herria, sacred music is one of the main pillars of Basque musical history in this era. Hence the reform of liturgical music exercised a great influence due to two factors of internal and external nature. On the one hand, we must remember that the majority of Basque musicians were trained in churches and convents, including, to mention a few, Bixente Goikoetxea and Nemesio Otaño, and that numerous Basque scholars and composers were priests or had trained with priests. At the same time, in the nineteenth century, a European movement emerged the Cecilian Movement, which reacted against sacred music in the Romantic style. This trend contributed to the publication in 1903 of *Motu Propio* by Saint Pius X, *Tra le sollecitudini*, which set forth the rules for the reform of liturgical music, and which influenced the development of the Fourth National Congress for Sacred Music in Vitoria-Gasteiz in 1928.

### Motu Proprio

In Euskal Herria, just as in the rest of Europe, it is fundamental to consider the influence exercised on the religious musical

---

[256] Julio César Huertas, *Músicos de aquí*, vol. 5 (Montevideo: Tradinco, S.A., 2000).

movement of the era by the publication in 1903 of *Motu Propio* by Saint Pius X, *Tra le sollecitudini*. This encyclical sets out rules for a reform of sacred music, which intends to dignify religious music by distancing it from other theater and secular genres that had distorted its essence. And so I will select a citation from this encyclical that asserts that:

> These qualities are found in the highest degree in Gregorian chant, which is, therefore, the Roman Church's proper song, the only one that the Church inherited from its ancient Fathers, and which it has zealously preserved over the course of centuries in its liturgical codices, which it prescribes exclusively in some parts of the liturgy, and which the most recent studies have fortunately restored to its purity and completeness. For these reasons, Gregorian chant was always regarded as the finished model for religious music, and a general law can rightly be framed: a religious composition will be more sacred and liturgical, the more it resembles Gregorian chant in its manner, inspiration and flavor, and it will be less worthy of the temple to the extent that it is farther from this sovereign model. And so, the traditional ancient Gregorian chant must be extensively restored in the ceremonies of worship; and it regarded as well-known and understood that no religious ceremony will be diminished in dignity even if no music other than Gregorian chant is performed. We must especially strive for the people to reacquire the custom of using Gregorian chant, so that the faithful again take an active part in the liturgical service, as they used to do formerly.[257]

---

[257] In Josu Okiñena, "La comunicación autopoiética fundamento para la interpretación musical: su estudio en la obra para voz y piano de José Antonio Donostia," PhD diss., University of Valladolid (UVA), 2009.

The implementation of this encyclical led to the organization of different congresses of sacred music, which standardized different steps for reviving the liturgical repertoire. They started with the First National Congress for Sacred Music in Valladolid (1907), organized by Bixente Goikoetxea Errasti (1854–1916) and by Nemesio Otaño Eguino, who were two of the most representative Basque composers of the liturgical musical reform. This was followed by the Second National Congress in Seville in 1908, and by the Third National Congress in Barcelona in 1912. In 1913, a Congress for Sacred Music was held in Baiona, Iparralde, and, lastly, in 1928, the Fourth Congress of Sacred Music in Vitoria-Gasteiz.

## Bixente Goikoetxea and Nemesio Otaño: The Architects of the Reform of Liturgical Music

Among the Basque composers who contributed to the reform of sacred music, the most outstanding in importance were Bixente Goikoetxea (Aramaiona, Araba 1854–Valladolid, 1916) and Nemesio Otaño (Azkoitia, 1880–Donostia-San Sebastián, 1956), who was a disciple of the former.

Bixente Goikoetxea was one of the first Basque composers who represented a reformist trend against theater and secular music and the Italianism prevailing in the religious arena. A self-taught musician, he only received a few classes from Felipe Gorriti [258] (1839–1896). In 1890, he took up the post of chapel master at the Metropolitan Cathedral of Valladolid and initiated a profound reform, influenced by the Cecilian Movement, which led him to replace the secular repertoire with great pieces by

---

[258] Chapel master, organist, composer, and teacher of composers such as Bixente Goikoetxea and Eduardo Mocoroa.

polyphonic sixteenth-century composers such as Palestrina or Victoria. Goikoetxea's most important professional facet was as a composer. Some masters assert that he is "the master of modern Basque polyphony." [259] Besides his masses, salves, and motets, his other noteworthy works include three pieces for Christmas, *Maitines, Kalendas,* and *Responsorias,* which as Salaberri asserts, "were written more than ten years before the reform of Saint Pius X."[260]

Goiketxea and Otaño were the organizers of the First National Congress of Sacred Music in Valladolid, in 1907, and starting from that time, Otaño became the standard-bearer for the reform of Spanish sacred music.

After the Congress of Valladolid, Otaño organized the publication of the journal *Música Sacra Hispana,* which was a fundamental vehicle for the establishment of the reform. Through this publication he maintained contact with the most important figures of the European musical reform movement. As Jesús María Muneta says, "it put him in contact with the best national and international masters of sacred music. These included De Santi, 'Otaño was a double of A. De Santi', Julio Bas, [who] 'was in communication with Otaño every week', Perosi, Mitterer, Grieshbacher, D'Indy."[261]

In 1908 he organized the Congress of Sacred Music of Seville, and in 1909 he published the *Antología Moderna Orgánica Española,* with works by Guridi, Mocoroa, and Urteaga, among others, which exercised great influence, since works of organists

---

[259] Arana Martija, *Música vasca,* 236.

[260] Sabin Salaberri, "Vicente Goicoechea Errazti," at http://www.euskonews.com/0027zbk/gaia2704es.html (last accessed April 12, 2018).

[261] Jesús María Muneta, "El P. Otaño, alma de la reforma de la música religiosa en la primera mitad del siglo XX," *Cuadernos de Sección. Música* 1 (1983), 132. At: http://hedatuz.euskomedia.org/7021/.

from this modern Basque school of organ appeared in foreign collections.[262]

One of the most important actions that Otaño undertook was the establishment of the *Schola Cantorum* in Comillas, Cantabria, in 1910, with which he worked assiduously until 1919, the year in which he was removed from the *Schola* by his religious superiors. It must be stressed that the assimilation of the reform was not easy, since the musical chapels, choral groups, and parish choirs often showed resistance to incorporating the new repertoire. Otaño successfully introduced the new repertoire into this group as an inherent part of liturgical activity by popularizing and extending the spirit of the reform, by programming classic and modern polyphony, by composing the majority of his choral work together with popular religious songs, and by creating a school of composers who were organists and choir directors.[263]

## The Fourth National Congress of Sacred Music, Vitoria-Gasteiz, 1928, and the Association of Organists of Saint Cecilia and Saint Gregory of the Diocese of Vitoria

As explained previously, various congresses on sacred music were organized after the time of *Motu Proprio*. An especially important congress was held in Vitoria-Gasteiz in 1928, since important lectures were given on the topic, including one by Azkue on "Tradition in our Popular Music" and another by Donostia on "The Popular Religious and Artistic Song in their Different Manifestations." Alfonso Ugarte[264] was in attendance as a sub-

---

[262] Arana Martija, *Música vasca*, 237.

[263] Muneta, "El P. Otaño," 132.

[264] Ainhoa Kaiero Claver, *Alfonso Ugarte (1879–1937) eta musika sakratuaren berrikuntza hego Euskal herrian = Alfonso Ugarte (1879–1937) y la reforma de la música*

delegate from Lizarra-Estella, and he offered up a report with all the steps taken in connection with sacred music at this location and its surroundings.

One of the most important consequences of this congress for reform of liturgical music in churches was the establishment of the Association of Organists of Saint Cecilia and Saint Gregory of the Diocese of Vitoria. The regulation, which was approved by the bishopric of Vitoria and by the civil government, was divided into five chapters and contains information fundamental for understanding the musical reform that was carried out in Euskal Herria in this era. Thus, chapter 1 determines the exclusively professional nature of the association and its members and defines the association's goals with an emphasis on (among other things): the restoration of religious music in keeping with church doctrine, the foundation of a school for organists in accordance with the diocesan seminaries and musical associations, and compliance with the provisions of the diocesan synods and the regulations for sacred music in force.[265]

## The Reform of Sacred Music in Euskal Herria and Basque Musical Nationalism

The reform of religious music in Euskal Herria was closely related to Basque musical nationalism. Two of the most representative composers of musical nationalism and authors of the most important Basque songbooks, Resurrección María de Azkue and Aita Donostia, were priests. Their religious profession, together with the task of compiling Basque folk music, demonstrate that the nationalist movement and the reform of sacred music in

---

*sacra en territorio vasco-navarro* ([Donostioa-San Sebastián]: Eusko Ikaskuntza, 2009).
[265] José María Zapirain Marichalar, *Sinfonía incompleta: apuntes para la historia de la vida musical en el Seminario Diocesano de Vitoria (1880–1960)* (n.p., 1992).

Euskal Herria evolved in parallel. Just as the resurgence of folk and popular motifs was brought about by musical nationalism, so the reform of sacred music, in the opinion of Ainhoa Kaiero Claver, "implied in a certain respect the need to introduce a reinvented tradition at the popular level. It was not so much a case of reviving a tradition as creating one by inserting and gradually assimilating these practices. And this reinvention of the tradition could only be accomplished by complete reeducation of the religious community and of the people."[266] Furthermore, this author asserts that, "this renovation was undertaken by searching for the own voice or essence and resorting for that purpose to reappropriating the original sources of the historical tradition (Gregorian chant and Renaissance polyphony). This is an aspect which, in turn, links it closely with the historicist movement underway since the mid-nineteenth century."[267]

This relationship between sacred music and the popular is also embodied in the repertoire of religious popular songs in Euskara, both those inspired by Basque folk motifs and those collected in the songbooks of a religious nature. Even Aita Donostia adapted texts in Euskara to many Latin chants, and his religious compositions in the vernacular were numerous. On the other hand, many organists who were involved in the Basque nationalist movement contributed to the use of Euskara in liturgical music.

All the ideas articulated above lead me to conclude that the reform of liturgical music that took place in Euskal Herria in the late nineteenth and early twentieth centuries constituted an evolution and renewal of musical language. While it may appear to represent a step back three centuries, the musical compositions took inspiration in the historical tradition, but adapted to the

---

[266] Kaiero Claver, *Alfonso Ugarte (1879–1937)*, 124.
[267] Ibid., 109

context in which they were created by incorporating nationalistic elements, such as texts in Euskara, and accepting the influence of European trends, such as the Cecilian Movement, of which Lorenzo Perosi (1872–1956) was the greatest exponent. As evidence of this, the most distinguished representatives of this reform of liturgical music were those who led other aspects of the musical reform, such as Aita Donostia, Azkue, and Guridi, among others.

## Ravel's Basque Identity

Maurice Ravel is one of the greatest composers of all time. There are numerous sources for the study of his life and work. Despite this, his "Basqueness" has been little discussed in the bibliography that I have consulted. And so in this section I present a dimension of this composer that is still unknown to many, but that I consider fundamental for understanding one of the most international of Basque composers: the Basque identity of Maurice Ravel and its influence on his work.

Maurice Ravel was born on March 7, 1875, in Ziburu (Ciboure), Lapurdi, in Iparralde. The son of a Swiss father and a Basque mother, Maria Delouart or "De huarte" or "de Ugarte," it is undisputed that Ravel's native language as a child was Euskara. The composer confirms that his mother put him to sleep singing him Basque songs,[268] and he recalls "the times when my godmother Gachoucha would speak to me in such pure Basque."[269] Ravel was proud to be Basque, and one of his main arguments was that he defined himself as Euskaldun, a Basque-speaker.[270]

---

[268] Hélène Jourdan-Morhange, *Ravel et nous: l'homme, l'ami, le musicien* (Genève: Éditions du milieu du monde, 1945).

[269] Étienne Rousseau-Plotto, *Ravel: portraits basques* (Paris: Séguier, 2004), 80.

[270] Arana Martija, *Música vasca*.

Although no letter of his has come down to us written entirely in Euskara, there are continual references in this language. As for the use of Euskara, it is worth noting that he always preferred to refer to the municipalities of Euskal Herria using the Basque place names. In a letter to the pianist Ida Godebska, dating from July 1911, he explains, "I have to go to Donibane Lohihilzun (Saint-Jean-de-Luz, as they say in France...) to see Mme. Vicq- Challet."[271]

His sense of Basque identity is obvious in a letter that the composer wrote to his teacher Eugéne Cools, to recommend that he accept Aita Donostia as a student, in which he writes, "Dear Cools: Your letter has solved a problem for me: I was looking for your address. I have a case here: a fellow countryman of mine—because you know that we Basques have two countries—Father Donostia from San Sebastián, has visited me to share with me his works and ask for my advice."[272] This sentiment can also be observed when Ravel tells his Swiss friend Jacques de Zogheb, "Listen, people have spoken of the sterility of my heart. It is untrue. And you know it. Since I am a Basque, and the Basques have strong feelings, but they open up very little and only to very few people."[273]

There are numerous references by the persons surrounding him to his Basque origin and identity, which are fundamental to understanding the personality and character of this musician from Ziburu. For instance, the legendary French pianist Marguerite Long declares that his build, his facial features, his general appearance, and also many qualities of his heart and spirit

---

[271] Maurice Ravel, Arbie Orenstein, Dennis Collins, and Jean Touzelet, *Lettres, écrits, entretiens* (Paris: Flammarion, 1989), 119.

[272] In Jorge de Riezu, *Cartas al P. Donostia* (San Sebastian: Grupo Doctor Camino de Historia de San Sebastian, 1980), 8.

[273] Pierre Narbaitz, *Un orfèvre basque: Maurice Ravel / Pierre Narbaitz* (Anglet: Côte Basque, 1975), 108.

belong to Basque Country.[274] For her part, the French violinist Hélène Jourdan-Morhange indicates that "the musician's secret, the friend's emotional modesty, the exclusive love that he had for music. There are many reasons that help us understand the extent to which Ravel bore the imprint of his Basque origins."[275] For his part, the composer's friend Roland-Manuel (1952) explains, "to ignore Ravel's Basque origin would mean overlooking many essential features of his character and of his genius."[276]

On his first visit to the United States, after his second concert in New York, several journalists asked him if he was Jewish. Ravel answered them: "No, I am not Jewish either from the religious standpoint, since I do not profess any religion; nor from the racial standpoint, since I am Basque."[277] The journalists, who did not know what Basque was, asked him about it, and Ravel answered them that it was very difficult to say precisely, that the origin of the Basques was unknown; that no one knew where they had come from. He asserted moreover that they were somewhat similar to the gypsies, since they showed, like the gypsies, nomadic tendencies, but that many centuries ago that settled definitively in the south of France.

## Ravel and Basque Folk Music

Based on all the evidence presented above regarding Maurice Ravel's Basque identity, it would be logical to think that one of the main elements for the creation of his works could be Basque

---

[274] Marguerite Long, *Au piano avec Maurice Ravel* (Paris: G. Billaudot, 1984).

[275] Jourdan-Morhange, *Ravel et nous*, 172.

[276] In Isidoro de Fagoaga, *Retablo vasco: Huarte, Ravel, Paoli, Gayarre, Eslava* (Bilbao: Editorial La Gran Enciclopedia Vasca, 1975), 30.

[277] Alexandre De la Cerda, "80ème anniversaire: Ravel et le Pays Basque," at http://www.baskulture.com/80eme-anniversaire-ravel-et-le-pays-basque-104961 (last accessed May 10, 2018).

folk music, especially since in the years in which Ravel composed his works, musical nationalism was in its heyday in Euskal Herria. The main feature of this musical nationalism was the revival of what is popular and autochthonous as raw material for musical creation. Basque folk music, as we have seen above, was the main element of identity for the musical nationalist movement.

We know that Ravel was acquainted with Basque folk music, but we can be just as certain that for Ravel popular melodies, "lost their essence and charm when they adopted the apparel of academic music."[278] Besides melody, dance is one of the main elements in Ravel's music, and Basque dances had a deep influence on his compositions. Thus, Jourdan-Morhange asserts that dance is one of the special features and needs of the Basque race, and he attributes to Ravel this characteristic of the Basques.[279]

Ravel's connection to Basque folk music is confirmed by his relationship with Aita Donostia, who was, as indicated above, one of the main exponents of Basque musical nationalism due to his facets as a composer and folk music collector. From the time when they became acquainted in Paris by way of the Catalan pianist Ricardo Viñes, they arranged to meet several times both at Ravel's residence in Donibane Lohizune (Saint-Jean-de-Luz) and at the Lekarotz College, in the Baztan Valley of Navarre, where Aita Donostia resided. At these meetings they discussed their musical concerns.

In 1937, on the occasion of Ravel's death, Aita Donostia wrote an article in the journal *Gure Herria*, which was published in Iparralde. In this article, Donostia sets out the reasons due to which Ravel, a Basque himself, does not use Basque popular motifs for the composition of his works. Donostia explains that

[278] Karlos Sánchez Ekiza, *Euskal musika klasikoa. Música clásica vasca. Basque Classical Music* (Donostia: Etxepare Euskal Institutua, 2012), 17.
[279] Jourdan-Morhange, *Ravel et nous*, 170.

Ravel had asserted to him: "Popular songs should not be treated in that way; they do not lend themselves to development."[280]

This special circumstance makes him a musician who is not a nationalist but rather must be valued for himself, Basque and universal.[281]

## The Basque Influence on Ravel's Compositions: The A-minor Trio, Zazpiak Bat, and the G-major Concerto for Piano and Orchestra

Although it is clear that Ravel did not use popular motifs for the composition of his works, it is no less clear that Maurice Ravel's Basque identity is obvious in many of his compositions. I will emphasize, among these, the A-minor Trio and also the G-major Concerto for piano and orchestra, the origins of which can be traced back to the unfinished project *Zazpiak bat*.

The Trio for piano, violin, and cello was composed entirely in 1914 in Donibane Lohizune. The analysis of this work informs us of numerous elements related to Basque music. Among these, I would emphasize the 8/8 meter in which the first movement is written, which is directly related with the 5/8 meter characteristic of the *zortziko*. The composer, in his writings, indicated that it had a Basque flavor.[282] But Ravel's greatest homage to Basque culture is represented by the unfinished project of the great work entitled *Zazpiak Bat*. The sources consulted confirm that in 1913 he had begun this project. But in 1914, when World War I broke out, he abandoned it. *Zazpiak bat*, or "the seven are one," is a coat of arms and motto that calls for the unity of the seven Basque regions, and it has always been related to the idea of the Basque nation. It originated in 1897, when Ravel was

---

[280] Donostia, *Obras completes*, vol. 3, 64.

[281] Arana Martija, *Música vasca*, 218.

[282] Ravel, Orenstein, Collins, and Touzelet, *Lettres, écrits, entretiens*.

twenty-two years old, and it emerged as a reaction to the loss of Basque rights and freedoms, due to the abolition of the *fueros* in Hegoalde and the French Revolution in Iparralde.

The origin of Ravel's *Zazpiak bat* can be traced back to an excursion that he took through Hegoalde, as his friend Gustave Samazeuihl explains: "I remember the excursion (in 1911) that took us through the admirable road of the pass of Lesaka, from Pamplona to Estella, and back by way of Roncesvalles, Donibane-Garazi and Maule. Ravel had already declared his plan for a Basque work for piano and orchestra, *Zazpiak bat*, and I saw very advanced sketches for this,"[283] continues Samazeuihl, indicating that he abandoned the project probably due to the difficulty of finding a central expressive theme. But these sketches prepared for the project *Zazpiak bat* were not forgotten, and Ravel would use them for the composition of his famous G-major Concerto for piano and orchestra of 1931, which Alfred Cortot refers to as the Basque concerto.[284]

The G-major Concerto was first performed by the French pianist Marguerite Long, together with the Lamoureux orchestra, under the direction of Ravel himself. The pianist herself, to whom Ravel dedicated this work, emphasized its Basque influence when she indicates that the titles "Basque Rhapsody" and "Basque Concerto" were suggested on numerous occasions for this work before its publication. She indicates moreover that "You would have to have seen, in Saint-Jean-de-Luz, one summer night, next to the blue tuna seiners that were poised under the light of the moon, how the young Basques were dancing when the first accents of a fandango emerged from the bandstand in the square . . . You would have to have seen this to understand that extreme spontaneity, that unbridled impulse of Ravel's country."[285]

---

[283] Gustave Samazeuihl, cited in Long, *Au piano avec Maurice Ravel*, 57–58.

[284] Arana Martija, *Música vasca.*

[285] Long, *Au piano avec Maurice Ravel*, 73–74.

The trio and the concerto both include numerous references to Basque popular motifs. Both works exhibit similarities to different Basque folk melodies, as well as rhythmic schemes directly influenced by Basque dances, as is the case of 8/8 meter explained previously. In any case, we can assert that even though Ravel did not incorporate motifs from Basque folk music when composing his works, his music is imbued with features of the Basque culture that evoke his origins and his identity, and realizing this is fundamental for the understanding of his work and enhancing the performance of his repertoire.

## Bibliography

Arana Martija, José Antonio. *Música vasca*. Bilbao. Caja de Ahorros Vizcaína, 1987.

Ansorena, José Luis. *Aita Donostia: P. José Antonio de San Sebastián (José Gonzalo Zulaica Arregui)*. Donostia: Fundación Kutxa, 1999.

Arozamena, Jesús María de. *Jesús Guridi: (Inventario de su vida y de su música)*. Madrid: Editora Nacional, 1967.

———. *Joshemari (Usandizaga) y la bella época donostiarra*. San Sebastián: n.p., 1969.

Azkue, Resurrección María de. *La Música popular baskongada*. Bilbao: Imprenta y Litografía de Gregorio Astoreca, 1901.

Bilbao Aristegui, Pablo. *Jesús Guridi*. Álava: Diputación Foral de Álava, Departamento de Cultura, 1992.

De la Cerda, Alexandre. "80ème anniversaire: Ravel et le Pays Basque." At: http://www.baskulture.com/80eme-anniversaire-ravel-et-le-pays-basque-104961 (last accessed May 10, 2018).

Díaz Morlán, Isabel. *La canción para voz y piano en el País Vasco, 1870–1939*. Madrid: Bubok Publishing, 2013.

Donostia, José Antonio de. *Obras completas del Padre Donostia*. 3

volumes. Bilbao: La Gran Enciclopedia Vasca, 1983.

Fagoaga, Isidoro de. *Retablo vasco: Huarte, Ravel, Paoli, Gayarre, Eslava.* Bilbao: Editorial La Gran Enciclopedia Vasca, 1975.

Huertas, Julio César. *Músicos de aquí.* Volume 5. Montevideo: Tradinco, S.A., 2000.

Iztueta Echevarría, Juan Ignacio de. *Viejas danzas de Guipúzcoa/Gipuzkoa'ko dantza gogoangarriak.* Bilbao: Editorial La Gran Enciclopedia Vasca, 1968.

Jourdan-Morhange, Hélène. *Ravel et nous: l'homme, l'ami, le musicien.* Genève: Éditions du milieu du monde, 1945.

Kaiero Claver, Ainhoa. *Alfonso Ugarte (1879–1937) eta musika sakratuaren berrikuntza hego Euskal herrian/Alfonso Ugarte (1879–1937) y la reforma de la música sacra en territorio vasco-navarro.* [Donostia-San Sebastián]: Eusko Ikaskuntza, 2009.

Lamazou, Pascal. *Chants pyrénéens 36 airs béarnais, 12 airs basques, 2 airs des Pyreénées orientales, avec traduction française.* Paris: Chez P. Lamazou, En dépot chez S. Richault, 1869.

Long, Marguerite. *Au piano avec Maurice Ravel.* Paris: G. Billaudot, 1984.

Manterola, José. *Cancionero basco: poesías en lengua euskara.* San Sebastián: Juan Osés, 1878.

Morel Borotra, Natalie. *La ópera vasca (1884–1937): "y el arte vasco bajó de las montañas".* Bilbao: Mínima, 2006.

Muneta, Jesús María. "El P. Otaño, alma de la reforma de la música religiosa en la primera mitad del siglo XX." *Cuadernos de Sección. Música* 1 (1983): 129–51. At: http://hedatuz.euskomedia.org/7021/.

Munguía, Gillen. "El folclore en la obra para voz y piano en lengua vasca de Jesús Guridi." Master's thesis, Universidad Internacional de La Rioja, 2017.

Narbaitz, Pierre. *Un orfèvre basque: Maurice Ravel / Pierre Narbaitz.* Anglet: Côte Basque, 1975.

Okiñena, Josu. "La comunicación autopoiética fundamento para la interpretación musical: su estudio en la obra para voz y piano de José Antonio Donostia." PhD dissertation, Valladolid: University of Valladolid (UVA), 2009.

Pliego de Andrés, Víctor. *Jesús Guridi.* Madrid: SGAE, 1997.

Ravel, Maurice, Arbie Orenstein, Dennis Collins, and Jean Touzelet. *Lettres, écrits, entretiens.* Paris: Flammarion, 1989.

Requejo Anso, Alberto Ángel. "A Study of Jesus Guridi's Lyric Drama *Amaya* (1910–1920)." PhD dissertation, University of Texas at Austin, 2003.

Riezu, Jorge. *Cartas al P. Donostia.* San Sebastián: Grupo Doctor Camino de Historia de San Sebastián, 1980.

Roland-Manuel, Alexis. *Ravel.* Buenos Aires: Ricordi Americana, 1952.

Rousseau-Plotto, Étienne. *Ravel: portraits basques.* Paris: Séguier, 2004.

Ruiz Descamps, Nicolás. *Música y nacionalismo vasco: la labor musical de Juventud Vasca de Bilbao y el uso de la música como medio de propaganda política (1904–1923).* Donostia: Eusko Ikaskuntza, 2010.

Salaberri, Sabin. *Vicente Goicoechea Errazti.* At: http://www.euskonews.com/0027zbk/gaia2704es.html (Last accessed April 12, 2018).

Sánchez Ekiza, Karlos. "El cancionero de Azkue desde una perspectiva etnomusicológica." In *Resurrección María de Azkue: euskal kulturaren erraldoia eta funtsezko zutabea,* edited by Iñaki Bazán Díaz and Maite Garamendi. Donostia: Eusko Ikaskuntza, 2003.

Sánchez Ekiza, Karlos. *Euskal musika klasikoa. Música clásica vasca. Basque Classical Music.* Donostia: Etxepare Euskal Institutua, 2012.

Thiesse, Anne-Marie. *La création des identités nationales: Europe, XVIIIe–XXe siècle.* Paris: Seuil, 2001.

Zapirain Marichalar, José María. *Sinfonía incompleta: apuntes para la historia de la vida musical en el Seminario Diocesano de Vitoria (1880–1960).* N.p., 1992.

**Electronic Sources**

https://aboutbasquecountry.eus/2011/05/05/maurice-ravel-el-vasco-que-creia-en-su-pais/

http://aunamendi.eusko-ikaskuntza.eus/es/gorriti-y-osambela-felipe/ar-67886/

http://aunamendi.eusko-ikaskuntza.eus/es/goicoechea-y-errasti-vicente/ar-149561/

http://aunamendi.eusko-ikaskuntza.eus/eu/otano-y-eguino-nemesio/ar-112961/

http://aunamendi.eusko-ikaskuntza.eus/eu/congreso-de-musica-sacra/ar-32095/

http://aunamendi.eusko-ikaskuntza.eus/es/fiestas-euskaras/ar-64777-144524/

http://aunamendi.eusko-ikaskuntza.eus/es/inza-arbeo-casto/ar-68866/

http://aunamendi.eusko-ikaskuntza.eus/eu/sarriegui-echeverria-raimundo/ar-107358/

https://www.elnortedecastilla.es/culturas/musica/201608/15/vicente-goicoechea-mentor-generacion-20160814202927.html

http://www.eresbil.com/web/sarriegui/Pagina.aspx?moduleID=2330&lang=es

http://www.liburuklik.euskadi.eus/handle/10771/25289

http://www.liburuklik.euskadi.eus/jspui/handle/10771/12026

http://www.memoriadigitalvasca.es/handle/10357/501

http://www.newworldencyclopedia.org/entry/Maurice_Ravel

https://mungiahistorianzehar.wordpress.com/2013/05/02/may
o-santos-eusebio-inchausti-larrauri-musico/
http://www.orfeondonostiarra.org/es/el-orfeon/historia
https://www.orfeonpamplones.com/es/orfeon/historia

## Music scores

Azkue, Resurrección María de. *Cancionero popular vasco*. Bilbao: Euskaltzaindia, 1990.

Bordes, Charles, and Paul Gravollet. *Chansons populaires: Douze chansons amoureuses du Pays Basque français*. Paris: Rouart, Lerolle & Cie., 1910.

Echeverría, José María, and Juan Guimón. *Ecos de Vasconia*. San Sebastián: A. Díaz y Cía., c.1893.

Iparraguirre, José, et al. *Álbum Iparraguirre: para canto y piano*. San Sebastián: Almacén de música de Santesteban, 1890.

Iztueta Echevarría, Juan Ignacio de. *Viejas danzas de Guipúzcoa /Gipuzkoa'ko dantza gogoangarriak*. Bilbao: Editorial La Gran Enciclopedia Vasca, 1968.

Karrikaburu Roger, Julie Adrienne. *Souvenir des Pyrénées 12 airs basques*. Paris: N.p., 1869.

Martínez Villar, Julián. *Álbum de cantos vascongados*. Madrid: Unión Musical Española, c. 1904.

Sallaberry, Jean Dominique Julien. *Chants populaires du Pays Basque. Paroles et musique originales, recueillies et publiées avec traduction française par J.D.J. Sallaberry*. Bayonne: Imprimerie de Veuve Lamaignère, 1870.

Santesteban, J. A. *Álbum Iparraguirre*. Donostia-San Sebastián: Almacén de música de Santesteban, c. 1889.

———. *Colección de aires vascongados para canto y piano*. Donostia-San Sebastián: Almacén de música de Santesteban, c. 1889.

Urkizu, Patri. *Viejas baladas vascas del cancionero de Chaho*. [Madrid]: [Universidad Nacional de Educación a Distancia], 2005.

Vinson, Julien. *Le Folklore du Pays basque, par Julien Vinson.* [Paris]: Maisonneuve et Larose, 1883. At http://gallica.bnf.fr/ark:/12148/bpt6k940238g.

# The Spanish Civil War and the Franco Dictatorship (1936–75)

Itziar Larrinaga Cuadra

On July 17, 1936, in Melilla and on July 18 on the peninsula, a part of the Spanish army staged an armed insurrection against the legitimate government of the Republic, thus beginning the Spanish Civil War. The final victory of the rebellious forces on April 1, 1939, entailed the establishment in Spain of a military dictatorship led by Francisco Franco that continued for almost forty years, until the death of the dictator on November 20, 1975.

Without a doubt, the Civil War formed the most important event in twentieth-century Basque history: it cut short the cycle of political, social, and cultural pluralism established in the region in 1876 after the last Carlist War and the abolition of the regional privileges (*fueros*); it meant the end of the Basque statute of autonomy approved by the parliament of the Spanish Republic on October 1, 1936, by which the first autonomous Basque government was constituted and whose president (*lehendakari*) was José Antonio Aguirre; and it entailed as well the suppression of the economic agreements of Gipuzkoa and Bizkaia with the central government.[286]

Navarre and almost all of Araba were immediately taken over by the insurgents in July 1936. On the other hand, Gipuzkoa and Bizkaia remained loyal to the government of the Republic, but fell into rebel hands in September 1936 and June 1937

---

[286] José Luis de la Granja, Santiago de Pablo, and Coro Rubio, *Breve historia de Euskadi. De los fueros a la autonomía* (Madrid: Debate, 2011), 191.

respectively. The Spanish Civil War was also a war among the Basque people, with the peculiarity that the two big Basque confessional parties, the Basque Nationalist Party and the Carlist Party or Traditional Communion, fought among themselves; the former supporting the Republic from which it had obtained its statute of autonomy, and the latter supporting the insurgents. Thus, in contrast to what was happening in the rest of Spain, in the Basque Country a fratricidal battle among Catholics took place.

Once under rebel control, a phase of absolute political and social homogeneity in the region was undertaken by new regime, which was characterized by an economic crisis as well, due to the policy of autarky established at the end of the war and that continued until the 1950s.[287] Around 1959—the year in which the stabilization plan was approved—a new phase of Franco's dictatorship began, distinguished by a plan for development that removed the country from the autarky of the postwar period and brought with it a new economic and social dynamic, as well as naming Juan Carlos de Borbón successor to the dictator as King of Spain in 1969.[288]

The present chapter attempts an overview of musical activity in the Basque Country during the Civil War—in the territory controlled by the insurgents—and during the dictatorship. It is addressed from the perspective of the relationship between music—and musicians—and political authority, and it is concerned with the field of what is called "classical" music. The text is presented in four principal categories: the purge of accountabilities after the war, the exile, musical activity during the period of autarky, and the opening up of the 1960s.

---

[287] Ibid., 192–93.
[288] Ibid., 215.

## Purging for Political Accountability

Once in power, the Francoists took control of official institutions and organisms. They appointed new authorities who represented the political and social groups that supported the coup d'état and made sure of the loyalty of public employees by making them go through a rigorous process of purging for political accountability. In this way, they sought total control of the administration through repression and punishment of the dissatisfied, the submission of the undecided, and the reward for those who had sided with the insurgents.

In February 1939, a little before the end of the Civil War, Franco announced the Law of Political Accountability, with the intention of "liquidating the sins of this class acquired by those who contributed by acts or by grave omissions to foment the red subversion" and "to erase their past errors by complying with just sanctions and steadfast will not to go astray";[289] he also proclaimed the Law of February 10, 1939, that established the norms for the purging of public employees. Those legal texts established a uniform administrative procedure for initiating dossiers and were based on the specific decrees that, in this respect, were created throughout the war, and that affected the greater part of the proceedings for purging that occurred in the music institutions dependent on Basque administrations. Such proceedings, because they happened at different times, were not homogeneous, although they followed the same punitive and preventive end.[290] As examples of said purging proceedings, we shall now mention those which affected musicians linked to the cities of Donostia-San Sebastián and Bilbao.

---

[289] As prescribed by the "Ley de responsabilidades políticas," *BOE* 44, February 13, 1939, 824–47.

[290] Aritz Ipiña, *La depuración y represión franquista de las empleadas y empleados del Ayuntamiento de Bilbao (1936–1937)* (Bilbao: Ayuntamiento de Bilbao, 2017), 19.

The city administration of Donostia-San Sebastián[291] proceeded to open dossiers against all the music personnel who had been absent from their posts during the capture of the city on September 13, 1936: abandoning one's post supposedly meant disaffection toward the new regime. The Municipal Commission for Promotion, on which the personnel were dependent, carried out the inquiry, and the director of the band and of the conservatory, Regino Áriz, as well as the assistant director and archivist, Felix Sistiaga, were called to testify. As a consequence of the proceedings, on December 19, 1936, the council decreed the dismissal of the absent forty-five music employees: forty-three belonged to the music band, four to the conservatory (three of them were also members of the band), and one to the *txistu* band; most were sympathizers of the political left, with only two musicians being supporters of Basque nationalism.[292]

Subsequently, employees who remained at their posts after the conquest of the city were investigated, a process completed in the first semester of 1938. Responsibility for this also fell to the Commission for Promotion. Reports on each employee were requested from a special service of the police created for the purpose. Those for whom no offense was found were eliminated from the investigation, and a file was opened for those employees for whom a considerable accusation already existed: the affected were asked to fill out a questionnaire about their political opinion and political and union affiliation and to present support for their declarations; they were given sheets of the charges and a time to answer the charges; moreover, people

---

[291] See Itziar Larrinaga, "*Dura lex, sed lex*. La depuración franquista en las instituciones dependientes del Ayuntamiento de Donostia-San Sebastián (1936–1937)," in *Music and Francoism*, ed. Gemma Pérez Zalduondo and Germán Gan Quesada (Turnhout: Breepols, 2013), 127–56.

[292] Ibid., 130–33.

who knew the employees were called to testify about their conduct and background.[293]

As a result of the process and despite having filed dossiers against eight musicians, only one was penalized—an employee of the Finance Commission integrating his post as *txistulari* with that of collector in the tax office—for his attraction to Basque nationalism. He was relieved of his post and salary for three months. However, the Ministry of Nation at Education, equally responsible for the purging of employees working in educational centers, penalized three other teachers at the conservatory, disqualifying them from holding directorial and trustworthy positions in cultural institutions, and two of the teachers were relieved of their posts and salary for three and six months respectively.[294]

All in all, comparing this with that happened in the first phase of the proceedings, we could say that this was a benevolent purge, as the president of the Council for Promotion noted when referring to the purging done by the Finance Commission: he thought it guided by "a Christian and very humanitarian sensibility" in order to "sweeten the situation of those employees on whom weighed certain charges" and to try "to avoid administrative disruption."[295] Despite this, the music band broke up on August 3, 1938, after two years of fruitless substitution for the 63 percent of the staff that had already left in 1936.

The City Council of Bilbao agreed to relieve employees of their work and salary on June 21, 1937, two days after the capture of the city; likewise, it forced them to remain at their posts and to apply for reinstatement in a fixed deadline of forty-eight hours; later it "ordered the initiation of an individual dossier of

---

[293] Ibid., 135–38.

[294] Ibid., 138–39.

[295] *Libro de Actas del Ayuntamiento Pleno,* Municipal Archive of Donostia-San Sebastián, A-01/L-617. Cited in Larrinaga, "*Dura lex, sed lex,*" 137.

purging for all those applying, in which the individual's political and social comportment would be analyzed, agreeing in the end to his definite dismissal or reintegration to the staff."[296] Three musicians in the band of *txistularis* did not reapply within the stated timeframe and were immediately dismissed.[297]

Members of the band, although not really employees, were also purged. At least nine of them requested reinstatement;[298] however, the city council, after having called the conductor Jesús Arámbarri to testify and inquiring about thirteen musicians, ordered the dissolution of the band on August 25, 1937. To do so, it relied on the authority given to it by article 19 of the band rules that established, moreover, that personnel could not oppose this or make any complaint: the principal motive, it contended, was that the group did not actually exist, either because there were some musicians who had managed to swell "the numerous bands of the militias that had been created during the dominance of the red-separatist faction" or because they belonged to the recently created band of the Falange Española Tradicionalista y de las Juntas de Ofensiva Nacional Sindicalista (Traditionalist Spanish Phalanx and of the Councils of the National Syndicalist Offensive, FET de las JONS).[299]

However, on November 20, the Purging Committee of Bilbao readmitted Jesús Arámbarri "without sanctions and with all due rights."[300] This is significant, since, as conductor of the Bilbao Symphony Orchestra, he had participated with this group

---

[296] Ipiña, *La depuración y represión franquista*, 58.

[297] "Destitución de varios individuos de la Banda de Tamborileros," Municipal Archive of Bilbao, 1939-563_9-S-1937.

[298] Archive of the Bilbao Symphony Orchestra, Box 332.

[299] "Acuerdo de disolución de la Banda Municipal de Música," Municipal Archive of Bilbao, C-14210/030.

[300] "La Comisión Depuradora Municipal acuerda la readmisión de Jesus Arámbarri," Municipal Archive of Bilbao, C-014259/004.

after the outbreak of the war in all the concerts that were performed specifically for the benefit of the Department of Social Assistance of the Basque government, which was charged with helping refugees; he was also involved in the concert to collect money for the Air Force of the Basque government, and also during the sixth Aberri Eguna or Basque national day organized by the youth organization of the Basque Nationalist Party (Juventud Vasca) and on the Komsomol Day of the youth organization of the Communist Party. This was the last performance of the orchestra on April 4, 1937, until the gala concert of February 25, 1939, at which the new Bilbao Municipal Orchestra and Band had its debut.

The modernity implied by this formula of fusion and city takeover of both entities has been highlighted and was followed by other cities like Valencia, Barcelona, and A Coruña;[301] yet only recently has anyone called to mind the savage proceedings of purging this caused.[302] Article 43 of the approved regulations acknowledged that all the teachers of the dissolved municipal band and of the Bilbao Symphony Orchestra would join it, but "only if in the judgment of the Governing Board the musicians were worthy of belonging to the New Group according to their moral and political conduct."[303] For this, the petitions needed to be accompanied, among other documents, by the same sworn testimony that the city employees had to fill out during the purging proceedings. We are able to present numbers for the

---

[301] Carmen Rodríguez, *Banda Municipal de Bilbao. Al servicio de la villa del Nervión* (Bilbao: Ayuntamiento, 2006), 80; Joseba Berrocal, "La Orquesta de Bilbao entre 1939 y 1980: el periodo central," in *Ochenta años de música urbana*, ed. Carmen Rodríguez (Bilbao: BBK, 2002), 153–54.

[302] Joseba Lopezortega, "La condición humana en el espejo de la BOS," *Hermes* 59 (2018), 70–76.

[303] *Reglamento de la Orquesta y Banda Municipal de Bilbao* (Bilbao: Escuelas Gráficas de la Sta. Casa de Misericordia, 1939).

municipal music band: in accordance with the rosters of 1937 and 1939, only twenty-two musicians (40 percent) entered the new group. Of the thirty-three musicians who remained outside (60 percent), Arámbarri testified about eleven (33 percent) in 1937.

It is important to emphasize that the purging affected not only public employees. The case of Fernando Remacha is well known. His 1924 string quartet received the National Music Prize in 1938, becoming "without planning for it beforehand . . . a symbol of republican resistance."[304] During the war, Ricardo Urigoiti delegated to him and to another person of trust the responsibilities as directors of the Filmófono movie corporation, for which Remacha had been working since 1929. In 1940, the composer underwent a purging procedure undertaken by the corporation's administrative council, and as a consequence he was fired; the thought was to send him to Argentina to work with Urigoiti who feared returning to Spain and had established himself there.[305] Remacha withdrew to Tutera (Tudela) in Navarre for eighteen years, where he worked in the family hardware store until 1957, when he was appointed director of the newly founded Pablo Sarasate Conservatory of Pamplona-Iruñea. His is a notable example of what has been called "interior exile."[306]

Another case worth highlighting is that of Pablo Sorozabal, composer of popular zarzuelas like *Katiuska* (1931), *La del Manojo de rosas* (1934), and *La Tabernera del Puerto* (1936), whose dossier for purging was in the hands of the Special Court for the Press, which had condemned the poet Miguel Hernandez to death. Thanks to the mediation of the librettist Federico Romero and Eduardo Marquina, the president of the General Society of Authors and Editors, the dossier was

[304] Marcos Andrés, Fernando Remacha. El compositor y su obra (Madrid: ICCMU, 1998), 122.

[305] Ibid., 122.

[306] Miguel Salabert, Interior Exile (New York: Simon and Schuster, 1961).

commission of this organization. Sorozabal was acquitted in 1939 with "the reservation of disqualifying him from performing directorial positions and those of confidence in said organization." This caused uproar among his enemies, who later would get even with the author for his republican complicity.[307] He was able to continue his profession in Madrid, where in 1945 he was appointed titular director of the philharmonic orchestra, a position he resigned from in 1952 because of a disagreement over the censorship of a concert that included Shostakovich's Seventh Symphony and his piece *Victoriana*.

The purge also took place among nonprofit organizations, like the Orfeón Donostiarra. On September 25, 1936, the Directive Council removed from that choral society ninety choral singers who had left the city. It also approved the obligation that they reapply through a printed form that asked about their disposition toward the "Glorious National Movement." This agreement was ratified on September 22, 1937, after the fall of Bilbao, foreseeing that many of the choral singers would seek to be readmitted without a "previous purging"; in this way, according to the director Juan Gorostidi, the Orfeón had "patriotically fulfilled its obligation to inspect and purge its members. All the choral singers presently members of the society are constantly giving proof of their Spanishness and Catholicism," he affirmed.[308]

---

[307] Javier Suárez-Pajares, "Pablo Sorozábal, Tomás Luis de Victoria y la séptima de Shostakovich," in *Estudios. Tomás Luis de Victoria. Studies*, ed. Javier Suárez-Pajares and Manuel del Sol (Madrid: ICCMU, 2013), 555–79.

[308] "Informe que la Dirección presenta sobre anulación de los acuerdos de Junta Directiva correspondientes a sus reuniones de 25 de septiembre de 1936 y 22 de septiembre de 1937," in Carmen de las Cuevas, "El Orfeón Donostiarra 1897–1997: Proyección social, cultural y educative," annex 16, PhD diss., Universidad del País Vasco (UPV-EHU), 1999.

However, Gorostidi echoed "certain inconveniences arising outside of the choral society, by some of his members" and, paying attention to the fact that the ex-singers had already been subject to a "police purging" in their working environment, proposed to the Directive Council a review of the situation "abounding in the spirit of Circular No. 75 of September 8, 1939, of the General Secretary of the FET y de las JONS asking to put into practice the motto 'glory to the victor and mercy for the defeated'"; consequently, the council agreed to revoke the obligation of filling out the form and stated that one could ask for readmission through a document sent to the president that would be resolved according to what was appropriate in each case.[309]

However, this measure came too late for many of the ex-choral singers. One of them asked after some time had passed: "Would the Easo Chorale have been formed if many of those belonging to it could have been readmitted easily to the group they had participated in before the conflict, the Orfeón Donostiarra, without being submitted to a stupid and incomprehensible discrimination?"[310] Of the ninety choral singers who left the city because of the Civil War and were expelled from the Orfeón Donostiarra (fifty-nine men and thirty-one women), sixty-four returned to Donostia-San Sebastián (thirty-eight men and twenty-six women), and thirteen reintegrated into the Chorale (two men and eleven women).[311] Many of the remaining men in 1940 founded the Easo Chorale for bass voices, which was under the tutelage of the Organization for Education and Leisure that was dependent on the Spanish Union Organization.

---

[309] Ibid.

[310] "Así nació el Coro Easo. Recordando sus inicios al celebrar el 70 aniversario," *Ahots batez* 10 (2009), 32–34.

[311] "Informe que la Dirección presenta."

The purging for accountability affected religious orders as well like the Capuchins and Carmelites. We should mention an incident that happened in the Capuchin School of Nuestra Señora del Buen Consejo in Lekaroz, Navarre, since it directly affected Father José Antonio de Donostia (Aita Donostia). In October 1936, twenty priests and three friars were sent to new destinations, including the following musicians: Father Donostia to Toulouse, Father Jorge de Riezu to Argentina, and Father Hilario and Agustin Olazarán to Chile. According to the superiors, this purge was due to military pressure; however, the priests and friars of the school gave witness that the purge came from within the order itself.[312]

Father Donostia was at first assigned a convent in Salamanca and asked to be sent "to some French convent, alleging that in Spain he feared for his life"; even so, the opinion spread that "he asked as a favor to go over the Pyrenees because there he would enjoy the same Basque climate."[313] His request was granted. However, the sudden change of destination sank him, with the passing of time, into a deep crisis of faith. In May 1941, he "felt his Capuchin vocation fall apart and amid great psychic suffering was about to request the annulment of his religious vows." He overcame his depression by composing the Motet *O Jesu Mi Dulcissime*, with the text in Latin, by which he reaffirmed his vows.[314]

In 1943, Donostia was able to return to Lekaroz and the following year he moved to Barcelona as a result of being appointed as a collaborator to one of the principal music organizations of the regime, the Institute for Musicology of the

---

[312] Eulogio Zudaire, *Lecároz. Colegio "Nuestra Señora del Buen Consejo" (1888–1898)*. (N.p.: N.p., 1989), 203.

[313] Rufino Mª Grández, *El asunto vasco en nuestra provincia capuchina de Navarra-Cantabria-Aragón. Datos para una reflexión*, unpublished ms. (Burlada, 1981).

[314] José Luis Ansorena, *Aita Donostia* (Donostia: Kutxa, 1999), 105–6.

Superior Council of Scientific Investigation, in which he could undertake his research until 1953, on a modest salary, in the setting of the folklore division, directed by the prestigious German ethnomusicologist Marius Schneider.

## Exile

Up to now we have dealt principally with those musicians who stayed in the country, but there were many who found themselves forced to go into exile due to the Spanish Civil War. However, it is not possible to know exactly how many Basques had to leave the country and, much less, how many musicians were among them: added to the inaccuracy of the sources is the fact that some people left the country several times.[315] One case that mirrors these movements of coming and going is that of the young composer Francisco Escudero who, having been a corporal in the Basque Army, crossed the border with the fall of Gipuzkoa and sought refuge in Auch and Éauze (Le Gers); he returned to the conflict again in March 1937 and secretly joined the Aralar Battalion of the Basque Nationalist Party; then he left permanently for France in July of that year, when Bizkaia was overtaken by the Francoist faction. His String Quartet in G is an autobiographical testament to the impact of the war on his life, the narrative key of which has recently been disclosed.[316]

In the institutional sphere we must mention the suspension of activities of Eusko Ikaskuntza, the Society for Basque Studies, with the resulting rupture of its intense musical

---

[315] De la Granja, de Pablo, and Rubio, *Breve historia de Euskadi*, 203.

[316] Itziar Larrinaga, "Cuarteto en sol de Francisco Escudero (1936–1937): ¿un programa secreto?" in *The String Quartet in Spain*, ed. Christiane Heine and Juan Miguel González (Bern: Peter Lang, 2016), 627–54.

life before the war.[317] Many of its members went into exile, among them the aforementioned Father Donostia, president of the society's Music and Dance Section since 1926. During his stay in France, Donostia thought about the activities that the section should continue to develop, both in the area of traditional music and in that of historical music. However, except for the two Congresses of Basque Studies held in Biarritz and Baiona (Bayonne) (France) in 1948 and 1954, it was not until 1978, with the transition to democracy, that the Society for Basque Studies was able to again resume its activities.

Eresoinka, the so-called Basque cultural embassy,[318] also merits special attention. It was a key piece of the propaganda framework of the Basque government, created by the express order of the *lehendakari* José Antonio Aguirre in August, 1937, after the loss of Bizkaia: "it wasn't for this that our spirit had died to others," he recalled in his memoirs. "We wanted to show from abroad how the Basque soul had been sacrificed for the sake of totalitarianism, a concept that was threatening to invade humanity, so we organized newspapers, magazines, and theater performances."[319]

It has been shown that the largest expenditure for propaganda of the Basque government-in-exile was assigned to maintain the chorus (and later dance company as well) Eresoinka.[320] The *lehendakari* himself indicated, in a letter in which he entrusts to Gabriel Olaizola the creation of the organization

---

[317] See Jon Bagüés and Itziar Larrinaga, "Eusko Ikaskuntzaren lana musikaren arloan (1918–1936 eta 1979–2013)." In *Euskaldunon mendea. Eusko Ikaskuntzak 100 urte*, ed. Juan Aguirre (Donostia: Eusko-Ikaskuntza, 2018), 280–86.

[318] José Antonio Arana, *Eresoinka-Embajada Cultural Vasca 1937–1939* (Vitoria-Gasteiz: Gobierno Vasco, 1986).

[319] José Antonio Aguirre, *De Guernica a Nueva York pasando por Berlín* ([Bilbao]: [Ekin], 1992), 61.

[320] Santiago de Pablo, *Guerra Civil, cine y propaganda en el País Vasco* (Madrid: Biblioteca Nueva, 2006), 104.

that, "in its preparation and debut nothing is to be spared. Managers, music critics, maestros, orchestra conductors, etc. Everything must be properly promoted. . . . My hope is that our chorus be the best that the select audiences of Europe and America have ever heard."[321]

We should note that music was one of Aguirre's "most loved hobbies," a fondness he had received from his family. He could play the violin and the flugelhorn, had a great love for vocal music (he was a baritone soloist in the Algorta chorus), and was an avid music-lover.[322] In his memoirs he highlights his personal conviction that "only by singing can we spread spiritual seeds."[323] This helps explain his personal involvement in Eresoinka and the mission he left in Olaizola's hands: to translate "the battle . . . to the artistic arena" and communicate to the world "through our melodies the memory of a nation that is dying defending liberty, because in foreign lands they still do not know that one does fight for liberty . . . Propaganda, of course, using propaganda to defend liberty."[324]

The *lehendakari* held the conviction that in singing the principal theaters and halls of France, Belgium, Holland, and England "the Basques would announce to the world that the same brute force which had banished from Euskadi those most beautiful songs, was capable of sealing the lips of those nations which considered themselves safe."[325] The Basque government, with these measures of propaganda, sought to move those

---

[321] Carta-Mandato de José Antonio Aguirre a Gabriel Olaizola para la creación del Coro Nacional Vasco. In Arana, *Eresoinka*, 59.

[322] José Antonio Rodríguez Ranz, "Madera de líder," in *La política como passion. El lehendakari José Antonio Aguirre (1904–1960)*, ed. Ludger Mees (Madrid: Tecnos, 2014), 28.

[323] Aguirre, *De Guernika a Nueva York*, 61.

[324] Ibid.

[325] Ibid., 61–62.

likeminded European governments to favor the Republican cause. However, those governments remained neutral in the Spanish conflict, although they soon entered into World War II. With the perspective of time, Aguirre grew disillusioned, as he stated that "the message of our artists was heard but not understood by many of those who would become victims of new invaders, the Nazis."[326]

The Eresoinka repertory included scenes and folkloric interludes inspired by an idealized tradition, harmonizations of traditional Basque songs, classical polyphonic works, and dances from Bizkaia and Gipuzkoa. The directive board of Eresoinka, endorsed by Aguirre, was presided over by the politician Manuel de la Sota. The other members were the musicians Gabriel Olaizola, representing the Basque National Chorus; Enrique Jordá, as artistic director; the *dantzari* (dancer) Jesús Luisa Esnaola, on behalf of the dance groups; and the painters Antonio Guezala, for staging and scenery, and José Maria Uzelai, the commissioner of fine arts. Other notable figures included the musician and choreographer José Uruñuela, who belonged to the technical staff of Eresoinka up until its performance in the Sala Pleyel in Paris and then moved to the group of children's dancers, Elai-Alai, founded in 1927 in Gernika by Segundo Olaeta, who also negotiated with the Basque government for the continuity of the company in exile; and the *txistulari* Jon Oñatibia, who was later appointed delegate of the Basque government in New York after the disappearance of Jesús Galindez in 1956.

The most direct antecedents of Eresoinka were, on one hand, the Eusko Abesbatza Chorus, founded by the same Olaizola in 1931 and allied to the Basque Nationalist Party, in whose headquarters in Donostia-San Sebastián they rehearsed; and, on the other hand, the entity responsible for the staging of

---

[326] Ibid., 62.

Basque folklore, Saski Naski, also from Donostia-San Sebastián, which was formed in 1928 and in 1929 performed with great success in the Champs-Élysées theater in Paris; the aforementioned Juan Gorostidi was a board member on the directive board of this organization led by Antonio Orueta. Because of the massive Basque exodus to France, Olaizola saw the "necessity and opportunity" to continue the project of the chorus in the neighboring country, an idea that caught on with the *lehendakari*[327] and ended by acquiring a larger dimension including dance groups, staging, and scenery.

Although the Eresoinka activity ended in the summer of 1939, a little before the outbreak of World War II, Saski Naski reappeared four years later in Buenos Aires: its debut was held at the Teatro Victoria there on July 12, 1943, under the artistic direction of Luis Múgica. Half of the Basque scenes performed echoed the first performance of Saski-Naski in Donostia-San Sebastián, and the first scene was the *Agur Jaunak*, the greeting with which Eresoinka began its performances.[328] Other shows followed thereafter, like that of August 5, 1946, in the Teatro Presidente Alvear, in which all the tickets were sold out. This led to a repeat performance on August 26 of the same year, and many different shows throughout Argentina and Uruguay, the group having been invited by the Euskal-Etxeak or Basque Centers. It is important to highlight that Father Jose Antonio de Madina composed original music and made musical arrangements for the new Saski-Naski. Madina had been assigned to Argentina by his Lateran superiors in 1932 and followed the course of the Civil War from there, where he had close contact with Basque exiles.

---

[327] Arana, *Eresoinka-Embajada cultural vasca*, 60.
[328] Imanol Olaizola, "Concierto en tres tiempos," *Musiker* 15 (2007), 232.

## Musical Activity during the Autarky

The idea that the Civil War era was culturally barren is a errant myth.[329] The study of texts on musical themes in newspapers of various cities ruled by the Francoists during the Spanish Civil War, among them Donostia-San Sebastián, Bilbao, and Vitoria-Gasteiz, has emphasized the contrast between the wide range of leisure offerings, including music, and the background of the war.[330] It is fitting to note, for example, that the vast cultural offerings before the war in Donostia-San Sebastián, a tourist destination fashionable among the aristocracy and upper classes, did not decline but actually increased during the war. The atmosphere of cultural vitality helped the city, among other factors, to be selected as headquarters of the Spanish Institute between 1937 and 1939. This institute was made up of six academies, including the Academy of Fine Arts of San Fernando, and the city would become a sort of "cultural headquarters for the Francoist regime."[331] In the summer of 1939, with the war over, the first edition of the Donostia-San Sebastián Musical Fortnight took place; it is now the oldest festival in the Spanish state.

A study of the press allows us as well to underscore the importance of music in Francoist propaganda: "writings in the music fields are very present in the clamor of discourse about the war, in the embarrassing statements designed to justify and exalt the war, to spread the announcements that helped explain the

---

[329] Iván Iglesias, "De 'cruzada' a 'puente de silencio': mito y olvido de la Guerra Civil española en la historiografía musical," *Cuadernos de música iberoamericana* 25–26 (2013), 188.

[330] Gemma Pérez Zalduondo, "'Elogio de la alegre retaguardia': La música en la España de los sublevados durante la guerra civil," *Acta musicológica* 90, no. 1 (2018), 78–94.

[331] José Ángel Ascunce. *San Sebastián, capital cultural (1936–1940)* (Zarautz: Michelena, 1999), 16.

New Spain, which convey the new styles and conduct, and which seek to uplift the spirit of backward folk."[332] At the same time, this study allows us to state that music formed another element of the "propaganda about the normality of daily life, a fundamental idea during the conflict both inside and outside Francoist Spain."[333]

In the same way, the press of the time emphasized the importance of music in diplomacy.[334] For example, on the occasion of the visit of the Nazi German ambassador to Spain, Wilhelm Faupel, the provincial government of Gipuzkoa organized on August 7, 1937, a gala concert to honor his wife; for this, the Victoria Eugenia theater of Donostia-San Sebastián displayed the Nazi swastika alongside the Spanish flag. The repertory was made up by Spanish and German composers: it included in the first part a revival of the zarzuela in one act *La patria chica* by Ruperto Chapí, in which the Orfeón Donostiarra took part; the second part was a recital by the singer Carlota Dahmen-Chao, accompanied on the piano by the pianist from Vitoria-Gasteiz, Francisco Cotarelo; and a third choral part by the aforementioned choral society.

The sources for the press have allowed us to document "the process of appropriation of composers, instruments, and repertory for the new official discourse."[335] The predilection for Spanish and German works referred to can be seen also in the programs of the Bilbao Municipal Orchestra. Comparing, for example, the programs of 1936 and 1937 with those of 1939, we find during this latter year a notable predominance of works by

---

[332] Gemma Pérez Zalduondo, "La música en la prensa de la España nacional durante la guerra civil española (1936–1939)," in *Music Criticism 1900–1950*, ed. Jordi Ballester and Germán Gan Quesada (Turnhout: Brepols, 2018), 41–69.
[333] Ibid., 42.
[334] Ibid.
[335] Ibid.

German and Spanish composers; among the latter Manuel de Falla stands out and, particularly, Joaquin Turina. Although a work by Arámbarri and *Marina* by Emilio Arrieta were programmed—the latter during the opera season organized in June 1939 within the commemorative celebrations for the "liberation" of the city by the Francoists—the contrast with the years 1936 and 1937 is significant, years in which practically in all the programs a work by a Basque composer was included. Among the 1939 concerts, that which took place in the lamination workshop of the Altos Hornos de Vizcaya company stood out, held within the new cycle "Joy through work." This short-lived idea was to bring the efforts of the orchestra to the working class according to the model of Nazi Germany: likewise, the establishment of the "popular concerts of sacred music" by the Bilbao Municipal Orchestra is noteworthy.

Later, in the programs of 1940, 1941, and 1942, the repeated programming of works by Jesus Guridi stands out. It should be emphasized that "he was one of the most programmed composers from official requests right after the war."[336] Guridi had been a professor at the Madrid Conservatory since 1927. In 1941 he was appointed a member of the General Council of Music. His opera *Amaya*, performed at the aforementioned sixth Aberri Eguna by the Bilbao Symphony Orchestra, was also included in performances of Spanish music that took place in Nazi Prague during 1940, along with *el amor brujo* and *el sombrero de tres picos* by Falla; likewise, Guridi's compositions were regularly included in the programs of the delegations of the Vicesecretariate of Popular Education, the principal entity for spreading the ideological model of the FET up until 1945.[337]

---

[336] Gemma Pérez Zalduondo, "El imperio de la propaganda: la música en los fastos conmemorativos del primer franquismo," in *Discursos y prácticas musicales nacionalistas*, ed. Pilar Ramos (Logroño: Universidad de La Rioja, 2012), 357.

[337] Ibid., 357.

As a composer, he took advantage of folklore as material for musical compositions—a theme approached in his speech on entering the Royal Academy of Fine Arts of San Fernando in 1947—that was suitable to show the richness and variety of the nation's folklore. He was "a counterpoint to the obvious Andalusian character of the other composers programmed like Turina" and was "very convenient at the moment when [national] unity was defined musically through the totality of regional 'folklores'."[338]

It is evident that Basque folklore was reinterpreted by Francoism.[339] An editorial in the *Voz de España* of Donostia-San Sebastián illustrates this point very well when it thanks Franco for spreading the hymn "Gernikako Arbola" once Bilbao was taken and states: "we are Basques, as Spaniards and within Spanish unity we wish to commit our all, absolutely our all-costumes, dances, traditions, languages, ancient laws, and the *Guernikako* [sic] *Arbola*. Everything typically ours, everything we have ever had, from much before separatism was born."[340] To understand these words better, we must remember that Basque Carlism fought on the Francoist side; as a conservative party, it also considered itself the guarantor of the traditions that Basque nationalism claimed for itself. According to Carlism, Franco made possible the recuperation of the "purity" of Basque traditions, which in the end would show itself devoid of the tag "separatist": "The *Guernikako* [*sic*] *Arbola* sleeps comfortably in the shade of the Spanish flag," the editorial concludes.[341]

---

[338] Ibid.

[339] Pérez Zalduondo, "'Elogio de la alegre retaguardia'," 91.

[340] Cited in ibid.

[341] Cited in ibid. It should be highlighted that in Navarre, Basque traditions were silenced in favor of those that were considered as properly Navarrese. The proclamation on September 25, 1936 by the military commander, Ricardo Sanz Iturria, is well known. It banned use of the word *agur* (goodbye) and requested

All of which explains the great success at the time of the *Diez melodías vascas* by Jesus Guridi that premiered in 1941; and the concert for piano and orchestra by Francisco Escudero, called the Basque concert, which received a secondary National Music Prize in 1947 and was widely diffused by Ataúlfo Argenta; genres like the Basque scenes and interludes—which exported Eresoinka and Saski-Naski—were also successful in the postwar Basque Country, and indeed at a later date works like the oratorio *Illeta* and the opera *Zigor* by Francisco Escudero would have great social success. These will be discussed below.

And lastly, we should in this chapter deal, if only briefly, with the Basque contribution to Francoist anthems. Composers like Juan Telleria, Francisco Cotarelo, and Nemesio Otaño, among many others, helped in praising the armed forces of the regime as well as the dictator. On February 28, 1937, decree 226 was published establishing the "Marcha Granadera" as the national anthem, which was the well-known "Marcha Real," the national anthem since the eighteenth century, except for the time of the Liberal Triennial and the First and Second Republics. The decree declared that the anthems "Cara al sol" of the Falange Española, "Oriamendi" of the Carlist movement, and "La Legión" would be "national songs."

Juan Telleria originally composed the music for the anthem "Cara al sol" in 1934 with the title "Dawn in Cegama." This composer created as well the *Himno de las Falanges Juveniles de Franco* and the *Canto de la División Azul*. In like manner, Francisco Cotarelo and Nemesio Otaño wrote, respectively, the anthems *El Caudillo* and *Franco! Franco!*, both in honor of the head of state. Otaño, moreover, played an important role in maneuvering the

---

in a period of 48 all objects and garments of a separatist nature, including *txistus* (Basque flutes), which he branded as "an unknown and imported exotic plant revealing all to us."

propaganda deployed by Franco to have the *Marcha Granadera* accepted as the national anthem; at first the Falange had rejected this in favor of *Cara al sol.*

As Otaño explained to Juan Gorostidi, the head of state wished "that one come to an opinion and that the decision about the national anthem fall spontaneously to the request of the majority"; for this, Franco charged him to provide "all types of guiding facts from articles in the press and from conferences."[342] With the purpose that the conferences-concerts that he designed would not be understood for what they actually were, "a shameless propaganda exercise over the anthem," Otaño outlined "an historic review of military marches, from the Middle Ages up to the nineteenth century"; the *Marcha Granadera* completed "this journey as an "historic milestone," thus confirming, according to Otaño, "its purely military aspect and relegating to a secondary level its Borbonic history and naming as *Marcha Real.*"[343] The event ended with a "shameless act of proselytizing in favor of the person of General Franco. So that, together with the *Marcha Granadera,* Otaño kept the last moments of the evening event to play the notes of the anthem *Franco! Franco!* he composed in honor of the dictator in 1936.[344] The Orfeón Donostiarra participated in the musical entertainment of the conferences; likewise, in a similar manner as the Orfeón Pamplonés, recorded various Francoist anthems on the Columbia Label, which had been established in Donostia-San Sebastián in 1923.

---

[342] Letter from Nemesio Otaño to Juan Gorostidi, December 12, 1936. Orfeón Donostiarra Archive, box 23, correspondence 1936. Cited in Igor Contreras, "El eco de las batallas: música y guerra en el bando nacional durante la contienda civil española (1936–1939)," *Amnis. Revue de civilisation contemporaine Europes/Amériques* (online journal) 10 (2011), 5.

[343] Ibid., 6.

[344] Ibid., 7.

Otaño was very well compensated for his contributions and was appointed, at the end of the war, a member of the General Commission of Music and director of the Madrid Conservatory, besides being president of the aforementioned General Council of Music, all positions of great trust. We could note that he was one of the most powerful people in the area of national music up until the political opening up of the 1960s.

## The Political Opening Up of the 1960s

The postwar political stagnation began to change throughout the 1950s, years in which structural reforms were made and industry was stimulated; in the Basque Country the cooperative movement of Mondragón stands out; this work of Father José María Arizmendiarrieta, which involved the opening of cooperatives like Ulgor (Fagor) in 1956.[345] Such movements also encouraged the creation of new musical institutions in the form of workers' cooperatives like the Donostia-San Sebastián city band, which was created in 1961 and which failed to fill the gap created by the breaking up of the municipal band in 1938.

In the realm of music we also see a certain transformation as early as the 1950s. For example, the Iparraguirre Prize of the provincial government of Gipuzkoa was awarded in 1953 to the oratory *Illeta* by Francisco Escudero, who was at the time professor of harmony and composition at the Conservatory of Donostia-San Sebastián, and later its director between 1962 and 1980. The work, written from an elegiac poem *Biotzean min dut* (My heart suffers) by Xabier Lizardi, who died in 1933 and was a preeminent personality in the Basque Nationalist Party of Gipuzkoa. He was considered by plastic artists like Jorge Oteiza a true example of the new "Basque renaissance"—in the 1960s, this new

---

[345] De la Granja, de Pablo, and Rubio, *Breve historia de Euskadi*, 215–16.

"Basque renaissance" had an important echo through what was known as the new Basque song, especially with the group *Ez dok amairu*, composed of Mikel Laboa, Lourdes Iriondo, Benito Lertxundi, and Xabier Lete, among others: "that was the greatest emotion in my life that I felt like a Basque artist," Oteiza pointed out after first hearing the work.[346] Nestor Basterretxea made the graphic illustrations for the programs of *Illeta*.

His success aided the recently established Bilbao association of friends of opera to commission from Escudero the opera *Zigor!* in 1957. Basque nationalist imaginary was evident in the libretto in Euskara by Father Manuel Lekuona and the composer himself; for example, reference is made to seven "Euskalerrias," daughters of the same mother, alluding to the Basque nationalist motto "Zazpiak bat."[347] This seems to indicate that the work was considered inoffensive at a time when the regime was already secure, and the opera was understood simply as folklore;[348] if this were not so, we cannot explain how the work could have escaped censorship, considering as well that Escudero was at the time director of the municipal conservatory and, as such, a person of trust for the city government of Donostia-San Sebastián. The opera debuted in concert form in the Coliseo Albia of Bilbao in 1967. It was immediately presented in all the Basque capital cities and in Madrid, and it was performed for the first time in the Teatro de la Zarzuela of Madrid in 1968 within the opera festival of the city.

---

[346] Letter from Jorge Oteiza to Francisco Escudero, Orio, Gipuzkoa, August 10, 1955, Escudero Family Archive.

[347] See Itziar Larrinaga, "Francisco Escudero y la música de escena: su primera ópera, *Zigor!*" in *La ópera en España e Hispanoamérica*, ed. Emilio Casares and Álvaro Torrente, vol. II (Madrid: ICCMU, 2002), 413–22.

[348] Ángel Medina, "Itinerarios de la Ópera española tras la Guerra Civil," in *La ópera en España e Hispanoamérica*, ed. Emilio Casares and Álvaro Torrente, vol. II (Madrid: ICCMU, 2002), 381.

After the premiere, the composer received the personal congratulations of the Information and Tourism Minister, Manuel Fraga Iribarne, for the composer's contribution to Spanish opera. In the Basque Country, *Zigor!* was considered a Basque opera, and in Madrid as a Spanish opera. Fraga Iribarne took on the title of minister in 1962, a position he held until 1969 and in which he made a notable effort to spread through propaganda not only the wager but also the opening up of the regime in the cultural field. Concerning music, we should mention at least three of the events that happened in what was termed the "opening up of 1964":[349] the "Concierto de la Paz," the Biennale of Contemporary Music, and the First Festival of Music from the Americas and Spain. These put "in the open the official attempt to promote some of the names and trends of the vanguard,"[350] among which we find the Basque composers Luis de Pablo and, to a lesser degree, Carmelo Bernaola.

Let us pause briefly on the first of these composers. Luis de Pablo had been head of the music section of the magazine *Acento Cultural,* published by the Spanish university union (Sindicato Español Universitario, SEU) and established by the Falange. Between 1960 and 1963, he was also president of Juventudes Musicales de Madrid and director of the distinctive concert series "Tiempo y Musica," which was dependent on the SEU and later on the National Service of Education and Culture. He continued this work through the music forum, within the national service and, above all, from 1965 until 1973, with the series of concerts and the Studio Alea—considered the first

---

[349] Ángel Medina, "Primeras oleadas vanguardistas en el área de Madrid," in José López Calo et al., *España en la música de Occidente,* vol. 2 (Madrid, INAEM, 1987), 381.

[350] Daniel Moro, "En torno a Carmelo Bernaola y la música de vanguardia," *Euskonews* (online journal) 718 (2017).

laboratory of electro-acoustic music in Spain—thanks to the sponsorship of the Navarrese businessman Juan Huarte.[351]

In 1963 Luis de Pablo was invited to participate in the sumptuous concert of June 16, 1964, organized to commemorate the twenty-fifth anniversary of the Franco regime and titled "Concierto de la Paz", to be broadcast on radio and television.[352] According to his biographer's account, this caused a "conflict within himself," both because of his strong beliefs against the regime and also because of his need to be recognized by it in order to carry out his artistic work: he feared that a rejection of the assignment could affect the course of his professional life.[353] De Pablo solved the problem by offering his work *Tombeau* for the occasion, which had already premiered at the Reconnaissance Festival of New Music in Brussels. He changed the title to *Testimony* and rejected any payment for the work. The program also included commissions from Cristóbal Halffter, who had recently been appointed director of the Madrid Conservatory, and Miguel Alonso, a work by Ángel Arteaga, which won the International Prize for Composition of the Ministry; and fragments of *La Atántida* by Manuel de Falla. The performance was in the hands of the Spanish National Orchestra and the Orfeón Donostiarra under the direction of Rafael Frübeck de Burgos.

The concert as a whole aimed from the very beginning at eclecticism. The participation of Joaquin Rodrigo, Xavier Montsalvatge, and Oscar Esplá was requested, although they

---

[351] Ángel Medina, "Primeras oleadas vanguardistas," 394–95.

[352] See Igor Contreras, "Three Commissions to Celebrate 25 Years of Francoism," in *Composing for the State: Music in Twentieth-Century Dictatorships*, ed. Esteban Buch, Igor Contreras Zubillaga, and Manuel Deniz Silva (Abingdon, Oxon.: Ashgate, 2016), 168–85.

[353] José Luis García del Busto, *Luis de Pablo* (Madrid: Espasa Calpe, 1979), 52–53.

excused themselves by one means or another from participating. And, in a sense, it also aimed at depoliticization. In the program it was noted that no specific program was imposed on the composers, but that they were asked, nevertheless, that the works correspond in context and intention to what was being celebrated. However, even today, "it is difficult to dissociate the musical works from the political events around them. . . . The *Concierto de la Paz* seems to be there to remind us that in fact an apolitical position is, in certain conditions, a very clear political statement."[354]

Indeed, as happened in the plastic arts with people like Eduardo Chillida and the aforementioned Oteiza, from the 1960s on the state used avant-garde music to reflect and export ideas of progress and opening up. Besides the already mentioned "Concierto de la Paz" in 1964, the state supported the International Biennale of Contemporary Music, in which were chosen, among other works, the piece *Espacios variados* by Bernaola, which was performed at the closing concert along with the already mentioned work *Testimonio* by Luis de Pablo, and *Atmosphère* by Ligeti; it also supported the First Festival of Music from the Americas and Spain, in which *Mixturas* by Bernaola was performed; and his works *Heterofonías* and *Espacios variados* were heard, respectively, in the second and third edition of the festival in 1967 and 1970. All this shows that the "relationship between the political power and music of the avant-garde was more complicated than a foreseeable opposition to the system."[355]

Nonetheless, we have to emphasize that the technocratic character of the Opus Dei, which had held a strong position in the government of the country since 1957, "was better matched by supporting avant-garde movements based on scientific

---

[354] Contreras, "Three Commissions," 183.

[355] Daniel Moro, *El compositor Carmelo Bernaola (1929–2002). Una trayectoria en la vanguardia musical española* (Bilbao: University of the Basque Country, 2019), chap. 5.

inspiration like the music of Luis de Pablo—considered by Llorenç Barber to be the Spanish 'Boulez'——rather than the music of other members closer to the line of Cage, like Juan Hidalgo."[356] Hidalgo, along with Walter Marcheti and Ramón Barce, founded the emblematic group ZAJ for musical theater, which with the passage of time was considered "one of the most relevant collectives of the vanguard on the Spanish artistic scene."[357] The founding concert of the group also took place in 1964. In November 1965 the first Festival ZAJ was held, and later collaborations with plastic artists began to emerge, among which we would highlight the collaboration undertaken with the painter José Antonio Sistiaga. On December 8 and 10, 1967, in the context of one of his exhibitions at the Museo de San Telmo in Donostia-San Sebastián, two ZAJ concerts took place under the direction of Juan Hidalgo and Walter Marcheti.

Previously, in December 1964, Sistiaga had given a noteworthy performance at the Galería Edurne of Madrid, at which he spoke moving his slips but without emitting any sound except for three words at intervals "I…We…Here…"; and a little later, he had staged a protest in Donostia-San Sebastián because of the withdrawal of a grant to the Association of Basque Artists in favor of a gastronomic society by presenting a lecture on impressionism while eating a cutlet and accompanied by José Luis Zumeta and Rafael Ruiz Balerdi.[358] These artistic actions were connected to the 1962 work *0'00"* by John Cage, in whose original score it was indicated: "in a situation provided with maximum amplification (no feedback) perform a disciplined action";[359] this

---

[356] Ibid., chap. 5.

[357] Carmen García, "Esther Ferrer: la (re)acción como leitmotiv," PhD diss., Universidad Miguel Hernández, 2014, 162.

[358] Ibid., 160–61.

[359] John Cage, *0'00": solo to be performed in any way by anyone* (New York: Henmar Press, 1962).

was a reference point for ZAJ. Sistiaga "participated very actively in vitalizing the Basque scene of the 1960s" and was responsible for putting ZAJ in contact with Esther Ferrer, a group in which, after the departure of Ramón Barce, this creative artist "would shape her particular language on a totally different direction than the dominant culture of pre-democratic Spain, and in which . . . questions related to the trinomial sex-gender-sexuality occupied a prominent place."[360]

Despite these incursions, any musical renewal arrived late to the Basque Country, at least if we consider, on a national level, that in Barcelona the first steps were taken toward the end of the 1940s with the creation of the Círculo Manuel de Falla and Club 49; and in Madrid the Music Hall of the Ateneo, in which the group Nueva Música was integrated, beginning its activities in the 1958–1959 season. Such renewal became felt in the Basque territory through appointed festivals like the Encuentros de Pamplona-Iruñea in 1972 and the Donostia-San Sebastián Vanguard Music Festival (1973 and 1974). The latter was led by the composer José Luis Isasa, who created the first laboratory for electronic music in the Basque Country, located in Villa Timi, in the Alto Miracruz in Donostia-San Sebastián, and gathered there the principal creators of the national music panorama, including the already mentioned Basque composers Bernaola, de Pablo, and Escudero, as well as Antón Larrauri, Félix Ibarrondo, and the Navarrese Agustín González Acilu. Unfortunately, none of these festivals lasted very long because of lack of financing, but they were replaced by the "day of Basque vanguard musicians" during Musikaste, a week-long celebration of Basque music, which began in 1973 and whose slogan was "to stimulate composers,

---

[360] García, "Esther Ferrer," 158.

give them the opportunity to debut their works, especially those facing the most difficulty."[361]

We will pause here somewhat with the Encuentros de Pamplona,[362] as they were truly extraordinary in the wide sense of the word. They took place between June 26 and July 3, 1972, under the direction of Luis de Pablo and the plastic artist José Luis de Alexanco, and with the support of the city council and the sponsorship of Juan Huarte. It was a remarkable festival whose star attraction was without a doubt the presence of John Cage, to whom tribute was paid on his sixtieth birthday. In the musical area, one sought to spread the most recent creations of the vanguard "programming concerts of experimental music where works composed by electronic means predominated" and also to present music "of ethnic and traditional character with the intention to bring together diverse oriental and western cultures."[363]

It was also a very controversial festival. The terrorist group Euskadi ta Askatasuna (Basque Country and Freedom, or ETA), founded in 1959, carried out two attacks, but without casualties, hoping to break up the festival. The motif of their boycott of the proceedings was published in handbills in which they highlighted that "the Encuentros were a show of 'bourgeois elitism' and the organizers 'lackeys of those in power'. According to the terrorist group, 'anybody not capable of understanding popular sentiment and having solutions for these sentiments was nothing more than an unaware actor and a peon in the service of fascism."[364] For ETA, the Encuentros were a maneuver to

---

[361] José Luis Ansorena, "En torno a Musikaste," *Oiarso* 74 (1974), 27–29.

[362] See Igor Contreras, "Arte de vanguardia y franquismo: a propósito de la politización de los Encuentros de Pamplona," *Uhuarte de San Juan. Geografía es Historia* 14 (2007), 235–55.

[363] Ibid., 238.

[364] Ibid., 242.

integrate "Popular Basque culture into the oppressive Francoist regime"; with its violent actions it sought to "mark a corrective action on cultural production."[365]

The Spanish Communist Party also considered the Encuentros a "maneuver of dominant class"; but criticism did not only come from the left: "notable figures from the Church, like the Archbishop of Pamplona, José Méndez Asenso, argued from the pulpit that the Encuentros were a complete waste of money and the ultra-right of Pamplona distributed handbills in which they threatened harm to the artists."[366.] Likewise, although there were artists who supported the event without reservation, others, once present, showed themselves against it, among other reasons because of the coercive measures taken by the sponsor to hinder a spontaneous discussion that was not on the program by raising the volume of an electroacoustic composition by Josep M. Mestres Quadreny, which angered the composer; and for the censorship of two paintings at the exhibition, *Encuentros,* by Dionisio Blanco and *Cristo amordazado* by Javier Morrás; this caused Agustín Ibarrola, "Arri," and Dionisio Blanco to withdraw their pieces in protest.[367] There was also criticism for the "[artistic] bets demanded by the Encuentros as a priority," some under the umbrella of "artistic research," or even because of the lack of the use of Euskara in the conferences. As we noted, "the majority ended up portraying themselves and their neighbors in an ideological key"; and, indeed, the "abnormality" in which the Encuentros took place ended up highlighting the "abnormality of the regime in Europe."[368]

---

[365] Daniel Palacios. "ETA contra los Encuentros de Pamplona: el desencuentro entre arte y política," *Anuario del Departamento de Historia y Teoría del Arte* 27 (2015), 63, 54.

[366] Contreras, "Arte de vanguardia y franquismo," 235.

[367] Ibid., 246, 249.

[368] Ibid., 254, 247.

Luis de Pablo recognized that "everything that happened in the Encuentros had a negative impact on his career." In his words, it changed into "a kind of stinky thing [that] he could not offer [his] services in any part of Spain."[369] This led him to seek residence outside the country, first in the United States and later in Canada. But even after his return to Spain after the death of Franco, despite the changes in politics, he continued to be seen as an "official composer." Without a doubt, his case, and that of many other artists, clearly explains the crossroads of how to develop an artistic career in the context of a dictatorship.

We do not want to conclude this section without a briefly mention of sacred music during this period of openness. The Constitution *Sacrosanctum Concilum* of December 5, 1963, issued by the Second Vatican Council (1962–65), launched a reform of the Catholic liturgy that substantially affected music. Thereafter, in 1967, the Instruction *Musicam Sacram* was promulgated to regularize the use of music in the liturgy and to properly apply the aforementioned constitution.

The Second Vatican Council had a singular impact on the entire Basque territory, since it allowed the use of Euskara as a language for worship, the use of traditional Basque instruments in the mass (such as the *txistu*, the *atabal*, the *txalaparta*, the *alboka*, and the tamborine), and the participation in masses of *bertsolaris* (improvisers of sung verses) and *dantzaris*. The Basque dioceses likewise fostered the creation of a new musical repertoire in the Basque language.

This contributed to the phenomenon of the so-called *herri mezak* (popular masses) and *Euskal mezak* (Basque masses, newly made and based on texts in Euskara), which were in their heyday in the context of the already cited "Basque renaissance" of the 1960s. The latter include the noteworthy

---

[369] Ibid., 251.

*Herriko Meza* and *Gure Meza* by Tomás Garbizu; the former was published in 1965 by the Eskila publishing house. It was founded in 1950 at the Benedictine monastery of Belloc (Urt), which contributed to the liturgical reform by publishing numerous scores of sacred music on texts in Euskara. And the latter was recorded by the Columbia record label in 1966 with the participation, among others, of the Orfeón Donostiarra.

## Conclusion

This chapter confirms that in the musical arena during Franco regime, "ideological and personal character were sought after more than artistic positions"; there was no "obsession about *degenerate art*" as in the case of Nazi Germany, neither were there "assemblies of official composers," nor critiques or editorials in the press in which one analyzed in detail after a debut the commitment of the composers and their works to the new state, as was the case of the Soviet Union under Stalin.[370] In this sense, the purging of political accountability after the Spanish Civil War could be understood as "political genocide," in line with that coined by Raphael Lemkin and transferred to the Basque situation by Xabier Irujo.[371] A social and workplace liquidation was achieved of all that was different as well as an exemplary intimidation of the undecided, for the sake of the attainment of a social and political homogeneity concomitant with the new state. This explains the continuity in the postwar period of the music composed before the conflict, and even the programming of works performed in political exile, with the necessary silencing of

---

[370] Ángel Medina, "Música española 1936–1956: ruptura, continuidades y premoniciones," in *Dos décadas de cultura artística en el franquismo (1936–1959)*, ed. José Luis Henares Cuéllar et al. (Granada: Universidad de Granada, 2001), 63.
[371] Xabier Irujo, *Genocidio en Euskal Herria (1936–1945)* (Iruña: Nabarralde, 2015).

discordant voices, and the necessary reinterpretations, which as regards Basque folklore has been studied.

During the stage of economic development, a new "Basque renaissance" occurred, which found its expressive form in the interior of the country due to the relative permissiveness of the regime once it was fully secure. Likewise, the state used vanguard music in order to export ideas of progress and openness. Public assets, on the one hand, and private, on the other, turned to the celebration of big events like the Concert for Peace and the Biennial of Contemporary Music, or the Encuentros de Pamplona—events in which the names of Basque composers stood out. One should also mention the organization of the First and Second Festival of Music of the Vanguard in Donostia-San Sebastián, and the Day of Basque Musicians of the Vanguard of Musikaste, the latter still functioning today.

In summary, this chapter offers an initial approximation of a period of music history in the Basque Country about which much remains to be studied and brought to light.

## Bibliography

Aguirre, José Antonio. *De Guernica a Nueva York pasando por Berlín.* [Bilbao]: [Ekin], 1992.

Andrés, Marcos. *Fernando Remacha. El compositor y su obra.* Madrid: ICCMU, 1998.

Ansorena, José Luis. "En torno a Musikaste." *Oiarso* 74 (1974): 27–29.

———. *Aita Donostia.* Donostia: Kutxa, 1999.

Arana, José Antonio. *Eresoinka-Embajada Cultural Vasca 1937–1939.* Vitoria-Gasteiz: Gobierno Vasco, 1986.

Ascunce, José Ángel. *San Sebastián, capital cultural (1936–1940).* Zarautz: Michelena, 1999.

"Así nació el Coro Easo. Recordando sus inicios al celebrar el 70 aniversario." *Ahots batez* 10 (2009): 32–34.

Azpiazu, José Antonio. *Franciscso de Madina: Priest and Basque Musician.* Oñati: Oñati Abesbatza, 2002.

Bagüés, Jon, and Itziar Larrinaga. "Eusko Ikaskuntzaren lana musikaren arloan (1918–1936 eta 1979–2013). In *Euskaldunon mendea. Eusko Ikaskuntzak 100 urte,* edited by Juan Aguirre. Donostia: Eusko-Ikaskuntza, 2018.

Berrocal, Joseba. "La Orquesta de Bilbao entre 1939 y 1980: el periodo central." In *Ochenta años de música urbana,* edited by Carmen Rodríguez. Bilbao: BBK, 2002.

Cage, John. *0'00": solo to be performed in any way by anyone.* New York: Henmar Press, 1962.

Contreras, Igor. "Arte de vanguardia y franquismo: a propósito de la politización de los Encuentros de Pamplona." *Huarte de San Juan. Geografía es Historia* 14 (2007): 235–55.

———. "El eco de las batallas: música y guerra en el bando nacional durante la contienda civil española (1936–1939)." *Amnis. Revue de civilisation contemporaine Europes/Ámeriques* (online journal) 10 (2011): 1–13. At: https://urnals.openedition.org/amnis/1195.

———. "Three Commissions to Celebrate 25 Years of Francoism." In *Composing for the State: Music in Twentieth-Century Dictatorships,* edited by Esteban Buch, Igor Contreras Zubillaga, and Manuel Deniz Silva. Abingdon, Oxon.: Ashgate, 2016.

Cuevas, Carmen de las. "El Orfeón Donostiarra 1897–1997: Proyección social, cultural y educativa." PhD dissertation, Universidad del País Vasco (UPV-EHU), 1999.

Cureses, Marta. *El compositor Agustín González Acilu: La estética de la tensión.* Madrid: ICCMU, 2001.

García, Carmen. "Esther Ferrer: la (re)acción como leitmotiv." PhD dissertation, Universidad Miguel Hernández, 2014.

García del Busto, José Luis. *Luis de Pablo*. Madrid, Espasa Calpe, 1979.

———. *Luis de Pablo, de ayer a hoy*. Madrid: Fundación Autor, 2009.

García Sánchez, Albano. "El músico José María Nemesio Otaño Eguino (1880–1956). Perfil biográfico, pensamiento estético y análisis de su labor propagandística y gestora." PhD dissertation, University of Oviedo, 2014.

Grández, Rufino Mª. "El asunto vasco en nuestra provincia capuchina de Navarra-Cantabria-Aragón. Datos para una reflexión." Unpublished ms. Burlada, 1981.

Granja, José Luis de la, Santiago de Pablo, and Coro Rubio. *Breve historia de Euskadi. De los fueros a la autonomía*. Madrid: Debate, 2011.

Iglesias, Iván. "De 'cruzada' a 'puente de silencio': mito y olvido de la Guerra Civil española en la historiografía musical." *Cuadernos de música iberoamerianca* 25–26 (2013): 177–88.

Intxarrandieta, Patxi. *Tomás Garbizu Salaberria*. Lezo: Lezoko Unibertsitateko Udala, 2002.

Ipiña, Aritz. La depuración y represión franquista de las empleadas y empleados del Ayuntamiento de Bilbao (1936–1937). Bilbao: Ayuntamiento de Bilbao, 2017.

Irujo, Xabier. Genocidio en Euskal Herria (1936–1945). Iruña: Nabarralde, 2015.

Larrinaga, Itziar. "Francisco Escudero y la música de escena: su primera ópera, *Zigor!*" In *La Ópera en España e Hispanoamérica*, edited by Emilio Casares and Álvaro Torrente. Volume 2. Madrid: ICCMU, 2002.

———."Tradición, identidad vasca y modernidad en la vida y en la creación musical de Francisco Escudero." PhD dissertation, University of Oviedo, 2009.

————. "Música y propaganda nacional vasca durante la Guerra Civil Española y el exilio: el caso de Francisco Escudero." *Revista de Musicología* 3, no. 1 (2009): 595–616.

————. *"Dura lex, sed lex.* La depuración franquista en las instituciones dependientes del Ayuntamiento de Donostia-San Sebastián (1936–1937)." In *Music and Francoism*, edited by Gemma Pérez Zalduondo and Germán Gan Quesada. Turnhout: Breepols, 2013.

————. "Cuarteto en sol de Francisco Escudero (1936–1937): ¿un programa secreto?" In *The String Quartet in Spain*, edited by Christiane Heine and Juan Miguel González. Bern: Peter Lang, 2016.

Larrinaga, Itziar, and Joseba Torre. "Ser en el sonido: entrevista a Félix Ibarrondo." *Musiker* 18 (2011): 283–326.

Lerena, Mario. *El teatro musical de Pablo Sorozábal (1897–1988). Música, contexto y significado.* Bilbao: Universidad del País Vasco, 2018.

López Estelche, Israel. "Luis de Pablo: vanguardias y tradiciones en la música española de la segunda mitad del siglo XX." PhD dissertation, University of Oviedo, 2013.

Lopezortega, Joseba. "La condición humana en el espejo de la BOS." *Hermes* 59 (2018): 70–76.

Medina, Ángel. "Primeras oleadas vanguardistas en el área de Madrid." In José López Calo et al., *España en la música de Occidente.* Volume 2. Madrid: INAEM, 1987.

————. "Música española 1936–1956: ruptura, continuidades y premoniciones." In *Dos décadas de cultura artística en el franquismo (1936–1959)*, edited by José Luis Henares Cuéllar et al. Granada: Universidad de Granada, 2001.

————. "Itinerarios de la Ópera española tras la Guerra Civil." In *La Ópera en España e Hispanoamérica*, edited by Emilio Casares and Álvaro Torrente. Volume 2. Madrid: ICCMU, 2002.

Moro, Daniel. "La música religiosa del compositor Carmelo A. Bernaola. Consideraciones a la luz de la reforma conciliar." *Musiker* 18 (2011): 217–45.

———. "En torno a Carmelo Bernaola y la música de vanguardia." *Euskonews* (online journal) 718 (2017). At: http://www.euskonews.com/0718zbk/gaia71803es.html.

———. *El compositor Carmelo Bernaola (1929–2002). Una trayectoria en la vanguardia musical española.* Bilbao: University of the Basque Country, 2019.

Olaizola, Imanol. "Concierto en tres tiempos." *Musiker* 15 (2007): 201–43.

Pablo, Santiago de. *Guerra Civil, cine y propaganda en el País Vasco.* Madrid: Biblioteca Nueva, 2006.

Palacios, Daniel. "ETA contra los Encuentros de Pamplona: el desencuentro entre arte y política." *Anuario del Departamento de Historia y Teoría del Arte* 27 (2015): 53–66.

Rodríguez, Carmen. *Banda Municipal de Bilbao. Al servicio de la villa del Nervión.* Bilbao: Ayuntamiento, 2006.

Pérez Zalduondo, Gemma. "El imperio de la propaganda: la música en los fastos conmemorativos del primer franquismo." In *Discursos y prácticas musicales nacionalistas*, edited by Pilar Ramos. Logroño: Universidad de La Rioja, 2012.

———. "La música en la prensa de la España nacional durante la guerra civil española (1936–1939)." In *Music Criticism 1900–1950*, edited by Jordi Ballester and Germán Gan Quesada. Turnhout: Brepols, 2018.

———. "'Elogio de la alegre retaguardia': La música en la España de los sublevados durante la guerra civil." *Acta musicológica* 90, no. 1 (2018): 78–94.

*Reglamento de la Orquesta y Banda Municipal de Bilbao.* Bilbao: Escuelas Gráficas de la Sta. Casa de Misericordia, 1939.

Rodríguez Ranz, José Antonio. "Madera de líder." In *La política como passion. El lehendakari José Antonio Aguirre (1904–1960)*, edited by Ludger Mees. Madrid: Tecnos, 2014.

Sacau-Ferreira, Enrique. "Performing a Political Shift: Avant-garde Music in Cold War Spain." PhD dissertation, University of Oxford, 2011.

Salabert, Miguel. *Interior Exile*. New York: Simon and Schuster, 1961.

Suárez-Pajares, Javier. "Pablo Sorozábal, Tomás Luis de Victoria y la séptima de Shostakovich." In *Estudios. Tomás Luis de Victoria. Studies*, edited by Javier Suárez-Pajares and Manuel del Sol. Madrid: ICCMU, 2013.

Zudaire, Eulogio. *Lecároz. Colegio "Nuestra Señora del Buen Consejo" (1888–1898)*. N.p., 1989

# Basque Music: From the Transition (1975) to the Present (2018)

Mikel Chamizo

## The Transition

The death of Francisco Franco on November 20, 1975, and the subsequent realignment process of Spain's political structures, a historical period known as the Transition, brought with it countless changes in all spheres of society, and it necessarily also affected the development of Basque music in Euskal Herria (the Basque Country). Between 1975 and 1980, the year when the Basque government was founded, some institutions associated with contemporary music experienced a crisis, while others emerged or were consolidated. Among those that disappeared is one of the most ambitious venues dedicated to this repertoire in Euskal Herria: the Avant-garde Music Festival of Donostia-San Sebastián, which in 1973 and 1974, under the leadership of the composer José Luis Isasa, hosted conferences, colloquiums, and premieres of new pieces by Carmelo Bernaola, Luis de Pablo, and Francisco Escudero, among others.[372] After numerous management problems, the festival was discontinued after the first two years.

In the arena of symphonic music, the only professional Basque orchestra active in those years, the Municipal Orchestra of Bilbao, suffered a serious crisis. The Bilbao orchestra had

---

[372] See José Luis Isasa, *1er Festival de Música de Vanguardia. 27, 28 , 29 y 30 de septiembre, San Telmo, San Sebastián*, hand program (San Sebastián: Centro de Atracción y Tursimo, 1973).

depended on the economic support of the Culture Ministries of the Franco regimes since 1939, in exchange for taking part in its propaganda strategies on various occasions,[373] but in the final years of the dictatorship...its status began to be seriously affected, and this situation worsened during the Transition. Subject to the vicissitudes of politics, the orchestra suffered serious budget cuts, and it wound up without a headquarters in which it could hold rehearsals and was in danger of having to disband.[374] That uncertainty, which continued until the administrative normalization of the orchestra in 1982 (then renamed as the Bilbao Symphony Orchestra), limited to a great extent its capability to commission and premiere new music during that period.

The greatest and longest-standing Basque classical music festival, the *Quincena Musical* of Donostia-San Sebastián, also experienced its own problems in the late 1970s. Immersed in a budget crisis and an identity crisis, the Quincena began to overcome its situation in 1979, when José Antonio Echenique, a musically progressive figure, became the director, stabilized the festival's finances, and expanded its range of programming.[375]

The turbulent period of the Transition witnessed the consolidation of other spaces associated with new forms of music, such as Musikaste, the Basque Music Week of Errenteria (Rentería) in Gipuzkoa, which celebrated its Avant-garde Day[376]

---

[373] See Joseba Lopezortega, "La Guerra Civil convirtió a la Bilbao Orkestra Sinfonikoa en un instrumento de propaganda franquista," in "Historias de los vascos" section, *Deia*, March 16, 2013.

[374] See Carmen Rodríguez Suso, *Orquesta Sinfónica de Bilbao. Ochenta años de música urbana* (Bilbao: Bilbao Bizkaia Kutxa, 2003).

[375] The critical year was 1979, in which the festival was suspended on its traditional dates in August and Echenique forced its holding in December to avoid its disappearance. See Maider Oyarbide, "Entrevista con José Antonio Echenique," *La Quincena 26* (March 2009), 6.

[376] Isidoro Echeverría, "Musikaste 74," *Oarso 12* (1974), 30–33.

for the first time in 1974. Since the Musikaste edition in 1977,[377] this annual encounter has been held with new creative work without interruptions. Its intention is to perform a wide range of Basque composers, from those who are still students to the consecrated figures.[378] In Bizkaia, since there was a lack of spaces dedicated to new music, the Twentieth Century Music Festival emerged in Bilbao. This would become the most important event in the calendar of contemporary Basque music during the 1980s[379] and 1990s, and it would continue its long life until well into the twenty-first century.

Even if we add other sporadic concerts to the aforementioned cycles and festivals, it nevertheless remains clear that the resources at the disposal of Basque composers during the Transition were very precarious, and that since there were no cultural policies that promoted their work, many of them pursued their artistic aspirations in other parts of Spain or abroad. It is worth noting that in the early 1980s, the three most prestigious Basque composers of avant-garde Basque music did not reside in Euskal Herria: Carmelo Bernaola and Luis de Pablo were living in Madrid, and Félix Ibarrondo, in Paris. Pablo Sorozabal had likewise been living in Madrid since 1930. Among the most famous creative musicians, only Antón Larrauri and Francisco Escudero lived in Euskal Herria. The limited capacity of the

---

[377] In 1976, it was not held for economic reasons and José Luis Ansorena, director of Musikaste, recorded "the repeated signs of regret we have been sent because of its absence." See José Luis Ansorena, "Musikaste 76," *Oarso* 14 (1976), 90.

[378] Since 2006, Musikaste has collaborated with the Composition Department of Musikene and dedicates a biennial concert to the music of its students. See María José Cano, "Cinco promesas para Musikaste," in "Cultura" section, *El Diario Vasco*, May 15, 2006.

[379] Already in its fifth edition, the festival offered around thirty premieres in Bilbao. See Jesús S. Villasol, "El Festival de Música del Siglo XX se reafirma en su quinta edición," in "Cultura" section, *El País*, November 19,1984.

Basque musical structures, however, did not bring the creation of music to a standstill. The composers continued to compose and premiere music, but they did the best they could, depending on their own initiative or that of a small number of performers, without support from a musical policy, which was nonexistent. As José Luis Pérez de Arteaga asserts, "The history of music and of politics during the Transition has not always had to do with 'musical policy': policy has been made, before and during the Transition, with music in the background, or with music as a pretext, or, on most occasions, without music."[380]

## The 1980s

On April 9, 1980, after approval of the Autonomy Statute of Basque Country on December 18, 1979, the Basque government was established and Ramón Labayen, a member of the Basque Nationalist Party (Partido Nacionalista Vasco, PNV), became Counselor of the Department of Culture.[381] One of Labayen's priorities was to reconstruct Basque cultural identity after the Franco regime;[382] and among the various measures that he planned for this purpose, such as a Basque public radio broadcasting entity, EITB,[383] was the creation of a "national"

---

[380] José Luis Pérez de Arteaga, "Música clásica," in *Doce años de cultura española (1976–1987)*, ed. Luis Urbez (Madrid: Ediciones Encuentro, 1989), 266.

[381] "Presentación del Gobierno Vasco," *ABC*, April 25, 1980, 6.

[382] In a retrospective interview for Euskonews, Labayen recalled that "we were children who believed in the nation" and that they committed to the model of "a society, a language, a culture, and a nation." See Josemari Vélez de Mendizabal, "Entrevista con Ramon Labayen," *Euskonews* (online journal) 597, Ocober 21–28, 2011, at http://www.euskonews.eus/0597zbk/elkar_es.html (last accessed January 24, 2019).

[383] "I was convinced that Euskera could not last without a radio station or television channel. It was a fundamental instrument for the development of our

orchestra. Thus, on February 15, 1982, the Basque government decreed the foundation of the Basque National Orchestra (BNO), based in Donostia-San Sebastián, which would have as one of its founding goals "to serve as a stimulus and platform for Basque performers and composers."[384] After its launch by Imanol Olaizola, one of the founders of the Jazz Festival of Donostia-San Sebastián in 1966, the BNO took up its activity in mid-1982, and from the beginning Basque music played a leading role. Leading composers such as Father Donostia, Jesús Guridi, Mauric Ravel, and José María Usandizaga, appeared repeatedly on the programs of those first concerts, together with a good number of living Basque composers.[385] Between 1982 and 1984, in particular, the BNO was scheduled to perform works by Pascual Aldave, Tomás Aragüés, José Luis Iturralde, Francisco Escudero, Pablo Sorozabal, and Carmelo Bernaola, the last of these with one of his commercial projects, the soundtrack for the silent film by King Vidor *Y el mundo marcha* (*The Crowd*, 1928). Bernaola was also the composer of the first avant-garde work tackled by the BNO (*Symphony no. 1 in C major*, in September 1985), and also the first person commissioned with an orchestral work (*Variaciones concertantes*, which premiered in Vitoria-Gasteiz, Donostia-San Sebastián, and Bilbao, January 27–29, 1986). By the late 1980s, the new Basque national orchestra also premiered works by Pascual Aldave (*Akelarre*, 1987), Tomás Aragüés Bernard (*Cuatro espacios sinfónicos*, 1987), Agustín González Acilu (*Concierto para*

---

language. I referred to the Ministry of Culture as the Ministry of Defence. We needed institutions that strengthened the backbone [of] the nation." Ibid.

[384] Article 5. of Decree 62/1982 of February 15, 1982, quoted on the Basque National Orchestra website, "Transparency>Functions" tab. https://es.euskadikoorkestra.eus/sites/default/files/funciones.pdf (last accessed January 22, 2019).

[385] Database of works programmed by the Basque National Orchestra since 1982, prepared by Nekane Zurutuza, archivist of the Basque National Orchestra.

*violonchelo y orquesta*, 1987), a very young Ramon Lazkano (*Sinfoniak*, 1988), Félix Ibarrondo (*Irrintz*, 1988), Francisco Escudero (*Juan Bautista*, 1988), and Carmelo Bernaola (*Abestiak*, 1989).[386]

Simultaneously, the Bilbao Symphony Orchestra, when its subscription season was reestablished in 1981–1982, gradually resumed its policy of premieres.[387] The first of these premiers, in November 1981, was *Euskal Herriaren Salmoa* by Francisco Escudero. In March 1983, in the context of a concert in homage to Antón Larrauri, his quartet *Dies illa* and the orchestral work *Soinua* were heard for the first time. In October of that same year the BSO premiered *Sinfonía Gorbea* by Ruperto Iruarrizaga, and in May of 1984, during a concert at Musikaste, the concerto for *txistu* and orchestra by Tomás Aragües. Later, the Bilbao orchestra presented world premieres of José María Etxebarrieta (*Kantak*, 1984), Antón Larrauri (*Maritxu*, 1987), Gotzon Aulestia (*Urgazak*, 1987), and Rafael Castro (*Mañana de primavera* in 1987 and *Music for cello and orchestra* in 1989), and reinstated works by Félix Ibarrondo, Javier Bello-Portu, Pablo Sorozabal, Carmelo Bernaola, Pascual Aldave, and Luis de Pablo.[388]

Although the presence of contemporary music in orchestras does not always reflect the programing trends of specialized circles, the group of composers selected by the Basque National Orchestra and the Bilbao Symphony Orchestra in the 1980s offered a sufficiently representative image of the main Basque composers at that time. Pablo Sorozabal, although he was in his eighties and had almost stopped composing,[389] continued to

---

[386] Ibid.

[387] Database of works programmed by the Bilbao Symphony Orchestra since the 1974–1975 season, prepared by Pablo Suso, head of production and the archive of the Bilbao Symphony Orchestra.

[388] Ibid.

[389] Between 1980 and 1984, the year in which he ceased his activity as a composer, Sorozabal's production was limited to nine works, all of them short

be an indispensable composer for the two Basque orchestras, while at the same time he also enjoyed great popularity among the choruses and bands. His very important musical theater, moreover, was restaged relatively frequently. In the shadow of Sorozabal, composers such as Tomás Aragüés, Rafael Castro, and Pascual Aldave wrote tonal music, often based on Basque folk melodies and rhythms, which thus continued the tradition already embodied by Jesús Guridi, Father Donostia, Tomás Garbizu, and other Basque composers from the early and mid-twentieth century.[390]

At the other extreme of the aesthetic spectrum, in a more avant-garde terrain, the names of Luis de Pablo, Carmelo Bernaola, and Félix Ibarrondo are worth noting. De Pablo (Bilbao, 1930) had ceased to be actively involved in organization of Basque musical life due to the traumatic experience of the Pamplona Meetings, which were subjected to threats from the terrorist group ETA in 1972.[391] Despite this, De Pablo remained in contact with the most progressive musical circles and maintained personal relationships with many Basque composers, and the importance of his production for magnetic tape from the 1970s and early 1980s on helped promote interest in electroacoustic and mixed music among the new generations.[392] As one of the great figures of the Spanish avant-garde, De Pablo was also a composer to whom the Basque musical institutions resorted on important occasions. He was commissioned, for

---

arrangements or pieces. See *Pablo Sorozabal* (microsite) at Eresbil.com, "Listado de obras," tab. http://www.eresbil.com/sites/sorozabal/es/lista-cronologica/ (last accessed January 24, 2019).

[390] See chapter 5 in this book.

[391] Daniel Palacio, "ETA contra los Encuentros de Pamplona: un desencuentro entre arte y política," *Anuario del Departamento de Historia y Teoría del Arte* 27 (2015), 53–66.

[392] In 1983, De Pablo offered a master class on electro-acoustic music at the Jesús Guridi Music School in Vitoria-Gasteiz, invited by Carmelo Bernaola.

instance, to compose the first avant-garde piece performed in the *Quincena Musical* after more than thirty years avoiding this repertoire. It was in 1984 that De Pablo composed for the occasion the *Cinco meditaciones* for instrumental group, which the Ensemble 2e2m, directed by Paul Méfano,[393] premiered. That concert, at the Victoria Eugenia Theater, with a completely contemporary program, was regarded as a provocation by a sector of the audience and by some responsible politicians. "A senior official of the Basque government criticized my presumption and lack of respect in organizing it," recalled José Antonio Echenique, director of the festival in Donostia-San Sebastián, in 1984.[394] The lack of sensitivity for, and even the hostility to, avant-garde music is a continual theme in the memories and anecdotes of the people who attempted to foster it during those years.[395]

Another composer who acquired great prestige in the 1980s was Félix Ibarrondo (Oñati, 1943). After studying composition with Juan Cordero at the Conservatory of Bilbao, he left for Paris in 1969 and came into contact with the French musical avant-garde. He studied with Max Deutsch and established very close relationships with Henri Dutilleux and Maurice Ohana, who had a decisive influence on the change in his compositional language, which moved from the neoclassicism of the works of his youth to a style in which the refinement in sound and technique of the French school of composition is combined with an extremely intense rhythmic and dynamic momentum.[396]

---

[393] José Luis Barbería, "Un estreno de Luis de Pablo en la Quincena Donostiarra," in "Cultura" section, *El País*, August 23, 1984.

[394] José Antonio Echenique, personal communication, June 21, 2018.

[395] In 1976, in his commentary on the Musikaste Avant-garde Day, José Luis Ansorena points out that "this genre produces in certain sectors something akin to a rejection or scandal." See Ansorena, "Musikaste 76," 90.

[396] Mikel Chamizo, "Setenta años viviendo en el sonido," program notes for the *Retrato de Félix Ibarrondo* concert held at the Fundación BBVA in Bilbao, January 8, 2013 (Bilbao: Fundación BBVA, 2013).

In 1983, the Trío à cordes of Paris premiered his trio *Phalène* with notable success. After hearing it, Harry Halbreich, one of the most influential of avant-garde thinkers, wrote that "Ibarrondo is the paragon of the independent composer . . . Passionately Basque, he fully embodies the qualities of his people: concentrated fervor, expressive passion that can even become violent, giving precedence to life experience over abstraction and systems, generosity and openness to the perspective of a humanism without concessions and without complacency."[397] This commentary, full of meaningless commonplaces, founded Ibarrondo's reputation as a quintessentially Basque composer, despite the fact that the awakening of his true artistic voice occurred in Paris and that his contact with the musical life of Euskal Herria was never particularly pronounced. Nevertheless, the fact that Ibarrondo's music—so distant from the ideas and the aesthetic of musical nationalism of a folk nature—was regarded internationally as one of the most authentic expressions of Basque music, constituted an invitation in a sense to reflect on the essence of Basque music and the elements that define it.[398]

---

[397] Quoted in Alain Féron, "Ibarrondo, Félix," in *Dictionnaire des Compositeurs* (Boulogne-Billancourt: Encyclopædia Universalis France, 2016).

[398] "The Basque quality of his music is, nevertheless, a controversial subject that Ibarrondo never wished to clarify, because for him 'it is something so evident that I cannot describe it with words'. Others have tried it in his place, comparing the abruptness of their music with the physiognomy of Basque mountain ranges or the violence of their expression with supposed features of the atavistic character of the Basques. But the answer could be closer to a concept as fundamental to a creator as is that of intuition. Ibarrondo recognizes that he invents his method of composition 'every day, in each new piece. I invent the material, the structure, the architecture, everything, from beginning to end. It is an invention every moment which, starting from nothing, from a single sound or conglomerate of sounds, tries to reach a coherent and necessary whole'. This is something recurrent in other great Basque artists. I refer, for example, to Balenciaga, who refused to prearrange his haute couture designs on paper, preferring to touch the fabric and give form to the outfit based on

Midway between the avant-garde and the traditional, we find the figures of Francisco Escudero and Antón Larrauri. Escudero (Zarautz, 1912) was entering the final phase of a long career in composition, which had started with Ravel's model in his youth and passed through a Modernist stage in the 1960s and 1970s. In 1982, he retired as professor of composition in the Conservatory of Donostia-San Sebastián to work exclusively on his own compositions, although he continued to give private classes to young composers such as Ramon Lazkano and Isabel Urrutia.[399] He invested the first years of his retirement in completing the opera *Gernika*, which premiered at the Arriaga Theater in Bilbao on April 25, 1987, the fiftieth anniversary of the bombardment of the Bizkaian town during the Spanish Civil War.[400] The creation and premier of *Gernika* were highpoints in the recent history of Basque music, since it was the only large-scale opera with a Basque subject matter and libretto in Euskara that had appeared in more than fifty years. Luis de Pablo, for example, has a portfolio of six operas, but none

---

its qualities of texture, structure and rigidity. The designer called this 'keeping the fabric happy'. Or to a younger composer, Lazkano, who in his pieces from the *Laboratory of Chalks* performs experiments in which 'the material begins to generate its own consequences at the moment it begins to exist'. In all three cases there seems to be a tendency to sublimate the work of the artisan, the one who has direct contact with material and the power to transform it." Mikel Chamizo, "Ibarrondo y el txistu: un encuentro afortunado," in "Cultura" section, *Noticias de Gipuzkoa*, October 17, 2015.

[399] See *Francisco Escudero* (microsite) at Eresbil.com, "Cronología" http://www.eresbil.com/web/escudero/presentacion.aspx (last accessed January 24, 2019).

[400] "At the request of the Bilbao Choral Society, he created Gernika (1979–1986), his second and last opera, in which the third act describes the bombing of the Vizcayan village during the Spanish Civil War." See Itziar Larrinaga, "El compositor Francisco Escudero," in *Mundoclasico.com*, September 11, 2002, at https://www.mundoclasico.com/articulo/3707/El-compositor-Francisco-Escudero (last accessed January 24, 2019).

has premiered in Basque Country and none utilizes Euskara. Regarded as the dean of composition in Gipuzkoa, "Maestro Escudero," as he was known in his final years,[401] received many honors and homages in the 1990s; and continued to compose until shortly before his death in 2002.[402]

Antón Larrauri (Bilbao, 1932), although one generation younger than Escudero, was in a certain way his equivalent in prestige in Bizkaia. Their respective career paths were also very different: Larrauri was partly self-taught as a composer, outside of academic circles and in parallel to his university studies of philology.[403] In 1960, he began working as a music critic in the most circulated newspaper in Bizkaia, *El Correo*, and it was not until 1968, at the age of thirty-six, that he publicly disclosed his facet as a composer. Despite this late start, his works were well received, and they were soon added to programs outside of Euskal Herria. If there was anything that set Larrauri apart it was the diversity of his talents,[404] which enabled him to leave his personal mark on works that were completely different from one another. From abstract proposals full of dissonances such as *Diálogos* (1974) and *Dualismos* (1976), to reworkings of Basque popular melodies in *Gardunak I-II* (1974) and *Maritxu* (1987), and the original chapter of his electronic music, which he pioneered in Bizkaia, Larrauri was a musician with very diverse interests who

---

[401] Ana Urroz, "Un busto en bronce recordará en Zarautz al maestro Escudero," in "Cultura y Espectáculos" section, *El Diario Vasco*, July 30, 1993.
[402] His last significant work, *Txorimalo*, dates from 1998. See *Francisco Escudero* (microsite) at Eresbil.com, "Obra," tab.
http://www.eresbil.com/web/escudero/presentacion.aspx
(last accessed January 24, 2019).
[403] Carmen Pilar Solar, *Antón Larrauri Riego, 1932–2000*, self-published in electronic form, 2016.
[404] "Its development expanded over time, making it very rich and diverse, and also allowing him to take in everything around him and what he was attracted to." Ibid, 5.

was nevertheless able to produce top-notch works in all cases. He classified his catalog of works into "contemporary" and "traditional," [405] although in the 1980s and 1990s the number of works in the latter category increased, together with the occasional pieces and soundtracks, at the expense of more avant-garde work. Larrauri was also an intellectual who subjected his love of traditional culture to a severe critical observation, [406] and who, in works such as *Ezpatadantza* (1972) and *Laiñoa* (1993), established new horizons for the handling of cross-cutting elements in Basque music such as the *zortziko* rhythm.

## The School of Bernaola

A watershed event for the future development of Basque music occurred in 1981, when Carmelo Bernaola assumed (Otxandio, 1929) the directorship of the Jesús Guridi Music School in Vitoria-Gasteiz. The prestige accrued by Bernaola at the national level can be inferred from the farewell ceremony for him held in Madrid on May 19 that same year: a dinner that, according to Antonio Iglesias, brought together "five hundred friends:" "There, musicians with very distinguished figures from the broad fields of culture, of the arts, came together, under the auspices of the Deputy Secretary of Education and Science and the Director

---

[405] He made this distinction in 1983, during a lecture given at the Jovellanos Chair of the Summer University of Gijón included in Emilio Casares, ed., *14 compositores españoles de hoy* (Oviedo: Servicio de Publicaciones de la Universidad de Oviedo, 1982).

[406] On his relationship with folklore, Larrauri said that "in man's environment are featured his customs, traditions, idiosyncrasies, political-social rights, freedoms, feelings and, of course, his relationship with the hereafter. That hereafter is the right here. That hereafter I believe to be inside man." Included in Círculo Larrauri, "Biografía," http://circulolarrauri.blogspot.com/p/biografia.html (last accessed January 26, 2019).

General of Music and Theater, Messrs. Lago Carballo and García Baquero."[407] The reasons for his transfer from the Royal Conservatory in Madrid to the Music School of Vitoria-Gasteiz were not completely clear, although his desire to be in closer contract with Euskal Herria—his family fled from Burgos during the Spanish Civil War, when Bernaola was only eight years old—seemed to take priority over considerations such as the lesser prestige of Vitoria-Gasteiz's Conservatory (it was not a higher school of music at that time) when compared with Madrid's, where Bernaola had taught since 1971. Vestiges of nostalgia for his own origins can also be found in his musical production at that moment: in March 1981, the March Foundation of Madrid held the premier of *Béla Bartók-i Omenaldia*, a trio that takes as a reference point Bartók's *Contrasts*, and in which, in Bernaola's words, "the material utilized comes from some popular songs from my village, Ochandiano [Otxandio]."[408]

The start of Bernaola's teaching activity in Vitoria-Gasteiz implied the introduction of new techniques and aesthetics into the arena of regulated musical instruction in Euskal Herria. In the early 1980s, the departments of composition in the conservatories of Bilbao and Donostia-San Sebastián were led by Juan Cordero and Francisco Escudero, and teaching was oriented mainly to writing tonal music. Bernaola, however, immediately introduced in Vitoria-Gasteiz the practice of varieties of non-tonal music among students of composition.[409] He created interval counterpoint exercises based on simple serial rules, informally called *pepas*,[410] which enabled his students to explore directly, easily, and in a controlled manner the composition of atonal

---

[407] Antonio Iglesias, *Bernaola* (Madrid: Espasa-Calpe, 1982), 138.

[408] Carmelo Alonso Bernaola, "Belá Bartók-i Omenaldia," in *Notas al programa del Ciclo Homenaje a Béla Bartók* (Madrid: Fundación Juan March, 1981), 54.

[409] Antonio Lauzurika, personal communication, January 24, 2019.

[410] Ibid.

music. He also fostered the practice of electroacoustics by inviting Luis de Pablo to hold a master class on the topic in 1983 and by earmarking economic resources for creation of an electroacoustics laboratory in 1985. This laboratory made Vitoria-Gasteiz a pioneering conservatory in Spain in incorporating electronic music into its study plans.[411] As a result of this, in 1987, the first electroacoustic music workshops in Vitoria-Gasteiz were organized under the auspices of the conservatory, which continue to be held today under the name Sinkro Festival, adopted in 2005.[412]

The passion transmitted by Bernaola to his students of composition[413] also affected some students of performance. Thus in 1985 the Instrumental Group Jesús Guridi was formed, made up of instrumental students and teachers from the conservatory interested in contemporary music and led by Juanjo Mena in its initial phase. One of the *raisons d'être* of the group was the performance of the works of young composers, who could listen to and work on their scores with the instrumentalists. In this way, in the ten years that he led the conservatory in Vitoria-Gasteiz,

---

[411] See "Laboratorio de música electroacústica – 25 años," on the Conservatorio de Música Jesús Guridi de Vitoria website, "El conservatorio>Laboratorio de electroacústica," http://www.conservatoriovitoria.com/es/subfamilia-7-Laboratorio_Electroac%C3%BAstica.html (last accessed January 26, 2019).

[412] Ibid.

[413] "He went beyond the idea of maestro-teacher, went further and that is what he did best: teach us the role of musician as artisan-artist and, within society, the role of the musician. . . . One of the ideas that he conveyed to us was the conscious impulse to stop being a student and become a composer. He pushed us into what we have chosen to be." Josune Vélez de Mendizabal, "Entrevista con Zuriñe Fernández Gerenabarrena," in *Euskonews* (online journal) 528, April 16–23, 2010, at http://www.euskonews.eus/zbk/528/zurine-fernandez-de-gerenabarrena-compositora-bernaola-hizo-sentirme-compositora-y-no-solo-estudiante/ar-0528002001C/ (last accessed January 26, 2019).

Bernaola created a fertile environment from which an important group of composers emerged, including Antonio Lauzurika, Zuriñe Fernández Gerenabarrena, Francisco Ibáñez, Bingen Mendizabal, Sofía Martínez, and Guillermo Lauzurica. The subsequent teaching responsibilities of Bernaola's students— Antonio Luzurika succeeded him as professor of composition in Vitoria-Gasteiz, while Zuriñe Gerenabarrena and Guillermo Lauzurica gave classes at Musikene—has kept the teachings of the Bernoala school in force, which today still serve as the entry path to atonal music for many young Basque composers.

After Bernaola's departure in October 1991, the Conservatory of Vitoria-Gasteiz continued to carry out important activities in the field of new music. The composer and engineer Alfonso García de la Torre, a professor of acoustics and electroacoustic music from 1990 and director of the laboratory, has been one of the main proponents of initiatives such as the Bernaola Festival, which began in 2004 in place of the former Twentieth-Century Music Cycle,[414] and Sinkro Space, a multidisciplinary project dedicated to the development of new means of musical expression by applying new technologies.[415]

## Toward the New Millennium

Unfortunately, the 1990s did not witness any significant growth in the structures that supported contemporary music in Euskal Herria. The scarcity of specialized performers was especially serious. The Twentieth Century Music Festival in Bilbao was linked from its beginnings with the composer Jesús Villa Rojo and the group led by him, the Musical Performance Laboratory

---

[414] Txema G. Crespo, "La música de Carmelo Bernaola vuelve a Vitoria," in "Cultura" section, *El País*, October 27, 2004.
[415] Ibid., note 40.

(MPL).[416] Thanks to MPL, many Basque composers could see their music performed and even recorded in a collection of CDs titled *Contemporary Basque Composers* that was published in seven volumes from 1991 to 2004, financed by the savings and loan BBK, the main patron of the festival of Bilbao. In Donostia-San Sebastián, in 1995, Ostots was formed, a top-quality group consisting of soloists from the Basque National Orchestra and led by Ramon Lazkano, but the group was short-lived and broke up in 1998.[417]

That same year, the Ensemble Oiasso Novis was founded, which had as its artistic directors the saxophonist Josetxo Silguero and the accordionist Iñaki Alberdi, two young performers who, twenty years later, continued to be very active in defending Basque contemporary music. Nevertheless, and despite heroic initiatives of this sort, the lack of performers and particular spaces for contemporary Basque music was increasingly unsustainable.

As the 1990s advanced, some composers, especially the younger ones, began to feel an urgent need to band together to battle the scarcity of resources that the institutions and musical agents were putting at the disposal of creating contemporary music. The definitive impulse for the associative fabric came from an Argentinian composer who had settled a few years earlier in Bizkaia, María Eugenia Luc.

In 1993, after various years training in Italy, Luc moved to Bilbao and became aware of the precarious situation of new music

---

416 The MPL, which would carry out a very proactive series of premieres throughout Spain for the next forty years, was founded in 1974 at the Second Donostia-San Sebastián Avante-Garde Music Festival. See Daniel Martínez Babiloni, "Conversar en el sosiego (I): Jesús Villa-Rojo," in *Mundoclasico.com*, September 12, 2014, at https://www.mundoclasico.com/articulo/19599/Conversar-en-el-sosiego-I--Jes%C3%BAs-Villa-Rojo (last accessed January 26, 2019).

417 Luis Daniel Izpizua, "Ostots," in "Tribuna" section, *El País*, September 4, 1998.

in Euskal Herria, but she also believed that this problem could be mitigated if the composers would join forces.[418] She took as her basis the Argentinian associations in which she had taken part in Rosario and Buenos Aires, bringing together a group of composers—including Ángel Enfedaque, José Ignacio Bilbao, Isabel Urrutia and Hilario Extremiana, among others[419]—to create the Kuraia Association. It held its first event on June 26, 1997, at the Auditorium of Deusto University, a concert shared by members of the Parisian Ensemble Arcema and a group of Basque musicians interested in performance of contemporary music. The nature of the event, midway between popularization and pedagogy, permitted a first glimpse of the nature of the proposals that the association would offer in coming years: concerts of very different natures, but also many courses aimed at composers and performers.

Another of the immediate concerns of the Kuraia Assocation was to foster electroacoustic music and multidisciplinary creation in Bizkaia.[420] Thus, KLEM (Kuraia Laboratory for Electroacoustic Music) was created, led by Iñigo Ibaibarriaga, to promote multidisciplinary creation based on music, visual arts, and also performance arts, dance, and sound installations, together with projects with great conceptual content.[421] First, in the framework of the KLEM-Kuraia Festival, and later in new workshops called *La eschucha errante*, KLEM raised awareness in Euskal Herria of some of the most advanced and experimental proposals of European and Latin American sound art and promoted the development of projects by artists such as

---

[418] Mikel Chamizo, "Respirar el sonido," liner notes, *María Eugenia Luc. De aire y luz*, CD (Madrid: Orpheus Classical, 2015).

[419] Andrea Cazzaniga, personal communication, June 26, 2018.

[420] Ibid.

[421] Ideology of the KLEM group, on the KLEM website, "Laboratorio KLEM," https://laboratorioklem.com/ (last accessed January 26, 2019).

Mikel Arce, Josu Rekalde, Juan Crego, and Elena Mendizabal. Sound artists in Gipuzkoa, however, found a place to meet, train, and develop in Audiolab, one of the departments of the creative center Arteleku in Loiola. Founded in 2003 and coordinated by Xabier Erkizia,[422] Audiolab brought to Euskal Herria a great number of artists in the field of electronic and experimental music, also promoting their collaboration with local artists; it launched sound art festivals such as ERTZ, promoted the artistic projects of composers such as Oier Etxeberria, and developed the ambitious archive Soinu Mapa, which, since 2005, has compiled hundreds of soundscapes from Euskal Herria.[423]

Some months later than the founding of the Kuraia Association, on September 21, 1997, a second association of composers, Musikagileak, was set up with the aim of bringing together creative people from the Basque Country and Navarre. According to Ramon Lazkano, one of the founders,

> in those years . . . Basque composers did not have structures that allowed us to look after our common interests, our collective activity and the exposure of our works. Groups emerged, some of which were short-lived such as Ostots, others with great support like Kuraia, and in this context a first assembly, housed naturally in the common home that is the Eresbil archives . . . was the first step that enabled us to team up and find, within our individual and disparate natures, a common impetus, the seed of our association. Some of us were still very young (Joseba Torre, Sofía Martínez . . .) and others were not so

---

[422] Audiolab path, on the Audiolab website, "Archivo>Arteleku-Audiolab 2002-2014," https://audio-lab.org/artxiboa/arteleku-audiolab-2002-2011/?lang=es (accessed 26 January 2019).
[423] See Soinu Mapa, at http://www.soinumapa.net/ (accessed on 26 January 2019).

young but with unquestionable importance (Javier Bello-Portu, Pascual Aldave, . . . ), the composers of Iruñako Taldea, and so many others who participated in the first great debate.[424]

The early years of Musikagileak focused on attracting the membership of Basque-Navarrese composers and proposing activities that would promote the popularization of and debate about composition in Euskal Herria.[425] In 2010, the association received a big boost with the creation of the Musikagileak Contemporary Music Circuit, which was held each fall in Donostia-San Sebastián, Bilbao, Pamplona-Iruñea, and Vitoria-Gasteiz, and which had as its foremost goal the popularization of the works of the associated composers: at present, more than one hundred composers of all ages, from the Basque Country and Navarre, or associated with these territories.[426]

Over the course of the years, the circuit has become the main annual showcase for new Basque music and an incentive for the creation of new works: in its 2017 season, forty-seven works by Basque composers were performed, twenty-three of which were world premieres. The agreements between Musikagileak and the Bilbao Symphony Orchestra and the Basque National Orchestra enable them moreover to carry out large-scale symphonic projects regularly.

Another sign of Musikagikleak's strategies for popularizing Basque musical creation is it membership, since 2014, of the International Society for Contemporary Music (ISCM), which has enabled works of Helga Arias, Iñaki Estrada,

[424] Ramon Lazkano, "Musikagileak," in *Dossier de presentación de Musika Bulegoa* (Vitoria: Musika Bulegoa, 2015).

[425] Ibid.

[426] Musikagileak website, "Miembros," tab. http://www.musikagileak.com/es/members/ (last accessed January 26, 2019).

and Gabriel Erkoreka to be heard in countries such as South Korea, Canada, and China.[427]

The role of these associations in supporting the infrastructures that contemporary music enjoys today in the Basque Country must not be underestimated. Over two decades, they have been able to provide the collective of Basque composers with tools that the government's cultural policies, historically more focused on subsidizing individual work or sporadic projects, had not been able to promote. The Kuraia Association gave rise to the Ensemble Kuraia, which is the specialist group that has commissioned, premiered, and defended more works than any other in the history of Basque music, and which has spread the fame of these works with numerous international tours. Musikagileak, in turn, has maintained rewarding relationships with educational centers such as Musikene, artistic centers such as the San Telmo Museum and Tabakalera, and with the *Quincena Musical,* by collaborating in the design of the programming of its contemporary music cycle. Although these associations operate under very precarious economic conditions, they have taken crucial steps toward consolidating the contemporary repertoire in the musical life of Euskal Herria.

## The Relationship with Folk Materials

A close relationship with folk materials has been constant in Basque music since the rise of musical nationalism in the late nineteenth century. The use of popular melodies, real or invented, and characteristic rhythms and dances, has been a resource to

---

[427] José Luis Besada, "ISCM 2017," interview with Iñaki Estrada and Helga Arias, in *Música viva*, radio show, Radio Nacional de España, October 29, 2017. Podcast online in http://www.rtve.es/alacarta/audios/musica-viva/musica-viva-iscm-2017-entrevista-inaki-estrada-helga-arias-29-10-17/4295044/ (last accessed January 26, 2019).

which a great number of twentieth-century Basque composers have resorted more frequently than is manifest in other European national movements. Not even during the autarchic period of the dictatorship (1939–59), in which the use of Euskara was subject to severe punishment, did Basque composers completely eradicate references to their folk motifs and language in their compositions. From 1979 on however, with the implementation of the autonomy statue, works with Basque themes flourished again. In 1980, after a phase distant from folk materials, Francisco Escudero wrote *Euskal Herriaren Salmoa*.[428] In 1981, Carmelo Bernaola composed the (already mentioned) *Béla Bartók-i Omenaldia* and, in 1989, *Abestiak*, in which he revisits Anchieta's legacy and blends it with popular music. Antón Larrauri had embraced Basque folk material already from the last years of the Franco regime, with works like *Ezpatadanza* (1972) and the *Tríptico vasco* (1975), and he continued to make use of this material regularly until his death in 2000. Between 1979 and 1983, Félix Ibarrondo wrote the powerful *Trois chouers basques a capella*, and in1980 Rafael Castro completed the first version of *Abenduaren lauean* for mime, chorus, chamber orchestra, harp, piano, and percussion, based on texts by the poet Gabriel Aresti. In the production of other Basque composers active in the 1980s, the use of Euskara and folk motifs reappears or is accentuated.

One of the most noteworthy authors for his use of folklore is Pascual Aldave (Lesaka, 1924–Donostia-San Sebastián, 2013), who incorporates it in an essentialized manner in numerous compositions for voice and piano and for choir groups. His use of popular material is usually very stylized, fluctuating between

---

[428] "After the Statute of Basque Autonomy, in 1979, Escudero went back to work on Basque subjects and texts in Basque and composed, on behalf of the government, *Euskalerriaren salmoa* (1980), without a doubt his work with the greatest extramusical nationalist content." Larrinaga, "El compositor Francisco Escudero."

modality and bitonality, a result of his training in Paris with Nadia Boulanger and Jean Françaix. Aldave was also a skilled orchestrator, with a keen sense of sound color, which he deploys especially in his most ambitious work of this period, the symphonic ballet *Akelarre* (Coven), on which he worked for ten years and was released in its final form in the *Quincena Musical* of 1996.[429] Commissioned by the Gipuzkoan provincial government in 1986, with the express request that "it should be based on and inspired by Basque popular music,"[430] *Akelarre* takes as a source of inspiration two stories by Pío Baroja: *La leyenda de Jaun de Alzate* (The Legend of Jaun de Alzate) and *La Dama de Urtubi* (The Lady of Urtubi).[431]

One should indicate, however, that in many cases the use of popular material was anachronistic in comparison with what was occurring in other European countries. Apart from some adaptations that follow Bartók's example, already outdated in the 1980s, and Ibarrondo's case, which made a political interpretation of choral singing in Euskal Herria, we largely find uses of folk material that can be traced back, due to the simplicity of approach to the morphology and processing of original material, to essentially the same point of departure that Usandizaga, Guridi, and Father Donostia already used in the early twentieth century, although in the technical and compositional garb of the tonal languages in vogue in 1970s and 1980s. In other cases, folk elements were introduced as a merely extra-musical element

---

[429] José Luis García del Busto, "Éxito de Aldave y su ballet 'Akelarre II'", in "Espectáculos" section, *ABC*, August 29, 1996.

[430] Ibid.

[431] "I considered the need to write a substantially Basque work, and for that reason I consulted texts by Don Pío Baroja. That is the origin of *Akelarre*." Statements by Aldave included in Mikel Chamizo, "El Akelarre de Aldave en el concierto más terrorífico de la OSE," in "Kultura" section, *Gara*, February 27, 2014.

linked to nostalgic feelings or a sense of identity. But Basque composers, as a group, do not seem to aim at new sonic or aesthetic discoveries that arise from the folk materials themselves as musical raw material.

The explanation of this tendency, in addition to the process of national reconstruction using culture that Euskal Herria was undergoing in the 1980s and 1990s—which entailed going over the same ground that had already been traveled before the Civil War—can also be sought in the manners of using folklore in the zones of influence of Basque Music: Spain, which during the Franco regime witnessed the prosperity of an extremely conservative approach to music with popular roots, the quintessence of which was Joaquín Rodrigo's "neo-casticismo"; and France, in whose musical history the thinking about folk motifs has always been of secondary concern.

Antón Larrauri elaborated original ideas about folk motifs in some pieces from the 1990s,[432] but we would have to wait until the end of the decade to find an unconventional and systematic approach to them. The architect of this was Gabriel Erkoreka (Bilbao, 1969), a student of Cordero at the Conservatory of Bilbao and of Bernaola at the Conservatory of Vitoria-Gasteiz, who moved to London in 1995 to complete his studies with Michael Finnissy. Since the 1970s this British composer had been working on the use of folk materials from the standpoint of philosophical and aesthetic considerations very different from those habitual in Euskal Herria. Finnissy proposes an "inauthentic" approach to folk sources, and he introduced them into his works with an attitude that sought to accentuate, instead of reconciling, the

---

[432] His most ambitious proposal is perhaps *Laiñoa* (1993), a half-hour creation for soprano, orchestra, and electronica, structured around a *zortziko* rhythm that Larrauri transforms and distorts to extreme limits. Listen to Antón Larrauri, "Laiñoa," in *Música Sinfónica Española Contemporánea 7*, CD (Audiovisuals de Sarrià, 1999).

differences between classical and popular traditions. According to Brian Marley, "Finnissy reverses the popular melodies with the musical equivalent of a complex psychology; his transcriptions go against the comfortable, sterile version of the rural life of the past as a country festival. . . . An elemental or ancestral violence seems to always be stalking us from some place in the background."[433]

After meeting Finnissy, Erkoreka immediately took an interest in these reflections on folk materials and composed *Kantak*, a concerto for piccolo and chamber group that was awarded the SGAE Prize for Young Composers in 1996. In *Kantak*, Erkoreka projected aspects of the music for *txistu* and *tamboril* using a timbre treatment of the modern instruments that reflects the rough and off-key nature of the folk instruments.[434] From this point on, all the popular material that Erkoreka uses is subjected to critical review, which turns on its head the value system traditionally associated with folk elements: their evocative power and power to create identity go up in smoke, since Erkoreka transforms them until rendering them almost unrecognizable, and their traditionally least desired aspects, such as lack of refinement, become a source for new compositional approaches.[435]

Its exquisite compositional technique, its originality in absolute terms and especially in the context of Spanish art, and the attention drawn to it by the SGAE Prize made *Kantak* a point of reference for the Basque music in the new millennium. After this, Erkoreka continued to delve into this vision of folk materials in works such as *Afrika* (2002), a concerto for marimba inspired in the sound of the *txalaparta*; *Rabel* (2003), on that bowed string

---

433 Brian Marley, "Avant," liner notes, in *Michael Finnissy, Folklore* CD (Northallerton: Metier, 1998).
434 Gabriel Erkoreka, *Comentario a Kantak*, assisted by the author.
435 Mikel Chamizo, "La transformación desde lo extremo," liner notes, *Gabriel Erkoreka. Kaiolan*, CD (Madrid: Verso, 2014).

instrument of the Cantabrian coast; and, more recently *Zuhaitz* (2016), a concerto for musicians of the oral tradition and orchestra in which the sounds of the *txalaparta*, the *alboka*, and traditional Basque singing appear integrated into an extremely complex orchestral fabric.[436]

Ramon Lazkano (Donostia-San Sebastián, 1968) was another key artist in Basque music at the turn of the century, although his creative world is linked more to thinking about the Basque cultural imaginary than to folklore itself, which appears very rarely in his scores. Lazkano was a student of Francisco Escudero in Donostia-San Sebastián and of Alain Bancquart and Gérard Grisey in the Paris Conservatory. From them he acquired a refined compositional technique and love for the craft of the great masters of the past, and also an ethical vision of exploration.[437] These influences guided his first steps on the path of a sonorous plenitude that, after a transcendental encounter with Helmut Lachenmann and his reformulation of sound as a negation of tradition, would end up opting for a concept, that of erosion, a fundamental part of his music from the mid-1990s on.[438] The dichotomy between a sound of orchestral fullness that is beautiful and inherited from the nineteenth century and early

---

[436] "I met with Xan and Thierry, and they showed me all the instruments they normally use. As a result of this meeting, I decided that the *txalaparta* would have a central role but that it would also be accompanied by other instruments of Basque folklore such as the *alboka*, the *xirula*, an *adarra* [horn], as well as other percussion instruments and, of course, voice. So, in reality, my work, rather than a concert for percussion, is a work for Kalakan and orchestra, since I have tried to fit them like a glove. Their voices will sometimes appear in a veiled form, and others directly intoning a popular song accompanied by drones from the orchestra's bass strings." In Mikel Chamizo, "Entrevista con Gabriel Erkoreka," in "Kultura" section, *Gara*, March 16, 2016.

[437] Mikel Chamizo, "Saltar al vacío para poder volar," liner notes, *Ramon Lazkano. Laboratorio de tizas*, CD (Madrid: Verso, 2013).

438 Ibid.

twentieth century, against "an implosion or internal gangrene of sound, which can no longer exist, given that the sociocultural mechanisms that gave rise to its birth have past,"[439] can be traced in works such as *Eriden* (1997–1998) and *Ur Loak* (1998), which are conceived in the manner of a diptych: a section that presents music as it seems it should be and another that, through erosion, shows a transformed aspect of the material through unconventional emission methods.

The interest in the idea of erosion led him to inaugurate, in 2001, a great cycle inspired by the *Laboratorio experimental* (Experimental Laboratory) of the sculptor Jorge Oteiza, which would last until 2011 with a total of fourteen works of great speculative scope around the sound ontology and its formal and metaphysical consequences.[440] Baptized as *Laboratorio de tizas* (Laboratory of Chalks), the cycle is one of the summits of Basque music in recent decades through its intellectual ambition and artistic results, but also its success, since it is performed regularly on the contemporary European circuit. In recent years, Lazkano's interest in the erosion of sound has grown, in the manner of an erosion process that affects all of his music, so that in recent compositions, such as *Hondar* (2016), it is extremely rare to come across traditional emission techniques on instruments.[441]

The approach of the new millennium also witnessed a rebirth of interest in the most widespread of the Basque folk instruments. Today the *txistu* continues to be deeply rooted in the imagination of Euskal Herria's identity. Many locations sustain a

---

[439] Ramon Lazkano, "'Two Feelings' with Lachenmann," *Contemporary Music Review* 23 (September 2004), 39–41.

[440] Mikel Chamizo, "El Laboratorio de tizas de Ramón Lazkano: un acercamiento crítico," final research project, Musikene, 2011.

[441] Mikel Chamizo, "Ingelesa al dente," program notes for the Basque National Orchestra concert held in   Auditorio Kursaal of Donostia-San Sebastián on April 16, 2018 (Donostia: Orquesta Sinfónica de Euskadi, 2018).

municipal *txistulari* band, and its use at institutional and political ceremonies continues, as well as in the streets. And although it is no longer used as a source of music for social dance, it continues to be associated with traditions such as the "dianas," processions that pass through towns and cities early in the morning on holidays. These practical functions, which date back at least to the eighteenth century, connected the *txistu* to a repertoire of dance pieces—such as fandangos and *biribilketas*—into which it continued to be classified until the early 1980s.

While Francisco Escudero was the director of the Conservatory of Donostia-San Sebastián, he opened the doors of regulated musical teaching to the *txitsu*,[442] a fundamental step in the training of *txistularis* with a solid basis in theory and performance. In 1983, the provincial council of Gipuzkoa began to hold the Isidro Ansorena Competition for composition of works for *txistu*, and the production for the instrument was revived. Already in those years we find some quite ambitious forays into the instrument, such as the *Concerto for txistu* by Tomás Aragüés, which premiered at Musikaste in 1984.[443] The publication of the Association of Basque *Txistularis*, the journal

---

[442] "He attained for the center several administrative distinctions, such as the rank of higher conservatory and the incorporation of *txistu* and accordion studies in regulated musical courses." Larrinaga, "El compositor Francisco Escudero."

[443] The soloist was José Ignacio Ansorena, a key figure in the modernization of *txistu*, active since the 1970s. Ansorena made improvements in the tuning of the instrument, created the *Txistu Gozoa* method, which is still the most widespread today for teaching the *txistu*, and gave it new visibility through his profile as an actor and promotor. He is also a prolific composer of works for *txistu* and director of the Donostia-San Sebastián Municipal *Txistulari* Band. See Perfil de José Ignacio Ansorena in the *Asociación de Txistularis de Euskal Herria* website, "Txistularis. José Ignacio Ansorena Miner," tab. http://txistulari.eus/es/jose-ignazio-ansorena-miner/ (last accessed January 26, 2019).

*Txistulari*, which began to appear in March 1955, also began to publish articles with a more variegated and advanced vision of the instrument's possibilities. The majority of the contemporary production for *txistu* however continued to be works linked to the instrument's popular roots.

In 1998, under the name of Berziztu, a group of people associated with the world of the *txistu* decided to band together to promote the presence of the instrument in musical life in Bizkaia. Among these was Amilibia, a *txistulari* virtuoso and current professor of the specialty at Musikene. The first meeting of Berziztu took place in Barakaldo, where the general guidelines were defined that the association would have to follow: publishing of scores, revival of music at risk of being lost, and, above all, updating the repertoire for *txistu* by commissioning new works from composers.[444] Two years later, the association relocated to Durango and, supported by the city hall of this locality, began a modernization of the *txistu*, which included the organological revision of the instrument, correcting problems such as tuning or dynamic imbalance between registers, and adding new members to the instrumental family, such as the bass *txistu*. Its policy of commissioning pieces also included composers closer to the avant-garde, which in turn expanded the range of performance techniques mastered by the *txistularis*.[445]

For compositional purposes, the *txistu* is an agile flute, with a range of two and a half octaves, many timbrical resources that remain unexploited and, if the *txistulari* accompanies himself with *tamboril* in his right hand, which offers the composer a remarkable versatility. Many composers like Jesús Eguiguren, David Cantalejo, Urtzi Iraizoz, and Francisco Domínguez have

---

[444] Mikel Chamizo, "La reinvención de un instrument," program notes for the Silboberri concert held in the Fundación BBVA of Bilbao, April 8, 2014 (Bilbao: Fundación BBVA, 2013).
[445] Ibid.

taken the *txistu*'s technical possibilities even further in the twenty-first century.

Together with the *txistu*, the folk instrument most characteristic of Basque music at present is the *txalaparta*. Rediscovered in the 1960s by the Zuaznabar brothers and later by José Antonio and Jesús Artze, and promoted in the context of the group *Ez Dok Hamairu* from 1966 on, the *txalaparta* was quickly accepted among Basque composers. In 1974, Francisco Escudero employed the *txalaparta* in his *Fantasía Geosinfónica*, but it was Luis de Pablo who, one year later, consecrated it by including it in one of the most valued creations of his catalog, *Zurezko olerkia*, for voices and wooden percussion, in which the *txalaparta* plays a structural role.[446] After that moment of novelty, however, the *txalaparta* has not been utilized with such abundance by composers, and it has remained associated instead with folk and street music. What has indeed come across is its signature sound and its idiosyncrasy for performance. Isabel Urrutia, for example, includes *txalaparta* techniques in her piece for marimba soloist *Mara-Mara* (2002),[447] and so does Gabriel Erkoreka in his concert for marimba and orchestra *Afrika* (2003). Oddly enough, one of the most successful creations for *txalaparta* in recent years has not

---

[446] "In the Pamplona meetings of 1972, I had seen the *txalaparta* being played by Artza Anaiak, from Usurbil. I had already known the instrument for more than ten years - I heard it at the opening of an exhibition by the sculptor Remigio Mendiburu in the early sixties . . . Perhaps this work is an experiment in multicultural dialogue (many of mine are. . . !), in which the txalaparta carries the singing voice." Luis de Pablo, "Zurezko Olerkia," in *Notas al programa del Concierto Especial 4* (Madrid: Fundación Juan March, 1977), 5.

[447] "This work for solo marimba is the result of the confrontation of very distinct rhythms, inspired by dances from Basque folklore, with other rhythmic forms that accelerate or decelerate 'ad libitum'. . . the auditor may perceive two different sound universes, sometimes independent, sometimes related, sometimes fused or confused . . . derived from Basque folklore and oral tradition." Isabel Urrutia, personal commentary on *Mara-mara*.

been the work of a Basque composer, but rather an Italian, Ivan Fedele, whose concerto *Txalaparta (Folkdance 2)*, premiered by the Basque National Orchestra in 2012, was subsequently performed at various locations in Italy, such as Turin in 2013 and the Venice Biennale in 2014.

## The Contact with the Singer-songwriters

The mention of *Ez Dok Amairu* compels us to take up the relationships of contemporary Basque music with this subset of urban musical forms. The influence that the singer-songwriter movement that emerged in the 1960s and was known as Euskal Kantagintza Berria (see chapter 10) has had on the field of classical music was explicitly recognized with the homages to Benito Lertxundi by the Basque National Orchestra in 1998 and to Mikel Laboa in the *Quincena Musical* of 1999.[448] In the homage to Laboa, various musicians who were very active in the Basque contemporary circuit collaborated, such as the saxophonist Josetxo Silguero and the composer Pascal Gaigne. Years later, in 2007, Elkar released a compilation CD of Laboa's music titled *Lekeitioak*, which was accompanied by program notes written by Ramon Lazkano, in which he recognized that "the artistic creation of Mikel Laboa has been, for those of us who feel or have felt immersed in Euskara, the point of orientation for the paths of doubts and questioning posed by our era."[449]

Mikel Laboa (Donostia-San Sebastián, 1934–Donostia-San Sebastián, 2008) followed the scene of contemporary music in the Basque Country very closely. He himself underwent his own experimental phase and interacted with musicians from advanced

---

[448] "Mikel Laboa vuelve con el Orfeón en el homenaje que hoy le rinde la Quincena," in "País Vasco" section, *El País*, August 5, 1999.

[449] Ramon Lazkano, sleeve notes, in *Mikel Laboa, Lekeitioak*, CD (San Sebastián: Elkar, 2007).

musical forms, and his presence was habitual at this type of concerts until a few months before his death in December 2008. Beyond his personal sympathies, Laboa's work exhibits a distinctive feature that made it unique among the multitude of Basque singer-songwriters: a notable tendency to experiment, in which he indulged freely, especially in ten pieces entitled *Lekeitioak*, which arose from the exploration of his memory and unconscious over the course of three decades, between 1968 and 1998. In these ten songs—nine, in reality, since the first one has been lost—Laboa explores the phonetic and poetic characteristics of Euskara.

The *Lekeitioak* take their name from the Bizkaian town of Lekeitio. Laboa's family took shelter there, in a farmhouse of the district of Gardata, when the Civil War broke out in 1936.[450] Laboa was only a two-year-old child, but he would remember those ten months as a refugee: memories of the death of his brother Andoni, of the passing of the German bombers on their way to Gernika on April 26, 1937, and of the difficult life in the farmhouse, where however there was no shortage of games and happiness. When he was an adult, these memories would come back to him mixed with the peculiar sound of the Euskara of the zone of Lekeitio, transformed into a sort of mythical language, since due to the repressive policies of the postwar era, Laboa forgot the language when he was still a child and would not rediscover it until the late 1950s.[451]

These "Lekeitios," with deep roots in those memories, are an exploration of the "means of expression characteristic of children and madmen,"[452] applied, in the case of Laboa, to the

---

[450] See Marisol Bastida, *Memorias. Una biografía de Mikel Laboa* (San Sebastián: Elkar, 2014).

[451] Ibid.

[452] Bernardo Atxaga, sleeve notes, in *Mikel Laboa, Xoriek 17* [CD] (San Sebastián: Elkar, 2005).

language. In his exploration of Euskara in these works, the singer-songwriter decided to ignore the meaning of the words and to dwell on the language's own special sonority, on the intrinsic expressivity of its pitch patterns, and on the blemish that it produces in the voice of the speaker.[453] Several of the *Lekeitioak* are actually sung in an imaginary language that resembles, but is not, Euskara, or that uses words in Euskara organized without meaning beyond that constructed by their phonetic combination. To the accompaniment of a guitar, which is usually simple and obsessive, Laboa also sings with shouts, onomatopoeias, guttural sounds, and other vocal resources that create a relationship between his work and the work being done in the same era by experimental singers such as Meredith Monk and Laurie Anderson, or composers such as John Cage, whose work Laboa came into contact with in 1972 at the Pamplona Meetings.[454]

"Availing himself of the *Lekeitios*, Laboa requests that we confront a new situation for Basque music," asserts Lazkano. "Using his artwork, Laboa has encouraged us to be willing to confront the plural capacity of Basque language and culture."[455] The most visible evidence of the influence that Laboa has had on Basque composers is offered by the Mikel Laboa Professorship at the University of Basque Country, which after its establishment in 2013 spearheaded a project entitled *Laboari Oihartzun*, which over the course of two years commissioned and premiered twelve chamber and symphonic pieces from contemporary composers, in which they expressed their vision of the singer-songwriter's

---

[453] Mikel Chamizo, "Pop & Rock en la vanguardia: encuentros y desencuentros," program notes for the *Pop & Rock en la vanguardia* concert (Madrid: Fundación Juan March, 2015).

[454] Ibid.

[455] Lazkano, *Mikel Laboa, Lekeitioak*.

work.[456] But Laboa is not the only proponent of the cross-fertilization between urban musics and avant-garde music. The singer-songwriter Sara Soto composed numerous works for choir and instrumental groups, among these two experimental pieces together with the sculptor Nestor Basterretxea (*Karraxis* in 1979 and *Cripta* in 1985). A more recent example is Pascal Gaigne, who has made a successful career as composer of movie scores (he won the Goya Award 2018 in this category), and who often performed as a guitarist together with singer-songwriters such as Imanol and Niko Etxart.[457]

## Choral Music

In his approach to handling the sound of Euskara, it is difficult to determine whether Laboa reflected influence from the work of the Navarrese composer Agustín González Acilu (Altsasu, 1929). González Acilu and the poet José Antonio Artze, close collaborators of Laboa, met in 1972 in Tolosa,[458] and soon they felt a mutual interest in their respective creative work. González Acilu had begun to experiment with phonetic composition in 1966, with a work of quasi-scientific approach to this subject entitled *Phonetic dilatation*. And shortly afterward in 1970, he carried out a first partial exploration of the tonological characteristics of Euskara in the *Oratorio Panlingüístico*.[459] González Acilu took an interest in composing a work entirely in Euskara after reading two

---

[456] Juan G. Andrés, "Visiones inesperadas de Mikel Laboa," in "Mirarte" section, *Noticias de Gipuzkoa*, December 10, 2014.

[457] Mikel Chamizo, "Entrevista con Pascal Gaigne," in "Kultura" section, *Gara*, April 6, 2018.

[458] Marta Cureses, *El compositor Agustín González Acilu: La estética de la tensión* (Madrid: ICCMU, 1995), 165.

[459] Gotzon Ibarretxe, "Etnología y lingüística en la obra musical de Agustín González Acilu," *Musiker* 10 (1998), 25.

books of poems that Artze had given him.[460] For this work he selected *Arrano Beltza*, a poem of great expressive force in which Artze retells tragic events in the history of Navarre; in the author's words, "a condemnation, by way of a chronicle, of the political blindness of our country." [461] Using this text, González Acilu designed a score for chamber choir with soloists that explores until its ultimate consequences the phonetic content of Artze's poem, with an expressive intensity that on some occasions engages in direct conflict with the tone or significance of the works, thus underscoring the impact of the work and its political connotations.

In 1977, the Chamber Choir of Pamplona premiered *Arrano Beltza* under the leadership of Luis Morondo, and it was greeted with success despite taking place in a context of certain tension, since Basque nationalist proclamations were made during the concert;[462] and, according to some witnesses,[463] an *ikurriña* or Basque flag was unfurled, a symbol that was still controversial in those years. After the initial performances and the recording made by the Chamber Choir of Pamplona, however, *Arrano beltza* went on to occupy an almost legendary place in Basque music: it was a well-known piece respected by many Basque composers, but the work was not performed again for more than thirty years. Its unconventional notation and the vocal virtuosity that the score requires meant that it was not within the reach of most Basque choirs, and furthermore its subject matter could become

---

[460] Ibid, 32.

[461] M.J. Alcocer and E. Hernández, "Entrevista con Agustín González Acilu y José Antonio Artze," *Unidad*, (January 1977), cited in Marta Cureses, "González Acilu: Ética y estética del límite," *Revista Internacional de Estudios Vascos* 56 (January 2011), 89.

[462] Ibarretxe, "Etnología y lingüística en la obra musical de Agustín González Acilu," 32.

[463] Mikel Chamizo, "Entrevista con David Gálvez," in "Kultura" section, *Gara*, August 20, 2017.

uncomfortable. It was the Chamber Choir of Pamplona that revived it on August 19, 2017, in the Quincena Musical of Donostia-San Sebastián.

The previous case introduces us to one of the defining aspects of current Basque choral music: its amateurism. Compositions for choral groups was one of the most important genres in Basque music throughout the twentieth century and almost all well-known composers—Usandizaga, Guridi, Zubizarreta, Beobide, Esnaola, Sorozabal, Otaño, Goicoechea, Zapirain, Uruñuela, Santesteban, Egaña, Iruarrizaga, Madina, Garbizu, and many others—dedicated an important part of their production to this genre. The density of choral groups in the 1960s was such that, in 1969, a Basque Music and Polyphony Competition was established in Tolosa, and connected to this, in 1972, the Composition Competition for Choral Masses.[464] In 1973, the Tolosa competition began to admit foreign groups;[465] and in the 1980s it attained great international prestige.[466] The competition, which promoted the defense of contemporary works among the participating choirs, enabled Basque composers interested in this repertoire to find out about the most recent trends in choral composition both in Europe and in Asia and the Americas. And, conversely, it also brought many choir directors from around the world in contact with Basque choral music.[467]

---

[464] Iñaki Linazasoro, *Tolosa: pueblo musical* (Tolosa: Ayuntamiento de Tolosa, 1985), 104.

[465] *Inicios del Certamen*, on the Centro de Información y Turismo de Tolosa website, "Certamen Coral>Historia," https://www.cittolosa.com/certamen-coral/historia/ (last accessed January 26, 2019).

[466] Mikel Chamizo, "Entrevista a Luis Miguel Espinosa," in "Kultura" section, *Gara*, November 1, 2018.

[467] "This competition has achieved two not insignificant objectives: to bring to music lovers the best contemporary choirs and enable choirs, choral societies and boys' choirs from the Philippines, India, Poland, Greece, Catalonia, and

For this reason, the composition competition associated with the choral competition sparked the interest of Basque composers, since the winning scores were published and received international attention. The first award-winners in the composition competition included composers such as Garbizu, Aramburu, Bastida, Ondarra, and Cordero.[468]

In 1975, the third prize in the Tolosa choral competition went to the Ederki choir from Valladolid, directed by a young family physician born in Hondarribia, Javier Busto, who, when he participated again in 1982, won the award for the best director in the competition. From 1977 on, Busto began composing and founded choirs that he directed himself (such as Eskifaia and Kanta Cantemus), with which he gradually perfected his knowledge of writing for vocalists. Busto soon become a very influential figure on the Basque choral circuit, training new directors who also performed his music. In 1987 and 1988 his pieces *Hiru eguberri kanta* and *Zai itxoiten* were selected as obligatory pieces in the Tolosa competition, and in 1990, so was his brief motet *Ave Maria*.[469] This last piece became part of the international repertoire thanks to the promotion carried out *a posteriori* by a Japanese choir participating in that year's competition and its publication by a Swedish publishing house, Gehrmans, which has sold more than 55,000 copies to date. Leaving aside a brief experimental period in the 1980s, which he

---

Andalusia to have Basque melodies in their repertoire. Therefore, the work performed in the competition and one of the two freely chosen are Basque in inspiration, lyrics, and music." Linazaroso, *Tolosa: pueblo musical,* 104.

[468] Inicios del Certamen, on the Centro de Información y Turismo de Tolosa website, "Certamen Coral>Historia," https://www.cittolosa.com/certamen-coral/historia/ (last accessed January 26, 2019)

[469] Ibid., "Obras obligadas," tab.

currently disavows,[470] Busto's music is characterized by a simple tonalism of Romantic nature, with peculiar harmonic features, such as unresolved dissonances, written extremely effectively so as to be comfortable for the singers.

The case of Busto's success, and that of other similar profiles such as Julio Domínguez in Galicia, served as an example for other young leaders of Basque choirs who set out on the terrain of composition under aesthetic canons similar to those of Busto. In the 1990s the names of Xabier Sarasola, David Azurza, and Junkal Guerrero began to stand out, and in the new millennium those of Eva Ugalde and Idoia Azurmendi, among others. All of these composers enjoy great diffusion in the Basque and Spanish choral circuits, thanks to pieces with pleasant melodicism that is very accessible for amateur choirs. Unfortunately, this trend has almost completely eradicated the choral productions of composers who do not share this aesthetic.

The case of *Arrano Beltza* sums up in itself the situation of choral music in the Basque Country: despite being regarded as one of the high points of Basque music in the second half of the twentieth century, its complexity means that no local chorus is able to undertake it. Ibarrondo's choral works, which are performed more often in France than in Euskal Herria, and also those of Luis de Pablo, are in a similar situation. The lack of professional choirs—with the exception of the Chamber Choir of Pamplona-Iruñea and the semi-professional Vocal Group KEA—and in many cases the aversion of directors and choir members toward avant-garde languages has brought with it the virtual disappearance of the advanced trends in choral creation in Euskal Herria. In the catalogs of composers such as Lazkano, Erkoreka, Luc, and Gerenabarrena, choral music is scarcely

---

[470] Mikel Chamizo, "Entrevista a Javier Busto," in "Eguneko gaia" section, *Gara*, December 28, 2015.

represented, and among the younger generation it is almost nonexistent. Conversely, composers specializing in choral music scarcely receive opportunities to create and premier works outside of their field. The lack of a defined cultural policy to guide the development of choral singing, one of the high points of Basque music in the twentieth century, has created a dysfunctional situation in which in the twenty-first century its evolution remains frozen.

## Education, Present, and Future

One of the main players in the standardization of the practice of contemporary music in the new millennium has been Musikene, the Higher School of Music of the Basque Country, which opened its doors in November 2001. This occurred in Donostia-San Sebastián, after a half-hearted territorial dispute that was resolved when the Donostia-San Sebastián City Hall offered one of the city's most charismatic buildings, the Miramar Palace, as the headquarters of the new conservatory. Musikene was one of the first centers in Spain to apply the new curriculum of the LOGSE[471] to musical education, which entailed incorporating superior studies of music into university-level studies. Established as a private foundation, Musikene hired as professors a group of first-rate active musicians, some of whom were very well-known, such as the flautist Jaime Martín, the violist Garth Knox, the harpist Sylvain Cambreling, and the conductor Jorma Panula. For the composition department, the center's management approached two of the young Basque composers with greater international reputations: Gabriel Erkoreka, who took charge of

---

[471] Educational System General Regulation Law. Its application to special music system teaching took place in 1999. "Order of June 25, 1999 establishing the curriculum for the higher degree in Music Education," *BOE* 158, July 3, 1999, 25473.

the subject of composition, and Ramon Lazkano, that of orchestration. And Zuriñe Fernández Gerenabarrena, Stefano Scarani, and Guillermo Lauzurika took charge of the subjects of harmony and counterpoint, composition with audiovisual media, and electroacoustics, respectively.

Although they would spend most of their academic hours with these professors, the composition students would also be exposed to even more diverse influences, since composers such as Joseba Torre, María Eugenia Luc, Isabel Urrutia, and José Luis Campana were incorporated into the optional subjects. From the opening of the center, an effort was likewise made to invite artists of great prestige to hold master classes. Kaija Saariaho, Peter Eötvös, Helmut Lachenman, and Michael Finnissy are only some of the long list of great composers who have worked with the different graduating classes of composition students at Musikene. The result of this exposure to multiple different forms of understanding creation, which was one of objectives intended by Erkoreka and Lazkano, was an enormous diversity among composers graduating from Musikene, who pursued very different aesthetic and professional paths. Among those who are better known are Mikel Urquiza, Xavier Otaolea and Ignacio Ferrando.

Research is another of the core activities in Musikene, and focuses on various areas of knowledge such as musicology, pedagogy, and artistic research, an innovative European trend that focuses on the activity of the practical musician, performer, or creator, and for whose development new conceptual models were proposed, such as that of Josu Okiñena, in his recent publication *La interpretación musical. Fundamentos científicos para su desarrollo* (Musical Performance. Scientific foundations for its Development, 2017).

Moreover, one of the most important contributions of Musikene to contemporary Basque music has been made in the field of training performers. Before the founding of Musikene, the higher conservatories of Donostia-San Sebastián and Bilbao, which followed the curriculum of studies known as *Plan 66*, did not include the specialization in contemporary music, and this was scarcely treated during the training of the instrumentalists, unless there was a specific interest on the part of the professor or student. As a result, it constituted an exception if instrumentalists trained at these conservatories could enter the job market with training adequate in technical and stylistic regards for tackling contemporary music. At the conservatory of Vitoria-Gasteiz, the familiarity with new music was significantly greater, which was a legacy of the dynamics introduced by Carmelo Bernaola in the 1980s. This repertoire however had not occupied a defined space in higher musical education in the Euskal Herria until the establishment of Musikene.

In recent years, due to the specific training in contemporary music received by its students, Musikene has given rise to different instrumental groups dedicated to this repertoire. The first was the Krater Ensemble, currently no longer active. In 2010, Xare arrived, an instrumental laboratory coordinated by Txaber Fernández, which encompasses both experimental music and popular repertoire. Another noteworthy group is the Zukan Trio, formed in 2014 by three students of the *txistu*, accordion, and percussion, which, thanks to an active policy of commissioning pieces, has been able to compile an entire repertoire for this unusual combination of instruments.

Although its implementation is still far from that in countries such as France or Germany, musical creation in Euskal Herria is in good health today. With two symphonic orchestras that support contemporary music, specialized instrumental ensembles, and very active performers, composers enjoy more

opportunities than ever before to develop their creative work in Euskal Herria. Although many of them continue to live abroad, this reality, ultimately, is also helping Basque music to internationalize: the contemporary music cycle of the BBVA Foundation, coordinated by Gabriel Erkoreka, and the contemporary music cycle of the Musical Fortnight, organized for a decade by Ramon Lazkano, have become windows upon the latest trends in European musical creation and enable contact between Basque composers and performers of international stature. A new body dependent on the Basque government, the Music Office, also promises to promote the dissemination of new Basque music both locally and internationally. All this, in addition to the fact that schools are providing more and better training for their students in this field, seems to promise a hopeful future for Basque musical creation.

## Bibliography

Andrés, Juan G. "Visiones inesperadas de Mikel Laboa." In "Mirarte" section, *Noticias de Gipuzkoa*, December 10, 2014.

Ansorena, José Luis. "Musikaste 76." *Oarso* 14 (1976): 90.

Barbería, José Luis. "Un estreno de Luis de Pablo en la Quincena Donostiarra." In "Cultura" section, *El País*, August 23, 1984.

Bastida, Marisol. *Memorias. Una biografía de Mikel Laboa.* San Sebastián: Elkar, 2014.

Bernaola, Carmelo Alonso. "Belá Bartók-i Omenaldia." In *Notas al programa del Ciclo Homenaje a Béla Bartók.* Madrid: Fundación Juan March, 1981.

Cano, María José. "Cinco promesas para Musikaste." In "Cultura" section, *El Diario Vasco*, May 15, 2006.

Casares, Emilio, ed., *14 compositores españoles de hoy*. Oviedo: Servicio de Publicaciones de la Universidad de Oviedo, 1982.

Chamizo, Mikel. "El Laboratorio de tizas de Ramón Lazkano: un acercamiento crítico." Final research project, Musikene, 2011.

———. "Saltar al vacío para poder volar." Liner notes. *Ramon Lazkano. Laboratorio de tizas*. Compact Disc. Madrid: Verso, 2013.

———. "Setenta años viviendo en el sonido." Program notes for the *Retrato de Félix Ibarrondo* concert held at the Fundación BBVA in Bilbao, January 8, 2013. Bilbao: Fundación BBVA, 2013.

———. "El Akelarre de Aldave en el concierto más terrorífico de la OSE." In "Kultura" section, *Gara*, February 27, 2014.

———. "La transformación desde lo extremo." Liner notes. *Gabriel Erkoreka. Kaiolan*. Compact Disc. Madrid: Verso, 2014.

———. "Observando los rincones de la creación." Liner notes. *Gabriel Erkoreka. Trío del agua*. Compact Disc. Madrid: Verso, 2014.

———. "Respirar el sonido." Liner notes. *María Eugenia Luc. De aire y luz*. Compact Disc. Madrid: Orpheus Classical, 2015.

———. "Ibarrondo y el txistu: un encuentro afortunado." In "Cultura" section, *Noticias de Gipuzkoa*, October 17, 2015.

———. "Pop & Rock en la vanguardia: encuentros y desencuentros." Program notes for the *Pop & Rock en la vanguardia* concert. Madrid: Fundación Juan March, 2015.

———. "Entrevista a Javier Busto." In "Eguneko gaia" section, *Gara*, December 28, 2015.

———. "Entrevista con Gabriel Erkoreka." In "Kultura" section, *Gara*, March 16, 2016.

———. "Entrevista con David Gálvez." In "Kultura" section, *Gara*, August 20, 2017.

————. "Entrevista con Pascal Gaigne." In "Kultura" section, *Gara*, April 6, 2018.

————. "Ingelesa al dente." Program notes for the Basque National Orchestra concert held in Auditorio Kursaal of Donostia-San Sebastián on April 16, 2018. Donostia: Orquesta Sinfónica de Euskadi, 2018.

————. "Entrevista a Luis Miguel Espinosa." In "Kultura" section, *Gara*, November 1, 2018.

Crespo, Txema G. "La música de Carmelo Bernaola vuelve a Vitoria." In "Cultura" section, *El País*, October 27, 2004.

Cureses, Marta. *El compositor Agustín González Acilu: La estética de la tensión.* Madrid: ICCMU, 1995.

————. "González Acilu: Ética y estética del límite," *Revista Internacional de Estudios Vascos* 56, no. 1 (January 2011): 54–106.

De Volder, Piet. *Encuentros con Luis de Pablo: ensayos y entrevistas.* Madrid: Fundación Autor, 1998.

Echeverría, Isidoro. "Musikaste 74," *Oarso* 12 (1974): 30–33.

Féron, Alain. "Ibarrondo, Félix." In *Dictionnaire des Compositeurs.* Boulogne-Billancourt: Encyclopædia Universalis France, 2016.

Gan Quesada, Germán. "Danzas de formas y volúmenes sonoros: Ramón Lazkano y su Igeltsoen Laborategia." *Musiker* 18 (2011): 349–62.

García del Busto, José Luis. "Éxito de Aldave y su ballet 'Akelarre II'." In "Espectáculos" section, *ABC*, August 29, 1996.

————. *Carmelo Bernaola: la obra de un maestro.* Madrid: Fundación Autor, 2003.

Ibarretxe, Gotzon. "Ritos y mitos en la obra musical de A. Larrauri." *BiTARTE* 11 (1997): 79–92.

————. "Etnología y lingüística en la obra musical de Agustín González Acilu." *Musiker* 10 (1998): 23–41.

————. "Luis de Pablo: notas para una etnomusicología surrealista." *Actas del IV Congreso de la Sociedad Ibérica de Etnomusicología*, edited by Karlos Sanchez Ekiza. Granada: SibE, 1998.

Iglesias, Antonio. *Bernaola.* Madrid: Espasa-Calpe, 1982.

Isasa, José Luis. *1er Festival de Música de Vanguardia. 27, 28, 29 y 30 de septiembre, San Telmo, San Sebastián.* Hand program. San Sebastián: Centro de Atracción y Tursimo, 1973.

Izpizua, Luis Daniel. "Ostots." In "Tribuna" section, *El País*, September 4, 1998.

Larrinaga, Itziar. "El compositor Francisco Escudero." In *Mundoclasico.com*, September 11, 2002. At: https://www.mundoclasico.com/articulo/3707/El-compositor-Francisco-Escudero (last accessed January 24, 2019).

Larrinaga Cuadra, Itziar, and Joseba Torre Alonso. "Ser en el sonido: entrevista a Félix Ibarrondo." *Musiker* 18 (2011): 283–326.

Lazkano, Ramon. "'Two Feelings' with Lachenmann." *Contemporary Music Review* 23 (September 2004): 39–41.

————. "Musikagileak." In *Dossier de presentación de Musika Bulegoa.* Vitoria: Musika Bulegoa, 2015.

Linazasoro, Iñaki. *Tolosa: pueblo musical.* Tolosa: Ayuntamiento de Tolosa, 1985.

Lopezortega, Joseba. "La Guerra Civil convirtió a la Bilbao Orkestra Sinfonikoa en un instrumento de propaganda franquista." In "Historias de los vascos" section, *Deia*, March 16, 2013.

Marley, Brian. "Avant." Liner notes. *Michael Finnissy, Folklore.* Compact Disc. Northallerton: Metier, 1998.

Martínez Babiloni, Daniel. "Conversar en el sosiego (I): Jesús Villa-Rojo." In *Mundoclasico.com*, September 12, 2014. At:

https://www.mundoclasico.com/articulo/19599/Conve rsar-en-el-sosiego-I--Jes%C3%BAs-Villa-Rojo (last accessed January 26, 2019).

"Mikel Laboa vuelve con el Orfeón en el homenaje que hoy le rinde la Quincena." In "País Vasco" section, *El País*, August 5, 1999.

Okiñena, Josu. *La interpretación musical. Fundamentos científicos para su desarrollo*. Madrid: Oe Oficina Editorial, 2017.

Oyarbide, Maider. "Entrevista con José Antonio Echenique." *La Quincena* 26 (March 2009): 6.

Pablo, Luis de. "Zurezko Olerkia." In *Notas al programa del Concierto Especial 4*. Madrid: Fundación Juan March, 1977.

Palacio, Daniel. "ETA contra los Encuentros de Pamplona: un desencuentro entre arte y política." *Anuario del Departamento de Historia y Teoría del Arte* 27 (2015): 53–66.

Pérez de Arteaga, José Luis. "Música clásica." In *Doce años de cultura española (1976–1987)*, edited by Luis Urbez. Madrid: Ediciones Encuentro, 1989.

"Presentación del Gobierno Vasco" *ABC*, April 25, 1980.

Rodríguez Suso, Carmen. *Orquesta Sinfónica de Bilbao. Ochenta años de música urbana*. Bilbao: Bilbao Bizkaia Kutxa, 2003.

Solar, Carmen Pilar. *Antón Larrauri Riego, 1932–2000*. Self-published in electronic form, 2016.

Urbez, Luis, ed. *Doce años de cultura española (1976–1987)*. Madrid: Ediciones Encuentro, 1989.

Urroz, Ana. "Un busto en bronce recordará en Zarautz al maestro Escudero." In "Cultura y Espectáculos" section, *El Diario Vasco*, July 30, 1993.

Vélez de Mendizabal, Josemari. "Entrevista con Ramon Labayen." *Euskonews* (online journal) 597, Ocober 21–28, 2011. At: http://www.euskonews.eus/0597zbk/elkar_es.html (last accessed January 24, 2019).

Vélez de Mendizabal, Josune. "Entrevista con Zuriñe Fernández Gerenabarrena," in *Euskonews* (online journal) 528, April 16–23, 2010. At: http://www.euskonews.eus/zbk/528/zurine-fernandez-de-gerenabarrena-compositora-bernaola-hizo-sentirme-compositora-y-no-solo-estudiante/ar-0528002001C/ (last accessed January 26, 2019).

Villasol, Jesús S. "El Festival de Música del Siglo XX se reafirma en su quinta edición." In "Cultura" section, *El País*, November 19, 1984.

Zubikarai, Antón. "Nacionalismo musical vasco, un capítulo aún por cerrar." *Cuadernos de Alzate: revista vasca de la cultura y las ideas* 2 (1985): 64–70.

# A Century of Euskal Swing: A Short History of Jazz

Mark Barnés and Patricio Goialde

## Part I: Origins of Jazz in the Basque Country (1919–1966): From 1919 up to the Beginning of the Civil War (1936)

Jazz, which emerged in the United States in the second half of the 1910s, arrived in Europe during World War I when a few American orchestras settled in Paris with the goal of offering periods of leisure for the troops deployed in the Old World. Very quickly, this music became popular, spreading rapidly to other countries like England, Germany, Italy, and Spain, such that among the headlining acts in the most important European cities it was common to see advertisements publicizing jazz-band orchestras from the end of the 1910s on.[472]

Jazz entered the Basque Country also at an early date; already in 1919 the first performance of a group listed as a jazz-band (Marcel's American Jazz-Band) took place in Donostia-San Sebastián, thus initiating a fashion that had a great boom above all in the 1920s. This was tied to tourism and the offer of leisure with which one hoped to satisfy the expectations of foreign visitors; the setting of Donostia-San Sebastián monopolized a large part of these performances.[473]

---

[472] Jeffrey H. Jackson, *Making Jazz French. Music and Modern Life in Interwar Paris* (Durham & London: Duke University Press, 2003), 16–20.

[473] A very similar situation took place on the Basque-French coast, which became a tourist center for well-off French society. In a large part of their social gatherings, dance was never lacking, or jazz orchestras of the time. We can cite as an example the La Chaumière club in Biarritz, in which its members got

A current review of jazz at that time, then, must not forget the many meanings of the term jazz-band: on the one hand, it was used to designate bands that played this new music, that is to say in its literal meaning as a "jazz band"; on the other, the term was used to name the drummers and indeed the instrument itself. Thus, by extension, the term became used to name any band that had a drum set, whether it played jazz or not. In Euskara the term *jazbana*, derived from jazz-band, has been used for many years in the Basque Country as a synonym for "small orchestra" and as such, recognized in current dictionaries.[474]

The fact that the drum set was the most novel component of these groups explains why this new music was identified with noise and din and criticized on numerous occasions when generally, one contrasted the beauty and serenity of classical music with the wild riot of jazz orchestras. Critics also noted that little by little, jazz musicians were displacing from the market those who were considered "true musicians": "What would violin virtuosos say if they knew a jazz-band is paid 75,000 pesetas monthly?" asked an anonymous newspaper reporter at the time.[475] This view opposing the two types of music, posited a similarity between the riot of jazz and the shape of modern, urban life was formed, as opposed to the tranquility of rural life and the composers who knew how reflect it; for example, Alfredo R. Antigüedad published a very important article in the Bilbao daily newspaper *El Liberal* in which he contrasts the harmony of the popular inspired music of Guridi with the noise of jazz and of the "Charleston."[476]

---

together to play bridge, dine, and dance while listening to jazz bands. See Édouard Labrune, *Côte basque. Les années folles* (Urrugne: Pimientos, 2015), 57.

[474] See "Jazbana," *Elhuyar Hiztegiak,* at https://hiztegiak.elhuyar.eus/# (last accessed March 6, 2018).

[475] "Un dancing," *El País Vasco*, June 3, 1923, 5.

[476] Alfredo R. Antigüedad, "La música de la ciudad y la música del campo," *El Liberal*, November 13, 1926, 2.

As noted above, on November 10, 1919, the first performance of a jazz-band took place in the Basque Country debuting in the Victoria Eugenia theater in Donostia-San Sebastián, Marcel's American Jazz Band.[477] Their performance was in a setting of "cinema and varieties" and headlined for a week, with two shows daily. The press of the day emphasized the novelty that the band's presence in the city involved, and also its extravagant, eccentric, and upsetting character. This meant that the performance was met with certain perplexity and doubts about its musical worth.[478]

After this performance, jazz music was fully introduced in the first half of the 1920s, linked principally to the activity of the two casinos in Donostia-San Sebastián, the Gran Casino and the Kursaal, which programmed various groups, basically in the summer; such as Padureano, Denny's Novelty Jazz-Band, and the Herné Jazz-Band. In Bilbao as well certain groups of this musical style were publicized in certain locales like the Club Marítimo del Abra, in Las Arenas-Areeta, as well as, for example, in August 1922 "a notable orchestra of jazz" made up of students from Cambridge University.[479]

---

[477] Before then, so-called modern dances (especially the one-step and the foxtrot) had been introduced in the Basque Country and their later development would be associated with jazz music. In fact, as Mario Lerena points out, in 1917 Pablo Sorozábal wrote a one-step for piano titled "The Odoro," one of the first Basque musical events related to jazz. See Mario Lerena, "'De mi querido pueblo': vasquidad y vasquismo en la producción musical de Pablo Sorozábal (1897–1988)," *Musiker* 18 (2011), 471. On the importance of these dances on the Basque scene before 1919, see also Mario Lerena, "'No me olvides': fuentes y apuntes para una memoria del jazz en la Costa Vasca (c. 1917–1927)," *Jazz-Hitz* 1 (2018), 75–95.

[478] Any related reports concerning this incident were published in *El Pueblo Vasco* (November 10, 1919), in *La Voz de Guipúzcoa* (November 11 and 12, 1919) and in *La Información* (November 16, 1919).

[479] *La Tarde*, August 7, 1922, 1.

Other locales, like the Salón Vizcaya, addressed in their advertisements the hiring of groups with an "original jazz-band," referring to the drummer.[480]

Among the numerous groups that visited Basque cities in this first phase, two well-known names in European jazz of the time stand out: the Sherbo American Band and Billy Arnold's Jazz Band, which performed in Donostia-San Sebastián in 1922. Their intention brought the Basque public closer, for the first time perhaps, to a jazz nearer to the so-called New Orleans style, characterized by collective polyphony in the thematic interpretation and in the improvised parts.

The hiring of these types of international groups, which was but a small part of the shows programmed by the casinos of Donostia-San Sebastián, depended in large part on the earnings obtained by gaming activity. In 1924, the dictatorship of Primo de Rivera ordered the prohibition of such activity, coinciding at that time with the temporary closure of the two casinos in Donostia-San Sebastián and an important change in the programming of refined leisure in the city, which became more limited due to a more restrained budget and the competition of other types of shows, like movies, which experienced an important boom at this time.

The closure of the casinos shifted jazz-bands to other locales in the cities or to private parties, using the terminology as a synonym for "dance orchestra," a group in which a drum player could not be absent. Thus, for example, La Perla del Océano, El Real Club Náutico, El Majestic Palace, el Casino de Igueldo, el Tabarín Souper Dancing, and el Gran Café del Rhin, all in Donostia-San Sebastián, were some of the clubs that programmed jazz bands in the second half of the 1920s. In its entertainment pages, the Bilbao press reflected a similar situation; thus, el Casino

---

[480]*El Liberal,* May 19, 1923, 2.

de Artistas in 1925 announced a large orchestra that included "a famous and well-received jazz-band;"[481] while the Club Vizcaya, in 1926, programmed an "orchestra with jazz-band;"[482] names that would be repeated in other locales like el Club Columnas, in which the Jazz Patiño orchestra played from 1926 on;[483] and the Salón Las Golondrinas.[484]

Among international shows in the second half of the 1920s, the presence of the *Black Follies* magazine stood out, presented here as *Gran Revista Negra* or *Revue Negre* at the end of December 1927, in the Arriaga theater in Bilbao and Victoria Eugenia theater in Donostia-San Sebastián. This show was directed by the dancer Louis Douglas, and the group included the clarinetist and soprano saxophonist Sidney Bechet, one of the principal figures in the jazz style of New Orleans, the city in which he was born and built the first part of his career before moving to Europe.

The popularity of the jazz-bands was such that soon some Basque musicians began to play in these groups. Thus, for example, the pianist Joaquín Dorronsoro led a quintet in which the presence of the drum player called "jazz-band Kroski" stood out,[485] the artistic name of a well-known musician from Donostia-San Sebastián, Luis Alberdi. One of the most notable cases is that of Carmelo P. Betoré, who conducted various groups like Sea Club Dancing, Okay, Jay, and the small orchestra Betoré. In the 1920s he made a few recordings with the Royal label (Donostia-

---

[481] *El Liberal,* February 21, 1925, 5. Later on, the Happy Orchestra Jazz performed in the same place. See *El Liberal,* June 15, 1929, 2.

[482] *El Liberal,* June 24, 1926, 5.

[483] *El Liberal,* October 20, 1926, 2. This same Columns Club later announced the "Great debut of the wonderful Nick-Hassy Jazz orchestra," which played their music in this venue until 1935. See *El Liberal,* September 17, 1927, 1.

[484] *El Liberal,* December 4, 1926, 2.

[485] *La Voz de Guipúzcoa,* February 21, 1925, 3; March 31, 1925, 10; and April 17, 1926, 12.

San Sebastián), among which we find a "Charleston" theme (RS 549, black label);[486] likewise, he published various scores related to the aforementioned "modern dances," such as "Noisy, eccentric one-step" (1924).[487] The violinist Pedro (Perico) Salinas, too, played in various jazz-band groups that were involved in movie entertainment and dances. He ended up moving to Madrid where he formed part of the celebrated orchestra Los Vagabundos.

In July 1929 the reopening of the Kursaal of Donostia-San Sebastián took place, and for this event the show *Hello Jazz* and *Two Hours in New York* by Harry Fleming were hired. Fleming also played in Bilbao at the beginning of August 1929. Also hired was the orchestra of Sam Wooding, a well-known American conductor, who had settled in Europe in the mid-1920s. According to the statements of Doc Cheatham,[488] a trumpet player in the group, Wooding played a much-varied repertory including a wide stylistic range, which must have caused some frustration among the musicians who were more interested in jazz. For this reason, according to Franco Orgaz, "when the show was over, they would go to a cabaret called *Chinatown*, in front of the Mᵃ Cristina Hotel, to play real jazz."[489] Which is to say, the musicians, once their professional duties were fulfilled, would get together in a club to participate in a kind of jam session, in which they could stick to a more jazzy repertory and with more freedom spend time on the improvised solo parts. Sam Wooding's performances in Donostia-San Sebastián constituted a high point

---

[486] *Catálogo general de discos Regal 1930: conteniendo todos los discos eléctricos publicados hasta fin de junio de 1930* (San Sebastián: Columbia Gramophone Company, 1930).

[487] Carmelo P. Betoré, "Noisy, excentric one-step" (1924), Errenteria, Eresbil-Basque Archives of Music, A'88/O-0004.

[488] José María García Martínez, *Del fox-trot al jazz flamenco. El jazz en España: 1919–1996* (Madrid, Alianza Editorial, 1996), 67.

[489] Ibid., 62.

in the history of the origins of jazz in the city since it was an opportunity to listen to jazz played to African-American musicians.

On April 5 and 6, 1930, Josephine Baker performed in the Teatro Principal of Donostia-San Sebastián. She was the principal star of the European version of vaudeville in the 1920s, accompanied on this occasion by the Demon's Jazz Orchestra. It was conducted by the maestro Demon (Lorenzo Torres), known as the "Spanish Paul Whiteman," whose band made many recordings for His Master's Voice.[490] In his tour of different cities, the artist also sang in Pamplona-Iruñea, and provoked the indignation of the most reactionary sectors of society, which tried to ban the show, but had the opposite effect by exciting the curiosity of the public even more.[491]

The first half of the 1930s was a period of marked decline in summer tourism, due to the political tension of the day and to the economic crisis,[492] which notably influenced Basque cultural and festive offerings that decreased both in quantity and in the international aspect of the subject: the hiring of foreign jazz-bands was very restricted and, indeed, the terminology began to be used less, substituted by terms like "orchestra" or "small orchestra." Nevertheless, the presence of jazz faded, becoming just another genre in the wide repertory of dance orchestras, with a limited appearance of groups specializing in the jazz of the moment. Among the foreign bands that visited the Basque Country, the presence in Donostia-San Sebastián of the German band Jazz Diamonds (May 1933) should be highlighted, as should that of the female orchestra Blue Jazz Ladies (July 1933) and the

---

[490] Jordi Pujol Baulenas, *Jazz en Barcelona 1920–1965* (Barcelona: Almendra Music, 2005), 38.

[491] T. Mendive, "Josefina Baker en Pamplona," *El Liberal,* April 12, 1930, 1.

[492] Luis Castells, "La Bella Easo: 1864–1936," in *Historia de Donostia-San Sebastián* (Donostia: Ayuntamiento de San Sebastián, 2000), 283–386.

French band Gregor et ses Grégoriens (September 1933 and March 1934, in Donostia-San Sebastián, and March 1934 in the Campos Elíseos theater in Bilbao).

As we can see from the above, jazz became known, in first place, through dance music; however, new technologies related to leisure that became popular in the 1920s and 1930s—film, radio, and recordings—contributed to the spreading of this musical genre. Jazz was a symbol of modernity not only for its newness, but also because it engaged and associated with the latest technological innovations.[493]

Film, through the screening of Hollywood movies, played an important role in spreading jazz in the 1920s and early 1930s. Headlining at that time were films like *El delirio del jazz-band*, a free translation of the original *Jazzmania* (1923), screened in May 1925, and *El jazz band del Follies* (*Pretty Ladies*, 1925), which premiered in Donostia-San Sebastián in 1926.[494] The talkies came to Basque Country in 1930 and, along with them, a new type of musical film was introduced, which in some cases had a direct relationship with jazz; thus, for example, *El rey del jazz* (*King of Jazz*, 1930), a movie about the conductor Paul Whiteman, premiered in Bilbao in 1930.[495]

Radio was another important means for the spreading of jazz, since an important part of its programming at this time was dedicated to the broadcasting of dance music that was related, as we have seen previously, to jazz of the day. For example, an analysis of the programming of Radio San Sebastián indicates the broadcasting of a great variety of musical styles, among which the presence of foxtrot, "shimmy" themes, and also a "hearing of danceable tunes of the American kind by the Jazz-band Sheverio"

---

[493] Jackson, *Making Jazz French*, 46.
[494] *La Voz de Guipúzcoa*, May 31, 1926, 10; and November 27, 1926, 12.
[495] *El Liberal*, December 13, 1930, 2.

stand out.[496] This radio station also transmitted live from the Kursaal shows by some of the orchestras programmed during the summer season, like los Galindo, Heredero, and Havane Cubains Jazz, in the repertory of which we also find "American dance music."[497]

The recording industry experienced a rapid process of globalization in the 1920s, since the principal American companies established branches in various European countries; the primary effect of this expansion was the internationalization of American music and, as a result, of jazz. In 1923 the Columbia Graphophone Company SAE arrived in Donostia-San Sebastián, and became the most important recording establishment in the Basque Country during the first third of the twentieth century. It was a subsidiary of the English Columbia company and produced recordings on two different labels: Regal and Columbia, with recordings in different styles of both local and international musicians.[498] The Regal catalog in 1924 dedicated twenty-seven pages to various dance orchestras, which in great part interpreted tunes of the foxtrot, "one-step," and "shimmy," like the Savoy Havana Band, Art Kickman Orchestra, among other groups, and authentic jazz bands like the Original Dixieland Jazz Band.[499]

## From the Civil War (1936) to the First Jazz Festival (1966)

As Iván Iglesias notes, the discourse about jazz in Spain during the Spanish Civil War and Francoist period has been supported

---

[496] *Ondas*, March 14, 1926, 10.

[497] *La Voz de Guipúzcoa*, July 29, 1930, 15; July 30, 1930, 15; and August 20, 1930, 15.

[498] Jaione Landaberea Taberna, "Guía de casas y sellos discográficos en Euskal Herria," *Musiker* 15 (2007), 373–446.

[499] *Catálogo general de discos dobles marca 'Regal,'* at http://bdh-rd.bne.es/viewer.vm?id=0000143262&page=1 (last accessed February 22, 2018).

traditionally by a series of themes: jazz was inexistent during the conflict, and after the Francoist victory, it suffered two decades of impoverishment due to the contempt of the rulers for this musical expression.[500] these valid opinions, and others like them, must be qualified since the true situation was more complicated than one could suppose from a superficial analysis.

During the war, the civil government in the provinces of Gipuzkoa and Bizkaia banned the holding of the dances in zones controlled by the insurgents.[501] As such, the presence of jazz was effectively scarce, yet it is still surprising that in a city like Donostia-San Sebastián, taken by Francoist troops on September 13, 1936, we see movies screened after that date like *La Venus Negra*, dedicated to the person of Josephine Baker, or to the aforementioned *El rey del jazz*, a tribute to Paul Whiteman.[502] It is also surprising that in the programming of Radio Requeté in Gipuzkoa and Radio España in Donostia-San Sebastián, jazz music was broadcast, with programs like "A musical evening with Paul Whiteman" or with the broadcasting of themes like "Jazz Hot" or "Solitude."[503] This all occurred despite some proposals, published in the local press shortly after the capture of the city, to eliminate programming of "these recordings of cannibalistic music, translated from the English," referring to what was called "stupid jazz music."[504]

At the end of the war, dancing was renewed with regular programming of this leisure activity in various locales in the Basque Country. It is not easy to determine what type of repertory

---

[500] Iván Iglesias, *La modernidad elusiva. Jazz, baile y política en la Guerra Civil española y el franquismo (1936–1968)* (Madrid: CSIC, 2017).

[501] *El Diario Vasco*, May 23, 1937, 6.

[502] *El Diario Vasco*, September 23, 1936, 2; and October 31, 1937, 7.

[503] *El Diario Vasco*, February 7, 1937, 2; May 15, 1937, 4; June 4, 1937, 7.

[504] Juan del Pueblo, "El cine y la radio. Observaciones del que ve y escucha," *El Diario Vasco*, September 20, 1936, 8.

these groups could have played, but the consulting of several resources reveals that, within a wide stylistic range, jazz was not missing. Thus, for example, the orchestra of Juan Pérez Heredero (Orchestra Heredero), probably the most important on the scene in Gipuzkoa in the post-Civil War period, played music of diverse genres like boleros, pasodobles, schottisches, waltzes, Latin music, and also arrangements of classical music; foxtrot tunes were never lacking, by American composers like Harold Arlen, Irving Berlin, and Cole Porter and also compositions of famous big band conductors like Duke Ellington, Count Basie, Benny Goodman, Woody Herman, and Glenn Miller.[505] The clarinetist of the Heredero orchestra during the postwar era, Ángel Amigo Vergara, confirmed in an interview the importance of American music in the orchestra's repertory.[506] In effect, when the band performed to reduced members, it was usually called "Heredero and his Swingtet."[507] It is probable that other dance bands followed a similar model as the former, for which reason these orchestras were one of the places where jazz was kept alive.[508]

At the end of the Civil War, the marquee of Bilbao began to return to normality and, along with a clear dominance of cinematographic activity, programming continued for shows in which groups related to the jazz of the day performed. In 1939, the Teatro Arriaga offered two shows that confirmed the presence of jazz: in the first "the fantastic Demon's Jazz Orchestra, with

---

[505] Juan Pérez Heredero, Fondo A80, Eresbil – Basque Archives of Music, at http://www.eresbil.com/sites/fondos/wp- content/uploads/ sites/11/2016/08/A80.pdf (last accessed February 21, 2018).

[506] Ángel Amigo Vergara, interview by Jon Bagüés, Eresbil, Errenteria, February 17, 2009, sound recording, Basque Archives of Music, F41-0494. [507] *El Diario Vasco*, January 18, 1942, 5.

[508] For example, another group, the Gurruchaga orchestra, was advertised in 1943 as "the best Swing orchestra." See *El Diario Vasco*, March 14, 1943, 2.

twelve soloist professors, artists of rhythm" was announced, led by the aforementioned Lorenzo Torres; in the second, in a show of international vaudeville the 8 Ibéricos Jazz Orchestra was programmed.[509] In March 1942, in the marquee the orchestra Manolo Bel was announced "with the eminent jazz vocalist Rina Celi," one of the principal singers of the postwar era, known for her recordings of the foxtrot, in which she at times included vocal jazz improvisations in scat style.[510] In August of the same year, the performance of the Rovira Orchestra of Barcelona was programmed in the sixth "Feria de Muestras de Bilbao," a swing and hot music band that imitated the most celebrated big bands of American music.[511]

In Donostia-San Sebastián, in the early 1940s, interesting shows relating to jazz were also announced: the Swing Quintet, with the saxophonist Napoleón Zayas, one of the dynamos on the Spanish jazz scene of the postwar,[512] played in the Tennis Club in September 1941; while in November of the same year in the Tea Room Pausi a "Tea-dance with the performance of the idol of swing Jorge Alpern and his jazz-band," was announced; Alpern was a pianist and composer who, in his own words, had arrived in Barcelona in 1940, playing jazz music, later becoming a famous composer of songs for variety shows.[513]

One of the most interesting people in Basque jazz of the 1940s was José Azarola (Zumaia, 1906–Mexico City, 1956), a pianist who played the virtuoso style of the "Harlem Stride Piano," arranged classical pieces for jazz, and introduced scat into his recordings; his recording of "Dulce Sweet" (a cover version of

---

[509] *La Gaceta del Norte*, May 16, 1939, 4; September 3, 1939, 4.

[510] *Hoja del Lunes de Bilbao*, March 2, 1942, 2; Iglesias, *La modernidad elusiva*, 172.

[511] *Hoja del Lunes de Bilbao*, August 17, 1942, 2; Iglesias, *La modernidad elusiva*, 149.

[512] *El Diario Vasco*, September 14, 1941, 3; Iglesias, *La modernidad elusiva*, 63.

[513] *El Diario Vasco*, September 14, 1941, 2; November 29, 1941, 3; and July 4, 1943, 6.

"Sue Sweet," 1943) is a fine example of his musical ideas.[514] Azarola performed on several occasions in summer festival programs in Donostia-San Sebastián in 1943 and 1944.[515] Another important musician was José "Joe" Moro (Portugalete, 1910–1980), one of the most outstanding trumpet players of "hot jazz" on the Spanish scene before and after the Civil War. He began his career in the municipal band of his native city and in the Casino de Artistas of Bilbao, before moving to Madrid.[516] At a later date, Moro worked with his own band during the whole summer season of 1959 in the Real Club Náutico of San Sebastián.[517]

In the second half of the 1940s, Vladimiro Bas, the saxophonist and clarinet player from Bilbao, known artistically as Vlady Bas, began his career. According to Rogelio Blasco,[518] in 1946 he formed the trio of Jazz Hot Club in Bilbao, along with José Torregrosa (piano) and Florentino San José (drums), a band that played several shows in the Artxanda Casino and that, at a later date, between 1949 and 1951, actively participated the program *Ritmo Club*, on Radio Bilbao. Vlady Bas subsequently moved to Madrid in 1952, from where he became an inevitable reference point when fixing a general state panorama of jazz in the second half of the twentieth century.

Among the promoters of jazz in the Basque Country in the post-Civil War period, two people of interest stand out:

---

[514] "El piano loco de José Azarola," at https://78revoluciones.wordpress.com/2015/02/05/el-piano-loco-de-jose-azarola-2/ (last accessed February 23, 2018). See also Iglesias, *La modernidad elusiva*, 149.

[515] *El Diario Vasco*, August 29, 1943, 2; July 30, 1944, 2; September 17, 1944, 2; and September 24, 1944, 2.

[516] "José Moro Casas (1910–1980): un trompetista de fama internacional," *Cuadernos Portugalujos* 20 (November 2015), 18–19, cited in Lerena, "'No me olvides'," 85.

[517] *El Diario Vasco*, July 19, 1959, 2.

[518] Rogelio Blasco, "Historia de la canción moderna en el Bilbao metropolitan," *Bidebarrieta: Anuario de Humanidades y Ciencias Sociales de Bilbao* 3 (1998), 332.

Agustín Bravo Olalde and Pío Lindegaard. The former was the author of a book titled *La música en los Estados Unidos* (Music in the United States), published in Bilbao in 1945, in which he dedicated one chapter to jazz.[519] It was probably the first time that a book about the history of music by a Basque author pointed out the existence and importance of jazz for North American and European music. The latter is known above all for his work on the radio, since from the early 1950s on he broadcast jazz through Radio Bilbao, in a program called *Drums and Double Bass* that, because of its longevity (forty-eight years on the radio), ended up having a rightful appreciation of fans of this type of music. Besides, he was the founder, in the early 1960s, of the Jazz Club of Bilbao, the organizing body along with the Hispano-American Cultural Association of Bilbao, of various shows in the Club Arizona on the Gran Vía, like the jazz septet of the Sixteenth United States Air Force Band, based in Torrejón de Ardoz.[520] The idea of having a jazz club was not exclusive to Bilbao, since in Vitoria-Gasteiz as well, after a jazz session held it the Hotel Canciller Ayala, the possibility of having such a club was put forward, according to what we read in the local press of the day.[521] In the first half of the 1960s, the presence of jazz in the Basque Country increased slightly; for example, in August 1961 the Real Club de Tenis of Donostia-San Sebastián programmed pianist Kenny Drew's band, who would later on become one of the principal figures of American jazz living in Europe, specifically in Denmark, where he made numerous recordings; in August 1963, the trumpet player Bill Coleman, an African-American jazz musician living in Europe, played at the same locale.[522] The media,

---

[519] Agustín Bravo, *La música en los Estados Unidos* (Bilbao: Escuelas Gráficas de la Santa Casa de Misericordia, 1945), 125–35.
[520] Iglesias, *La modernidad elusiva*, 273; *La Gaceta del Norte*, February 27, 1962, 2.
[521] *El Diario Vasco*, August 31, 1961, 3.
[522] *El Diario Vasco*, August 22, 1961, 12; August 18, 1963, 2.

as well, began to pay more attention to this music, with articles of a certain length that highlighted the qualities and success of jazz, like that titled "The Popularity of Jazz Music," which mentions its importance in the musical marketplace of North America and Europe, or others dedicated to covering the musical biographies of such people as Nat King Cole or to announce the publication of books on the history of jazz, like *El Jazz* by J.E. Berendt and *El verdadero Jazz* by Hugues Panassié.[523]

As a general conclusion, the role played by the two cities, Donostia-San Sebastián and Bilbao, produced a pendular movement in the development of jazz in the Basque Country: in the first period, before the Civil War, Donostia-San Sebastián played the prominent role, since the presence of jazz was tightly linked to tourist activity; in the second period, after the conflict and the initial decline, but not disappearance, of this type of music, Bilbao occupied a more important position, both because of its musicians and its initiatives in the diffusion of jazz (clubs, radio programs, and so on).

Paradoxically, this back-and-forth movement continued in the 1960s, since Donostia-San Sebastián, which did not enjoy a specific jazz environment in the period immediately before this decade, welcomed an event of great magnitude: an international jazz festival, originally motivated by reasons of attracting tourism. Thus the circle was complete that began in 1919 with the first performance of a jazz-band and that ended in 1966 with the first edition of the Jazz Festival of San Sebastián.

---

[523] *El Diario Vasco*, June 30, 1963, 16; December 20, 1964, 13; and June 20, 1965, 10.

## Part II: The Development and Institutionalization of Jazz in the Basque Country (1966–2018): From the First Jazz Festival (1966) to the Inclusion of Jazz in the Official Teaching of Music (1995)

During the 1960s the Basque Country and Navarre experienced a great social and economic transformation due to accelerated industrialization, an enormous urban expansion, and a massive tourist invasion, to the extent that their gross domestic product tripled between 1960 and 1973.

It is in this context of economic boom in which the first of the Basque jazz festivals came to be and, as mentioned above, this happened mainly with a view to attracting tourism. This was the result of the synergy of a number of fans and of certain people linked to the Centro de Atracción y Turismo de San Sebastián, among whom we find the recently deceased chemist, musicologist, and music impresario Imanol Olaizola. Having witnessed the enthusiasm shown by the public at a Count Basie concert in the Salle Pleyel in Paris in May 1964, Olaizola put forth the idea of organizing in Donostia-San Sebastián an international festival like the ones that were then taking place in Nice and Antibes (France) and Lugano (Switzerland), but that were still unknown in all of Spain.[524]

---

[524] Pello Leiñena Mendizabal, "Conversaciones con Imanol Olaizola," Musiker 16 (2008), 299–330; Imanol Olaizola Etxeberria, "Nacimiento de un Festival. Orígenes del Jazzaldia donostiarra," at http://www.euskonews.com/0448zbk/gaia44803es.html (last accessed May 13, 2018). Imanol Olaizola Etxeberria (1920–2018). The son of the composer José de Olaizola (1893–1969), his management was also linked to, besides the jazz festival, the international organ week, the Bach festival and the musical fortnight in Donostia-San Sebastián. He was, likewise, president of the Basque Symphony Orchestra, of the Easo and Maitea choruses, and of the Euskal Dantzarien Biltzarra association. There is a catalog of part of these document resources at http://www.eresbil.com/sites/fondos/es/a054-imanol-olaizola/ (last accessed April 29, 2018).

Nevertheless, tourist inducement was not the only motive for undertaking such a task, since already from the second half of the 1930s jazz had turned into a kind of "emblem of liberty, racial equality, and democracy,"[525] which meant that, considering the repressive situation of the country at the time under the dictatorial Francoist regime, jazz was seen as something transgressive, subversive, and liberating. It is precisely at this moment when the first *ikastolas* (Basque-language schools) would open as well as the movement of the various anti-Francoist singer-songwriters that would emerge throughout Spain; in the Basque case, the movement known as Euskal Kantagintza Berria, New Basque Songwriting.

Thus the first edition of the festival in Donostia-San Sebastián saw the light of day in September[526] 1966, exactly the same year in which the public presentation of *Ez Dok Amairu*[527] took place. And, due to its initial meager budget, the organizers chose to apply a formula that included a fan contest.[528] At the same time, they decided to celebrate the concerts in the emblematic Plaza de la Trinidad, a project of the architect Luis Peña Ganchegui constructed in 1963 in order to commemorate the centenary of the razing of the city walls. Moreover, they made

---

[525] Iván Iglesias, "(Re)construyendo la identidad musical española: el jazz y el discurso cultural del franquismo durante la segunda guerra mundial," *HAOL (Historia Actual Online)* 23 (2010), 125.

[526] This would be the only edition held in September because, from the second edition on, the organization decided to move it to July, so as not to conflict with the dates for the holding of the film festival.

[527] Auritz Aurtenetxe Zalbidea, "Ez dok amairu tradizioa eta modernitatea, nortasunaren bila," *Jentilbaratz* 12 (2010), 135–57.

[528] Among the members of the jury of the fan contest were representatives of the Hot Clubs of Baiona and France, and the then director of the Donostia-San Sebastián Conservatory Francisco Escudero (1912–2002), one of the most representative of Basque composers of the twentieth century. His document resources can be consulted at http://www.eresbil.com/sites/fondos/es/a123-francisco-escudero/ (last accessed April 29, 2018).

good use of the occasion to produce an exhibition of *txalaparta* with the Zuaznabar brothers in charge.

During the first decade of the history of the festival, the person responsible for hiring the artists was Pierre Lafont, then president of the Hot Club of Baiona (Bayonne) and a fan of more traditional jazz. However, in all the first editions there was practically no participation of Basque groups and, when that did happen, even if in a purely anecdotal manner, it was always in the amateur groups section.[529] Curiously, the local musician with the greatest international reputation, the saxophonist from Navarre residing in Madrid, Pedro Iturralde, was at this time making the first attempts at jazz hybridization, though not precisely with the folklore of his native land but rather with flamenco. For this he would depend on the collaboration of the very young Paco de Lucía, resulting in three recordings—two produced in Spain and a third in Germany[530]—that, as noted by Iván Iglesias, were not lacking a series of winks at political subversion. This was because of their connection with the singer Antonio Mairena and the poet Federico García Lorca, two people who were "uncomfortable" for the regime.[531]

---

[529] It was not until the fourteenth edition (1979) that a group led by a Basque musician performed among the professional groups. This was the quartet of the aforementioned saxophonist, Vlady Bas. See Jesús Torquemada, *Jazzaldia 50* (San Sebastián: Victoria Eugenia Antzokia, 2015), 197.

[530] *Jazz Flamenco, Vol. I* (Hispavox, 1967), *Jazz Flamenco, Vol. II* (Hispavox, 1968), and *Flamenco Jazz* (MPS, 1967). De Lucía figures in the credits as "Paco de Algeciras" for contractual reasons. See García Martínez, *Del fox-trot al jazz flamenco*, 199. There is a brief analysis of these recordings in Juan Zagalaz, "Contactos tempranos entre jazz y flamenco en España. Una perspectiva analítica de la serie *Jazz – Flamenco* de Pedro Iturralde y Paco de Lucía (1967–1968)," *Jazz-Hitz* 1 (2018), 127–44; and in Iván Iglesias, "La hibridación musical en España como proyección de identidad nacional orientada al mercado: el jazz flamenco," *Revista de Musicología* 28, no. 1 (2005), 826–38.

[531] Iván Iglesias, "A contratiempo: una breve historia del jazz en España," in *Jazz en español: derivas hispanoamericanas*, ed. Julián Ruesga Bono (Valencia: Generalitat Valenciana, 2015), 196.

A while later, the aforementioned saxophonist and clarinetist from Bilbao, Vlady Bas, would record three records in collaboration with the drummer and arranger Pepe Nieto on the Acción label, created in 1968 for Cadena SER, two of them in a style closer to fusion jazz and funk, *Viva Europa!* (1972) and *Rompiendo la barrera del sonido* (1973), and the other recorded live in a style closer to modal jazz than what the title would suggest, *Free Jazz: Vlady Bas en la Universidad* (1973).[532]

The Donostia-San Sebastián festival grew rapidly both in quality—due to the high standards of the artists who participated in it—and in growing popularity among the public, which contributed to the fact that Spanish public television began to transmit some of the programs starting in 1970. Nevertheless, the stylistic line of the festival remained strongly conservative. This would change in 1974 thanks to the visit of double bassist Charles Mingus, which entailed not only a widening of perspectives in the programming of the organization, but also involved a move to concerts in larger spaces than the Plaza de la Trinidad. After the historic show of Mingus, the festival celebrated its tenth anniversary by hiring none other than Ella Fitzgerald, Oscar Peterson, and Dizzy Gillespie. From then on, the great majority of big stars of jazz would play on the stages of the sports palace and bike-racing track of Anoeta, with much greater capacity than the emblematic square. Thus, everything seemed to indicate a massive reception of jazz in Donostia-San Sebastián, at least for a few days of the year.

The arrival of democracy involved increased interest not only in jazz, but also of all other kinds of urban popular music, since the new democratic institutions, hoping to show a clear desire for cultural modernization, considerably increased the budget for cultural activities and supported the development of

---

[532] Ibid., 198.

various music festivals and programs paid for with public monies.[533] Thus were born the new festivals of Getxo (1975) and Vitoria-Gasteiz (1977), both emerging initially thanks to the collaboration of the festival of Donostia-San Sebastián.[534]

The Getxo festival survived precariously until it became dependent on the local council's culture department in 1985.[535] The following year it established its group competition and, from 1989 until 2001, the festival was defined as being dedicated exclusively to European jazz. The festival in Vitoria-Gasteiz, on the other hand, focused on a more conventional formula: in 1981 it began to program the big stars and, two years later, it began to have repeat performances.[536] However, in 1990 it established the *Jazz del siglo XXI* cycle, accommodating bolder vanguard ideas.

In 1983 the Ministry of Culture promoted the first campaign of itinerant jazz, hoping that part of the shows that could only be seen in cities like Madrid and Barcelona would reach other Spanish cities. In its first edition, Bilbao was one of the three cities chosen, whose program, made in collaboration with the daily newspaper *Tribuna Vasca*, was shown in the now extinct Astoria movie theater.[537] The second edition programmed almost

---

[533] Jorge García, "El trazo del jazz en España," in *El ruido alegre: jazz en la BNE* (Madrid: Biblioteca Nacional de España, 2012), 50.

[534] For a brief review of the Basque jazz festivals, see Mark Barnés Larrukert, "Una historia sobre jazz: un acercamiento a la situación actual del jazz vasco," *RIEV* 52, no. 2 (2007), 567–89.

[535] See https://www.getxo.eus/es/getxo-jazz/el-festival/historia-getxo-jazz (last accessed May 11, 2018).

[536] Barnés Larrukert, "Una historia sobre jazz," 576. Both the Gipuzkoa and Araba festivals proudly include the history of the concerts scheduled on their respective websites: http://heinekenjazzaldia.eus/es/ediciones-anteriores-2/ and http://jazzvitoria.com/es/festival/historia.php (last accessed May 12, 2018).

[537] "Campaña itinerante de 'jazz' por ciudades españolas," *El País*, May 12, 1983, at https://elpais.com/diario/1983/05/12/ cultura/421538409_850215.html (last accessed May 12, 2018).

a hundred concerts in more than twenty Spanish cities, among them Pamplona-Iruñea;[538] even if, as Jorge García points out, its approach was somewhat centralized as if it was an extension of the jazz festival of Madrid[539]

Another of the benefits brought by democracy was the ease of proceeding with the necessary steps to open locales and clubs that offered live music. This caused a rapid proliferation of jazz throughout the territory of the state, forming a network that served as a circuit in which native musicians and foreigners on tour could engage in musical activities: to name the most prominent in the area under study here, Etxekalte, Be Bop Bar, and Altxerri Bar & Jazz, all in Donostia-San Sebastián and in this order,[540] began to present shows in the mid-1980s. Somewhat earlier, in 1982, the Boulevard Jazz Bar of Pamplona-Iruñea opened its doors, while the Bilbaína Jazz Club cultural association, established by a series of fans around Pío Lindegaard,[541] began its activities somewhat later, in 1991, although it was the Bizkaian locale that would maintain a more stable programming.

At the end of the 1980s, the great number of concerts in the Donostia-San Sebastián festival began to decline with respect

---

[538] José Ramón Rubio, "100 conciertos en el próximo festival itinerante de 'jazz'," *El País*, May 18, 1984, https://elpais.com/diario/1984/10/18/cultura/466902009_850215.html (last accessed May 12, 2018).

[539] García, "El trazo del jazz en España," 51.

[540] Fernando "Ferri" Culla, founding member of Be Bop Bar in 1985, in conversation with the author, April 2018.

[541] Per Erik "Pío" Lindegaard Gredsted-Larsen (1920–1999). Danish Consul in Bilbao, critic, and important champion of jazz whose radio program *Drums and Double Bass* was broadcast for forty-eight years (1952–1999). His archive can be consulted in the library of the "Andrés Isasi" music school in Getxo (Bizkaia). At http://www.getxo.eus/es/musika-eskola/fonoteca/colecciones-biblioteca (last accessed April 29, 2018). See also Igor Cubillo, "La familia de Pío Lindegaard cede a Getxo 20.000 artículos relacionados con el jazz," *El País*, December 16, 1999, at https://elpais.com/diario/1999/12/16/paisvasco/945376821_850215.html (last accessed April 29, 2018).

to public attendance, to such a point that in 1988 a situation of economic deficit was reached, which made City Hall decide to delegate the organization of the festival to a private concern, Tiburón Concerts. This company opted for a model of mixed programming, in the manner of festivals like Montreux (Switzerland), in which styles not necessarily categorized as jazz were accommodated. However this formula did not work out, since in the three editions in which it was tried (1989–1991) not only did it fail in its attempt to attract the desired audience, but also in programming such artists as Kenny G[542] led the festival to lose prestige. From 1992 on, the organization returned to the city administration and retook the Plaza de la Trinidad as the main location for its concerts, although it would add new spaces in the city—the terraces of the City Hall and the Council Chambers of the same until 1998, the auditorium of the Kursaal and its terraces from 1999, the beach of Zurriola from 2002, the Victoria Eugenia theater from 2007—and programed numerous free concerts with the clear intention of bringing jazz to the streets and generating a fan base among the population of Donostia-San Sebastián and its visitors.

In 1990 *Jazz aux Remparts* in Baiona was born, and joined the Basque summer jazz offerings, since it was also held in July. Directed by the trumpet player Dominique Burucoa, the festival in Lapurdi was different from the others in that it voluntary avoided the presence of the big stars in favor of less famous names, yet of no less quality.

Whether it was because of the influence shown by the festivals themselves, or by the proliferation of jazz clubs and the various jam sessions that were organized, or because of the effort of diffusion by the media, what is certain is that by the 1980s and

---

[542] "Pat Metheny on Kenny G," Jazz Oasis, at http://www.jazzoasis.com/methenyonkennyg.htm (last accessed May 13, 2018).

early 1990s we see a greater Basque participation both in the Donostia-San Sebastián festival and in the statewide tour of jazz clubs. To already classic names like Pedro Iturralde, Vlady Bas, and Michel Portal, we could add the names of other musicians of note from that time, as is the case of the saxophonists Javier Garayalde, Iñaki Askunze, Mikel Andueza, Gorka Benítez, Víctor de Diego, Santi Ibarretxe, Jon Robles, Jean-Louis Hargous, Iñaki Arakistain, and the Pole residing in Bilbao since 1954, Andrzej Olejniczak; the trumpet players Jackie Berecoechea, Dominique Burucoa, and Juan de Diego; the guitarists Jean-Marie Ecay, Ángel Unzu, and the Basque-Argentinian Dani Pérez; the pianists Tomás San Miguel, Iñaki Salvador, and the New York native also rising in Bilbao, Joshua Edelman; the double bassists Javier Colina and Gonzalo Tejada; the drummers Antoine Gastinel and Ángel and Víctor Celada; the vocalists Paula Bas, Itxaso González, and Miren Aranburu; and those from bands like Odeia, Eiderjazz, Kursaal, Pork Pie Hat, Tálamo, Fausto, Naima, La Noche, Infussion, and Zubipeko Swing, among many others.[543]

Perhaps we could consider the musicians of this generation the Basque equivalent of what Robert Gottlieb terms "soldiers of jazz,"[544] since they reached a high level of excellence at a time when it was frankly very difficult to have access to knowledge due to a lack of an advanced educational system and the non-existence of technological tools available today. Not for nothing did a large number of these

---

[543] Elena López Aguirre, "¿Hubo un jazz vasco?" in *Historia del rock vasco: edozein herriko jaixetan* ([Vitoria-Gasteiz]: Aianai, 2011), 437–56.

[544] Robert Gottlieb, ed., *Reading Jazz: A Gathering of Authobiography, Reportage, and Criticism from 1919 to Now* (New York: Vintage Books, 1999), cited in Mikel Andueza Urriza, "Análisis de la situación de la enseñanza del saxo jazz en la Comunidad Autónoma Vasca y Navarra," PhD dissertation, Universidad del País Vasco (UPV-EHU), 2017, 62. https://addi.ehu.es/bitstream/ handle/10810/25888/TESIS_ANDUEZA_U RRIZA_MIKEL.pdf? sequence=1&isAllowed=y.

musicians find it necessary to go outside the borders of the Basque Country to foster their musical development.

Except for those special few who had the opportunity to go to the most important American schools or other isolated cases in which they decided to be educated in cities like London, Paris, Amsterdam, and Copenhagen, the majority of Basque musicians would move to Madrid and, above all, to Barcelona, which was at the time the most important center for jazz in the country, besides housing the Taller de Músics (music workshop) and the Classroom of Modern Music and Jazz. These were two educational centers that, although not able yet to offer official academic degrees, included an international teaching staff and used a pedagogical method based on the one in use at the prestigious Berklee College of Music in Boston.

Several of these Basque musicians took up residence in the Catalan city, while others opted to study there and return home later. Some of the latter taught in academies or private schools that began to emerge in the Basque Country toward the end of the 1980s, being pioneers those in Donostia-San Sebastián: Studio 4 Music School Musikarte;[545] and fundamentally Jazzle.[546] The latter came about through the efforts of Alberto Lizarralde, Sorkunde Idigoras, Patri Goialde, and Rodolfo Ramos in 1988,[547] and would become a reference point for jazz studies and improvised music up until the introduction of a jazz specialty in the curriculum of the official schools of music. In 1994, Lizarralde

---

[545] *Boletín Oficial del País Vasco*, no. 161, Friday, August 26, 1988, at https://www.euskadi.eus/y22- bopv/es/bopv2/ datos/1988/08/8801936a.shtml (last accessed April 29, 2018).

[546] Official website of the Departamento de Administración Pública y Justicia del Gobierno Vasco, register of associations, "Jazzle" (Música Moderna y Jazz), http://www.euskadi.eus/gobierno-vasco/-/asociacion/jazzle-musica-moderna-y-jazz/ (last accessed April 28, 2018).

[547] J. T., "Jazzle, un centro para estabilizar la difusión y enseñanza del jazz en Euskadi," in "Kultura" section, *Egin*, September 18, 1988.

and Idigoras also created the Zirrara record collection,[548] specializing in improvised music and Basque jazz. Moreover, between 1999 and 2003, they organized the interdisciplinary festival of the avant-garde Plaza.[549]

In 1991, a little after the founding of Jazzle, its equivalent in Bilbao would be established, Mr. Jam, which is still active today[550] although its teaching program is not limited to jazz but also encompasses rock and similar styles.

## From the Inclusion of Jazz in the Official Schools of Music until Today (2018)

As a result of the growing interest evoked by the new schools of modern music that were emerging throughout the land, the official institutions reconsidered the integration of urban popular music in the curricula of official studies of music during the 1990s. Thus, in 1990 the restructuring of the national educational system occurred with the introduction of the Ley de Ordenación General del Sistema Educativo (General Law of Organizing the Educational System, LOGSE).[551] Two years later, a law of the Ministry of Education and Science was published that noted that musical studies should accommodate styles like jazz, pop, and rock.[552] And, finally, in 1995 a royal decree was published

---

[548] See http://www.zirrara.info/ (last accessed May 19, 2018).

[549] See http://festivalplaza.org/ (last accessed May 19, 2018).

[550] See "MrJam cumple 25 años," at http://mrjam.com/conocenos/69-presentacion/167-mrjam-cumple-25-anos (last accessed May 18, 2018).

[551] Ley Orgánica 1/1990, de 3 de octubre, de Ordenación General del Sistema Educativo, *Boletín Oficial del Estado*, no. 238, Thursday, October 4, 1990, 28927–28942, at
https://www.boe.es/boe/dias/1990/10/04/pdfs/A28927-28942.pdf (last accessed May 20, 2018).

[552] Orden de 30 de julio de 1992 por la que se regulan las condiciones de creación y funcionamiento de las Escuelas de Música y Danza, *Boletín Oficial del Estado*, no. 202, Saturday, August 22, 1992, 29396–29399, at http://www.boe.es/boe/dias/1992/08/22/pdfs/A29396-29399.pdf

by which jazz was established in the higher education curriculum in music schools, along with other courses of study that until then had not been accommodated in the official curricula, like flamenco, ethnomusicology, and the instruments of traditional and popular music.[553] With this new legal framework, various institutions would establish a concentration in jazz within the higher studies. In the case of the Basque Country, the private foundation of the higher school of music in the Basque Country (Musikene),[554] based in Donostia-San Sebastián, began functioning in the 2001–2002 school year, although the jazz elective would be established a little later.[555] And in the case of Navarre, it would be the Superior Conservatory of Music in Navarre,[556] founded in Pamplona in 2002.

The new legislation envisioned consequently the possibility of studying jazz both at the elementary level, in the

---

(last accessed May 20, 2018).

[553] As prescribed by Real Decreto 617/1995, de 21 de abril, por el que se establece[n] los aspectos básicos del currículo del grado superior de las enseñanzas de Música y se regula la prueba de acceso a estos estudios, *Boletín Oficial del Estado*, no. 134, Tuesday, June 6, 1995, 16607–16631, at https://www.boe.es/boe/dias/1995/06/06/pdfs/A16607-16631.pdf (last accessed May 20, 2018).

[554] As prescribed by Decreto 73/2001, de 24 de abril, de implantación en la Comunidad Autónoma del País Vasco de los estudios superiores de Música de acuerdo con la Ley de Ordenación General del Sistema Educativo, *Boletín Oficial del País Vasco*, no. 86, Tuesday, May 8, 2001, 9031–9033, http://musikene.eus/wp-content/uploads/BOPV73-2001.pdf (last accessed May 20, 2018).

[555] The specialties of piano, guitar, electric bass, double-bass, drums, and voice were introduced in the 2002–2003 school year. In the following school year, 2003–2004, the same would be done for the specialties relating to wind instruments.

[556] As prescribed by Orden Foral 423/2002, de 27 de agosto, del Consejero de Educación y Cultura, por la que se establece el currículo de grado superior de las enseñanzas de música en la Comunidad Foral de Navarra, *Boletín Oficial de Navarra*, no. 123, Friday, October 11, 2002, 9080–9098, at http://www.navarra.es/home_es/Actualidad/BON/Boletines/2002/123 (last accessed May 20, 2018).

public music schools, as well as higher education, in the superior conservatories. However, in the exceptional situation that existed until finally the first higher degrees materialized, the Basque government created an "authorization for special teachers in the music schools" with the aim that musicians without official degrees could teach courses in modern music in the aforementioned public schools. The result of this new situation was that both students and teachers in private centers like Jazzle would migrate to these public schools—the Municipal School of Music and Dance of Donostia-San Sebastián being the focal point of such schools—which hastened the closure of Jazzle in 2005 and provoked a series of bureaucratic conflicts tied to the new legislative norms.[557]

On the other hand, as we have seen, jazz had begun to find a place both in primary education as well as in higher education. However, it found no place at the intermediate level, that is to say, in the professional conservatories. Thus, it happened that to gain access to a higher level of jazz studies, aspiring students had to face a demanding entrance examination, but still there was no place in which students could prepare for such an aptitude test. This is a problem that exists even today, although there are certain centers that have tried to remedy the situation bit by bit; such is the case with the following professional conservatories: "Francisco Escudero"[558] in Donostia-San Sebastián, "Juan Crisóstomo de Arriaga"[559] in Bilbao; "Jesús Guridi"[560] in Vitoria-Gasteiz, and "Pablo Sarasate"[561] in

---

[557] Mikel Andueza Urriza, "Análisis de la situación de la enseñanza del saxo jazz en la Comunidad Autónoma Vasca y Navarra," 72–75.

[558] See http://conservatorioescudero.eus/es/ (last accessed May 26, 2018).

[559] See http://www.conservatoriobilbao.hezkuntza.net/web/guest/inicio (last accessed May 26, 2018).

[560] See http://www.conservatoriovitoria.com/es/index.php (last accessed May 26, 2018).

[561] See http://conservatoriopablosarasate.educacion.navarra.es/ (last accessed May 26, 2018).

Pamplona-Iruñea, as well as the "Joaquín Maya"[562] music school in Pamplona-Iruñea and the Errenteria Musikal[563] music school in Gipuzkoa. At this moment, however, they can do so by means of separate courses, without the organization and stability of an official and educational project to support them. Thus, many of those aspiring to a higher level decide to study in the private sector, either with private teachers or resorting to specialized centers in the area under study, like the aforementioned Mr. Jam and the Jazz Cultural Theatre,[564] both in Bilbao, and the Zabalza School of Music[565] in Pamplona-Iruñea.

Despite the evidence of certain incongruities like those mentioned above, the process of the institutionalization of jazz in the Basque Country continued. On the one hand, in 1977 the four biggest jazz festivals (Donostia-San Sebastián, Getxo, Vitoria-Gasteiz, and Baiona) undertook a promotional campaign together abroad with the support of the Basque government and the Regional Council of Aquitaine, offering presentations in Barcelona, Madrid, Bordeaux, Paris, London, and New York. During those same years, they received the Prize for Tourism given out by the Tourist Council of the Basque government.[566] However, the French-Basque festival came to an end in 2002, after having held its thirteenth edition.

On the other hand, new smaller festivals were emerging throughout the Basque territory: in 1990, the Arriola Jazz-Blues

---

[562] See http://www.pamplona.es/VerPagina.asp?IdPag=203&Idioma=1 (last accessed May 26, 2018).
[563] See http://musikal.errenteria.eus/es/ (last accessed May 26, 2018).
[564] See http://jazzculturalbilbao.com/ (last accessed May 26, 2018).
[565] See http://escmzabalza.blogspot.com.es/p/inicio.html (last accessed May 26, 2018).
[566] "Crónica de la 32 edición del Festival de Jazz de San Sebastián," at http://heinekenjazzaldia.eus/es/historia/32-edicion-1997/ (last accessed 11 May 11, 2018).

festival in Elorrio (Bizkaia) started;[567] in 1995, the Jazz Festival of Pamplona-Iruñea began (and was active until 2000) and later gave rise to the engagements of Jazzfermín (1998) and Jazz in the Street (2001);[568] and in 2004, Debajazz began.[569] Some were sponsored by the Basque government, the provincial council of Gipuzkoa, and the city halls of Elgoibar, Soraluze, Elgeta, Deba, and Mutriku, and organized by the recording company Gaztelupeko Hotsak, which covers the label specializing in Basque jazz Errabal.[570] In turn, Gaztelupeko also coordinates the Blues-Jazz of Bizkaia circuit, which includes the towns of Leioa, Basauri, Zornotza, Markina, and Ermua.[571] Also in Bizkaia, but now with private funding, we find the case of the 365 Jazz Bilbao, a meeting organized by the Bilbao Foundation 700-III Millenium Fundazioa (2007).[572] In the case of Araba, 2006 would see the establishment of Jazzaharrean, the jazz festival of the Old Quarter of Vitoria-Gasteiz.[573]

And third, the offering of courses and seminars in which one could acquire knowledge of jazz was gradually growing. Taking advantage of the visits of great musicians who came to play in the city, the Vitoria-Gasteiz festival began to schedule them to do so in 1985. Thus, musicians of the stature of Joe Pass,

---

[567] See http://www.arriolaka.eus/es/festivales/jazz-bluess/ (last accessed May 21, 2018).

[568] "Yerbabuena: veinte años y unos cuantos días de jazz en Pamplona." Interview with Pilar Chozas by Pachi Tapiz, at https://www.tomajazz.com/web/?p=25312 (last accessed May 21, 2018). [569] "Debajazz/Ibentoko Jazza Debabarrenian. El jazz no se acaba con el verano," at http://www.hotsak.com/festivales/debajazz-ibetondoko-jazza-debabarrenian?set_language=fr (last accessed May 21, 2018).

[570] Errabal-Jazz, at http://www.hotsak.com/Errabal-es (last accessed May 21, 2018).

[571] Blue Jazz of Bizkaia circuit, at http://www.hotsak.com/festivales/circuito-blues-jazz-de-bizkaia (last accessed May 21, 2018).

[572] 365 Jazz Bilbao, at http://www.bilbaopedia.info/365-jazz-bilbao (last accessed May 21, 2018).

[573] Jazzaharrean: Gasteizko Alde Zaharreko Jazz Jaialdia, at https://jazzaharrean.wordpress.com/ (last accessed May 21, 2018).

Monty Alexander, Wynton Marsalis, and Pat Metheny worked as teachers in these courses and, between 1998 and 2008, these seminars were taught by musicians from the prestigious Juilliard School of New York. The Getxo Festival also organized seminars occasionally, however not with the regularity of the festival of Araba and, in the case of Gipuzkoa, one should mention the creation of the International Jazz Seminar of Zarautz in 1999—which was active until 2009 and was organized in collaboration with Musikene from 2004—thus coinciding with the dates of the Donostia-San Sebastián festival. Connected to this seminar, in 2003 the Pyrenees Jazz Orchestra was born, a project subsidized by three parties: the Basque government, the Navarrese government, and the Department of Aquitaine. And it involved the participation of musicians from the three regions, which is why it was considered the first "trans-border" big band of Europe.[574]

It goes without saying that, parallel to the regulated and formal presentation of jazz, since the very beginning of its history and all over the world, jazz has also been transmitted in an informal way or, at least, not in a formal manner. Although it is impossible to mention all the musicians in the area under study who have brought their experience to this field, we would like to recall the person of the Austrian double bassist Reinhard Valeruz, resident in the Basque Country from 1971 until his death in 2003. Given the nickname "Renato" by those closest to him, he organized weekly workshops in various cities like Bilbao, Pamplona-Iruñea, Logroño, and in his own home in Errenteria

---

[574] Dossier de la Pirineos Jazz Orchestra, at http://www.turismonavarra.es/NR/rdonlyres/51E217C4-780C-4724-B284-F338E437AACF/6283/DossierPirineosJazzOrchestra1.pdf (last accessed May 21, 2018). Carlos Pérez Conde, interview with Iñaki Askunze (Pirineos Jazz Orchestra), December 2003, at http://www.tomajazz.com/perfiles/askunze_inaki_pirineos_2003.htm (last accessed May 21, 2018).

(Gipuzkoa), thus becoming an important teacher and disseminator of jazz throughout the Basque-Navarre territory.[575]

The economic crisis that began in 2008 had the result that many recording labels as well as some smaller festivals, clubs, big bands, jazz schools, and seminars gradually closed; moreover, this obligated the big festivals to turn to private financing more and more in order to survive, a strategy not limited only to jazz or the Basque Country.[576] Since then, these festivals have often been criticized for their excessive commercialization and for accommodating musical endeavors whose principal objective seems to be to garner the biggest attention possible from the media, independent of their authenticity or their tie to the jazz style.[577] Not without effort, the social rituals that occur during festivals go beyond the traditional reception of jazz by the typical small audience to become giant mass events with an important social and economic impact.[578] This is something that has begun to attract the interest of anthropologists.[579]

However, despite the various economic problems and the reception of some of the public, without a doubt, Basque jazz activity has grown continuously. An example of this would be the new big bands that have emerged linked to the distinct educational

---

[575] Marcelo Escrich Bayón, "10 años de Jazz en el Conservatorio Superior de Navarra. Presente y futuro de la planificación pedagógica," Master's Thesis, Universidad Pública de Navarra, 2012, 15–16.

[576] Tino Carreño Morales, "La gestión de festivales en tiempos de crisis: análisis de las estrategias financieras y laborales e impacto de la recesión económica," PhD diss., Universitat de Barcelona, 2017.

[577] Leo Sánchez, "La ambigua personalidad del festival de jazz," *Cuadernos de Jazz* 119–120 (2010) 87–88; Chema García Martínez, "El tocino y la velocidad," in "Cultura" section, *El País*, July 16, 2016.

[578] José Manuel Gómez, "El impacto de los festivales," in "Cultura" section, *Tiempo*, June 25, 2012; EFE, "Los tres festivales generan 46 millones de euros para San Sebastián," In "País Vasco" section, *El Mundo*, June 3, 2017.

[579] Carmen Díez Mintegui and Jone M. Hernández García, "La culpa fue del... jazz(aldia). O de cómo una ciudad se transforma en festival," *Musiker* 17 (2010), 329–64.

centers. Thus, in the case of public music schools, there are the Big Band of the School of Music and Dance of the city hall of Donostia-San Sebastián, the Deba Musika Eskola Big Band, and the Big Band Berri of the "Luis Aramburu" school in Vitoria-Gasteiz; in the case of the professional conservatories, there are the Gasteiz Big Band, the Pablo Sarasate Big Band, the Francisco Escudero Big Band, and the EIJO[580] project; and, in the case of the higher music schools, there are Cherokee Big Band, linked to the Conservatory of Navarre, and the Reunión Big Band and the Free Da Orkestra linked to Musikene.

Moreover, for more than a decade now, the two centers have begun to offer higher degrees in jazz, for which reason the proliferation of musicians trained in the region has been unstoppable. Sadly, and despite the high standing of many of them, we are forced by space restrictions in this text not to be able to mention them.

Despite all this, the complaints among musicians are constant because of their limited presence both in the jazz festivals and in the press, and obviously, this is something that does not only happen in the Basque Country.[581] To try to alleviate this deficiency, in 2006 the Jazzaldia of Donostia-San Sebastián began to introduce a dozen proposals selected from a competition of local groups that took place months before the festival. Later, in April 2013, Jazzaldia signed a contract with Musikene in which the former looked forward to the participation of its alumni groups, as well as the free access to the several master classes organized by the festival.[582]

---

[580] Euskadiko Ikasleen Jazz Orkestra, at https://eijoweb.com/inicio/ (last accessed May 26, 2018).

[581] See the manifesto declaring support for "Nuestro Jazz," at http://www.tomajazz.com/clubdejazz/roundjazz/manifiesto_nuestro_jazz.h tm (last accessed April 29, 2018)

[582] Official website of Musikene, Higher School of Music of the Basque Country, "Convenios y colaboraciones externas," at http://musikene.eus/musikene/convenios-y-colaboraciones-externas/ (last accessed May 30, 2018).

One of the criticisms of the local proposals presented in these festivals has to do with doubts relating to the existence of a specific type of characteristic jazz, that is to say, referring to the debates generated concerning the existences or non-existences of a particular "Basque-jazz"[583] since, except for the rare experiments of hybridization with Basque folklore that have been made, the accurate use of indigenous instruments, and the use of Euskara in the texts, the great majority of proposals put forth follow a post- or neo-bop esthetic and, in the case of vocal jazz, the use of English is widespread.

This problem is related to a series of critiques concerning the process of formal schooling that has been developing at an international level over various years, fundamentally related to the failure of official programs of jazz instruction to develop the authentic voice of the students, excessive pedagogical codification, and the canonization of a particular repertory, apart from the real contradiction between the informal ambiance in which jazz developed historically and the formal ambiance of advanced instruction that had to adopt a Eurocentric focus, imitating the world of classical music education that it was so criticized some years ago.[584]

Nonetheless and despite several mishaps it has suffered throughout its recent history, the institutionalization of jazz in the Basque Country is a reality today and our contemporary musicians are better trained than ever. However, we should not forget that there are still some loose ends to tie up, like the normalization of

---

[583] Ainara Zubizarreta Gorostiza, "Jazz a la koxkera," at http://www.culturalresuena.es/2017/05/jazz-la-koxkera/ (last accessed April 29, 2018).
[584] David Ake, "Learning jazz, teaching jazz," in *The Cambridge Companion to Jazz*, ed. Mervyn Cooke and David Horn (Cambridge: Cambridge University Press, 2002), 260–68, cited in Escrich Bayón, "10 años de Jazz en el Conservatorio Superior de Navarra," 17–21.

the study plans at the high school level; producing a stable circuit in which musicians can present their proposals precisely at the moment when the most important club in the Basque Country is at a crisis point;[585] and, of course, that the ideas for debate to be kept open between the new-traditionalist and anti-traditionalist positions in the teaching carried out in the higher music schools.[586]

## Bibliography

Ake, David. "Learning Jazz, Teaching Jazz." In *The Cambridge Companion to Jazz*, edited by Mervyn Cooke and David Horn. Cambridge: Cambridge University Press, 2002.

Andueza Urriza, Mikel. "Análisis de la situación de la enseñanza del saxo jazz en la Comunidad Autónoma Vasca y Navarra." PhD dissertation, Universidad del País Vasco (UPV-EHU), 2017. At: https://addi.ehu.es/bitstream/handle/10810/25888/TE SIS_ANDUEZA_URRIZA_MIKEL.pdf?sequence=1&i sAllowed=y.

Antigüedad, Alredo R. "La música de la ciudad y la música del campo." *El Liberal*, November 13, 1926.

Aurtenetxe Zalbidea, Auritz. "Ez dok amairu tradizioa eta modernitatea, nortasunaren bila." *Jentilbaratz* 12 (2010): 135–57.

---

[585] Bilbaína Jazz Club Kultur Elkartea, "SOSBJC, Salvemos la Asociación," at http://www.bilbainajazzclub.org/sosbjc-salvemos-la-asociacion/ (last accessed on May 26, 2018).

[586] Escrich Bayón, "10 años de Jazz en el Conservatorio Superior de Navarra," 42–43 and 71–72.

Barnés Larrukert, Mark. "Una historia sobre jazz: un acercamiento a la situación actual del jazz vasco." *RIEV* 52, no. 2 (2007): 567–89.

Blasco, Rogelio. "Historia de la canción moderna en el Bilbao metropolitano." *Bidebarrieta: Anuario de Humanidades y Ciencias Sociales de Bilbao* 3 (1998): 329–45.

*Boletín Oficial del País Vasco* 161, Friday, August 26, 1988. At: https://www.euskadi.eus/y22-bopv/es/bopv2/datos/1988/08/8801936a.shtml (last accessed on April 29, 2018).

Bravo, Agustín. *La música en los Estados Unidos*. Bilbao: Escuelas Gráficas de la Santa Casa de Misericordia, 1945.

"Campaña itinerante de 'jazz' por ciudades españolas." In "Cultura" section, *El País*, May 12, 1983. At: https://elpais.com/diario/1983/05/12/cultura/4215384 09_850215.html (last accessed on May 12, 2018).

Carreño Morales, Tino. "La gestión de festivales en tiempos de crisis: análisis de las estrategias financieras y laborales e impacto de la recesión económica." PhD dissertation, Universitat de Barcelona, 2017.

Castells, Luis. "La Bella Easo: 1864–1936." In *Historia de Donostia-San Sebastián*. Donostia: Ayuntamiento de San Sebastián, 2000.

*Catálogo general de discos Regal 1930: conteniendo todos los discos eléctricos publicados hasta fin de junio de 1930*. San Sebastián: Columbia Gramophone Company, 1930.

Columbia Gramophone Company. *Catálogo general de discos Regal 1930: conteniendo todos los discos eléctricos publicados hasta fin de junio de 1930*. San Sebastián: Columbia Gramophone Company, 1930.

Cubillo, Igor. "La familia de Pío Lindegaard cede a Getxo 20.000 artículos relacionados con el jazz." In "País Vasco" section, *El País*, December 16, 1999. At: https://elpais.com/diario/1999/12/16/paisvasco/94537

De Alba Eguiluz, Baikune. "Las escuelas de música del País Vasco. Análisis de una realidad educativa." PhD dissertation, Universidad del País Vasco (UPV-EHU), 2015. At: https://addi.ehu.es/bitstream/handle/10810/17750/9082-379-8-DeAlbaTH-INet.pdf?sequence=1&isAllowed=y.

"Debajazz/Ibentoko Jazza Debabarrenian. El jazz no se acaba con el verano." *Gaztelupeko Hotsak*. At: http://www.hotsak.com/festivales/debajazz-ibetondoko-jazza-debabarrenian?set_language=fr (last accessed May 21, 2018).

Decreto 73/2001, de 24 de abril, de implantación en la Comunidad Autónoma del País Vasco de los estudios superiores de Música de acuerdo con la Ley de Ordenación General del Sistema Educativo. *Boletín Oficial del País Vasco* 86, Tuesday, May 8 (2001): 9031–33. At: http://musikene.eus/wp-content/uploads/BOPV73-2001.pdf (last accessed May 20, 2018).

Díez Mintegui, Carmen, and Jone M. Hernández García. "La culpa fue del… jazz(aldia). O de cómo una ciudad se transforma en festival." *Musiker* 17 (2010): 329–64.

EFE. "Los tres festivales generan 46 millones de euros para San Sebastián." In "País Vasco" section, *El Mundo*, June 3, 2017.

Eresbil, Basque Archive of Music. Fondo A54, Imanol Olaizola. At: http://www.eresbil.com/sites/fondos/es/a054-imanol-olaizola/.

———. Fondo A80, Juan Pérez Heredero. At: http://www.eresbil.com/sites/fondos/es/a80-juan-perez-heredero/.

————. Fondo A123, Francisco Escudero. At: http://www.eresbil.com/sites/fondos/es/a123-francisco-escudero/

Escrich Bayón, Marcelo. "10 años de Jazz en el Conservatorio Superior de Navarra. Presente y futuro de la planificación pedagógica." Master's Thesis, Universidad Pública de Navarra, 2012.

Festival de Jazz de Vitoria-Gasteiz. "La historia del festival." At: https://jazzvitoria.com/es/festival/historia.php (last accessed May 26, 2018).

García, Jorge. "El trazo del jazz en España." In *El ruido alegre: jazz en la BNE*. Madrid: Biblioteca Nacional de España, 2012.

García Martínez, José María. *Del fox-trot al jazz flamenco. El jazz en España: 1919–1996*. Madrid: Alianza Editorial, 1996.

————. "El tocino y la velocidad." In "Cultura" section, *El País*, July 16, 2016.

Getxo, Bizkaia. Ayuntamiento: Aula de Cultura. History [of the jazz festival]. https://www.getxo.eus/es/getxo-jazz/el-festival/historia-getxo-jazz_(accessed on 11 May 2018).

————. Library / Fonoteca de la Escuela de Música "Andrés Isasi."http://www.getxo.eus/es/musika-eskola/fonoteca/colecciones-biblioteca (accessed on 29 April 2018).

Gobierno Vasco. Departamento de Administración Pública y Justicia, Registro de asociación "Jazzle" (Música Moderna y Jazz). At: http://www.euskadi.eus/gobierno-vasco/-/asociacion/jazzle-musica-moderna-y-jazz/ (last accessed April 28, 2018).

Gómez, José Manuel. "El impacto de los festivals," In "Cultura" section, *Tiempo*, June 25, 2012.

Heineken Jazzaldia, Donostia-San Sebastián. "Ediciones anteriores." At:

https://heinekenjazzaldia.eus/es/ediciones-anteriores-2/ (last accessed May 12, 2018).

Ibarra Aguirregabiria, Ale. "365 Jazz Bilbao." At: http://www.bilbaopedia.info/365-jazz-bilbao (last accessed May 21, 2018).

Iglesias, Iván. "La hibridación musical en España como proyección de identidad nacional orientada al mercado: el jazz flamenco." *Revista de Musicología* 28, no. 1 (2005): 826–38.

———. "(Re)construyendo la identidad musical española: el jazz y el discurso cultural del franquismo durante la segunda guerra mundial." *Historia Actual Online* 23 (2010): 119–35.

———. "A contratiempo: una breve historia del jazz en España." In *Jazz en español: derivas hispanoamericanas*, edited by Julián Ruesga Bono. Valencia: Generalitat Valenciana, 2015.

———. *La modernidad elusiva. Jazz, baile y política en la Guerra Civil española y el franquismo (1936–1968)*. Madrid: CSIC, 2017.

J. T. "Jazzle, un centro para estabilizar la difusión y enseñanza del jazz en Euskadi." In "Kultura" section, *Egin*, September 18, 1988.

Jackson, Jeffrey H. *Making Jazz French: Music and Modern Life in Interwar Paris*. Durham & London: Duke University Press, 2003.

Labrune, Édouard. *Côte basque. Les années folles*. Urrugne: Pimientos, 2015.

Landaberea Taberna, Jaione. "Guía de casas y sellos discográficos en Euskal Herria." *Musiker* 15 (2007): 373–446.

Leiñena Mendizabal, Pello. "Conversaciones con Imanol Olaizola." *Musiker* 16 (2008): 299–330.

Lerena, Mario. "'De mi querido pueblo': vasquidad y vasquismo en la producción musical de Pablo Sorozábal (1897–1988)." *Musiker* 18 (2011): 465–95.

————. "'No me olvides': fuentes y apuntes para una memoria del jazz en la Costa Vasca (*c.* 1917–1927)." *Jazz-Hitz* 1 (2018): 75–95.

Ley Orgánica 1/1990, de 3 de octubre, de Ordenación General del Sistema Educativo, *Boletín Oficial del Estado*, núm. 238, jueves 4 de octubre: 28927–28942. At: https://www.boe.es/boe/dias/1990/10/04/pdfs/A289 27-28942.pdf (last accessed May 20, 2018).

López Aguirre, Elena. "¿Hubo un jazz vasco?" In *Historia del rock vasco: edozein herriko jaixetan.* [Vitoria-Gasteiz]: Aianai, 2011.

Mendive, T. "Josefina Baker en Pamplona." *El Liberal,* April 12, 1930.

MrJam, Centro Moderno de Música. "MrJam cumple 25 años." At: http://mrjam.com/conocenos/69-presentacion/167-mrjam-cumple-25-anos (last accessed May 18,2018).

Metheny, Pat. "Pat Metheny on Kenny G." In *Jazz Oasis.* At: http://www.jazzoasis.com/methenyonkennyg.htm (last accessed May 13, 2018).

Olaizola Etxeberria, Imanol. "Nacimiento de un Festival. Orígenes del Jazzaldia donostiarra." *Euskonews & Media* (online journal) 448 (2008). At: http://www.euskonews.com/0448zbk/gaia44803es.html (last accessed May 13, 2018).

Orden de 30 de julio de 1992 por la que se regulan las condiciones de creación y funcionamiento de las Escuelas de Música y Danza, *Boletín Oficial del Estado,* núm. 202, sábado 22 de agosto: 29396–29399. At: http://www.boe.es/boe/dias/1992/08/22/pdfs/A2939 6-29399.pdf (last accessed May 20, 2018).

Orden Foral 423/2002, de 27 de agosto, del Consejero de Educación y Cultura, por la que se establece el currículo de grado superior de las enseñanzas de música en la

Comunidad Foral de Navarra, *Boletín Oficial de Navarra*, núm. 123, viernes 11 de octubre: 9080–9098. At: http://www.navarra.es/home_es/Actualidad/BON/Bol etines/2002/123 (last accessed May 20, 2018).

Pérez Conde, Carlos. Interview with Iñaki Askunze (Pirineos Jazz Orchestra). *Tomajazz* (online journal) (December 2003). At: http://www.tomajazz.com/perfiles/ askunze_inaki_pirin eos_2003.htm (last accessed May 21, 2018).

Pujol Baulenas, Jordi. *Jazz en Barcelona 1920–1965*. Barcelona: Almendra Music, 2005.

Real Decreto 617/1995, de 21 de abril, por el que se establece[n] los aspectos básicos del currículo del grado superior de las enseñanzas de Música y se regula la prueba de acceso a estos estudios, *Boletín Oficial del Estado*, núm. 134, martes 6 de junio: 16607–16631. https://www.boe.es/boe/ dias/1995/06/06/pdfs/A166 07-16631.pdf (last accessed May 20, 2018).

Reino, Gorka, and Carlos Gracia. "SOSBJC, Salvemos la Asociación" (2018). Official website of Bilbaína Jazz Club Kultur Elkartea. At: http://www.bilbainajazzclub.org/ sosbjc-salvemos-la-asociacion/ (last accessed May 26, 2018).

Rubio, José Ramón. "100 conciertos en el próximo festival itinerante de 'jazz'." In "Cultura" section, *El País*, October 18, 1984. At: https://elpais.com/diario/1984/10/18/ cultura/4669020 09_850215.html (last accessed May 12, 2018).

Sánchez, Leo. La ambigua personalidad del festival de jazz, *Cuadernos de Jazz* 119–120 (2010): 87–88.

Tapiz, Pachi. "Yerbabuena: veinte años y unos cuantos días de jazz en Pamplona." Interview with Pilar Chozas by Pachi Tapiz, at *Tomajazz* (online journal), July 5, 2016. At: https:// www.tomajazz.com/web/?p=25312 (last accessed May 21, 2018).

Torquemada, Jesús. *Jazzaldia 50*. San Sebastián: Victoria Eugenia Antzokia, 2015.

"Un dancing." *El País Vasco*, June 3, 1923.

Zagalaz, Juan. "Contactos tempranos entre jazz y flamenco en España. Una perspectiva analítica de la serie *Jazz – Flamenco* de Pedro Iturralde y Paco de Lucía (1967–1968)." *Jazz-Hitz* 1 (2018): 127–44.

Zirrara: a collection of jazz and improvisation recordings produced by Sorkunde Idigoras and Alberto Lizarralde. At: http://www.zirrara.info/ (last accessed May 19, 2018).

Zubizarreta Gorostiza, Ainara. 2017. "Jazz a la koxkera." *Cultural resueña*, May 26, 2017. At: http://www.culturalresuena.es/2017/05/jazz-la-koxkera/ (last accessed April 29, 2018).

## Websites

Arriola Jazz Blues Jaialdia. Website. At: http://www.arriolaka.eus/es/festivales/jazz-bluess/ (last accessed May 21, 2018).

Circuito Bluess-Jazz de Bizkaia. Official website of Gaztelupeko Hotsak. At: http://www.hotsak.com/festivales/circuito-blues-jazz-de-bizkaia (last accessed May 21, 2018).

Conservatorio de Música Jesús Guridi de Vitoria-Gasteiz. Official website. At: http://www.conservatoriovitoria.com/es/index.php (last accessed May 26, 2018).

Conservatorio Profesional de Música Francisco Escudero de San Sebastián. Official website. At: http://conservatorioescudero.eus/es/ (accessed on 26 May 2018).

Conservatorio Profesional de Música Pablo Sarasate de Pamplona. Official website. At: http:// conservatoriopablosarasate.educacion.navarra.es/ (last accessed May 26, 2018).

Conservatorio Juan Crisóstomo de Arriaga de Bilbao. Official website. At: http://www.conservatoriobilbao.hezkuntza. net/web/gu est/inicio (last accessed May 26, 2018).

Errabal-Jazz. Official website. At: http://www.hotsak.com/ Errabal-es (last accessed May 21, 2018).

Errenteria Musikal Udal Musika Kontserbatorioa. Official website. At: http://musikal.errenteria.eus/es/ (last accessed May 26, 2018).

ESCM Zabalza: escuela de jazz y música moderna. Official website. At: http://escmzabalza.blogspot.com.es/p/ inicio.html (last accessed May 26, 2018).

Escuela Especial de Música Joaquín Maya de Pamplona. Official website. At: http://www.pamplona.es/VerPagina.asp? IdPag=203&Id ioma=1 (last accessed May 26, 2018).

Euskadiko Ikasleen Jazz Orkestra (EIJO). Official website. At: https://eijoweb.com/inicio/ (last accessed May 26, 2018).

Jazz Cultural Theatre of Bilbao. Official website. At: http://jazzculturalbilbao.com/ (last accessed May 26, 2018).

Jazzaharrean: Gasteizko Alde Zaharreko Jazz Jaialdia. Official website. At: https://jazzaharrean.wordpress.com/ (last accessed May 21, 2018).

Musikene, Centro Superior de Música del País Vasco. Official website. At: http://musikene.eus/ (last accessed May 26, 2018).

Pueblo, Juan de. "El cine y la radio. Observaciones del que ve y escucha." *El Diario Vasco*, September 20, 1936.

Pirineos Jazz Orchestra. At:http://www.turismonavarra.es/NR/ rdonlyres/51E217C 4-780C-4724-B284- F338E437AACF/6283/DossierPirineosJazzOrchestra1. pdf (last accessed May 21, 2018).

Plaza: International Festival of Multidisciplinary Artistic Creations, created and directed by Sorkunde Idigoras & Alberto Lizarralde, 1999–2003. At: http://festivalplaza.org/ (last accessed May 19, 2018).

# Women and Basque Music

## Gotzone Higuera Bilbao

### Historical Perspective of Women in Music

The role of women in music, as in many other aspects of culture
and society, has been immersed in ostracism for many years.
Various quotes from a misogynist viewpoint and from former
times have helped to perpetuate these differences. Thus,
Corinthians states that: "Women should be silent in the church"
(1, Corinthians 14:34). The intellectual ability of women has also
been questioned. Juan Bermudo (1510–1565), a Franciscan
monk, music theorist, and composer of the Renaissance,
published two didactic music treatises: one for men in 1549 and
another for women in 1550, "addressed to the illustrious and very
reverend Lady Doña Ysabel Pacheco, abbess of the monastery of
Sancta Clara in Montilla." The latter work, titled *Arte Tripharia*, is
only a third part of the original and is limited to the basic elements,
supposing that women had less intellectual ability.[587] Doctor
Huarte, a titular doctor in Baeza (Jaén) at the time of Philip II and
author of *El examen de ingenios para las ciencias*, stated in 1645 that
"women, because of the cold and humidity of their gender, would
never possess a deep understanding."[588]

Later papal proclamations fell into this creative castration
of women. In 1686, Pope Innocent XI declared, "music is totally
harmful to the modesty corresponding to the female gender,

---

[587]Biblioteca Digital Hispánica, "Arte tripharia," at http://bdh.bne.es/
bnesearch/Search.do? (last accessed November 15, 2017).

[588] Juan Huarte de San Juan, *Examen de ingenios para las ciencias* (Madrid:
Cátedra, 1989), 614.

because they are distracted from subjects and occupations better suited to them" and he continues: "no women either single, married or widow from whatever rank, status or condition, including those who live in convents or conservatories, under no pretext should study music with the pretention of performing it, nor can they learn to sing from men, nor play any type of instrument."[589]

Other illustrious sentences have come down to us throughout history. Thus, Jean-Jacques Rousseau, whose ideas were influential well into the nineteenth century, spoke in this manner: "There are no correct morals for women outside of marriage and domestic life," and "The formal education of women should fall to men."[590]

This social silence of the female sphere in the music world has begun to break up with the appearance of musical incentives supported by them. We must remember that the presence of women in symphonic orchestras has been very limited up until recently. For example, the orchestra conductor Herbert Von Karajan said in 1979 that in his orchestra there were no women because they were confined to the kitchen, and until the 1980s there were no women in his orchestra.[591]

As Josep Marti explains,[592] the activity of women has been less than that of men but we should consider the traditional male-centered perspective of musicology, which has not visualized the work that women have developed, principally in the private realm. This discrimination is not limited to determined styles or genres, but rather extends to the totality of the musical experience. We

---

[589] Cited in Anna Bofill Levi, *Los sonidos del silencio. Aproximación a la historia de la creación musical de las mujeres* (Barcelona: Editorial Aresta, 2015), 87.

[590] Ibid., 133.

[591] Alba Sanfeliu Bardi, *Las mujeres, la música y la paz* (Barcelona: Icara Editorial; Instituto de la mujer. Ministerio de igualdad, 2010), 19

[592] Josep Martí, *La música como generadora de realidades sociales* (Balmes: Deriva Editorial, 2000).

ought to take into consideration that the first feminist musicological studies only began in 1970.[593]

In Spain, Franco's dictatorship made it especially difficult to adopt models of better integration of women in society like in other European countries. Thus, Rosario Sánchez sets forth the role women played based on the ideology of the Falange: "A woman was only a shadow. A shadow of herself, as a form that was empty of distinct and unique content. A shadow in that it would be her unique destiny to be a project of others. The family as a transcendent destiny. In the shadow of a man. In the shadow of growing children."[594]

## Basque Women in Music: First Notices

Despite this social condition of women, we find certain historical traces of the role of women in the musical realm. If we go back several centuries, we find that in classical antiquity, women were present in the arts, taking part in distinct rituals as priestesses or as rhapsodists, instrument players, singers, and dancers. In the Iberian Peninsula, the arrival of Islam implied a setback in the social function of women, but between the eighth and thirteenth centuries under the Umayyrad and Abbasud dynasties,[595] music and the presence of women acquired greater importance at court. Data taken from bio-bibliographical archives show the presence

---

[593] Susan McClary, *Feminine Endings: Music, Gender & Sexuality* (Minneapolis: University of Minnesota Press, 1991), 5.

[594] Rosario Sánchez, *Entre la importancia y la irrelevancia. Sección femenina de la República a la transición* (Murcia: Consejería de Educación y Cultura, 2007), 12–14.

[595] The Umayyad caliphate was an Arab dynasty that held the power of a caliphate first in the Middle East, with its capital in Damascus, and later in Al-Andalus, with the capital in Cordoba, Spain. The Abbasid Caliphate was a Caliphate dynasty founded in 750, which took power by eliminating the Umayyads.

of women singers, both as free women and as slaves; data also show the social status and the level of power that women had attained.[596] We can also verify hierarchical differences among them: the slave singers could be humble singers, singers of medium status, or elite singers who would practice their trade in the upper levels of the caliphate or in the palaces of the emirs.[597]

The first notice we find of a Basque woman in music history leads us to Kalam or Qualam, a princess mother. She was the daughter of a Vascon leader who was recorded as the result of a Muslim incursion into Vasconia. She was captured, imprisoned, and sold as a slave when a child. Together with Fadl and Alam, both of Eastern origin, she lived as a music slave in the harem of Abdel-Rahman II (792–852).[598] In Andalusia at the turn of the ninth century, they were known as *las medinesas*. Qalam, who distinguished herself as an exceptional singer, was soon one of the three women preferred by the emir. A master of the arts of verse, music, and dance, she was also a poet and historian. When she delivered her firstborn son, she was named princess mother. At that time, the Caliph established a school for singers in Andalusia, which attained the prestige and renown of the school in Medina. Qalam, along with another slave singer, organized all the court music.[599]

---

[596] Manuela Cortés García, "Estatus de la mujer en la cultura islámica: las esclavas- cantoras (SS XI–XIX)," in *Mujer Versus Músicas. Itinerancias, incertidumbres y lunas*, ed. Rosa Iniesta Masmano (Valencia: Colección Música e Interacciones. Editorial Rivera, 2011), 139–99.

[597] Tsampika Paraskeva, "Imagen de las cantoras en el mundo árabe medieval a través de las páginas del *Kitáb al-Agání*," PhD diss., Universidad de Granada, 2015, 107.

[598] The fourth Umayyad emir from 822 until his death.

[599] Patricia Adkins Chiti, *Las Mujeres en la música* (Madrid: Alianza Música, 1995), 29.

And in the tenth century, another female slave-musician of Basque origin appears reflected in writings of Al-Andalus: Subh Umm Wallad or Subh "the Vascon lady." She was taken prisoner and removed to Cordoba as a slave as a child. She enjoyed great intellectual and artistic training. People describe her as a very beautiful woman who knew how to attract the attention of Alkahen II.[600]

Various documents describe the profile and function of the slave-musicians. They were women possessing great artistic talents, whose mission was to entertain the court through music and poetry. Despite being slaves, they held a certain level of power and enjoyed certain privileges. Subh won the favor of the caliph Alkahen II, becoming his favorite and mother of the heir. She had great influence on the political development of the Cordoba Caliphate during the second half of the tenth century. Besides her musical training as composer and singer, she was trained in poetry and knew how to move among the political establishment of the Medina, becoming the first woman to take control of the Caliphate in Al-Andalus and governing as regent for her son, the caliph Hisham II, with the support of Al-Manzour.[601]

## Women Minstrels

One area in which we find documentation about the musical role of women is that of minstrels and troubadours. Female minstrels accompanied male minstrels, sharing an itinerant life and performing. They had a bad reputation and, at times, were confused with prostitutes although they had nothing to do with

---

[600] Second Umayyad caliph of Cordoba from 961 until his death.
[601] Manuela Marín, "Una vida de mujer Subh," in *Biografías y género biográfico en el occidente islámico. Estudios onomástico-biográficos de Al-Ándalus*, ed. María Luisa Ávila and Manuela Marín (Madrid: Consejo Superior de Investigaciones Científicas, 1997), 425–46.

that practice, and indeed, at times belonged to high social classes and were educated and refined.

The word *minstrel* was very ambiguous since it was used to indicate the interpreter as well as the entertainer and the adaptor of the texts or the simple instrumentalist, whether they were professionals or amateurs. Women minstrels also had different specialties, although the main ones were as dancers and singers. Many miniatures represent women artists dancing, or accompanying themselves with instruments like castanets or tambourines. Men minstrels, on the other hand, are usually portrayed playing string instruments or wind instruments.[602] In the cathedral of Pamplona-Iruñea there is a picture representing a women minstrel playing a rebec or gigue with two strings.

Higinio Angles, a Spanish priest and musicologist (1888–1969), in his extensive work *Historia de la Música Medieval en Navarra*, analyzes documentation concerning the economic transactions that took place at the Navarrese Court; we have verified the presence of women minstrels by the economic payment reflected in the documentation. In 1339 mention is made of Johannot and María, minstrels of the bishop of Pamplona-Iruñea, with the annotation of how much they were paid for their work: "Johannot and María, minstrels of the bishop of Pamplona to whom the King orders thankful payment of XX gold coins."[603] María belonged to a noble family. She had her own property and frequented the courts of the Kings of Castile and Leon, the monarchs Fernando II and Alfonso X.

---

[602] Donatella Siviero, "Mujeres y Juglaría en la Edad Media: Algunos aspectos," *Medievalia* 15 (2012), 127–42.

[603] Higinio Anglés, *Historia de la Música Medieval de Navarra* (Pamplona: Diputación Foral de Navarra. Institución Príncipe de Viana. 1970, Obra póstuma), 327.

The minstrel and dancer Graciosa is pointed out as someone who "has shown her gifts as a singer and dancer before King Carlos III of Navarre," and received fourteen florins for this. This minstrel was in the service of the King of Aragon, Martin I, for several years, and later she moved to France in the service of Queen Isabel; it seems, moreover, that for a while she was at the Navarrese court performing for the Princess Doña Isabel of Navarre, since there are documents that testify to payment for her services and for her stay in Olite (Navarre).[604]

We also find in Navarrese documents information about male and female minstrels who played the harp and came from England. Thus, in 1385 we find the presence of the singer Isabel and her husband, minstrels to the King of England, Richard II.

## Nun-Musicians

Despite the male-centric position of the Catholic Church, it would be in the intimacy of the monastic environment that many women were able to develop their musical abilities. Numerous sixteenth- and seventeenth-century documents provide information about the work undertaken by nuns in the convents in the musical field. It is not surprising that the first Spanish musical piece known to be attributed to a woman is by a nun, Gracia Baptista, the author of a short advent hymn for three voices and keyboard based on the hymn *Conditor Alme*, included in the *Libro de Cifra Nueva* by Luis Venegas de Hinestrosa in 1557.[605]

---

[604] Ibid., 330

[605] Josemi. Lorenzo Arribas, "La Historia de las mujeres y la historia de la música: ausencias, presencias y cuestiones teórico-metodológicas," in *Cuadernos Inacabados Música y Mujeres genero y poder*, ed. Marisa Machado Torres (Madrid: Horas y horas la editorial, 1998), 19–39.

We also find musical treatises directed especially at female convents, as is the case of the Augustinian Brother Pedro Maldonado, who dedicates in 1606 one of his works, titled *Del choro y Officio Divino*, to his sister Elvira Maldonado, a nun in the Augustinian Convent of San Leandro in Seville.[606]

Although because of their work, which is somewhat anonymous, we do not have specific names, we do have information on how their musical training developed and on their lives inside the convents. In the case of the Basque Country and Navarre, there is no detailed study of the work of these nuns, only some isolated data. The nuns who lived a cloistered life had their own chapel directed by a professional musician who presented a varied repertory. The sisters training to be musicians received a musical education from their maestros in voice, instrumental practice, and composition. The best source of information that we have comes from the correspondence found between maestros of distinct chapels and between these teachers and their students. Of special importance are the epistolary discoveries of Miguel de Irízar y Domenzain (1635–1684), a music director and composer baptized in Artaxoa (Artajona) in Navarre, and music director of the collegiate church of Vitoria-Gasteiz until 1671; and from the correspondence of Miguel Gómez Camargo (1618–1690), a music director in Medina del Campo, Burgo de Osma, and Salamanca.

Nuns who wished to become musicians had to have specific qualities that would enable them in their profession: a good voice, facility in accompanying the choir and in harmonizing choral works, the ability to improvise various accompaniments,

---

[606] María Sanhuesa Fonseca, "Música de señoras: las religiosas y la teoría musical española del siglo XVII," in *La clausura femenina en España: Actas del simposium: 1/4-IX-2004*, ed. Francisco Javier Campos y Fernández de Sevilla, vol.1 (San Lorenzo de El Escorial: R.C.U. Escorial-Mª Cristina, Servicio de Publicaciones, 2004), 167–80.

knowledge of how to interpret fugues, fantasias, concerts, and so on. And they had to pass a selective exam.

The correspondence of de Irízar points out the qualities that any woman aspiring to be a music director needed to show:[607] "Knows twelve or thirteen scores for high and low voice, fully knows the lyrics of all the keys; understands the code; knows counterpoint, concerts of three and four low voices, on triple, on plain song, the same with three and four voices; and has a pretty voice and can sing with the harp and can accompany the songs."

The only place in which women could undertake this musical task was in the convents, since in the chapels of the nobility, all references to music directors were men. Women who could offer service musically in the chapels were exempt from paying a dowry when they entered the convent and even received a small salary, like the male music directors. Young women who wished to enter the convent but came from poor families that were not able to pay the dowry found in the practice of music an opportunity, allowing them to enter religious orders.

The female chapel master was responsible for composing specific music for the various religious holidays: Corpus, Christmas, and Easter; and there existed an exchange among the convents, since, on certain occasions, they did not have sufficient time to produce all the compositions. Various letters asking for an exchange of music testify to this practice: "from the convent of Santa Cruz of Vitoria letters were sent out asking for a composition for the Corpus." Some names are quoted like Marian de Jesús from the Convent of Santa Clara of Vitoria, Josefa Salinas

---

[607] Matilde Olarte Martínez, "Las monjas músicas en los conventos españoles del Barroco. Una aproximación etnohistórica," *Revista de Folklore* 13, no. 146 (1993), 2–3.

of San Pedro de Salvatierra, and Francisca de Herrera from the convent of Santa Cruz de Vitoria.[608]

From the convents male chapel masters were asked for to provide the services of the musically trained nuns when there were vacancies, and on some occasions it was the masters themselves who tried to place their students in other centers. Many students left the cathedral of Pamplona-Iruñea for Puebla de Montalbán in Toledo, Medina del Campo, and Santo Domingo de la Calzada.

In the convent of the order of Saint Clare of Arizkun (Navarre) nine books of plain song on parchment dating from the eighteenth century and other music books that contain polyphonic works are preserved, from which we see that the nuns displayed an intense musical life. Female names appear like Inés Fulgencia de Barrenetche, who was named organist in 1731, and María de Arizkun, from Pamplona-Iruñea, who entered the convent as a nun-musician and was tested in the organ, harp, and plain song by the chapel master of the Cathedral of Pamplona-Iruñea in 1783. Many nun-musicians set out from Pamplona-Iruñea to convents in Toledo in the period 1725–1800, a good example being the daughter of the musician Miguel Palacios, who would become nun-musician at the Jeronymite monastery in Madrid.

In the women's convent of the Carmelites of Araceli in Corella (Navarre) an interesting musical archive is preserved that includes a *Graduale*[1] dated 1745 with the chant written in tetragrams and a book of music by María Josefa Marco. This book is in manuscript form and made up of seventy-six pages and contains various pieces for keyboard and anonymous dance pieces. This work shows us the secular repertory performed in the convent as well as in homes at times of leisure. The search for

---

[608] Matilde Olarte-Martinez, *Una correspondencia singular: Maestros de capilla, ministriles y bajonas, tomando el pulso de la música española del último barroco* (Salamanca: Ediciones Universidad Salamanca, 2016).

information on the authorship of the book has been unproductive. We know that it was not a nun from the convent of Araceli of Corella, since her name is not included in the book of entrants, or in the foundation book, or in the book of the deceased.

Among the works we find two *zortzikos* written in 6/8, but not in 5/8 tempo,[609] one of which makes use of the well-known Basque song *Donostiako Iru Damatxo*. The book remains unpublished although there are recordings of some of the pieces.[610]

## Women and the Enlightenment

The eighteenth century was the century of the cultural and intellectual movement known as the Enlightenment. Thinkers and ideologues of the period maintained that human knowledge was able to combat ignorance, superstition, and tyranny to build a better world; this implied a change both in scientific, economic, and political aspects as well as in cultural and social aspects. This manner of thinking spread among the bourgeoisie and part of the aristocracy through publications and reunions held in the homes of aristocrats and the bourgeoisie in which intellectuals and politicians took part to express and debate subjects like science, philosophy, politics, and literature. In the Basque Country in this context, during the annual festival held in Bergara in 1764 the Real Sociedad Bascongada de Amigos del Pais (Royal Basque Society of the Friends of the Country RSBAP) was founded. This society would play an important role in the economic, social, intellectual, and artistic fields.

---

[609] 5/8 was usual for this nineteenth-century dance.
[610] María Gembero-Ustárroz, *Navarra. Música* (Pamplona: Gobierno de Navarra, 2016).

In the musical aspect, the RSBAP was very important in the composing, performing, teaching, and study of music, since in the Basque Country there was not wide cultural dissemination. The first theater built in Bilbao was in 1799; before that, concerts and performances took place in the open.[611] One of the main concerns of the society would be its educational work, so a school was opened in Bergara in which seven student members of the society worked as teachers. The Marquis of Rocaverde[612] was in charge of the music classes. Concerts of great impact[613] were held in his house in Donostia-San Sebastián, on August 31 Street.

Despite women not having a decisive place in society in these fields, some of them became involved in the movement. The objective of women's education was not for them to be active and useful members of society or in political affairs; rather, the aim was to educate women as wise counselors or as teachers of citizens. Besides possessing wisdom and abilities, women were expected to be discreet and modest, but these Enlightenment values allowed women to take an active part in organizing salons, and cultural and artistic circles.[614]

It is in this domestic and family domain that the emerging aristocratic and bourgeois class of the Basque Country would organize concerts and gatherings, often times led and enlivened by women. One such woman was Doña Antonia de Moyúa

---

[611] Carmen Rodríguez Suso. "El Patronato de la Música en el País Vasco durante el Antiguo Régimen." Special issue, "III Symposium 'Bilbao, una ciudad musical'," *Bidebarrieta* 3 (1998), 41–77.

[612] An original member of the RSBAP since its founding, he was an infantry captain, living in Bergara, and great music enthusiast. See Jon Bagües Erriondo, *Ilustración musical en el País Vasco* (Donostia-San Sebastián: Real Sociedad Bascongada de los Amigos del País; Departamento de cultura del País Vasco, 1990), 100.

[613] Ibid., 108.

[614] Lucía Criado Torres, El papel de la mujer como ciudadana en el S XVIII: la educación y lo privado," (2209), at http://www.ub.edu/SIMS/pdf/MujeresSociedad/MujeresSociedad-09.pdf.

(1757–?), the daughter of the Marquis of Rocaverde who, at a later date, would marry her uncle Don Juan Rafael de Mazarredo, both founders and precursors of the RSBAP.

Antonia de Moyúa, a great music enthusiast, converted her home into one of the principal salons in the Bizkaian capital, organizing various concerts and literary circles in Bilbao. As a child, she participated in the opera Peñaflorida's opera *El borracho burlado*. She lived for many years in Paris, and on her return to the Bizkaian capital, she sponsored all types of gatherings and cultural activities. It should be pointed out that Paris had a great intellectual and artistic milieu and salons led by aristocratic women for the most part proliferated. These were meeting places for politicians, intellectuals, and artists.[615] Antonia de Moyúa's daughter, Doña Juana (1785–?), was the person who assured the success of these musical soirées. Married to her cousin, Doña Juana kept up her enthusiasm welcoming to her house in Bilbao, next to the church of Saint Nicolás, the high society of Bilbao to cultural and musical reunions.[616]

In his article "Más sobre la escritura del *zortziko* en 5/8," Father Donostia studies and analyzes two *zortzikos* published in Paris in 1813, one by Peñaflorida and another attributed to Mª Antonia de Moyúa, Mazarredo's wife.[617] These are the first two samples of Basque secular music that we know of.[618] Recently, a

---

[615] Francisco García Martínez, "Saloniéres: Mujeres que crearon sociedad en los salones ilustrados y románticos de los siglos XVIII y XIX," in *VII Congreso Virtual sobre Historias de las mujeres*, ed. Manuel Cabrera Espinosa (Jaén: Archivo Histórico Diocesano de Jaén, 2015).

[616] Padre Donostia, *Conferencias del 1-13*, vol. 4, *Obras Completas del Padre Donostia* (San Sebastián: La gran enciclopedia Vasca; Editorial EuskoIkaskuntza. 1985), 308.

[617] Padre Donostia, *Artículos 58–78*, vol. 2, *Obras Completas del Padre Donostia* (Bilbao: La gran enciclopedia Vasca, 1983), 319–29.

[618] Jose Antonio Arana, "La edición musical en Bilbao," spec. issue, "III Symposium 'Bilbao, una ciudad musical'," *Bidebarrieta* 3 (1998), 221–23.

small minuet for piano attributed to this same author was discovered.

Another aristocratic music lover was Epifanía de Argáiz y Munibe, the Countess of Peñaflorida. She was born in Donostia-San Sebastián in 1812, and died in Markina-Xemein in 1889. After her marriage in 1836, she lived in Donibane Lohizune (Saint-Jean-de-Luz), fleeing the Carlist War. Once the war was over, she returned to Markina-Xemein. Her father had studied at the Real Seminario Patriótico Bascongado (Royal Basque Patriotic Seminary) in Bergara from 1793 on, and stood out for his study of music. Her husband was also a great music lover, so that at her home in Markina-Xemein one lived in a pleasant musical atmosphere. We possess a notebook containing various musical works, among which a "Vals brillante" stands out, authored by the Señora Condesa and dedicated to her husband. In the same notebook, moreover, her name is found on two other pieces, a *zortziko* dedicated to her niece and a waltz; we cannot discard the idea that all the pieces in the notebook are of her authorship.[619]

Another woman who, just like the preceding women, had a close relationship with the RSBAP, was María del Pilar de Acedo y Sarriá, Third Countess of Echauz and Marquise of Montehermoso (1784–1869). Born in Tolosa, she received exquisite education. She is seen as being cultured: she spoke French and Italian, wrote poetry, painted miniatures, and played the guitar and the piano. She moved to Madrid with her husband and achieved importance for her relationship with Joseph Bonaparte or Joseph I of Spain. She would eventually move to France where she died. In the palace in which she lived with her husband, gatherings of the cultural elite were organized that she

---

[619] Jon Bagües, "Dos mujeres compositoras en la Bizkaia Ilustrada y Romántica," *El boletín de la sociedad filarmónica de Bilbao* 6 (March 2008), 4–7.

or her husband led; he being anti-clerical, liberal, and against the Inquisition.

## Women and Music in the Nineteenth and Twentieth Centuries

The composer, organist, and professor Celestina Ledesma y Anciona was born at the turn of the nineteenth century in 1822. We must point out the importance of the family context in the development of women, especially the implication of male members, whether fathers, brothers, or husbands. Such is the case of Celestina, daughter of the composer and organist Nicolás Ledesma. She was married to Luis Bidaola, also an organist. In 1879 she published in Bilbao her *Divertimenti* for major and minor keys preparatory for piano pieces, a pedagogical work consisting of fifty-six studies, two for each tonality, designated for advanced piano students. [620]

In the French Basque Country, another woman of the upper bourgeoisie and animator and promoter of concerts and compiler of popular music in the Basque Country stands out: Julie Adrienne Karrikaburu Roger (1827–1898), to whom Father Donostia dedicated an article called "Memories of the Pyrenées (Mme. De la Villéhélio)," in which he gathers together her life and work. [621]

Born in Zuberoa, in the Sohüta (Chéraute) palace, her father made his fortune in Mexico in the early nineteenth century, and upon his return, he bought the castle in which Julie and her five brothers were born. She learned music and studied piano and created, with her brother, a quartet of amateurs. She married

---

[620] See Auñamendi Eusko Ikaskuntza, at http://aunamendi.eusko-ikaskuntza.eus/ (last accessed January 23, 2018).
[621] Padre Donostia, *Artículos 58–78*, vol. 2, *Obras Completas del Padre Donostia*, 361–90.

Saulnier de la Villéhélio, this being the reason that she is also known as Madame de la Villéhélio. Between 1848 and 1850 she began to collect songs from Zuberoa performed by her father and the local people. In 1869, she published in Baiona (Bayonne) ten songs and two piano pieces: a *zortziko* and a march of the Zuberoan masquerades,[622] with harmonizations. These are the first examples of Basque secular music that we know of.

In late nineteenth- and early twentieth-century Bilbao, Enma Chacón Lausaca (1886–1972), a Catalan composer born in Barcelona and resident there, developed her artistic career. She studied music in Barcelona with Enrique Granados and José Ribera Miró. After settling in Bilbao in 1915, when she married the painter José Ribera, she belonged to the philharmonic society of the city,[623] where in 1947 for the first time her works were performed. In 1952 her work was performed by the Symphonic Orchestra of Zaragoza in the Teatro Principal. Enma Chacón looked for opportunities to present her work. She established Ediciones Impulso in order to publish her work and in her home she organized concerts and cultural circles. Despite her dilettante character, we should appreciate her extensive oeuvre in that she managed to publish sixty-two scores and organized some seventeen concerts.[624]

We place Anita Idiartborde Bringuet (1891–1943) in Iparralde, in the French Basque Country. She was born in Rosario, Argentina, of Basque origin and lived in Iparralde. When she died,

622 The *maskarada* is a carnival festival in Zuberoa in which dance and speeches are combined.

623 Founded in 1896 to promote concerts and musical activities, among its activities was the creation of the academy of music of Bilbao (the origin of today's conservatory), the Orchestra of Bilbao, and the musical review. See Patricia Sojo, "La Sociedad Filarmónica de Bilbao: mucho más que una Sociedad de conciertos centenaria," special issue, "III Symposium 'Bilbao, una ciudad musical'," *Bidebarrieta* 3 (1998): 257–63.

624 Isabel Díaz Morlan, *Enma Chacón, una compositora bilbaína* (Bilbao: Temas Vizcaínos, Bilbao Bizkaia Kutxa, 2000), 86.

she bequeathed all her works to the Basque Museum of Baiona, among them a letter of the composer to Father Donostia, in which she laments the little worth her family awarded her musical work. She complains that at her death her work will be lost in some attic and for this reason she has decided to bequeath all of it to the Museum in Baiona. We had access in this museum to her musical compositions and found twenty-eight works, of which only the following have been published: "Suite Humoristique para piano" (1931), "Páginas argentinas pour piano" (1926), and "Six petits moreaux trés fáciles pour piano" (1937); all on the Max Erding label. The remaining compositions are in manuscript form and in excellent condition. The composer had a special love for her symphonic piece "Histoire de Roland," whose content according to Anita herself deals with "our Roland and our Basque mountains;"[625] unfortunately, she left only a sketch of the piece.

In Gipuzkoa, we find Maria Carmen Figuerido Torija (1904–1988), a violinist and composer born in Irun. She began her musical studies with her father, the famous violinist César Figuerido Guelbenzu. Her work is not very well known, but she wrote numerous pieces for strings of which only one was published in Madrid, a minuet for violin and piano. Like many women of the time, she signed some of her works under a pseudonym, in her case Gueritorfly.[626] These works included "Death of Jesús" written for piano, two violins, viola, and double bass, "Basque song" for piano, two violins, cello, and double bass, and "Gratitude" for violin and piano.

---

[625] Jose Luis Ansorena, "Mujeres compositoras vascas," *Euskor* 11 (1985), 30–32.

[626] Ana Vega Toscano "Compositoras españolas: apuntes de una historia por contar," in *Cuadernos Inacabados Música y Mujeres genero y poder*, ed. Marisa Machado Torres (Madrid: Horas y horas la editorial, 1998), 135–59.

## Emiliana de Zubeldia

The most important woman composer that we have had and of wider international acclaim deserves without a doubt a section apart: the Navarrese Emiliana de Zubeldia Indra.

She was born in Salinas de Oro-Jaitz (Navarre) in 1888 to a textile merchant family. When she was three years old, her family decided to move to Pamplona-Iruñea in search of better opportunities to school their children. She began her musical studies at the age of four, and, after finishing in Pamplona-Iruñea, she took the exams for the eight corresponding courses at the Conservatory of Music and Declamation in Madrid, obtaining the academic certification. She was seventeen years old, and with her diploma, set out for Paris. This was at the beginning of the twentieth century, and the spirit of Berlioz, Bizet, Franck, and the great impressionist painters like Manet, Toulouse-Lautrec, Renoir, and Cezanne was felt there. She witnessed the social and philosophic transformations moving through Europe in the early twentieth century. In the French capital, the option for musical education was either the vanguard of the conservatory or the Schola Cantorum,[627] a school for singing and religious that followed a more conservative method of teaching centered on older and religious music. It was here that Emiliana would study composition with the great maestro Vincent D'Indy, a student of Cesar Franck and piano with Blanche Selva. On the death of her father, she had to return to Pamplona-Iruñea, where she opened the "Emiliana de Zubeldia" academy of music, a project she would combine with piano recitals. It was at this time that her admiration for Father Donostia began.

---

[627] Great musicians of the stature of Albéniz, Satie, Turina, Messiaen, and Milhaud took classes with him.

Her career as a concert pianist took her throughout Spain and gave her the opportunity to give a few concerts in France. She would also compose her first pieces dedicated to her female students, using the pseudonym of Emily Bydwealth.

In 1919 she married a famous scientist and director of the Agricultural Laboratory of Navarre, closed the academy, and obtained through exams the position of professor of piano in the Academy of Music of Pamplona-Iruñea. She remained in that position for only two years. Her husband asked for a leave of absence so that she could live in Paris and soak in the cultural life of the French capital. But she would not return to Navarre. She left her husband and started a life alone. Only on one occasion would she return to her native Navarre, when her brother was gravely ill. No one in her surroundings, except her brother and her assistant, knew of her presence in the family house.

Her career as a composer began to take off. Her first composition, "La muñeca de vidrio," relates her personal situation after the failure of her marriage. She would continue with a series of Basque preludes, "Esquisses d'un après midi Basque." After this she would write pieces for piano and cello, a quartet, a Spanish trio, Spanish and Basque melodies, numerous pieces for piano, and a few orchestral notes. She would continue her career as concert pianist throughout Europe: Germany, Belgium, Italy, Switzerland, and so on, work that she combined with that of a church organist, and as a pianist in Diaghilev's ballets ruses rehearsals. But despite the distance separating her from her native land, she would never forget her roots. In each and every one of her programs, she would include representative and descriptive pieces of her country, with nationalist evocations like: "Basque Preludes," "Basque Capriccio," "Zortziko," "Traditional Basque Songs," "From my mountains," a sonatina on a popular Basque theme, a "Basque Suite," and various songs. Likewise, she

composed the "Triumphal March to Sabino Arana" and the symphonic poem "Euskadi." Father Donostia would dedicate an article in the *Diario de Navarra* on April 6, 1927, to the Spanish songs for voice and piano: "Harmonization reflecting the secrets of modern refinement."[628]

On the death of her mother in 1927, she decided to leave for the Americas. She settled in Rio de Janeiro, where she contacted the Spanish Center, which would bring her into the musical environment in which she continued her work as a concert pianist and composer. Her trio for piano, violin, and cello would garner notable success.[629]

She continued her American travels, heading to Montevideo. There she met some musicians, like the guitarist Luis de la Maza, to whom she dedicated her "Basque capriccio for guitar" to a *zortziko* rhythm. She would be introduced into the literary milieu of Latin America through the auspices of the poet Juana de Ibarbourou,[630] and began her "Poets of America" project, which she would develop throughout her life, composing one hundred songs based on Latin American poetry.

She continued her chamber concert tour and arrived in Buenos Aires. Emiliana dedicated her Latin American cycle, "El buen día" and "Mi corazón fue una hoguera," to the Basque Ensemble of Buenos Aires, whose members organized concerts and shows with the support of the large Basque family of the Laurak Bat Basque Center, the Basque Nationalist Action, the French Basque Center, the Navarrese Center, the Zazpiak bat, the Euskaldunak Denak Bat, and the Gure Herria seminary.

---

[628] Padre Donostia, *Diarios- Reseñas*, vol. 3, *Obras Completas del Padre Donostia*, 551–52.

[629] Leticia Varela Ruiz, *Emiliana de Zubeldia. Una vida para la música* (Pamplona: Personajes navarros. Gobierno de Navarra, 2012), 41.

[630] She took the surname Ibarbourou when she married Captain Lucas Ibarbourou; her maiden name was Juana Fernández Morales, and she was born in Uruguay of a Galician father and a mother of Spanish origin.

She performed her first concert all of her own works for the "Friends of Art of Buenos Aires," which garnered much success and which she would repeat throughout her Argentinian tour. When she arrived in Argentina, where she stayed for various months, she began the presentation of her "Cuadros de Ezpatadantza" with the enthusiastic support of the Basque Nationalist Action of Buenos Aires. The program debuted on November 19, 1929, in the opera theater.[631]

Her first contact in New York City was with the Basque Center and the American Women's Association (AWA). Her stay there was notable no doubt due to her meeting Augusto Novaro, a Mexican musician and researcher who was in New York to publicize his composition system. This system is based on the natural laws of the fundamental harmonic scales and includes the development of new instruments with a temperament adapted to the system. Although it had wide diffusion and was enthusiastically received by many composers, it did not flourish as much as was hoped. Emiliana was a fierce defender of the system, which she studied thoroughly and of which she published a few pieces.[632]

It was in New York City Hall where the first works composed with the Novaro System would be premiered. During her time in New York, her work as composer, performer, and director was intense. The *New York Times* wrote the following critique concerning Emiliana:

> The program was typically Basque with folkloric songs. Pieces for piano and popular dances, evocative of the culture of one of the oldest races of Europe; it was warmly

---

[631] Leticia Varela Ruiz, "Emiliana de Zubeldia en América," *Cuadernos de Sección. Música* (1993), 121–34.

[632] Augusto Novaro, *Sistema natural de la Música* (México: Editorial Manuel Casas, 1951)

received by an audience including many compatriots. The versatile composer performed her rhythmically vigorous "Suite en tres tiempos" for two pianos and offered only one encore on audience demand.[633]

During her time in New York, the city was a cultural hotbed. On its streets strolled the most avant-garde artists of the movement, many of whom were fleeing the warlike situation in Europe. Here she had the opportunity to meet Andrés Segovia and the Basque harpist Nicanor Zabaleta, for whom she composed musical pieces. After a second tour of the Caribbean, her final destination was Mexico. After six years in Manhattan, she began a stage influenced by her meeting Novaro and his Natural System of Music. For this reason, she settled in Mexico, and here she lived the rest of her long life.

For twelve years she would be Novaro's student and collaborator and take on his system of composition in part of her own works, maintaining her traditional style of composition in works like *Sinfonica elegíaca*, composed in memory of her dead sister Eladia and which won the National Prize for Composition at the beginning of 1957. Within this system of composition are included eleven tientos, five studies for piano, and four songs with lyrics by the poet Ana Mairena. The remaining works that she composed, as well as the instruments made and adapted for this compositional system, are now housed by the only daughter of Maestro Novaro, Rosita Novaro.

Emiliana was invited by the rector of the University of Sonora in Hermosillo to become part of the teaching staff of the center, giving musical training to the university students and forming student choruses in high schools and teacher-training

---

[633] Varela Ruiz, *Emiliana de Zubeldia*, 53.

colleges attached to the young university. This would cause a definitive change in Emiliana's life.

One of the matters that impacted Emiliana was the large number of students with Basque last names that she had in her classes: Arriaga, Arriola, Ochoa, Elizondo, Echeverria, Iberri, Ibarra, Barrenechea, Salazar, Munguia, Zazueta, Zatarain, Uribe, Sainz, Urrutia, and Valderrain, among others.

From this moment she began a stage of frenetic activity: directing various children's, young adults', and women's choruses, and composing and training a large group of pianists, many of whom went on to have successful careers on the international stage. Zubeldia's life during the school year revolved around the University of Sonora and the hotel in which she would live the rest of her life. During the summers she would visit Mexico City so as not to lose contact with her teacher and the circle of intellectuals in the capital city.

As the years passed, she organized tours and concerts of her students and university chorus throughout the entire country, as well as multiple conferences and educational talks directed to Hermosillo society. In 1954 the university's Academy of Music was founded, of which Emiliana became director, combining this work with that of director of the chorus ensembles that she led.

Novaro would die a little after his brother Néstor, with whom he maintained a close correspondence: Emiliana continued working as a composer, pianist, chorus director, and professor of piano, organ, and composition. To this we must add her intense activity organizing events, concerts, festivals, and tours throughout Mexico.

Her long life extended to the age of ninety-eight. Up until then, she continued with her intense activity, including tours with her choruses, a presence at festivals, and competitions with her students, but she fell and fractured her femur. The operation weakened her, and in the end she died in Sonora. The funeral was

a big event in the city. Thousands of people paid their last respects to the maestra. The Sonora press published articles, mementos, remembrances for months. They also honored her by naming a street after her.

In 1993, the Navarrese cinematographer Helena Taberna made a documentary film about Emiliana Zubeldia.[634]

## Contemporary Women

Let us begin with a composer and harpsichordist who throughout her life fought to make visible women composers silenced for many decades. Maria Luisa Ozaita Marqués was born in Barakaldo in 1939. She studied with Fernando Remacha and continued her studies in Copenhagen with Leifv Thybo and K.J. Isaksen. She studied harpsichord in France and in Darmstadt. She performed internationally in Europe, North America, and Eastern Europe. As a composer, her works have been performed in various international festivals: Frauen Music in Vienna, Donne in Musica in Rome, Alicante, and the Festival of Women in Music in Getxo, among others.

In 2006 the Orchestra and Chorus of the Community of Madrid (ORCAM) commissioned her work *Amiga, no te mueras*, a polyphony for four mixed voices and piano, premiered at the Fundación Canal that same year with soloists from the chorus of the ORCAM and dedicated to her dead sister. In 2007 the Office of Culture of the Community of Madrid commissioned a chamber piece entitled *Homage to Bernard Shaw*, for actress and guitar, a caustic piece directed at the world of music critics. In 2009 the OSE premiered her work *Cartones goyescos*, to close the Festival Musikaste, and in June 2010 the Symphony Orchestra of Bilbao (Bilbao Orkestra Sinfonikoa, BOS) premiered her piece

---

[634] See http://www.helenataberna.com/.

for mezzo-soprano and orchestra *Idilio.* At the 2009 COMA Festival, the violinist Manuel Guillen premiered *Suite* for solo violin and dedicated to this violinist. In November 2010, she premiered at the Cadiz Festival her suite *Peace beneath the Rain.* She is also the composer of the opera "Pelleas and Melisande."

The publishing house Boileau published her *Nine Micropieces* and her *Four Hispanic-Arabic songs on anonymous poems by women poets of Al-Ándalus, for mezzo-soprano and piano, Three small pieces* (solo flute), and *Cartones goyescos* for symphony orchestra, *Idilio* for mezzo-soprano, and also the *Suite for solo violin.*

As a pioneer in the field of music and gender, one of her major concerns was the diffusion of music by contemporary women and rescuing women, who throughout history have been silenced, from neglect. She published various articles and gave conferences in varied forums. She is the author of the chapter on Spanish women composers in the book by Patricia Adkins Chiti.[635] Maria Luisa Ozaita was founding president of the Spanish Association of "Women in Music" in 1989 and remained its president for twenty years. In 1992 she organized the Eighth International Conference "The other story of music," held in Bilbao.[636]

She was a member of the Real Sociedad Bascongada de Amigos del País from 1983. She died on April 5, 2017, at the age of seventy-seven. In 2001 the pianist María José Martín submitted to the University of Cincinnati her dissertation on the music of Ozaita, entitled "Drama and Poetry in the Music of Maria Luisa

---

[635] Adkins Chiti, *Las Mujeres en la música.*
[636] The presentations can be consulted in "The other story of music," Eighth Women's International Congress of Music. Presentations delivered in Bilbao, March 18–22, 1992. Bilbao: Department of Culture of the Basque Government, 1994.

Ozaita."[637] In the locality of Pinto, in the community of Madrid, a street bears her name.

The Navarrese Teresa Catalán was the same age as Maria Luisa Ozaita, a composer of wide international reputation. She was born in 1951, and pursued her musical studies at the "Pablo Sarasate" Conservatory in Pamplona-Iruñea, where she was trained by maestros like Fernando Remaca, Luis Taberna, and Pilar Bayona. She attended advanced courses at the Academia Musicale Chigiana of Siena (Italy) with the composer Franco Donatoni.

She was co-founder in 1985 of the Pamplona-Iruñea composers' group, Iruñeako Taldea Musikagileak. In 1990, by exam, she obtained the full professorship of composition, instrumentation, and musical forms, a position she now holds at the Real Conservatorio Superior de Música de Madrid.

As a composer, her music falls into the form of post-tonal music and in her extensive catalog we find both pieces for piano and chamber works, and orchestral and choral works. She has received commissions from numerous performers and distinct national and international institutions. Her work has been programmed in festivals in various countries in Europe and the Americas.

The winner of various prizes for composition and interpretation, on December 6, 2011, she was honored by the Ministry of Foreign Affairs on the recommendation of the Ministry of Culture, with the Encomienda de la Orden del Mérito Civil. Moreover, in 2017, the Ministry of Education, Culture, and Sports awarded her the National Prize for Music in the field of composition.

---

[637] María José Martín, "Drama and Poetry in the Music of María Luisa Ozaita (B. 1039)," PhD diss., University of Cincinnati, 2001.

The pioneer of the present generation would be the composer, orchestra conductor, and teacher from Gipuzkoa, born in Arrasate-Mondragon in 1961, Beatriz Arzamendi. She began her violin studies in Donostia-San Sebastián and would continue them in London. She worked in the Laboratory of Electro-acoustic Music with Zulema de la Cruz and pursued advance training with maestros like Comissiona and Celidibache. She combined her activities as composer and orchestra conductor with teaching in high schools. In her career as conductor, Arzamendi was interested in the training of young musicians as a conductor of the Orchestra of the Municipal School of Music of Pozuelo de Alarcón (Madrid) and the Arrasate Musical Symphony Orchestra. Her works have been premiered at the International Festival of Music of Santander, the Theater of Fine Arts in Mexico City, the Juan March Foundation in Madrid, and in the Teatros del Canal among others. Her catalog includes symphonic works, chamber music, sound tapes, choral music, electro-acoustic music, and many arrangements for orchestras and distinct chamber groups. At present, she is in charge of the Music Section of the Teatros del Canal in Madrid.

Another composer with strong links to orchestral conducting is Margarita Lorenzo de Reizábal, who is a composer, pianist, and conductor, and holds a PhD from the University of the Basque Country (UPV-EHU). She began her training in Bilbao and continued her conducting studies in London. She began collaborating with the BOS in Bilbao as a pianist, combining this work with that of a teacher. She has been an orchestrator and arranger of music. As a composer, her first two international prizes for composition for high voice choruses stand out, convoked by the section for women at Sestao City Hall, the works being *Mujer Paloma* and *Impressions of the Andes*, with lyrics and music by the composer. These works are heard often in the choral repertory. Other choral pieces are her "Kyrie,"

351

"Nana para dormir una rana" for children's chorus, and "I don't know why I love you" for mixed chorus SATB, among others. Among her works "American souvenir: IO American postcards" stands out for being the first work for a band by a Basque woman composer.

Likewise, among our women composers we have examples of eclectic artists who place their inventions somewhere between the world of popular folklore and the so-called classical world. An example of this would be Sara Soto, born in Gorliz, a coastal village of Bizkaia in 1941. When she was a child her family moved to Irun in Gipuzkoa. From a young age, she had limited mobility due to a muscular disease she suffered. She explored other artistic venues like drawing, painting, and literature, and especially poetry. She studied harmony with Professor José Antonio Canoura. In the field of musical composition she was self-taught.

Her musical legacy is varied. Her first works fall within the mark of popular music. She was influenced by the Ez dok amairu movement,[638] especially by Lourdes Iriondo and Xabier Lete, both of whom she established a deep friendship with. Sara began to compose her songs on the guitar, and Xabier Lete, Txomin Artola, and Lourdes Iriondo would write the lyrics for various of her compositions. In the 1970s, inspired by several musicians, she explored contemporary compositions. It then that the sculptor form Bermeo, Nestor Basterretxea[639] commissioned her to compose music for his *Serie Cosmogónica Vasca*. The result was the work of contemporary esthetics *Karraxis*, choral

---

[638] Basque avant-garde movement working between 1966 and 1972 to recuperate Basque culture.

[639] A painter, sculptor, and movie director as well as the founder of important artist groups in Spain: in 1957, "Equipo 57," along with Juan Cuenca, Agustín Ibarrola, and Jorge Oteiza; and in 1966 the group "Gaur" along with Eduardo Chillida and Oteiza. In 2005, he received the Prize for the Humanities, Culture, Arts and Social Sciences from Eusko Ikaskuntza (the Society of Basque Studies) and in 2008 he won the Lan Onari medal for his work.

poem based on the poetry of Basterretxea. This work was premiered January 23, 1979, in the Victoria Eugenia theater in Donostia-San Sebastián. Sara would be inspired by this same sculptor in another of her works, "Cripta" (1984–85), a piece for organ inspired by the murals painted by the artist for the crypt of the Basilica of Arantzazu. This piece has been performed many times by the famous organist José Manuel Azkue. Her legacy also includes the choral works "Inhuma," "Four Basque songs," "Elurretako Printzesak," "Gure margo eder horiek," "Martintxo," "Txori bat bezala," and "Nafarroako azken erreginak dona pauleun" for soloists and chorus of four mixed voices. Sara died in Irun in 1999.

Another versatile woman composer, here linked to the jazz world, is Silvia San Miguel. A composer, pianist, and teacher born in Vitoria-Gasteiz in 1963, she completed her studies at the Real Conservatorio Superior de Música in Madrid and furthered her studies of composition in Holland and Boston. In 1993 she received the Writing Division Award Prize from Berkelee. Its origin is tied to the world of the accordion.

In 2001 she returned to Vitoria-Gasteiz, where she is now a teacher of combos and an arranger at the Luis Aramburu music school, activities she shares with composing. In her musical journey she is eclectic, as she explains: "It is not important to talk about jazz or classical music because in the end Bach was a born improviser, what differentiates him from jazz are not the notes but the rhythm, the swing . . . the circle, there is no beginning or end, everything is a part of the same thing."[640]

Centered on contemporary music and in constant search for new sound languages, we find Isabel Urrutia, born in Algorta, Bizkaia in 1967. She completed her studies of composition, piano,

---

[640] Elena López Aguirre, *25 Mujeres que la música no debería olvidar* (Vitoria-Gasteiz: Ediciones Baga Biga; Diputación Foral de Álava, 2015), 120.

and music pedagogy in Bilbao and Madrid and thereafter continued her training with professors Francisco Escudero and José Luis Campana. Currently, she is professor of harmony, counterpoint, and compositional techniques at Musikene, the Centro Superior de Musica del Pais Vasco.

Her works have been premiered by international soloists of the Ensemble Intercontemporain, the Paris Orchestra, and the Philarmonic Orchestra of Radio France; soloists like Pierre Strauch, André Cazalet, Jean Geoffroy, and Julien Guénebaut; and by international ensembles as well like the Ensemble Arcema of Paris and the Arditti Quartet.

She has visited various concert halls and music festivals in Europe, the Americas, and Asia. She gives talks and masterclasses about her music in various universities and conservatories in Europe and the Americas. The prize of the Spanish Association of Symphony Orchestras for her work *Gerok* stands out, as does that she obtained at the International Competition for Composition in 2012, Grazyina Baciewicz in Poland, for her work *Haizearen nahiak*, a concert for clarinet in sib (B flat) and string orchestra.

In 2010 her piece "Sei" was selected to represent Spain at the International Tribune of Composers at UNESCO. She has received commissions from different organizations and groups: the BBVA foundation, the CDMC (Center for the Diffusion of Contemporary Music) the ARCEMA ensemble, Neopercusión. Since 1998, when she premiered her work *Oihartzunak* for alto saxophone and accordion, her oeuvre has been extensive, with more than thirty works including symphonic, chamber, and vocal pieces.

Currently, she is involved in a new and innovative creative project, the World Timbres Mixture (WTM), which is, as the composer herself explains,

a new method of composition with sounds that we choose for esthetic reasons and which basically consist of mixing instruments of the classical orchestra with timbres coming from different continents, cultures and countries. We have found, with respect to this "mix" of timbres, a strange, unexpected world and unlimited to new sonorities for our chamber and orchestral scores.[641]

Another composer of the same generation would be Zuriñe F. Gerenabarrena, born in Vitoria-Gasteiz in 1965. She relates that her beginnings in music are due to a gift from her grandmother, who gave her an accordion "so that she could play at family dinners." [642] She studied composition with Carmelo Bernaola at the Jesús Guridi Conservatory in Vitoria-Gasteiz and with Franco Donatoni in the Scuola Civica of Milan. During her training, she attended several international composition seminars.

As the composer herself explains, her music, by very freely treating the development of sound, expresses itself in fragmented gestures and figurations in a labyrinthine discourse based on timbre as an organizing element. It marks the importance of using electronic means, transforming the soundscape, and deepening the possibilities of metamorphosis to the point of becoming thought extending itself to her instrumental and vocal oeuvre. She defines herself as versatile and for this reason works of varying formats coexist in her catalog, from commissions for soloist, symphony orchestra, theater, dance, orchestration for the cinema, electronic opera, electroacoustic, and multi-disciplinary projects. Her works have been performed by the Euskadi Orkestra Sinfonikoa (Basque National Orchestra), the BOS, Sinkro, Klem, Kuraia and the Sound Workshop.

---

[641] Isabel Urrutia, interview by author.
[642] López Aguirre, *25 Mujeres que la música no debería olvidar*, 172.

She has been in attendance as composer and performer at various international forums like Sinkro, Musikaste, the Quincena Musical, the BBVA Foundation, Auditorio Nacional, Kleiner Konzertsaal in Munich, Sibelius Accademy in Finland, the Visiones Sonoras festival in Mexico, and Sound Images in Buenos Aires, among others. The composer emphasizes the importance that having been able to enjoy artistic residences in different laboratories and art centers has had on her career, which has allowed her to expand her compositional range.

She has received commissions from the Basque government, the Quincena Musical, the Basque National Orchestra, the BBVA Foundation, the Ministra Kultury i Dziedzictwa Narodowego of Poland, the Zurich University of the Arts, and the Ensemble Nob of Japan. She has collaborated with the cinema orchestrating music for some films with the composer Bingen Mendizabal, who was also a student of Bernaola. These movies include Enrique Urbizu's *Cómo ser infeliz y disfrutarlo*, as well as *Airbag, Secretos del corazón, Cachito*, and *Ecstasy*. Her work as a teacher began at the Jesus Guridi Conservatory in Vitoria-Gasteiz. Currently, she teaches harmony and counterpoint for composition majors at Musikene.

If the Basque Country stands out in the field of music, it is, without a doubt, for the proliferation of choruses found there. A woman very much tied to this choral ambience is, Eva Ugalde. This singer and composer was born in 1973 in Donostia-San Sebastián. She studied composition and choral directing, and her work is principally centered on choral music. She has composed many pieces for choruses, one of the most outstanding is *Tximeletak* (butterflies), with lyrics by the Basque author Bernardo Atxaga. It was premiered in the Quincena Musical of Donostia-San Sebastián in 1999 as part of the "Musics of the Twentieth Century" season. Her choral pieces have been performed in various countries like Sweden, Japan, the United

States, and Italy. Although her music is basically tonal, the influence of jazz harmonies and new age rhythms are also present. Among her choral works I would highlight her "Ave Maria," "Hitz jolasak," "Neguan," "Pinda vara," and her three songs for a child.

I am well aware that many important women in Basque music have been overlooked here because of lack of space. I have simply tried to brush and give a name and a voice to some who represent us all. I hope and wish that with this small contribution we begin the journey of trying to awake from negligence of so many women who, by one means or another, have been decisive in the musical history and culture of our Basque Country.

## Bibliography

Adkins Chiti, Patricia. *Las Mujeres en la música*. Madrid: Alianza Música, 1995.

Anglés, Higinio. *Historia de la Música Medieval de Navarra*. Pamplona: Diputación Foral de Navarra; Institución Príncipe de Viana, 1970.

Ansorena, Jose Luis. "Mujeres compositoras vascas." *Euskor* 11 (1985): 30–32.

Arana Martija, Jose Antonio. *Música Vasca*. Bilbao: Biblioteca Musical del País Vasco; Caja de Ahorros Vizcaína, 1987.

———. "La edición musical en Bilbao." Special issue, "III Symposium 'Bilbao, una ciudad musical'." *Bidebarrieta* 3 (1998): 221–32.

Bagües Erriondo, Jon. *Ilustración musical en el País Vasco*. 2 Volumes. Donostia-San Sebastián: Real Sociedad Bascongada de los Amigos del País; Departamento de cultura del País Vasco, 1990.

————. "Dos mujeres compositoras en la Bizkaia Ilustrada y Romántica." *El boletín de la sociedad filarmónica de Bilbao* 6 (March 2008): 4–7.

Beristain, María Teresa. "Arte y mujer en la cultura medieval y renacentista." *Asparkía* 6 (1996): 135–46.

Bofill Levi, Anna. *Los sonidos del silencio. Aproximación a la historia de la creación musical de las mujeres.* Barcelona: Editorial Aresta, 2015.

Catalán, Teresa. "Teresa Catalán: de la vida y otras músicas." *Revista Internacional de Estudios Vascos* 56, no. 2 (2011): 486–518.

Centro de Documentación de Música y Danza. *INAEM. Compositoras españolas: la creación musical femenina desde la Edad Media hasta la actualidad.* Madrid: Ministerio de Cultura, 2008.

Cortés García, Manuela. "Estatus de la mujer en la cultura islámica: las esclavas-cantoras (SS XI-XIX)," In *Mujer Versus Musica. Itinerancias, incertidumbres y lunas,* edited by Rosa Inisesta Masmano. Valencia: Colección Música e Interacciones; Editorial Rivera, 2011.

Criado Torres, Lucía. "El papel de la mujer como ciudadana en el S XVIII: la educación y lo privado" (2009). At: http://www.ub.edu/SIMS/pdf/MujeresSociedad/Mujer esSociedad-09.pdf.

Dentici Nino. *Diccionario Biográfico de Cantantes Vascos de Opera y Zarzuela.* Bilbao: Diputación Foral de Bizkaia, 2002.

Díaz Morlan, Isabel. *Enma Chacón, una compositora bilbaína.* Bilbao: Temas Vizcaínos. Bilbao Bizkaia Kutxa, 2000.

Donostia, Padre. *Artículos 1–57.* Volume 1. *Obras Completas del Padre Donostia.* Bilbao: La gran enciclopedia Vasca, 1983.

————. *Artículos 58–78.* Volume 2. *Obras Completas del Padre Donostia.* Bilbao: La gran enciclopedia Vasca, 1983.

————. *Diarios–Reseñas.* Volume 3. *Obras Completas del Padre Donostia.* Bibao: La gran enciclopedia Vasca, 1983.

————. *Conferencias del 1–13.* Volume 4. *Obras Completas del Padre Donostia.* San Sebastián: La gran enciclopedia Vasca; Editorial Eusko Ikaskuntza, 1985.

Frega, Ana Lucía. *Mujeres de la Música.* Buenos Aires: Sb Editorial, 2011.

García, Emilio. "Huarte de San Juan, Un adelantado a la teoría modular de la mente." *Revista de Historia de Psicología* 24 (2003): 9–25.

García Martínez, Francisco. "Saloniéres: Mujeres que crearon sociedad en los salones ilustrados y románticos de los siglos XVIII y XIX." In *VII Congreso Virtual sobre Historias de las mujeres,* edited by Manuel Cabrera Espinosa. Jaén: Archivo Histórico Diocesano de Jaén, 2015.

Gembero-Ustárroz, María. *Navarra. Música.* Pamplona: Gobierno de Navarra, 2016.

González-Allende, Iker. *Introduction (partial) to Pilar de Zubiaurre, Evocaciones: Artículos y diario (1909–1958).* Donostia: Editorial Saturrarán, 2009.

Gorosabel, A. "Atucha Urtizberea, Teresa." In *Diccionario de la Música Española e Hispanoamericana,* edited by Emilio Casares. Volume 6. Madrid: Sociedad General de Autores y Editores, 1999.

Huarte de San Juan, Juan. *Examen de ingenios para las ciencias.* Madrid: Cátedra, 1989.

López Aguirre, Elena. *25 Mujeres que la música no debería olvidar.* Vitoria-Gasteiz: Ediciones Baga Biga; Diputación Foral de Álava, 2015.

Lorenzo Arribas, Josemi. "La Historia de las mujeres y la historia de la música: ausencias, presencias y cuestiones teórico-metodológicas." In *Cuadernos Inacabados Música y Mujeres*

*genero y poder,* edited by Marisa Machado Torres. Madrid: Horas y horas la editorial, 1998.

———. "De cómo y cuando se comenzó a investigar y escribir sobre las mujeres medievales y la música." In *Mujer Versus Musica. Itinerancias, incertidumbres y lunas,* edited by Rosa Inisesta Masmano. Valencia: Colección Música e Interacciones. Editorial Rivera, 2011.

Marín, Manuela. "Una vida de mujer Subh." In *Biografías y género biográfico en el occidente islámico. Estudios onomástico-biográficos de Al-Ándalus,* edited by María Luisa Ávila and Manuela Marín. Madrid: Consejo Superior de Investigaciones Científicas, 1997.

———. *Mujeres en Al-Andalus.* Madrid: Consejo Superior de Investigaciones científicas, 2000.

Martí, Josep. *La música como generadora de realidades sociales.* Balmes: Deriva Editorial, 2000.

Martín, María José. "Drama and Poetry in the Music of María Luisa Ozaita (B. 1039)." PhD dissertation, University of Cincinnati, 2001.

McClary, Susan. *Feminine Endings: Music, Gender, and Sexuality.* Minneapolis: University of Minnesota Press, 1991.

Novaro, Augusto. *Sistema natural de la Música.* México: Editorial Manuel Casas, 1951.

Olaizola, Imanol. "María Teresa Hernández Usobiaga." *Euskor* 14 (1986): 46–47.

Olarte-Martinez, Matilde. "Las monjas músicas en los conventos españoles del Barroco. Una aproximación etnohistórica." *Revista de Folklore* 13, no. 146 (1993): 56–63.

———. *Una correspondencia singular: Maestros de capilla, ministriles y bajonas, tomando el pulso de la música española del último barroco.* Salamanca: Ediciones Universidad Salamanca, 2016.

Paraskeva, Tsampika. "Imagen de las cantoras en el mundo árabe medieval a través de las páginas del Kitáb al-Agání." PhD dissertation, Universidad de Granada, 2015.

Quiñones Leyva, Isabel, and María Isabel García Alegría, compilers. *Cartas a Emiliana*. Hermosillo, Sonora: Colección Epistolar, 2004.

Ramírez Escudero, Juan Carlos. *El crítico musical bilbaíno, Isusi*. Bilbao: Temas Vizcaínos. Bilbao Bizkaia Kutxa, 1997.

Rodríguez Suso, Carmen. "El Patronato de la Música en el País Vasco durante el Antiguo Régimen." Special issue, "III Symposium 'Bilbao, una ciudad musical'." *Bidebarrieta* 3 (1998): 41–77.

Sánchez, Rosario. *Entre la importancia y la irrelevancia. Sección femenina de la República a la transición*. Murcia: Consejería de Educación y Cultura, 2007.

Sanfeliu Bardi, Alba. *Las mujeres, la música y la paz*. Barcelona: Icara Editorial; Instituto de la mujer; Ministerio de igualdad, 2010.

Sanhuesa Fonseca, María. "Música de señoras: las religiosas y la teoría musical española del siglo XVII." In *La clausura femenina en España: Actas del simposium: 1/4-IX-2004*, edited by Francisco Javier Campos y Fernández de Sevilla. Volume 1. San Lorenzo de El Escorial: R.C.U. Escorial-Mª Cristina, Servicio de Publicaciones, 2004.

Siviero, Donatella. "Mujeres y Juglaría en la Edad Media: Algunos aspectos." *Medievalia* 15 (2012): 127–42.

Sobh, Mahmud. "La poesía árabe, la música y el canto." *Anaquel de estudios árabes* 6 (1995): 149–84.

Sojo, Patricia. "La Sociedad Filarmónica de Bilbao: mucho más que una Sociedad de conciertos centenaria." Special issue, "III Symposium 'Bilbao, una ciudad musical'." *Bidebarrieta* 3 (1998): 257–63.

Varela Ruiz, Leticia T. "Emiliana de Zubeldia en América." *Musiker: cuadernos de música* 6 (1993): 121–34.

————. *Emiliana de Zubeldia. Una vida para la música.* Pamplona: Gobierno de Navarra, 2012.

Vega Toscano, Ana. "Compositoras españolas: apuntes de una historia por contar." In *Cuadernos Inacabados Música y Mujeres genero y poder*, edited by Marisa Machado Torres. Madrid: Horas y horas la editorial, 1998.

## Online Sources

Zuriñe F. Gerenabarrena: http://www.zfgerenabarrena.com.

Isabel Urrutia: http://www.isabelurrutia.es/.

Beatriz Arzamendi:
http://www.compositoresfaic.com/compositorescurriculum.php.

Auñamendi Eusko Ikaskuntza: http://aunamendi.eusko-ikaskuntza.eus/.

Helena Taberna: http://www.helenataberna.com/.

Teresa Catalán: http://www.teresacatalan.com/es/index.html.

Eresbil: http://www.eresbil.com/.

Mujeres en la Música: http://www.mujeresenlamusica.es/.

Musée Basque/Baionako Euskal Museoa: http://www.musee-basque.com/.

# Popular Music Revisited

Itziar Navarro

## Music and Resistance: "Ezaren gudaz baietza sortuz"[643]

When the hardships of the postwar years subsided, the Franco regime continued to exercise strict control of politics, public life, the communication media, education, and cultural activity in general. Ration cards continued to be used officially until 1952, but surveillance and censorship continued in all areas of social, political, economic, and cultural life. At the borders, the free movement of citizens and the import of consumer goods, were restricted, and literature, music, and film became contraband products. The church managed education and in large part youth leisure activities, under the watchful gaze of a dictatorial regime that attempted to achieve absolute control and indoctrination. In this manner, a disobedience that was more or less organized became a necessary response to preserve basic aspects of Basque culture. But at the end of the 1950s, although the dictatorship had perfected its mechanisms of repression and censorship, other events weakened their force. On the one hand, in 1958 ETA (Euskadi Ta Askatasuna, Basque Country and Freedom) was created as a movement of resistance against the dictatorship with social, political, and cultural ideals, and it would lead to armed conflict. On the other, in January 1959, Pope John

---

[643] Quote from the song "Izarren hautsa" (Stardust) by Xabier Lete, meaning "to create something positive, fighting denial."

XXIII convened the Second Vatican Council, which his successor Paul VI would close in 1965, an event of significance when attempting to understand certain changes that link religion, government, and culture.

## The 1960s: Beginnings of the New Basque Song

In the 1960s, the so-called new Basque song emerged in Euskal Herria, although it was preceded by some memorable pioneers. One such pioneer was the priest Nemesio Etxaniz from Gipuzkoa, who published his songbook *Kanta-kantari* in 1951 with Ordorika, a publishing house in Bilbao. In the prologue of this work,[644] the author warns that foreign melodies enjoy greater popularity among the Basque youth, and he advances the opinion that the survival of the language will necessarily require the modernization of the song: the revival of the lyrics of traditional songs and the creation of more exotic new pieces in Euskara. The songbook not only brought together traditional Basque songs, but also Euskara versions of tangos, rumbas, schottisches, and cha-cha-chas; this, together with his facet as performer not only brought him criticism, but also, as indicated by Joxemari Iriondo,[645] incited ridicule and scandal in equal parts at the Círculo Cultural de Donostia-San Sebastián. As the 1960s advanced however, the warnings given by Etxaniz were gradually fulfilled. The Basque-language music scene expanded beyond the *kantu zaharrak* (old songs), *ochotes,* and choral groups, thanks to, in the words of Elena López, "Soroak, Michel Labéguerie [also spelled

---

[644] See http://www.donostiaeuskaraz.eus/donostia/gorosti/testuak/00151.htm.

[645] Joxemari Iriondo, "Euskal musika giroa 1960ko hamarkadan," *Jakin* 200 (2014), 84.

Mixel Labéguerie], Lourdes Iriondo, and Mikel Laboa, with the birth of Ez Dok Amairu in 1966 as a spectacular highpoint."[646]

The publishing house and record label Goiztiri of Baiona (Bayonne)[647] provided the infrastructure necessary for the first EP (extended play, a record format between the dingle and LP) by Soroak (1963), the first two EPs by Labéguerie (1961 and 1963), as well as those of Laboa (1964 and 1966). Soroak was made up of Iker, Ugutz, and Irkus Robles-Arangiz—sons of the exiled politician and president of the trade union ELA Manu Robles-Arangiz—and the guitarist Txabi Villaverde, who had formed part of the trio Los Yucatecos.[648] Starting in 1958,[649] they were pioneers in singing Afro-American spirituals and folklore in Euskara both on the radio and in nightclubs. Labéguerie, the politician from Lapurdi, recorded two EPs in 1961 and 1963. Among the eight tracks were "Gazteri berria" and "Aurtxo-aurtxoa," with explicitly *abertzale* (Basque nationalist) lyrics and guitar accompaniment. These records were smuggled into the peninsular Basque Country, slipping through the police's border control, and exerted a great influence on later young singer-songwriters.[650] And so Goiztiri would be fundamental, especially in the context of the Franco regime's censorship.

Ximun Haran—a pharmacist, *pelotari* (Basque handball player), and founder of the Enbata movement[651]—made those first recordings with a magnetic tape recorder that he had brought with him from Germany. He had previously made field recordings in Iparralde (the Northern Basque Country), which were released

---

[646] Elena López Aguirre, *Historia del rock vasco. Edozein herriko jaixetan* (Gasteiz: Aianai, 2011), 33.

[647] Goiztiri was preceded by Agorila, founded in 1949. See http://www.badok.eus/diskoetxe/agorila/.

[648] See http://www.bilborama.com/rock/b01/txabi-2/.

[649] López Aguirre, *Historia del rock vasco*, 34.

[650] Xabier Lete, "Kanta berria, erresistentzi abestia," *Jakin* 4 (1977), 18–19.

[651] See http://aunamendi.eusko-ikaskuntza.eus/eu/enbata/ar-38969/.

by the Musée Basque (founded in 1955) under the title *Club du Disque Basque*. This corpus and the various songbooks would be a source of inspiration for later musicians as important as Laboa.

### Instruments: Research, Revival, and Popularization

The conscious search for Basque cultural identity led different agents to conduct research and develop their creative work based on these investigations. Searching through archives, field research, and experimentation with instruments were also indispensable activities in that cultural rebirth. The revival of instruments and traditional repertoire was spearheaded by singer-songwriters and collectives, dance groups, musicians, researchers, and, afterward, folk groups.

The *txistu* and the *tamboril* were noteworthy since they constituted symbols of nationalism and enjoyed a history of institutional support. Their incorporation into the conservatories brought about a clear advancement in the field of classical music. The improvements in interpretive technique, construction, and tuning, moreover, facilitated their participation in different instrumental groups beyond the municipal bands and the ceremonial groups.

The *txistu*, the *trikitixa*, the accordion, and the *dulzaina* were already part of the usual soundscape of some regions. Other traditional instruments however had been forgotten or were not even part of the collective memory. Little by little, a revival began of the *xirolarrua*, the *xirula* and the *ttun-ttun*, the *musukitarra*, the *arribita*, the *txanbela*, and so on, although this revival did not enjoy the same success as the processes for revitalizing the *alboka* and the *txalaparta*.

Following in the footsteps of traditional *albokaris* (alboka players) such as Leon Bilbao, Silbestre Elezkano or "Txilibrin," and Eugenio Etxebarria, young musicians would revive this wind

366

instrument in the 1960s, largely by teaching themselves. Luis Mari Bandrés introduced the *txalaparta* into the shows of Ez Dok Amairu; Juan Mari Beltran, into the dance group Argia; and Mariano Barrenetxea, a member of the Andra Mari group from Galdakao in addition to being a performer and advancing initiatives, published different studies on the instrument with the aid of Father Riezu.[652] The *alboka* gradually increased in popularity and presence in dance groups and folk groups.

The *txalaparta* was almost unknown at the beginning of the 1960s. In 1963, Jorge Oteiza mentioned it in his book *Quousque tandem...!* In 1964, the Zuaznabar brothers from the hamlet Sausta (Lasarte) could be heard playing it in the short film *Pelotari* by Fernando Larruquert[653] and Nestor Basterretxea, and this performance made an impression on Joxan Artze and sparked his interest. The Artze brothers (Joxan and Jesus Mari) learned to play from them, and they included the *txalaparta* in the performances of Ez Dok Amairu. Various members of the Goizaldi dance group from Donostia-San Sebastián also learned from the Zuaznabars, as did the Beltrans (Juan Mari and Bixente) in the Argia group, and they complemented that training with the Goikoetxeas from Erbetegi-Etxeberri (Astigarraga).[654] Young musicians took the *txalaparta* to the urban environment, and new schools emerged with the contribution received from the traditional performers.

In 1972, the Pamplona-Iruñea Meetings were held, attended by Luis de Pablo, John Cage, and Steve Reich, among others, at which the Artze brothers played the *txalaparta*. Afterward, they took part in various recordings under the stage name Arza Anaiak, including *Txalaparta '75 Iraila*

---

[652] *Folklore vasco* (1963), *Alboka. Entorno folklórico* (1976), *La alboka y su música popular vasca* (1986), and *Aclaraciones sobre la alboka* (2000).

[653] The same movie director included the txalaparta in *Ama Lur* (1968) and *Euskal herri-musika* (1978).

[654] Juan Mari Beltran, *Txalaparta*, Book-CD-DVD (Donostia: Nerea, 2009), 99.

(Cramps Records, 1975), recorded at the Ricordi studios in Milan and *Zurezko olerkia* by Luis de Pablo (1975), which premiered with the Westdeutscher Rundfunk of Cologne.

The initiatives of the following decade would reaffirm the research, revival, and popularization of traditional instruments. And so, starting in 1985, Beltran was a forerunner in offering classes in *txalaparta* and *alboka* at the music school in Hernani, and he would go on to create the most widely extended musical notation system for the *txalaparta* and a method for the *alboka*. Moreover, his *Euskal Herriko Soinu Tresnak* (1985) project would collect, based on important fieldwork, a sample of the instruments and instrumentalists of Euskal Herria.[655]

### The Period 1965–72: The Legendary collective: Ez Dok Amairu. Beginnings and Persons Involved

In the field of cultural activism, the collective Ez Dok Amairu began to take shape in 1965, by making an artistic and political commitment to society, Basque culture, and Euskara. It brought together numerous artists, including Lourdes Iriondo, Mikel Laboa, Benito Lertxundi, Joxan and Jesus Artze, Jose Angel and Juan Migel Irigarai, Julen Lekuona, and Xabier Lete, as well as the musical groups Yoloak, Oskarbi, and Bihurriak. Not all the participants played leading roles or participated to the same extent over the course of the group's seven years of existence.[656] The sculptors Jorge Oteiza and Nestor Basterretxea, the filmmaker Fernando Larruquert and the painter José Luis Zumeta also collaborated and played significant parts in the collective.

---

[655] 1985 (IZ); republished in 2017 by Elkar as *Soinu-tresnak Euskal herri musikan; 1985–2010*.

[656] Jon Martin Etxebeste, "Euskal kantagintza berria eta Ez Dok Amairu," in *XXIV Psikodidaktikako ikerkuntza jardunaldiak* (Bilbo: EHU, 2017), 112.

An important source of inspiration came from the Catalan movement of the *Nova Cançó* and from the group Els Setze Jutges (1961), which Mikel Laboa got to know close up in 1964 during a stay in Barcelona. The members of Ez Dok Amairu were also influence by Latin American songwriting (such as Atahualpa Yupanqui, and Violeta Parra), French songwriting (for example, Georges Brassens and Jacques Brel) and the new folk music from the United States (such as Pete Seeger, Bob Dylan, and Joan Baez).[657]

Moreover, the collective was surrounded by many other creative initiatives. The most prominent of these were: the avant-garde theater group Jarrai, the dance and folklore group Argia (directed by Juan Antonio Urbeltz), the relaunched magazine *Zeruko Argia*, the LUR publishing house in Donostia-San Sebastián, the Gaur group of plastic and visual artists—composed of Jorge Oteiza, Eduardo Chillida, Remigio Mendiburu, Rafael Ruiz Balerdi, Amable Arias, José Antonio Sistiaga, Néstor Basterretxea, and José Luis Zumeta as well as their their correlated groups Orain (Araba), Emen (Bizkaia), Danok (Navarre), and Baita (Iparralde)—the *ikastola* (Basque-language school) movement, the founding of the Herri Irratia radio station in Loiola, and the beginnings of the Basque Book and CD/Record Fair in Durango. The highlights are considered to be Oteiza's essay *Quousque tandem . . . !* (1963), the book of poems *Harri eta Herri* by Gabriel Aresti (1964), and the feature film *Ama Lur* by Basterretxea and Larruquert (1968).

There were also a series of groups and soloists associated with the pop and ye-ye scenes, linked to Ez Dok Amairu and that often shared the stage with the collective, such as Jose Antonio Villar—who recorded with Orquestina Arrasate—and the

---

[657] Pako Aristi, *Euskal kantagintza berria. 1961–1985* (Donostia: Erein, 1985), 15.

abovementioned Yoloak and Bihurriak. The groups Koltrapuntoak and Urretxindorrak, who regularly occupied the top positions in the bimonthly radio show *Euskal Hit Parade* by the journalist Juan Manuel Ares,[658] performed Euskara versions of commercial hits, which was a political matter at that time despite the apolitical nature of the lyrics.[659]

## Performances and Going Professional

On March 6, 1966, Ez Dok Amairu performed at the Fine Arts Museum in Irun and were received with great enthusiasm by the audience. That same year they performed in many villages, and also in the second edition of Durangoko Azoka, the book and record fair.[660] Ez Dok Amairu raised the matter of professional musicianship; in that climate of activism and volunteerism, however, matters of remuneration and technical conditions were not considered to be a priority.[661] The censorship of Franco's regime prohibited concerts, records, songs, and texts, and it obligated performers to use metaphors, to record in Iparralde, or to use stage names.

In 1970, they created *Baga biga higa sentikaria*, a show that combined the raditional *mutil-dantza* of Baztan (Navarre)—in which all members danced—with traditional songs, original compositions, *txalaparta*, *toberak*, theater, dance, and poems. The collective toured Euskal Herria (the Basque Country), Catalonia, and Brittany, but at the end of 1972, it broke up due to artistic and ideological differences, and the recordings from the show were never released.[662] From Ez Dok Amairu, Ikimilikiliklik was born,

---

658 López Aguirre, *Historia del rock vasco*, 82.
659 Gotzon Elizburu, "Ye-ye euskaldunen historia ahantzia," *Argia*, July 17, 2011, 22.
660 Martin Etxebeste, "Euskal kantagintza berria eta Ez Dok Amairu," 114.
661 Aristi, *Euskal kantagintza berria*, 47.
662 Martin Etxebeste, "Euskal kantagintza berria eta Ez Dok Amairu," 117.

made up of the brothers Artze, Laboa, and Zumeta, on the one hand, and Zazpiribai, with Iriondo, Lete, Lertxundi, Irigarai, and a few more singer-songwriters like Pantxoa eta Peio, Ugutz Robles-Arangiz, and Manex Pagola, together with Maite Idirin and various musicians from Argia, on the other.

### Singer-songwriting, Folk and Rock: "Guk euskaraz, zuk zergatik ez?"[663]: Singer-songwriters in Times of Turmoil

Between 1964 and 1978, Lourdes Iriondo was active as a singer-songwriter. She sang in public for the first time at an event supporting the *ikastola* of Andoain, and, in 1965, her cousin Joxemari Iriondo invited her to perform live at the Herri Irratia radio station in Loiola. It was an immediate success, and in 1967 she gave 170 recitals.[664] That same year she released two EPs and the LP *Kanta zaharrak* with the Catalan label Belter. From 1969 on, she recorded her own compositions, collaborations with Xabier Lete, and traditional songs on local record labels.

The multifaceted artist Mikel Laboa performed traditional songs (*Goizuetan, Haika mutil, O Pello Pello, Bereterretxen kantoria*) and set contemporary poets to music, such as Joxan Artze (*Txoria txori, Gure bazterrak*), Gabriel Aresti (*Apur dezagun katea, Egun da Santimamiña*), Bertolt Brecht (Liluraren kontra, Gaberako aterbea), Xabier Lete (Ihesa zilegi balitz, Izarren hautsa), Bernardo Atxaga (Lizardi, Antzinako bihotz), and Joseba Sarrionandia (Lili bat, Sorterriko koblak). He also developed an interesting experimental facet in his *Lekeitioak*, compositions with phonetic games and shouting, which date from different decades, but which have been the subject of a recent recompilation (Elkar, 2007). Laboa is clearly the Basque singer-songwriter with the greatest influence on

---

[663] Single by singer-songwriter Urko: "We speak Basque, why don't you too?"
[664] Joxemari Iriondo, *Lourdes Iriondo (1937–2005)* (Gasteiz: Eusko Jaurlaritza, 2006), 15.

subsequent generations, since younger artists have produced numerous versions of his works. Pako Aristi speaks of his legend as created by the press and the audience.[665]

Xabier Lete will go down in history for the poetic dimension of his musical creation. He performed his own texts, both on social topics (*Langile baten seme, Haur andaluz bati seaska kanta*) and on existentialist topics (*Ni naiz, Haizea dator ifarraldetik*), some of which are especially important for the history of Basque song (*Xalbadorren heriotzean, Habanera, Seaska kanta o Izarren hautsa*). He set to music poems by Bernart D'Etxepare, Xabier Lizardi, Federico Krutwig, Cesare Pavese, and Rainer Maria Rilke, while at the same time authoring lyrics for his contemporaries. He collaborated with Lourdes Iriondo, Julen Lekuona, Antton Valverde, and Karlos Gimenez, among others, and published important anthologies dedicated to figures of *bertsolaritza* (improvised oral sung poetry).[666]

Benito Lertxundi, who first became known as the author of *Zenbat gera* and *Loretxoa*, has made a career that is worth noting today. At a moment when the Argia dance group was researching traditional instruments, he interpreted Basque epic themes,[667] and he also revived the traditional Zuberoan repertoire.[668] The Breton and Irish influences of Lertxundi (Alan Stivell) can be heard in different melodies and arrangements, especially on the record *Mauleko bidean* (1987, Elkar) dedicated to the eighteenth-century harpist Turlough O'Carolan. In the last two decades, he has released more intimate albums that echo the influence of Leonard Cohen, which Lertxundi himself recognizes.

---

[665] Aristi, *Euskal kantagintza berria*, 173.

[666] *Bertso zaharrak*, 1974, Herri Gogoa/Edigsa; *Txirrita-ren bertsoak*, 1976, Herri gogoa/Edigsa; *Berrehun urtez bertsotan*, 7 CDs (Elkar, 2001).

[667] *Altabizkar / Itzaltzuko bardoari* (Elkar, 1981).

[668] ...*Eta maita herria, ükhen dezadan plazera* (Artezi, 1975); *Zuberoa / Askatasunaren semeei* (Artezi, 1977).

After Franco's death, singer-songwriters, festivals, and rallies of all sorts multiplied.[669] In Iparralde, we find the duos Etxamendi ta Larralde and Pantxoa eta Peio, who were active from the late 1960s on, but who tasted success, especially in the 1970s. Etxamendi ta Larralde composed the chorus *Yup la la!* on the death of the then president of the Francoist government Luis Carrero Blanco. Pantxoa eta Peio sold 15,000 records and 25,000 cassettes of their self-titled album in 1975, which included lyrics by Telesforo Monzón in songs such as "Batasuna," "Itziarren semea," and "Lepoan hartu ta segi aurrera," and texts by Manex Pagola in "Azken dantza" and "Urtxintxak." Along the same political lines, the group Guk was formed, with Beñat Sarasola and Joanes Borda, among others.

In Bizkaia, worth noting are Maite Idirin (in exile during the period 1969–73), Gontzal Mendibil, Xeberri, and the Argoitia brothers, without forgetting Estitxu, the youngest member of the Robles-Arangiz family. In Araba, the most exceptional figures were Gorka Knörr and Patxi Villamor. In Gipuzkoa, there were singer-songwriters such as Iñaki Eizmendi, Hibai Rekondo, and Jose Antonio Larrañaga "Urko." The latter was the bestselling author at that time, selling more than 70,000 copies of *Sakonki Maite Zaitut Euskal Herria* (Novola, 1976), which included the choral track "Guk euskaraz."

Imanol Larzabal, a *dantzari* in the Argia group, recorded his first EP with Goiztiri in 1969 under the stage name Michel Etxegaray. In 1971, after six months in prison for membership of ETA, he went into exile in France, where he met Paco Ibáñez, who not only accompanied him on the guitar, but also significantly influenced his poetics. In 1973, he coincided in Paris with Georges Brassens, Leo Ferré, Georges Moustaki, and others. In this era he wrote protest songs and began to collaborate with

---

[669] Aristi, *Euskal kantagintza berria*, 125.

the Breton group Gwendal. Later, accompanied by the group Klabelin Komik—with the brothers Santi and Karlos Gimenez— he recorded *Sentimentuen auspoz* (1979) and *Jo ezan* (1981). From this moment on, traditional topics and contemporary poems set to music with a touch of jazz were preferred, both in Euskara and in Spanish.

## The Rise of Folk, Verbena, and Rock

The 1970s witnessed the rise of folk groups. One of the first was Oskarbi, a mainly vocal group that shared the stage with Ez Dok Amairu. These were followed by Izukaitz, who released two records, and Haizea, led by Txomin Artola, who became famous with a self-titled record in 1977, and were inspired by the British group Pentangle.[670] After Artola left, the group recorded only one more record, and the lead singer Amaia Zubiria also took her own path, although both singers would collaborate again afterward. In 1976 and 1979, the group Ortzadar from Pamplona-Iruñea released two albums using traditional instruments, while Fanfarre Xut was preparing its first record.

Of all these groups, Oskorri was clearly the most consolidated and prolific Basque folk band.[671] It was founded in the early 1970s in Bilbao, led by Natxo de Felipe, Anton Latxa, and Bixente Martinez, and it remained active for five decades until its farewell in 2015. Oskorri dedicated its first LPs to the poet Gabriel Aresti from Bilbao (1976) and Bernat Etxepare, the sixteenth-century priest from Lower Navarre (1977). It recorded important collections of children's songs,[672] original songs with lyrics by poets and bertsolaris, traditional songs, and dances and

---

[670] Aristi, *Euskal kantagintza berria*, 131.

[671] See http://www.badok.eus/euskal-musika/oskorri.

[672] With Elkar: *Katuen testamentua* (1993), *Marijane kanta zan!* (1997), and *Doktor Do Re Mi eta Benedizebra* (2005).

large-scale projects such as *The Pub Ibiltaria,* which recapped the Basque song book in thirteen records, with audience participation recorded during live performances. Its popularity on the European folk circuit enabled the group to collaborate with artists from different countries and to combine indigenous instruments with those of other cultures, creating an easily recognizable sound.

In the 1970s the *romería* groups Egan and Akelarre were also formed. Both bands—the first led by Xabier Saldias, and the second made up of the ex-members of the former group Los Mansos[673]—were pioneers in performing festival repertoire completely in Euskara, and their popularity and longevity were considerable. Likewise in the 1970s, the beginnings of rock in Euskara left us the names of bands such as Minxoriak (led by Niko Etxart), Koska, Enbor, Lisker, Sakre, and others. The history of many of these groups, like that of the two most prolific ones I will recount below, demonstrates that intersections between rock and *verbena* (open-air dance) were frequent in that era.

In Iparralde, Errobi emerged, a band made up of Anje Duhalde and Mixel Ducau, who also had their origins in the world of *verbena.* Errobi released a self-titled record, which is considered the first rock album in Euskara (*Errobi,* 1975). Its lyrics—explicitly political—were the work of Daniel Landart, and its politically committed folk rock enjoyed great success, especially in Hegoalde.[674] After *Gure lekukotasuna* (1977) and the live recording *Bizi-bizian* (1978), came *Ametsaren bidea* (1979). This project combined sounds from progressive rock with touches of *xirula,* *alboka,* *irrintzis* (shrill yells), vocal harmonies, rhythmic ostinatos, Indian *tabla,* and Ducau's saxophone. Errobi had released its albums with local record labels up to that time, but due to the positive critical reception of *Ametsaren bidea,* the French label CBS made them an offer for a recording. Shortly thereafter, the

---

[673] See http://www.badok.eus/euskal-musika/akelarre/.

[674] See http://www.badok.eus/euskal-musika/errobi#biografia.

divergent political ideas of the group's two main members led to its breakup. Since then both Ducau and Duhalde have continued to be active in different groups.

In 1978 Itoiz, created from the *verbena* group Indar Trabes, released its first record. It went through two phases:[675] the first close to symphonic rock and folk with the LP *Itoiz* (1978) and the conceptual album *Ezekiel* (1980); and the second, more pop-rock, with *Alkolea* (1982), *Musikaz blai* (1983), *Espaloian* (1985), and *Ambulance* (1987). The change in style was brought about by the arrival of Jimmy Arrabit to the group, and especially by the introduction of Jean Mari Ekai, who played an important role in the composition and production of *Musikaz blai* together with the group's leader and vocalist, Juan Carlos Pérez. Due to exhaustion and tensions among the members, it broke up after the live record *Eremuko dunen atzetik dabil* (1988). Pérez continued to be active and has released nine records of very different sorts.

As reflected in production of music, after Franco's death the climate was favorable for Euskara. On March 27, 1976, the team from Herri Irratia organized the famous radio marathon *24 orduak euskaraz* (twenty-four hours in Basque), with a closing festival in the Donostia-San Sebastián velodrome, which drew more than 11,000 people. Its consequences were felt, motivating other broadcasters to pay attention to the new Basque song. This climate also encouraged different singers, such as Luis Mariano and Mocedades, to release records with tracks in Euskara.[676]

## The Reality of Record Labels

The Herri Gogoa (1967) and Artezi (1973) record labels—both associated with Ez Dok Amairu and directed by Iñaki Beobide

---

[675] See https://www.argia.eus/argia-astekaria/2007/juan-carlos-perez-itoiz-en-lehenengo-letrak-barregarriak-dira.
[676] Aristi, *Euskal kantagintza berria*, 45.

and Jose Angel Irigarai, respectively—accomplished memorable work. One of the highlights of the former is the collection *Herrikoi Musika Sorta*, dedicated to traditional instruments. The Bilbao label Cinsa (1957), which had released works by various singer-songwriters, made important contributions such as *Alboka, bailables vascos* (1967). Multinational labels also included folk in their catalogs, leaving valuable works for posterity: Columbia had the first recordings of *trikitixa* (Basque accordion music)[677] (Trikitrixa of Zumarraga, Eibar, Elgoibar, Azpeitia) and followed this with *Antología de instrumentos vascos* (1975). Movieplay, in turn, released *Herriko musika* (1977).

As the first championships were organized and the *trikitilaris* (accordionist) movement took shape, its discography gradually grew, supported by the IZ label. Founded in 1975 under the leadership of Fernando Unsain and with technicians such as Anjel Katarain and Kaki Arkarazo, it initially focused on folk and traditional styles, but also released *bertsolaritza*, rock, and jazz. The trio of record labels in this decade was rounded out by Xoxoa and Elkar. Jaime Iarritu created the former in 1978, and its catalog includes important works of many folk and rock groups of the 1970s. Finally, in 1972, the publishing house and record label Elkar was founded in Iparralde, and it soon acquired the Goiztiri label. In 1977 it officially set up operations in Donostia-San Sebastián, where it would become the leader in the sector. In the 1980s it acquired the catalogs of Artezi (1981), Soñua (1984)—which would later become Oihuka—as well as Herri Gogoa (1985) and Xoxoa (1990).[678]

---

[677] See http://trikitixa.eus/trikimailua/sailak/diskografia.htm.
[678] Jaione Landaberea Taberna, "Guía de casas y sellos discográficos en Euskal Herria," *Musiker* 15 (2007), 373–446.

## Youth, Rebellion, and Self-governance: "Mucha policía, poca diversión."[679] Social and Musical Context

The punk wave, which reached Euskal Herria in the 1980s, reinvigorated the music scene and left behind important vestiges for subsequent decades. Josu Zabala, the accordionist of Hertzainak, comments that they found little that was original in the work of the singer-songwriters, either in the message or the music, and they sought to break with what had gone before.[680] The DIY philosophy of punk, embodied in British groups such as the Sex Pistols and The Clash, was introduced into Basque Country by individuals who had encountered the beginnings of this movement during their stays abroad and in important visits, such as that of The Clash in 1981.

Young people gave shape to self-governed initiatives— *gaztetxes* (self-managed social centers, generally but not exclusively linked to the youth), fanzines, record labels, and radio stations— encouraged by the empowering message of punk that said to them: "express yourself, do it yourself." Ecologist, antimilitary, feminist, and internationalist groups, together with groups in favor of amnesty for Basque prisoners and in favor of the use of Euskara as well as alternative festival committees also became prominent. The generational change took hold, and numerous bands with the support of that network of self-governed initiatives stirred up the Basque scene.[681]

The 1980s was an era of crisis, economic restructuring, and working-class struggles, with the closing of companies— especially shipbuilding companies (the case of Astilleros

---

[679] "Lots of police, little fun." Song by Eskorbuto, which became a political slogan.
[680] Iker Trebiño, *Salda badago* (Donostia: Orio Produkzioak, 2002), 3:00.
[681] There is an account of this decade in Irun (Gipuzkoa) in Juanma Sarasola Murgia, *Moskuko urrea. Kultur eta gizarte mugimenduen eztanda Irunen, 1983–1993* ([Irun]: Self-published, 2014).

Euskalduna and its workers' struggle is emblematic) and makers of steel and electric machinery—and devastating unemployment rates.[682] In an especially turbulent political atmosphere marked by distrust toward the Transition, there were terrorist attacks by ETA and the paramilitary GAL groups. Paradoxically, the intense police presence did not prevent the proliferation of illegal drugs in the late 1970s, especially heroin, which wreaked havoc among young people. Chaotic urbanism, the lack of public services, and ecological problems[683] rounded out the image of this moment. Industrial cities such as Errenteria, Irun, Arrasate-Mondragón, Bilbao, Vitoria-Gasteiz, and Pamplona-Iruñea acted as nerve centers. A large part of the youth in these cities were children of workers who had come from other parts of Spain, the offspring of the baby boom of the 1960s.[684]

## Punk Groups

In this context there were various waves of new groups that at first only had demos or homemade recordings. Starting from the period 1983–84, the first records began to be cut.[685] Zarama (which means "garbage") were founded in 1977 in Santurtzi, right in Bilbao's Left Bank, the west bank of the Nervión River, which has a remarkable working-class character. Led by Roberto Moso, who learned Euskara in order to sing with the band, they won the Euskal Musika (Basque music) competition, which was held in the Mandiope Hall in Itziar (Gipuzkoa) in 1980. This enabled them to record and release their track "Bildur naiz" in the competition's

---

[682] In Irun it almost reached a quarter of the population at the beginning of the 1990s. See Sarasola Murgia, *Moskuko urrea*, 13; youth unemployment in the Basque Country rose up to between 40 and 50 percent. See Ion Andoni Del Amo, *Party & Borroka* (Tafalla: Txalaparta, 2016), 54.

[683] Del Amo, *Party & Borroka*, 54.

[684] See https://www.rebelion.org/hemeroteca/cultura/040327rr.htm.

[685] Iker Trebiño, *Salda badago* (Donostia: Orio Produkzioak, 2002), 15:30.

compilation record.[686] Shortly thereafter, the Amezaga brothers founded Discos Suicidas in Bilbao for the purpose of releasing the first two singles, "Nahiko" (1983) and "Zaramaren erdian" (1983). Around 1980, Oskar Amezaga took part in founding the music magazine *Muskaria*, together with Roge Blasco and Jose Mari Azkorra. This was followed by various LPs with the collaboration of Jean Phocas, the bassist in Errobi,[687] as sound engineer; the most noteworthy of these is *Dena ongi dabil* (1987), which included "Bihotzak sutan" and the previously released "Maiatzaren lehena," among others.

Eskorbuto, with Iosu Expósito, Juanma Suárez, and Pako Galán, also emerged out of Bilbao's Left Bank. The first two died in 1992 for heroin-related reasons. They released the demo *Jodiéndolo todo* (1983) and the single "Mucha policía, poca diversion" (Spansul Records, 1983). The lyrics to this demo led to their arrest in Madrid, after which they contacted Gestoras Pro Amnisía (a support group for Basque political prisoners). Since they did not receive displays of support from this group, they became hostile to the so-called *abertzale* or Basque nationalist left, which is evident in several of their subsequent songs (such as "Haciendo bobadas" and "A la mierda el País Vasco"). Afterward came the well-known record *Zona Especial Norte* (Spansul Records, 1984),[688] which they shared with the group RIP, and then various albums, such as the noteworthy *Antitodo* (Discos Suicidas, 1985).

In Arrasate-Mondragón, after the abovementioned joint album, *Zona Especial Norte*, RIP recorded its album *No te muevas* (1987) with the Basati Diskak label, which was created with the

---

[686] *Euskal Musika-80*, 1981, IZ.

[687] See http://artxiboa.badok.eus/artista.php?id_artista=118.

[688] This title referred to the so-called ZEN Plan, designed by Spain's Interior Minister José Barrionuevo (of the Partido Socialista Obrero Español or PSOE, the Spanish Socialist Workers' Party) and presented in 1983. It was a precursor of the Anti-terrorism Law of 1984.

support of three fanzines[689] precisely in order to release this album. This album included the choruses "Enamorado de la muerte," "Antimilitar," "Terrorismo policial," "Mundo muerto," and a cover version of "Lepoan hartu ta segi aurrera," written by Telesforo Monzón and popularized in the 1970s by Pantxoa eta Peio. Almost at the other end of Gipuzkoa, Errenteria became the cradle of various punk groups, including Basura and Odio, who were mainly involved in live performances and took decades to record.

The case of Hertzainak resembles that of Zarama, in the sense that Xabier Montoia—the first lead singer of the band from Vitoria-Gasteiz—learned Euskara ij order to sing in the group.[690] These two bands, together with Jotakie (from Urola, Gipuzkoa), were authentic exceptions in a scene dominated by Spanish.[691] Montoia was soon replaced by Iñaki Igon Garitaonandia or "Gari." The alma mater of the group, nevertheless, would be Josu Zabala, a restless multi-instrumentalist who composed the music for most of the songs. They recorded their first demo at the studios of IZ (1983), and the LP *Hertzainak* (Soñua, 1984) followed soon thereafter with the anthological tracks "Eh txo!," "Pakean utzi arte," "Ta zer ez da berdin," and "Drogak AEKn." Their second album *Hau dena aldatu nahi nuke* (Soñua, 1985), featured "Egunero" (a cover version of "Everyday" by The Selecter) and "Eutsi gogor," dedicated to the workers of the Euskalduna shipbuilding company Astilleros Euskalduna.[692] *Salda badago* (Elkar, 1988) and *Amets prefabrikatuak* (Oihuka, 1989) consolidated the group's popularity, especially with the ballad "Aitormena," which was also recorded in an arrangement for

---

[689] López Aguirre, *Historia del rock vasco*, 165.

[690] Iker Trebiño, *Salda badago* (Donostia: Orio Produkzioak, 2002), 9:00.

[691] After them came Kortatu, BAP!!, and Delirium Tremens, which sang in Basque.

[692] See http://www.badok.eus/euskal-musika/hertzainak/.

string quartet. After a live album, there followed *Mundu berria daramagu bihotzean* (Aketo,[693] 1991), and their farewell album *Denboraren orratzak* (Oihuka, 1992).

In Bilbao, MCD (Me Cago en Dios) was also formed in the late 1970s; they recorded a few tracks, but they did not release their first, acclaimed album *Bilboko gaztetxean* until 1987 (Discos Suicidas). Las Vulpes began to play in the early 1980s, but their career was cut short by the scandal unleashed after their performance on the program *Caja de Ritmos* on the Spanish public television channel TVE.[694] This was because of their performance of "Me gusta ser una zorra" ("I like being a slut"), a cover version of "I wanna be your dog" by The Stooges (1969). This resulted in the cancellation of the television program, and the breakup of the band.

La Polla Records was created in Agurain (Salvatierra, Araba). Under the leadership of the irreverent and ingenious lyricist Evaristo Páramos, they released the LPs *Salve* (1984) and *Revolución* (1985) with the Soñua label, after which they produced an extensive discography with various labels. Together with Barricada, a group from Pamplona-Iruñea led by Enrique Villareal or "El Drogas," they became one of the most widely known Basque groups throughout Spain in the 1980s. Barricada debuted with the album *Noche de rock&roll* (Soñua, 1983), followed by *Barrio conflictivo* (Oihuka, 1984) and *No hay tregua* (RCA, 1986), which included its well-known tracks "Contra la pared," "No hay tregua," and "Okupación." Both groups continued to rack up successes in the following decades.

Cicatriz—initially called Cicatriz en la matriz—was rehearsing in the early 1980s at a detox center in Vitoria-Gasteiz, but they did not go on to record until 1985, when Soñua released

---

[693] Aketo was a record company created by them, which dissolved soon after.
[694] Fueled by newspaper *ABC*, which published the song's lyrics two weeks later.

the album shared with Kortatu, Kontuz hi!, and Jotakie. Afterward, they released three studio albums and one live album; the most noteworthy of these is *Inadaptados* (Oihuka, 1986). The four original members of the band died of AIDS or heroin overdoses.

Kortatu was formed in 1983 in Irun, and it had a short, but fertile and especially influential career. Its members Fermin and Iñigo Muguruza and Javier Armendariz or "Treku" released their first LP *Kortatu* (Soñua, 1984), which included "Zu atrapatu arte," "Sarri sari,"[695] and "Nicaragua Sandinista," among others. *El Estado de las cosas* (Soñua, 1986) featured "La línea del frente" and "Hotel Monbar," a track that narrated how the GAL assassinated various Basque political refugees in Baiona, with whom Fermin Muguruza had spent time on that same day. The LP *Kolpez Kolpe* (Oihuka) was released in 1988 and was recorded entirely in Euskara, which constituted an important new direction for the group. The album included hits such as "After boltxebike" and "Etxerat!," and also featured the collaboration of Mikel Laboa in a cover version of M-ak's "Ehun ginen." That same year they took their leave with the live album *Azken guda dantza*, on which Kaki Arkarazo picked up the guitar to accompany them.

Later Potato (Gasteiz) and Tijuana in Blue (Iruñea) arrived on the scene, offering "a response to the speed and the negativity of punk that was dominant at the time." [696] They adopted as their own the battle-cry in favor of a "Euskadi tropikal" [697] by Hertzainak to ska and reggae rhythms.

---

[695] A cover of "Chatty Chatty" by Toots and the Maytals, which describes a jailbreak from Martutene prison by two ETA members, Joseba Sarrionandia and Iñaki Pikabea. It was recorded immediately after the news broke, and was played that summer in Euskal Herria, giving a cheerful chronicle of what had happened.

[696] Iker Trebiño, *Salda badago* (Donostia: Orio Produkzioak, 2002), 44:30.

[697] From its song "Arraultz bat pinu batean" (*Hertzainak*, 1984).

As had been the case with other Basque singer-songwriters, their reception by the local media was not free of controversy. At first, not even the newspaper *Egin* accepted punk rock in Euskara as Basque music.[698] There were exceptions that referred to this new music, such as the Pablo Cabeza's program *Alguien te está escuchando* on Radio Euskadi. In other respects, the fanzines and the free radios were mainly responsible for spreading new developments. After a certain point, the bestselling press covered the scene in its supplements (such as "Dvórame" and "Bat, bi, hiru"), but the Spanish media —including Rock de Lux— neglected these groups.[699]

In 1985, the left-wing Basque nationalist party Herri Batasuna organized a campaign entitled Euskadi alaitsu eta borroka kementsu (Martxa eta Borroka), and scheduled various groups in the so-called Rock Radical Vasco (Basque radical rock, RRV) movement to take part in concerts for large audiences. Some bands like Kortatu, Zarama, La Polla, and Barricada accepted, while others like Eskorbuto and Cicatriz refused, since they considered it a way of capitalizing politically on the scene.

## Beyond RRV

In 1980, Ruper Ordirika, whose style was influenced by time spent in England in the 1970s, recorded *Hautsi da anphora*, a record that dressed up part of Bernardo Atxaga's collection of poems *Etiopia* as pop rock. These two individuals became closer in the legendary literary group Pott, founded in Bilbao in 1977, together with Joseba Sarrionandia and Joxemari Iturralde, among others. As he had done in *Ni ez naiz Noruegako errege* (1983), he continued to set

---

[698] According to Del Amo, the 1983 *Egin* yearbook did not include any rock and punk in the "Basque Music" category, but considered them to be "Modern groups." See Del Amo, *Party & Borroka*, 70.

[699] Iker Trebiño, *Salda badago* (Donostia: Orio Produkzioak, 2002), 47:05.

to music poems by the members of his former band, while in turn acting as lyricist, always surrounded by Basque musicians, as well as musicians from the United States. His extensive discography[700] makes him a leading singer-songwriter with an urban and personal style.

M-ak—made up of Kaki Arkarazo, Anjel Gonzalez Katarain, Xabier Montoia, and Mikel and Fernan Irazoki—was formed in 1982, and they released five studio albums.[701] Although at first they did not enjoy great success, this rock group, combining funk and with experimental tendencies, clearly influenced later bands that defined the 1990s such as Negu Gorriak, discussed below.

Doctor Deseo, a group from Bilbao, began to record with Discos Suicidas and Oihuka a rock that alluded to cabaret. Already in the previous decade, Orquesta Mondragón from Donostia-San Sebastián had contributed a different aesthetic; according to Elena López, "it would actually become one of the most groundbreaking groups in the country, although they did not produce any musical innovations." [702] In Pamplona-Iruñea, Aurora Beltran formed the group Belladona, and afterward, Tahures Zurdos; the latter recorded with Oihuka and later signed with the multinational EMI. In the folk arena, the 1980s were the era of the groups like Azala, Txanbela, Ganbara, and Lauburu.

---

[700] See http://www.badok.eus/euskal-musika/ruper-ordorika/.
[701] See http://www.badok.eus/euskal-musika/m-ak#diskografia.
[702] López Aguirre, *Historia del rock vasco*, 135.

## Push for Normalization: "Euskalduna naiz eta harro nago!"[703] The Advance of Euskara

When the decade changed, many of the groups from the 1980s stopped playing, and they gave way to a greater stylistic diversity, in which Euskara regained a central role, even in punk.[704] Bands from the 1980s such as MDC, La Polla, Doctor Deseo, and Barricada began to include "a track in Euskara in their records or in collective records."[705] The general atmosphere was favorable: the Basque-language newspaper *Euskaldunon Egunkaria* was founded, there was a boom in *bertsolaritza*,[706] the public radio station for young people Euskadi Gaztea was created, and the Basque-language watchdog association Euskararen Gizarte Erakundeen Kontseilua (Kontseilua) was founded, together with the resultant strategic agreement *Bai Euskarari* (an agreement based on a commitment to use Basque); progress was also made in introducing teaching in Euskara at the university level, plans to introduce Euskara in the workplace, and so on. The normalization of the language seemed to have become a common social goal.

On the youth scene a greater ideological alignment with the Basque nationalist *abertzale* left was perceptible, reflected in the lyrics of up-and-coming groups, which contrasted with the conflict-ridden relationship of the first generation of punk groups.[707] In 1994, the *Gazte Topaguneak* began, annual youth

---

[703] From the song "Esan ozenki" by Negu Gorriak (1990), which chants "Say it loud, I'm Basque and I'm proud!" paraphrasing James Brown's "Say it loud, I'm black and I'm proud."

[704] Del Amo, *Party & Borroka*, 103.

[705] Ibid., 104.

[706] See Joxerra Garzia, ed., *The Art of Bertsolaritza: Improvised Basque Verse Singing* (Donostia: Bertsozale Elkartea, 2001). The author mentions the TV program *Hitzetik Hortzera,* launched in 1988, and to the young bertsolari generation that came afterward, which renewed the movement and brought a new influx into shows and bertso-schools.

[707] Del Amo, *Party & Borroka*, 104.

political festivals with high turnouts, through which many of the decade's leading groups would pass. Likewise, 1995 witnessed the birth of Euskal Herria Zuzenean (EHZ), an alternative summer festival held in Iparralde.

The presence of Basque music in the media seemed to become the norm: in the newspaper music supplements "Gaztegin" (*Egin*), "Devórame" (*Diario Vasco*), and "Barkatu, ama" (*Euskaldunon Egunkaria*), the program *Igo bolumena* (on radio station Egin Irratia), and the programming of the public radio Euskadi Gaztea together with its demo competition, which launched groups such as EH Sukarra, Sorotan Bele, and Latzen.[708] ETB1 broadcast the specialized program *Katu Kale*. In 1996 the music magazine *Entzun*, in color and completely in Euskara, was created with the assistance of the Ubeda brothers (from the band Deabruak Teilatuetan), and with the promotion of the Esan Ozenki label.

Although some *gaztetxes* were dislodged (the Bilboko gaztetxea in Bilbao, for example), squatters occupied new spaces (Bonberenea in Tolosa, and Euskal Jai in Pamplona-Iruñea), and concert halls were opened, such as Jam in Bergara and the Kafe Antzokia in Bilbao.[709]

## Groups and Record Labels

In 1990 Negu Gorriak—who took their name from the song "Gaberako aterbea" by Mikel Laboa—debuted with their self-titled album. The group consisted of Fermin and Iñigo Muguruza (from Kortatu), Kaki Arkarazo (from M-ak), Mikel Abrego, and Mikel Kazalis, and it attracted attention both on the Basque scene and abroad with its mixture of hardcore, funk, and hip hop styles, and also with its politically committed attitude and its powerful

---

[708] See http://www.badok.eus/historia/90eko-hamarkada-oparoa/.

[709] See http://www.badok.eus/historia/90eko-hamarkada-oparoa/.

staging. Its tracks are full of references to Basque culture and to foreign trends, in the form of textual citations or sampling;[710] with field recordings of traditional Basque musicians;[711] with an extract from the National Bertsolari Championship of 1986;[712] together with snippets from rappers such as Ice T and Eric B & Rakim. In its music, Negu Gorriak cited Spike Lee, NWA, and Funkadelic as well as icons of Basque popular culture such as Xabier Lete and Luis Mariano.

Their greatest organizational contribution was the creation of the Esan Ozenki label (1991–2001), with its ideology of self-governance and assemblies, which set limits on the sale prices of their albums in stores and distributed the profits equitably between the groups and the record labels. A catalog of these is essential for understanding the development of Basque music in this decade:[713] they included metal and thrash (Su Ta Gar, Anestesia, PI.L.T., and Etsaiak), punk-rock and hard rock (EH SUkarra, Kashbad, Deabruak Teilatuetan, and BAP!!), punk-noise (Ama Say and Akauzazte), post-hardcore (Dut and Lisabö), ska (Betagarri and Skunk), singer-songwriters (Anari and Xabier Montoia), reggae (King Mafrundi), Latin music (Joxe Ripiau), hip-hop (Selektah Kolektiboa), triki-rap-rock (Lin Ton Taun), electronic music (Basque electronic diaspora), and so on. In 1995 they created the sub-label Gora Herriak for releasing foreign groups, such as the Italians Banda Bassotti and the Argentinians Todos Tus Muertos.

In the 1990s, other important record labels emerged, such as Gor, created by Marino Goñi, who had already passed through Soñua and Oihuka. These released the premiers of Exkixu (later

---

[710] All musical quotes can be found in a blog by two fans: http://ngsamples.blogariak.net/.

[711] "Sarrera," the first track on *Gure jarrera* (1991), starts with *sunpriñu* sounds by Juan Mari Beltran, extracted from *Euskal Herriko Soinu Tresnak* (IZ, 1985).

[712] The track "Bertso-hop" (*Negu Gorriak*, 1990).

[713] See http://www.badok.eus/diskoetxe/esan-ozenki/.

Gatibu), Urtz, Hemendik At!, [714] Zea Mays, and Berri Txarrak. Likewise, Gaztelupeko Hotsak emerged in Soraluze; at first it had a blues orientation, but it gradually expanded its range to include Mikel Markez, Mikel Urdangarin, Petti, and Txuma Murugarren, among others. The group Zazpi Eskale, made up of young bertsolaris Igor Elortza and Unai Iturriaga and the ex-Hertzainak member Josu Zabala merged folk-rock and bertsos, and released albums with both labels. [715]

The consolidated labels Elkar and Oihuka followed in their footsteps. The former sponsored the new, successful genre of triki (accordion) pop, represented by Maixa ta Ixiar, Gozategi, Etzakit, and Alaitz eta Maider, as well as the Irish folk rock of Sorotan Bele. Oihuka release harder sounds, such as the bands Latzen and Soziedad Alkoholika. Elkar and IZ, in turn, inaugurated new infrastructures, and the recording studios Lorentzo Records and Katarain were established. [716] After 2000, other bands of different kinds of styles appeared: Hesian, Kerobia, The Uskis, Kauta, Kuraia, Sagarroi, Sextysexers, Katamalo, Karidadeko Benta, Makulu Ken, Skakeitan, Willis Drummond, and so on. The best known were Ken Zazpi, Gatibu, and Esne Beltza, who are still active and are still being heard today on the Basque radio.

In 2001, the Metak label was created, the heir to Esan Ozenki. It shut down in 2006 due to a drop in sales, and from its ashes, Bidehuts emerged, a project managed by the groups from its catalog: Lisabö, Inoren Ero Ni, Anari, Mursego, Willis Drummond, and so on.

---

[714] Del Amo notes that alternative circuits did not always accept techno, even if it was political and in Euskara; it was even received with chants such as "hau ez da gure estiloa!" (this is not our style). See Del Amo, *Party & Borroka*, 21.

[715] The same members would round up their collaboration in the project *Gu ta Gutarrak* (Lanku, 2007).

[716] See http://www.badok.eus/historia/90eko-hamarkada-oparoa/.

## The Return of Folk and Building Bridges with Iparralde

The 1990s and the 2000s revealed a strengthening of folk: Oskorri, Alboka, Aintzina, Xarnege, Zaldibobo, Bidaia, Amaia Zubiria, Olatz Zugasti, Beltran, and so on. In 1999 Jesus Artze released *Sakanatik Arbaila ttipira*, together with Pello de la Cruz, Mikel Artola, and Iker Muguruza (Kirikoketa), and with the collaboration of Mikel Laboa, Iñaki Salvador, and Mixel Etxekopar. The *albokari*, Ibon Koteron, stands out with *Leonen Orroak* (Elkar, 1996). The duo made up of Joseba Tapia and Xabier Berasaluze or "Leturia" (Tapia eta Leturia) opened up the way to modernize the *trikitixa*, and they were followed by Imuntzo eta Beloki and Kupela. Tapia also forms Hiru Truku together with Bixente Martinez and Ruper Ordorika.

The *trikitixa* of Kepa Junkera became known in Euskal Herria and outside thanks to the musician's many collaborations.[717] He received gold records with *Bilbao 00:00* (Resistencia, 1998) and *Maren* (EMI Odeon, 2001), and a Latin Grammy with the live album *K* (EMI Odeon, 2004). Based in Iparralde, Kalakan offers arrangements of traditional Basque songs mainly with voice and percussion. The trio achieved sudden fame due to its tour with Madonna in 2012, although they had already released a self-titled album (ZTK, 2010).

The political borders dividing the Basque Country seem to be weakening, and we hear mention more often of Mixel Etxekopar, Maddi Oihenart, Jean Mixel Bedaxagar, and Amaren Alabak in Hegoalde. Two noteworthy records are *Lürralde Zilarra* (Agorila, 1998) and *Ilhargi-min* (Metak, 2003).

---

[717] See http://www.badok.eus/euskal-musika/kepa-junkera#biografia.

## New Proposals (and Not So New): *Fuck you revivals* [718]

The situation of cultural activity in favor of Euskara (*euskalgintza*) serves to illustrate the current scenario. There have been extraordinary advances at the linguistic level in the last six decades.[719] Even so, the *bertsolari* and sociologist Jon Sarasua warns that the normalizing initiatives, both popular and institutional, have promoted a "normalized fiction,"[720] an illusion of linguistic normalcy. This vision prevents us from seeing "where the bottle is leaking."[721] And it has brought with it a more relaxed attitude toward the struggles and demands of the previous decades.[722]

This is also reflected at the musical level. Ion Andoni del Amo warns that "releases in Spanish outnumber those in Euskara, and strong numbers are being recorded for works in English."[723] Of course, there have been recent English-language precedents, such as El Inquilino Comunista or Cancer Moon, from the so-called Getxo Sound in the 1990s.[724] However, this trend seems to have become stronger with the passing of the years, as in the case of Delorean, We Are Standard, and Audience, in the field of

---

[718] Quote from "Kalima" by Glaukoma (*Kalima*, 2017).

[719] Such as the implementation of Euskara in education, the standardization of the language, adult literacy programs, the setting up of the Basque public media, initiatives to increase Euskara in the public and private sectors. However, improvements in some of these areas have lately stalled.

[720] Feminist author Amelia Valcárcel's concept of "illusion of equality" resonates. See Amelia Valcárcel, *Feminismo en un mundo global* (Madrid: Editorial Cátedra, 2008).

[721] Jon Sarasua, "Kultur bizitzaren azterketa kualitatiboaren emaitzak, ondorioak eta proposamenak," *BAT Soziolinguitika Aldizkaria* 83, no. 2 (2012), 22.

[722] Del Amo warns us that this mainly refers to the Basque Autonomous Community, and not so much to Iparralde or Navarre. See Del Amo, *Party & Borroka*, 163.

[723] Ibid., 114.

[724] López Aguirre, *Historia del rock vasco*, 275.

electronic music.[725] The choice of a foreign language seems to be to a great extent an aesthetic one, and even a reaction against the politicization of Basque music in previous decades.[726] Despite this, many of these groups also include songs in Euskara[727] or traditional elements such as irrintzis and txalaparta. The reference to Laboa made by Delorean (*Mikel Laboa*, 2017) and also by WAS (*Gau Ama*, 2016) is worth noting.

As regards alternative festival circuits—*gaztetxes*, *txoznas*, and bars—the conflict between mainstream music and more alternative music seems to have been decided in favor of the former, and it has passed from the retromania for the Basques of the 1980s and 1990s[728] to the commercial replay lists of the radio format, without apparent social conflict. The journalist and activist Kattalin Miner of the trans-feminist group Medeak complains that this aesthetic of openness to other styles—such as reggaeton or the so-called "tacky" songs—has not occurred based on unconventional and political beliefs, but rather merely to continue to appeal to the audience and "maintain the space."[729] Lorea Agirre comments that the "identity of resistance" and the "protest cycle" have apparently been left behind.[730] This would explain why "cultural spaces—even the so-called alternative ones—are interpreted in codes specific to leisure and relaxation."[731] The critic and cultural journalist Gorka Bereziartua tops off the analysis by diagnosing the loss of symbolic force of

---

[725] We could also mention multilingual groups like Belako, Izaro, John Berkhout, Ainara Legardon, Eraul, and Ama Say.

[726] Del Amo, *Party & Borroka*, 198.

[727] Or turn back to Basque, which is the case of various musicians named in this article: http://www.badok.eus/musika/lyrics-etatik-hitzetara/.

[728] Del Amo, *Party & Borroka*.

[729] Ibid., 239.

[730] Lorea Agirre, "Euskal kulturgintza: nondik gatoz, non gaude, nora jo beharko genuke," *Jakin* 183 (2011), 20.

[731] Del Amo, *Party & Borroka*, 262.

the "musical counterculture, which was structured in the 1990s around the izquierda abertzale."[732]

According to Koldo Otamendi, the director of the webzine *MusikaZuzenean*, the Basque musical scene has increased in scale and in diversity, but not in audience.[733] The increasing supply of records and concerts is greater—and more varied—than the demand. The interviews conducted by Del Amo (2016) with players on the Basque music scene, and the testimonies collected in the publication *Aho bete doinu #2* (2016) of the music magazine *Entzun* coincide in this analysis: on the one hand, they point to the low turnout of the youngest generation at concerts. The festival format seems to be the one that attracts the largest audiences, at events like BBK Live and Hatortxu Rock. On the other hand, there is the overwhelming popularity of groups in the radio format: The Top 40 or Basque public radio aimed at the young, Gaztea (formerly, Euskadi Gaztea). Many artists agree in criticizing the commercial evolution of Gaztea and the lack of specialized music programs or of a more variegated public channel. As early as 2001, even Edurne Ormazabal herself, the ex-director of Gaztea, raised the question: "Why do we want public media if they are increasingly similar to the private media?"[734]

Jon Eskisabel observes that in Euskal Herria the range of styles has expanded enormously over the course of the years:[735] skilled musicians are trained, quality discs are produced, there are good studios and sound engineers, and there are also specialized communications media, concert halls[736] and festivals. But, although it is important to recognize the progress—as in the case of Euskara—we must not become so comfortable with what has

---

[732] Ibid., 116.

[733] Iñigo Martínez, ed., *Aho bete doinu #2* (Astigarraga: Eragin, 2016), 33.

[734] Jon Eskisabel, *Aho bete doinu #1* (Iruñea: Eragin, 2001), 124.

[735] Jon Eskisabel, *Euskal kantagintza/La canción vasca/Basque Songwriting: pop, rock, folk* (Donostia: Etxepare, 2012), 9.

[736] See some well-known venues at http://kulturalive.com/eu/salas-2/.

been achieved that this clouds our vision: we must ask new questions and consider the real weaknesses.

There is a need for networks and initiatives that showcase the variety of local music and organize the Basque Country beyond its administrative borders. In Iparralde, festivals as fascinating as Xiru, Errobi, Usopop, and EHZ are held, to name only a few. The internet and the digital platforms are and will continue to be key in publicizing different musical approaches. There are necessary projects such as *Badok*;[737] *Musikazuzenean*,[738] and *Entzun*.[739] The role of public communications media is also crucial. And in the midst of all this, as Gorka Bereziartua warns,[740] the apparently egalitarian range of possibilities of Spotify and YouTube conceals strategies for directing consumers' tastes.

The innovative attitude continues today on a mainly underground circuit that offers very different experimental propositions: Mursego, Amorante, Joseba Irazoki, Beñat Axiari, Mixel Etxekopar, Pantxix Bidart, Neighbor, Lurpekariak, Lisabö, Inoren Ero Ni, and Paxkal Irigoien. The now extinct festival Ertz held in Bera (Navarre) and the BET youth gatherings in Bergara (Gipuzkoa)[741] have created frameworks for visualization. These coexist with initiatives such as the self-governed club Larraskito in Bilbao[742] and the Astra culture factory in Gernika, Bizkaia, which dedicate their spaces to experimentation and innovation. On the other hand, rap (2zio, La Basu, Glaukoma, Bad Sound System, and 121 Krew), trap (Nizuri Tazuneri), and different kinds of electronic music (El_Txef_A, Las Tea Partys, the

---

[737] See http://www.badok.eus/.

[738] See http://musikazuzenean.com/.

[739] See http://www.entzun.com/.

[740] See https://www.argia.eus/blogak/boligrafo-gorria/2018/10/16/spotify-rekin-bukatu-zen-musika-deskubritzeko-gogoa-edo-ia/.

[741] Bergarako Elektronika Topaketak (Electronic Encounters of Bergara).

[742] See http://clublelarraskito.tumblr.com/. Also: http://www.tiumag.com/features/interviews/larraskito-club-placer-la-escucha/.

More Jaia collective, Koban, and Anita Parker) are more present than in previous decades. Moreover, a growing feminist awareness promotes the visibility and enables women to become involved with creating music, and this begins the necessary reflection on a cultural sector that is evidently male-dominated.[743]

Between Michel Labéguerie and Neighbor there are decades of history that have gradually changed not only the profile and background of the musicians, but also their aesthetics, the industry, their production, and the spaces. Every generation has opened up a new divide, disputing, delineating, and broadening the concept of what it considers to be "Basque popular music." Beyond repeating established schemata, the task of today's musicians is to offer contemporary proposals that are a product of the conditions of their times.

## Bibliography

Agirre, Lorea. "Euskal kulturgintza: nondik gatoz, non gaude, nora jo beharko genuke. Eztabaidarako proposamen bat." *Jakin* 183 (2011): 11–91.

Aristi, Pako. *Euskal kantagintza berria: 1961–1985*. Donostia: Erein, 1985.

Barroso Arahuetes, Amparo. "Iglesia Vasca (2001): na Iglesia De http://www.jstor.org/stable/41325098.

Beltran Argiñena, Juan Mari. *Txalaparta*. Book-CD-DVD. Donostia: Nerea, 2009.

———. *Alboka. Inguru folklorikotik eskolara*. Soinuenea: Oiartzun, 2013.

---

[743] Igone Mariezkurrena Fernandez, *Aho bete doinu #3. Musika & Generoa* (Iruña: Eragin, 2017).

Del Amo, Ion Andoni. *Party & Borroka. Jóvenes, músicas y conflictos en Euskal Herria.* Tafalla: Txalaparta, 2016.

Elizburu, Gotzon. "Ye-ye euskaldunen historia ahantzia." *Argia,* July 17, 2011, 21–23. At: http://www.argia.eus/astekaria/docs/2285/pdf/21- 23.pdf.

Elustondo, Miel Anjel. "Juan Carlos Perez: 'Itoiz-en lehenengo letrak barregarriak dira'."*Argia,* September 18, 2005. At: https://www.argia.eus/argia-astekaria/2007/juan-carlos-perez-itoiz-en-lehenengo-letrak-barregarriak-dira.

Eskisabel, Jon, ed. *Aho bete doinu #1: euskal musikagintzaren iragana, oraina eta geroari buruzko elkarrizketak.* Iruñea: Eragin, 2001.

———. *Euskal kantagintza/La canción vasca/Basque Songwriting: pop, rock, folk.* Donostia: Etxepare, 2012. At: http://www.etxepare.eus/media/uploads/publicaciones/euskal_kantagintza_pop_rock_folk.pdf (last accessed July 22, 2018).

Gaiteros de Pamplona. "Zuberoko artista bat. Caubet Chubuko Arhan: txanbela eta khantoriak (I)." *Cuadernos de etnología y etnografía de Navarra* 28 (1977): 483–507.

———. "Zuberoko artista bat. Caubet Chubuko Arhan: txanbela eta khantoriak (II)." *Cuadernos de etnología y etnografía de Navarra* 28 (1978): 117–80.

Garzia, Joxerra, ed. *The Art of Bertsolaritza: Improvised Basque Verse Singing.* Donostia: Bertsozale Elkartea, 2001.

Hurtado Mendieta, Enrike. "Txalaparta y vanguardia, un análisis de sus características communes." *AusArt* 3, no. 2 (2015): 58–68.

Irazu Ibáñez, Alberto. *Rocka puntua!.* Iruña: Pamiela, 2017.

Iriondo, Joxemari. *Lourdes Iriondo (1937–2005).* Gasteiz: Eusko Jaurlaritza, 2006. At: http://www.euskara.euskadi.net/appcont/sustapena/datos/44%20IRIONDO.pdf (last accessed July 20, 2018).

———. "Euskal musika giroa 1960ko hamarkadan." *Jakin* 200 (2014): 77–94.

Landaberea Taberna, Jaione. "Guía de casas y sellos discográficos en Euskal Herria." *Musiker* 15 (2007): 373–446. At: http://hedatuz.euskomedia.org/7185/1/15373446.pdf.

Larrinaga Arza, Josu. "Ttakun eta scratch, euskal pop musikaren hotsak." PhD dissertation, Euskal Herriko Unibertsitatea-Unversidad del País Vasco (EHU-UPV), 2014. At: http://www.euskara.euskadi.eus/appcont/tesisDoctoral/P DFak/Josu_Larrinaga_TESIA.pdf.

Lete, Xabier. "Kanta berria, erresistentzi abestia." *Jakin* 4 (1977): 18–19.

López Aguirre, Elena. *Historia del rock vasco. Edozein herriko jaixetan.* Gasteiz: Aianai, 2011.

Mariezkurrena Fernandez, Igone. *Aho bete doinu #3. Musika & Generoa.* Iruña: Eragin, 2017.

Martin Etxebeste, Jon. "Euskal kantagintza berria eta Ez Dok Amairu." In *XXIV Psikodidaktikako ikerkuntza jardunaldiak.* Bilbo: EHU, 2017.

Martínez, Iñigo, ed. *Aho bete doinu #2.* Astigarraga: Eragin, 2016.

Sarasola Murgia, Juanma. *Moskuko urrea. Kultur eta gizarte mugimenduen eztanda Irunen, 1983–1993.* [Irun]: Self-published, 2014.

Sarasua, Jon. "Kultur bizitzaren azterketa kualitatiboaren emaitzak, ondorioak eta proposamenak." *BAT Soziolinguitika Aldizkaria* 83, no. 2 (2012): 11–28. At: http:// www.soziolinguistika.eus/files/Jon%20Sarasua_0.p df.

Valcárcel, Amelia. *Feminismo en un mundo global.* Madrid: Editorial Cátedra, 2008.

## Websites

Badok: Basquye music secition of *Berria*: http://www.badok.eus/.
*Entzun*: Basque music journal: http://www.entzun.com/.
Eresbil: Basque Archives of Music: http://www.eresbil.com/.

## Personal sources

Beltran Argiñena, Juan Mari. Interview in Oiartzun, August 31,

## Documentaries

Frank Dolosor, director. *Estitxu*. DVD. 2017. At:
https://www.eitb.tv/es/video/estitxu/
Iker Trebiño, director. *Salda badago*. Donostia: Orio Produkzioak,
2002. At https://www.eitb.tv/eu/bideoa

# Sources and Bibliography

## Musical Sources

The oldest music sources in the Basque territories belong to different institutions of the Catholic Church: the cathedrals of Pamplona-Iruñea and Tutera (Tudela) in Navarre, the Franciscan convent of Arantzazu in Gipuzkoa, and the collegiate church of Vitoria-Gasteiz in Araba. We would have to wait until the end of nineteenth century to have institutions that provided a whole range of civil document sources to music such as choral societies and orchestras, or the libraries of educational institutions and archives like Eresbil.

## ERESBIL – Basque Archives of Music

ERESBIL-Musikaren Euskal Artxiboa.
Alfonso XI, 2. 20100 Errenteria.
Tel.: 943.000.868.
e-mail: bulegoa@eresbil.eus.
http://www.eresbil.eus

Founded in 1974 in Errenteria (Gipuzkoa), its main purpose is the research, compilation, preservation, and difussion of musical heritage, and especially the production of Basque composers. It preserves Basque music production in all type of supports, whether textual, audiovisual, or iconographic. Since 2000, Eresbil has kept a legal depository copy of scores and sound recordings from the Basque Autonomous Community.

Since it was established, it has collected both private and institutional sources. There are more than 180 sources, with those relating to composers particularly noteworhty. An online guide of the sources in Eresbil can be consulted at http://www.eresbil.com/sites/fondos/es/.

Of special interest are the sources of composers, such as those of Valentín Zubiaurre (1837–1914), César Figuerido (1876–1956), Beltrán Pagola (1878–1959), José Olaizola (1883–1969), Tomás Múgica (Tolosa, Gipuzkoa, 1883–Tacuarembó, Uruguay, 1963), Jesús Guridi (Vitoria-Gasteiz, Araba, 1886–Madrid, 1961), José Mª Usandizaga (Donostia, Gipuzkoa, 1887–Donostia, 1915), José Mª Uruñuela (Vitoria-Gasteiz, 1891–Donostia, 1963), Norberto Almandoz (1893–1970), Jesús Arámbarri (1902–1960), Luis de Aramburu (1905–1999), Rodrigo A. de Santiago (1907–1985), Francisco Escudero (1912–2002), Mª Luisa Ozaita (1937–2017), and Gotzon Aulestia (Ondarroa, 1940–Donostia, 2003).

Eresbil disseminates the work of Basque composers through the Musikaste festival, held annually in May in Errenteria (Gipuzkoa).

## Collections

Manuscript scores (19,000); printed scores (60,000); monographs (20,000); journals (1,300 titles); sound recordings (110,000); audiovisual documents (2,500); program collections (1,300); poster collections (1,300); photographs (8,500); documentation (20,000).

## Archivo de la Música y de las Artes Escénicas de Navarra (The Navarrese Music and Scenic Arts Archive)

archivomusica@navarra.es

It was created in 2017 as an addition to the document archives from the fields of music, dance, and theater preserved in the Archivo Real y General de Navarra (Royal and Gerneral Archive of Navarre), in Pamplona-Iruñea, with the aim of preserving, organizing, disseminating, and placing value on the heritage of Navarre. Basically, the program is supported by donations such as bequests from creators or their relatives, as well as from relevant institutions in the aforementioned fields.

It contains the archives of Fernando Remacha, Jesús García Leoz, Emilio Arrieta, Tomás Asiáin, Martín Zalba, and José Láinez-Concha Martínez (dance), among others. Moreover, the music libraries of Arturo Campión, the Aita Donostia manuscripts, and those of the Huarte-Solchaga family stand out. Likewise, the Orfeón Pamplonés archive is included in deposit.

## SOINUENEA

Tornola kalea, 6 – 20180 Oiartzun.

Tel.: 943.493.578.

Email: soinuenea@soinuenea.eus.

http://www.herrimusika.org/

Documentation center and meeting place for popular music located in the Gipuzkoan town of Oiartzun. Soinuenea is also a traditional music archive with a wide scope. Soinuenea has the following aims:

- To set up an information center promoting knowledge and research and serving as a meeting place for anyone with an interest in traditional music and instruments.

- To make Basque culture, and in particular Basque music, available to a wide public in a comprehensible, entertaining, and instructive way.
- To offer active theoretical and practical classes in music to educational institutions and music schools, as a complement to their musical studies.

## Araba

The library of the "Jesús Guridi" conservatory of music in Vitoria-Gasteiz preserves the archives of José García del Diestro, José Rada, and the Dimas Sotés (1901–72) library.

The Diocesan Seminar of Vitoria preserves the music archive of the Santa Maria Cathedral as well as the music archive of the Diocesan Seminary.

The Archivo Histórico Diocesano de Vitoria (Diocesan Historical Arhive of Vitoria) preserves the archives of the music chapel of Santa María of Laguardia.

The Archivo Histórico Provincial de Álava (Historical Provincial Archive of Araba) in Vitoria-Gasteiz includes a collection of 361 pieces, such as religious codex with music notation, most of them copied between the twelfth and sixteenth centuries.

## Bizkaia

The Historic Archive of the Provincial Council of Bizkaia preserves among its archives in Bilbao the historic collection of scores from the Sociedad Coral de Bilbao, the Teatro Campos Elíseos, the Olaeta ballet archive, and other archives of composers like Emma Chacón (1886–1972) and Carmelo Bernaola (1929–2002), as well as a sound recording and video collection devoted to ethnographic programs developed by the provincial council.

The Central Library of Bidebarrieta in Bilbao preserves the original archive of the composer Juan Crisóstomo Arriaga (1806–1826).

The Azkue Library of Euskaltzaindia, the Royal Academy of the Basque Language, in Bilbao includes, among other things, the archive and library of the philologist, folklorist, and composer Resurrección Mª de Azkue (1864–1951), and, moreover, sound recordings made both for the Atlas linguistic project in Euskal Herria and those made by Irale in the Bizkaian dialect.

The Historic Ecclessiastic Archive of Bizkaia in Derio includes some choir books, the Diocesan seminary archive, as well as the vinyl record collection of Radio Popular and an archive of oral sources.

The library of the "Andrés Isasi" Municipal School of Music in Getxo preserves archives from composers like Andrés Isasi (1890–1940), Antón Larrauri (1932–2000), and the sound collection of the jazz specialist, Pio Lindegaard.

## Gipuzkoa

The Franciscan sanctuary of Arantzazu preserves archives from the old music archive of the Sanctuary of Arantzazu (c. 1680–1835), the modern music archive (c. 1865–present), and the archive of Jose Mª Arregui (1879–1955).

The Diocesan Historic Archive in Donostia-San Sebastian perserves music archives from the Santa María del Coro Basilica (Donostia-San Sebastian) and the Ernialde parish church, and also archives from the Schola Cantorum seminary and José María Maidagan.

The Santa Maria parish church in Tolosa contains the Archivo de la Capilla de Música (Music Chapel Archive) that includes archives from composers such as Felipe Gorriti and Eduardo Mocoroa.

The "P. Nemesio Otaño S.J." Archive and Library in Loiola, in addition to being the archive that gives its name to the institution, contains the archives of different Jesuits priests as well as the archives of Jesuits schools.

The library of the "Francisco Escudero" Professional Conservatory of Music houses the archives of the orchestra and brass band of the Donostia-SanSebastian Conservatory, as well as that dedicated to the composer and pianist Fabián Furundarena.

**Navarre**

https://www.capillademusicapamplona.com/historia/archivo/

Pamplona Cathedral has maintained a rich music archive since the thirteenth century as well as bequests from different musicians like Leocadio Hernández Ascunce (1883–1965), Javier Redín Mainz (1922–80), José Mª Herrero (1917–85), Justo Sevillano (1906–1984), Domingo Galarregui (1913–90), Bonifacio Iraizoz (1883–1951), and Pío Iraizoz (1914–91). The music archive catalogue is available online (http://www.archivomusica-catedralpamplona.org/).

The Ecclesiastic Archives and Library of the Tudela Cathedral (http://www.palaciodecanaldetudela.com/palacio/archivos.html) houses the Cathedral Musical Archive with scores dating from 1750 to the present.

The Central Library of the PP. Capuchins in Pamplona contains the bequest of the composer, folklorist, and researcher P. J.A. de Donostia (1886–1956), the musicologist Dionisio Preciado (Pío de Salvatierra)(1919–2007), and the composer Lorenzo Ondarra (1931–2012), as well as music collections from different Capuchin monasteries like Lekaroz (Lecároz), Altsasua (Alsasua), Hondarribia (Fuenterrabía), Extramuros, and San Antonio in Pamplona-Iruñea.

The library and museum in Orreaga-Roncesvalles preserves music archives from the collegiate church, which include works from the sixteenth to eighteenth centuries, although it also contains a thirteenth-century evangelarium.

The Biblioteca Mediateca Fernando Pérez Ollo, in the Ciudad de la Música (http://ciudaddelamusica.navarra.es/) contains diverse bequest and music libraries from musicians such as José Mª Beobide, Felipe Aramendía, Sainz de los Terreros, Abel Lumbreras, and the music critic Fernando Pérez Ollo, who gives his name to the library.

## Iparralde

The Médiathèque de Bayonne houses the music archive of the composer Adrien Barthe (1828–1898).

The Musée Basque de Bayonne (Baiona Basque Museum) library preserves the music manuscripts from the composer Anita Bringuet-Idiarborde (1891–1943) as well as printed music by Lucien Tenaro (1889–1971).

## General Bibliography

Álvarez Cañibano, Antonio, Mª José González Ribot, Pilar Gutierrez Dorado, and Cristina Marcos Patiño, eds. *Compositoras españolas: la creación musical femenina desde la Edad Media hasta la actualidad.* Madrid: Centro de Documentación de Música y Danza, 2008.

Andrés, Marcos. *Fernando Remacha. El compositor y su obra.* Madrid: ICCMU, 1998.

Anglés, Higinio. *Historia de la Música Medieval de Navarra. Obra póstuma.* Pamplona: Diputación Foral de Navarra. Institución Príncipe de Viana, 1970.

———. *Scripta musicological.* 3 volumes. Roma: Edizioni di Storia e Letterature, 1976.

Ansorena, José Luis. *Aita Donostia.* Donostia: Kutxa, 1999.

Arana Martija, José Antonio. *Euskal musika.* San Sebastián: Erein, 1985.

———. *Música vasca.* 2nd edition. Bilbao: Caja de Ahorros Vizcaina, 1987.

Aristi, Pako. *Euskal kantagintza berria: 1961–1985.* Donostia: Erein, 1985.

Armistead, Samuel G., and Joseba Zulaika, eds. *Voicing the Moment: Improvised Oral Poetry and Basque Tradition.* Reno: Center for Basque Studies, Univerity of Nevada, Reno, 2005.

Arrieta Elizalde, Idoia. *Ilustración y Utopía: Los frailes vascos y la RSBAP en California (1769–1834).* Donostia-San Sebastián: RSBAP, 2004.

Aulestia, Gorka. *Escritores vascos.* Vitoria-Gasteiz: Fundación Caja Vital Kutxa, 1996.

Azkue, Resurrección María de. *La Música popular baskongada.* Bilbao: Imprenta y Litografía de Gregorio Astoreca, 1901.

———. *Cancionero popular vasco.* 3rd edition. Bilbao: Euskaltzaindia, 1990

Azpiazu, José Antonio. *Franciscso de Madina: Priest and Basque Musician*. Oñati: Oñati Abesbatza, 2002.

Bagüés, Jon. *La música en la Real Sociedad Bascongada de los Amigos del País*. Volume 1 of *Ilustración musical en el País Vasco*. Donostia-San Sebastián: Real Sociedad Bascongada de los Amigos del País, 1990.

————. *El Real Seminario Patriótico Bascongado de Vergara*. Volume 2 of *Ilustración musical en el País Vasco*. Donostia-San Sebastián: Real Sociedad Bascongada de los Amigos del País, 1991.

Barandiarán, José Miguel de. *El hombre primitivo en el País Vasco*. Zarauz: Itxaropena, 1934.

————. "Excavaciones en Atxeta (Forua, 1960)." In *José Miguel de Barandiarán Obras completas*, volume 14. Bilbao: La gran enciclopedia vasca, 1980.

Bastida, Marisol. *Memorias. Una biografía de Mikel Laboa*. San Sebastián: Elkar, 2014.

Beltran, Juan Mari. *Soinutresnak euskal herri musikan*. [Bilbao]: Orain, 1996.

————. *Herri Musikaren Txokoa Oiartzunen*. Oiartzun: Oiartzungo Udala, 2008.

————. *Txalaparta*. Donostia: Nerea, 2009.

*Bidebarrieta: Anuario de Humanidades y Ciencias Sociales de Bilbao* 3. Third Symposium "Bilbao, una ciudad musical = Bilbo, musika-hiria." Bilbao: Ayuntamiento de Bilbao, 1998.

Bofill Levi, Anna. *Los sonidos del silencio. Aproximación a la historia de la creación musical de las mujeres*. Barcelona: Editorial Aresta, 2015.

Buisson Dominique. "Les flûtes paléolithiques d'Isturitz (Pyrénées-Atlantiques)." *Bulletin de la Société préhistorique française* 87, nos. 10–12 (1990): 420–33.

Cahours, J. B. *Musiciens au Pays Basque. Du Moyen Âge au XXe siècle*. Anglet: Atlantica, 2001.

Contreras, Igor. "Arte de vanguardia y franquismo: a propósito de la politización de los Encuentros de Pamplona." *Uhuarte de San Juan. Geografía e Historia* 14 (2007): 235–55.

Cuevas, Carmen de las. *El orfeón Donostiarra 1897–1997: proyección social, cultural y educativa.* Bilbao: Euskal Herriko Unibertsitateko Argitalpen Zerbitzua-Servicio Editorial de la Universidad del País Vasco, 2000.

Cureses, Marta. *El compositor Agustín González Acilu: La estética de la tensión.* Madrid: ICCMU, 2001.

De Volder, Piet. *Encuentros con Luis de Pablo: ensayos y entrevistas.* Madrid: Fundación Autor, 1998.

Del Amo, Ion Andoni. *Party & Borroka. Jóvenes, músicas y conflictos en Euskal Herria.* Tafalla: Txalaparta, 2016.

Dentici, Nino. *Diccionario Biográfico de Cantantes Vascos de Ópera y Zarzuela.* Bilbao: Diputación Foral de Bizkaia, 2002.

Díaz Morlan, Isabel. *Enma Chacón, una compositora bilbaína.* Bilbao: Temas Vizcaínos. Bilbao Bizkaia Kutxa, 2000

———. *La canción para voz y piano en el País Vasco 1870–1939.* N.p.: Bubok, 2013.

Eskisabel Urtuzaga, Jon. *Euskal Kantagintza/La canción vasca/Basque Songwriting: Pop, Rock, Folk.* Donostia: Etxepare Basque Institute, 2012. At http://www.etxepare.eus/media/uploads/publicaciones/euskal_kantagintza_pop_rock_folk.pdf (last accessed January 30, 2019).

Etxebeste Espina, Elixabete. *Oteiza y la música.* Alzuza: Fundación Museo Jorge Oteiza Fundazio Museoa, 2014.

García del Busto, José Luis. *Carmelo Bernaola: la obra de un maestro.* Madrid: Fundación Autor, 2003.

———. *Luis de Pablo, de ayer a hoy.* Madrid: Fundación Autor, 2009.

García Sánchez, Albano. "El músico José María Nemesio Otaño Eguino (1880–1956). Perfil biográfico, pensamiento estético y análisis de su labor propagandística y gestora." PhD Dissertation, University of Oviedo, 2014.

Gembero-Ustárroz, María, ed. *Estudios sobre música y Músicos de Navarra. Conmemoración del VIII Centenario de la Chantría de la Catedral de Pamplona como dignidad eclesiástica (1206–2006).* Pamplona: Gobierno de Navarra, 2006.

———*Navarra. Música.* Pamplona: Nafarroako Gobernua/ Gobierno de Navarra, 2016.

Gómez Muntané, Maricarmen. *Historia de la música en España e hispano América. De los orígenes hasta c. 1470.* Volume 1. Madrid: Fondo de Cultura Económica, 2009.

Gosálvez, Carlos José. *La Edición Musical Española hasta 1936: guía para la datación de partituras.* Madrid: Asociación Española de Documentación Musical, 1995.

Guerberof Hahn, Lidia. "El archivo musical del convento franciscano de Celaya (México)." *Anuario Musical* 65 (2010): 251–68.

Haritschelhar, Jean. "La Soule dans la littérature basque." In *Le Pays de Soule.* Baigorri: Izpegi, 1994.

Inisesta, Rosa, ed. *Mujer Versus Musica. Itinerancias, incertidumbres y lunas.* Valencia: Colección Música e Interacciones. Editorial Rivera, 2011.

Intxaurrandieta, Patxi, and Patri Urkizu. *Tomás Garbizu Salaberria 1901–1989.* Lezo: Lezoko Unibertsitateko Udala, 2002.

José Antonio de Donostia. *Música y músicos en el País Vasco.* San Sebastián: Biblioteca Vascongada de los Amigos del País, 1951; reprint in *Obras completas del P. Donostia*, volume 2. Bilbao: *La Gran Enciclopedia Vasca*, 1983.

———. *Obras completas del Padre Donostia.* Volumes 1–3. Bilbao: La Gran Enciclopedia Vasca, 1983.

————. *Obras completas del Padre Donostia*. Volumes 4–10. San Sebastián: Sociedad de Estudios Vascos – Eusko Ikaskuntza, 1985–2016.

Kalzakorta, Jabier. *Euskal baladak: azterketa eta edizio kritikoa*. 2 volumes. Bilbao: Labayru Fundazioa – Bilbao Bizkaia Kutxa Fundazioa, 2017.

*Kantuketan: L'univers du chant basque*. Coordination, I.C.B/E.K.E. Donostia: Elkar Argitaletxea, 2002.

Laprérie, Christian. *Histoire de la musique basque. Du moyen âge à nos jours*. Biarritz: Atlantica, 2016.

Larrinaga, Itziar. "Francisco Escudero y la música de escena: su primera ópera, *Zigor!*" In *La ópera en España e Hispanoamérica*, volume 2, edited by Emilio Casares and Álvaro Torrente. Madrid: ICCMU, 2002.

————. "Tradición, identidad vasca y modernidad en la vida y en la creación musical de Francisco Escudero." PhD Dissertation, University of Oviedo, 2009.

Larrinaga Cuadra, Itziar, and Joseba Torre Alonso. "Ser en el sonido: entrevista a Félix Ibarrondo." *Musiker* 18 (2011): 283–326.

Leiñena, Pello. "Guía de editoriales musicales en Euskal Herria." *Musiker* 15 (2007): 327–72.

Lerena, Mario. *El teatro musical de Pablo Sorozábal (1897–1988): Música, contexto y significado*. Bilbao: Universidad del País Vasco/Euskal Herriko Unibertsitatea, Argitalpen Zerbitzua, 2018.

Long, Marguerite. *Au piano avec Maurice Ravel*. Paris: G. Billaudot, 1984.

López Aguirre, Elena. *Historia del rock vasco. Edozein herriko jaixetan*. Gasteiz: Aianai, 2011.

López Estelche, Israel. "Luis de Pablo: vanguardias y tradiciones en la música española de la segunda mitad del siglo XX." PhD Dissertation, University of Oviedo, 2013.

López-Calo, José. *Nemesio Otaño, S.J.: Medio siglo de música religiosa en España.* Madrid: ICCMU, 2010.

Machado, Marisa, ed. *Cuadernos Inacabados Música y Mujeres genero y poder.* Madrid: Horas y horas la editorial, 1998.

Martín, María José. "Drama and Poetry in the Music of María Luisa Ozaita (b. 1039)." Thesis (DMA), University of Cincinnati, 2001.

Mazo Pérez, Carlos, Carlos García Benito, and Marta Alcolea Gracia. "Un caso de Arqueología Experimental aplicado a la Arqueología Musical." *SALDVIE* 15 (2015): 65–91.

McClary, Susan. *Feminine Endings. Music, Gender & Sexuality.* Minneapolis: University of Minnesota Press, 1991.

Morel Borotra, Natalie. *La ópera vasca (1884–1937): "y el arte vasco bajo de las montañas"* Bilbao: Mínima, 2006.

Moreno Moreno, Berta. *Felipe Gorriti: Compositor, maestro de capilla y organista.* Pamplona: Gobierno de Navarra, 2011.

Moro, Daniel. *El compositor Carmelo Bernaola (1929–2002). Una trayectoria en la vanguardia musical española.* Bilbao: Universidad del País Vasco/Euskal Herriko Unibertsitatea, Argitalpen Zerbitzua, 2019.

Nagore Ferrer, María. *La revolución coral: Estudio sobre la Sociedad Coral de Bilbao y el movimiento coral europeo (1800–1936).* Madrid: ICCMU, 2001.

———. *Pablo Sarasate: El violín de Europa.* Madrid: ICCMU, 2013.

Ochoa de Eribe, Javier Esteban. *Discursos civilizadores: Escritores. Lectores y lecturas de textos en euskera (c. 1767–c. 1833).* Madrid: Silex, 2018.

Paya, Xabier. *Antología de Literatura Oral Vasca.* Donostia: Instituto Etxepare, 2013.

Quiñones Leyva, Isabel, García Alegría, and María Isabel, eds. *Cartas a Emiliana.* Hermosillo, Sonora, Mexico: Universidad de Sonora, 2004

Requejo Anso, Alberto Ángel. *A Study of Jesus Guridi's Lyric Drama Amaya (1910–1920)*. Ann Arbor, MI: UMI, 2005.

Rodríguez Suso, Carmen. "El canto litúrgico romano y la música vasca. Una intersección decisiva en la historia de nuestro lenguaje musical." In *Nuevas formulaciones culturales: Euskal Herria y Europa. XI Congreso de Estudios Vascos*. Donostia-San Sebastián: Eusko Ikaskuntza, 1992.

———. *La monodia litúrgica en el País Vasco (Fragmentos con notación musical de los siglos XII al XVIII)*. 3 volumes. Bilbao: Bilbao Bizkaia Kutxa, 1993.

———. "El empresario Nicola Setaro y la ópera italiana en España: La trastienda de la Ilustración." *Il Saggiatore Musicale* 5, no. 2 (1998): 247–70.

Rosen, Barbara. *Arriaga, the Forgotten Genius: The Short Life of a Basque Composer*. Reno: Basque Studies Program, University of Nevada, Reno, 1988.

Rousseau-Plotto, Étienne *Ravel: portraits basques*. Paris: Séguier, 2004.

Sacau-Ferreira, Engrique. "Performing a political shift: avant-garde music in Cold War Spain." PhD Dissertation, University of Oxford, 2011.

Sagaseta, Aurelio. *El polifonista Michael Navarrus (ca. 1563–1627)*. Pamplona: Capilla de Música de la Catedral de Pamplona, 1983.

Salaberri Urzelai, Sabin, ed. *La Música en Álava*. Vitoria: Fundación Caja de Ahorros de Vitoria y Álava, 1997.

Salaberría, Miguel. *Órganos de Bizkaia*. Bilbao: Diputación Foral de Bizkaia, 1992.

Sánchez Equiza, Carlos. *Del danbolin al silbo: Txistu, tamboril y danza vasca en la época de la Ilustración*. Pamplona: Carlos Sánchez Equiza, 1999.

————. *Euskal musika klasikoa/Música clásica vasca/Basque Classical Music.* Donostia-San Sebastián: Etxepare Basque Institute, 2012.

Summers, William J. "The MISA VISCAINA: An Eighteenth-Century Musical Odyssey to Alta California." In *Encomium Musicae: Essays in Memory of Robert J. Snow.* Hillsdale, NY: Pendragron Press, 2002.

Torres, Jacinto. *Las publicaciones periódicas musicales en España (1812–1990): estudio crítico-bibliográfico, repertorio general.* Madrid: Instituto de Bibliografía Musical, 1991.

Truffaut, Thierry. "Les instruments de musique utilisés dans le Labourd à travers les textes anciens et l'iconographie." *Cuadernos de etnología y etnografía de Navarra* 52 (1988): 403–14.

Urbeltz, Juan Antonio. *Danza vasca: aproximación a los símbolos.* Lasarte-Oria: Etor-Ostoa, 2001.

Valdivielso Zubiria, Maider. *Inventario de libros manuscritos de música sacra existentes en el Territorio Histórico de Álava.* Vitoria-Gasteiz: Arabako Foru Aldundia, 2007.

Varela Ruiz, Leticia T. *Emiliana de Zubeldia. Una vida para la música.* Pamplona: Personajes navarros. Gobierno de Navarra, 2012.

Zulaica, Teresa, and Jose Barroso, eds. *Al unísono estamos: Epistolario Donostia-Pedrell, 1915–1918.* Pobra do Caramiñal: Fundación Digital Bible; Editorial Mendaur, 2016.

## Online Repositories

Auñamendi: Eusko Entziklopedia. http://aunamendi.eusko-ikaskuntza.eus/en/

Bilketa: Portail des fonds documentaires basques. http://www.bilketa.eus/fr/

Euskaltzaindia: Publications. https://www.euskaltzaindia.eus/en/

Eusko Ikaskuntza: Fondo multimedia. http://www.eusko-ikaskuntza.eus/es/fondo-documental/fondo-multimedia/

Liburuklik: Basque Digital Library.

      http://www.liburuklik.euskadi.eus/jspui/?locale=en

**Phonography**

**The Prehistory, Antiquity, and Middle Ages of Music in the Contemporary Basque Country**

*Bereterretchen oinatzak*. Khantoria. CD. [Bilbao: Kap Produkzioak, 2011].

*E Ultreia! Chemins de Santiago*. Cum jubilo – Catherine Ravenne. CD. [Troyes]: Les Bellers Ecouteuses; 2018.

*La música del reino*. I, El evangelario de Roncesvalles, primer tesoro musical del viejo reino (siglos ca. XII–XIII). Kantika – Kristin Hoefener. CD. Pamplona: Gobierno de Navarra, Departamento de Cultura y Turismo, Institución Príncipe de Viana, D.L. 2010.

Rossé, François. *Aspaldian* [Création contemporaine pour ensemble de flûtes en os de vautour, avec récitant clarinette et flûte basses arbrassons percussion et dispositif électro-acoustique]. Mixel Etxekopar. CD. [Donazaharre]: ZTK, [2012].

Teobaldo I, Rey de Navarra (1201–1253). *Thibaut de Navarre.* Atrium Musicae de Madrid, Gregorio Paniagua, dir. LP. Saint-Michel de Provence: Harmonia Mundi, 1979.

———. *Thibaut de Champagne: Le chansonnier du Roi: Amour courtois et chevaliere au XIIIe siècle*. Alla Francesca, Brigitte Lesne, dir. CD. Paris: Outhere-Music-France, 2012.

*Tres culturas: judíos, cristianos y musulmanes en la España medieval.*
Eduardo Paniagua. CD. Madrid: Pneuma, D.L. 1998.

*Zantxo azkarra.* LP. [Pastorale sung by the people of Altzai
(Zuberoa) and recorded in 1973]. [San Sebastián: Herri
Gogoa], D.L. 1973.

## Renaissance and Baroque: Between Tradition and Change

*XVI. eta XVII. mendeak.* CD. [Hernani]: Egin, 1997.

*XVIII. mendea (1).* CD. [Hernani]: Egin, L.G. 1997.

*XVIII. mendea (2).* CD. [Hernani]: Egin, L.G. 1997.

*XVIII. Euskal tekladurako musika/Música vasca para tecla del s.
XVIII. KD 1.* 2 CDs. Orio: ausArt records, [ca. 2008].

*A casarse con el alma: Música litúrgica y Villancicos de Urbán de Vargas
(1600–1656).* Nova Lux Ensemble, Josep Cabré. CD.
Pamplona: Coral de Cámara de Pamplona, 2014.

Albero, Sebastián de. *6 Recercatas, Fugas & Sonatas.* Alejandro
Casal, harpsicord. Brilliant Classics, 2016.

———. *Sonatas para clavicordio,* Joseph Paine, harpsicord- N.p.:
n.p., 1993

Anchieta, Juan de (c. 1462–1523). *Passio secundum Mattaeum.*
Donosti Ereski Abesbatza, Migel Zeberio, dir. CD. Orio:
aus_Art_records, 1999.

———. *Missa Sine Nomine.* Capilla Peñaflorida, Ministriles de
Marsias, Josep Cabré, dir. CD. [Barcelona]: Marco Polo &
Naxos Hispánica, 2000.

———. *Missa Rex Virginum; Motecta.* Capilla Peñaflorida, Josep
Cabré, dir. CD. [Longeville-les-Metz]: K617, 2005.

*Berpizkundeko euskal musika: XV eta XVI. mendeetako musikagileak.*
Pirinaeus Renaissance Consort. CD. [Donostia]: 5Gora,
2014.

*Euskal Herriko organoak/Órganos de Vasconia. Nº 9.* José Benantzi
Bilbao, org. CD. [Orio]: aus_Art_records, [2005].

*Euskaldunen organu eresi hautatuak. III.* Esteban Elizondo Iriarte, org. LP. [Donostia]: Ots, 1978.

*Euskel Antiqva/Le legs musical du Pays Basque/Legacy of the Land of Basque.* Euskal barrokensemble. CD. [Bellaterra]: Alia Vox Diversa, D.L. 2015.

*Godalet: XVII eta XVIII mendeko euskal kanta eta dantzak/canciones y danzas populares vascas de los siglos XVII y XVIII.* Ensemble Diatessaron. CD. [N.p.: Ensemble Diatessaron], 2016.

Irizar, Miguel de (1635–1684). *Ecos y afectos.* Capilla Jerónimo de Carrión, Escolanía de Segovia, Alicia Lázaro, dir. CD. [Madrid]: Banco de Sonido, 2004.

Iribarren, Juan Francés de. *Salmos Villancicos y Cantadas.* Nova Lux Ensemble, David Guindano, dir. 2 CDs. [Madrid]: Radio Nacional de España, 2007.

*Juan García de Salazar (1639–1710).* Capilla Peñaflorida. CD. [Donostia]: Elkar, L.G. 1991.

*Le Basque.* Ensemble Diatessaron CD. [Donostia]: [NB], 2007.

*Missa de Nostra Dona.* Capilla Peñaflorida, Josep Cabré, dir. CD. [Donostia]: NB, 2007.

*Música en la Catedral de Pamplona n. 1: Siglo XVIII.* Capilla de Música de la Catedral de Pamplona, Aurelio Sagaseta, dir. CD. Orio: aus_Art_records, 1993, 2002.

*Música en la Catedral de Pamplona n. 2: Michael Navarrus (ca. 1563–1627),* Capilla de Música de la Catedral de Pamplona, Aurelio Sagaseta, dir. CD. Orio: aus_Art_records, 1996, 2016.

Navarrus, Michael. *Primeras vísperas para San Fermín.* Nova Lux Ensemble, David Guindano (dir). 2 CDs. [N.p.]: Geaster, 2007.

Vargas, Urbán de. *Quicumque.* Capilla Peñaflorida, Ministriles de Marsias, Josep Cabré, dir. CD. [Donostia]: NB, 2008.

## Music in the Basque Country in the Enlightenment: The RSBAP

*Arantzazuko musica/La música en Arantzazu: Siglo XVIII, I. Egiguren, Gamarra, Mir, Patiño.* Musikalis. Orio: aus_Art_records, 2004.

*Arantzazu musikaren mendeetan 1. Siglos XVII–XVIII. mendeak.* CD. [Orio]: aus_Art records, [2003].

*Azkoitico [sic] zalduntxoen musika: XVIII'garrengo Euskal Musica [sic]/Musique du XVIIIe siècle.* Single. Bayonne: Musée Basque, [195?].

*Fray José de Larrañaga: Arantzazu XVIII.* Capilla Peñaflorida, Fabio Bonizzoni, cond. CD. Vitoria-Gasteiz: NB, 2005.

*Klabezinbaloa lagunduz.* Khantoria. CD. [Bilbao]: Bapo bapo produkzioak, D.L. 2015.

*Klawiszowa muzyka baskijska XVIII wieku/Música de tecla en el País Vasco siglo XVIII/Basque Keyboard Music of the Eighteenth Century.* Maria Banaszkiewicz-Bryla, klawesyb/clavecín/harpsicord. CD. Poznan: Akademia Muzyczna, 2013.

*Le Basque.* Ensemble Diatessaron. [Donostia: Nicolás Basarrate], 2007.

*Tesoros de Aránzazu. Vol. 1, Arias con órgano obligado.* Elena López Jaúregui, sop., Norberto Broggini, org. CD. Madrid: Classics World Sound, D.L. 2009.

*Xuxurlak.* Josu Okiñena. CD. Madrid: Sony Music, 2018.

### Music in the Nineteenth Century

Albéniz, Pedro (1795–1855). *Obras para piano a cuatro manos de Pedro Albeniz.* Miguel Zanetti and Fernando Turina. CD. Madrid: Radio-Televisión Española, 1995.

—————. *Fantasías, variaciones y rondinos para piano y cuerdas.* Valvanera Briz, p., Juan Carlos Gómez, vl., Gonzalo

Cabrera, vl., Sviatoslav Belonogov, vla., Naomí Barron, vcl., Conrado Flores, ctb. CD. [Madrid]: SEM, Sociedad Española de Musicología, 2007.

Arriaga, Juan Crisóstomo de (1806–1826). *Arriaga*. Ainhoa Arteta, sop., Orquesta de Cadaqués, Sir. Neville Marriner, dir. CD. [Barcelona]: Tritó, 2007.

———. *Juan Crisóstomo de Arriaga*. María José Moreno, sop., Joan Cabero, ten., Iñaki Fresán, bass, Pablo Benavente, tipl., Coro Easo Abesbatza, Orquesta Sinfónica de Euskadi, Cristian Mandeal, dir. CD. Thun (Switzeland): Claves Records, 2006.

———. *Obras vocales/Vocal works: 1821–1825*. Violet Serena Noorduyn, sop., Robert Getchell, ten., Mikael Stenbaek, ten., Hubert Claessens, bar., Brieuc Wathelet, voz blanca, Il Fondamento; Paul Dombrecht, dir. CD. [Nivelles (Belgique)]: Fuga Libera, 2006.

———. *Sinfonía en Re mayor*. Orquesta Sinfónica de Bilbao, Juan José Mena, dir. CD. [Barcelona]: Marco Polo & Naxos Hispanica, D.L. 2000.

———. *The Complete String Quartets: On Period Instruments*. La Ritirata. CD. San Lorenzo de El Escorial: Glossa, 2014.

Arrieta, Emilio (1821–1894). *Marina: ópera en tres actos*. Mercedes Capsir, sop. (Marina), Hipólito Lázaro, ten. (Jorge), Marcos Redondo, bar. (Roque), José Mardones, bass (Pascual), Gran Orquesta Sinfónica y Coros, Daniel Montorio, dir. 2 CDs. Barcelona: Aria Recording, 1997.

———. *Ildegonda*. Carlos Álvarez, Ana María Sánchez, José Bros, Ángel Rodriguez, Stefano Palatchi, Mariola Cantarero, Orquesta Titular del Teatro Real, José Luis López Cobos, dir.; Coro Titular del Teatro Real, Martín Merry, dir. CD. Madrid: Radiotelevisión Española, 2005.

———. *La conquista di Granata*. Mariola Cantarero (Zulema), Ana Ibarra (Isabel), José Bros (Gonzalo), Ángel Ódena (Lara),

The History of Basque Music

David Rubiera (Boabdil), Alastair Miles (Muley-Hassem), David Menéndez (Alamar), María José Suárez (Almeraya), Tomeu Bibiloni (Officer), Coro y Orquesta Sinfónica de Madrid, Jordi Casas Bayer, maestro de coro, Jesús López Cobos, dir. 2 CDs. Genova: Dynamic, 2008.

Eslava Elizondo, Hilarión (1807–1878). *Antología*. CD. [Orio]: aus_Art_records, [ca. 2002].

———. *Miserere*. José Bros, ten., Flavio Oliver, contraten., Carlos Álvarez, bar., Jesús Manuel Carnicero, tipl., Antonio Sanz, 2. tipl., Solistas de la Escolanía del Real Monasterio de San Lorenzo de El Escorial, Coro de la Asociación de Amigos del Teatro de la Maestranza, Real Orquesta Sinfónica de Sevilla, Luis Izquierdo, dir. CD. Madrid: Universal Music Spain, 2008.

———. *Hilarión Eslava*. Coral de Cámara de Pamplona, Óscar Candendo Zabala, órg., David Guindano Igarreta, dir. CD. Alerre (Huesca): Geaster S.L., D.L. 2008.

Gaztambide Garbayo, Joaquín Romualdo (1822–1870). *Gozos a Santa Ana*. Fernando Remacha, instr., Coro de Tudela de la Escuela de solfeo y canto "Joaquín Gaztambide" con acomp. de orquesta, Javier Bello Portu, dir. Single. San Sebastián: Columbia, 1968.

Goicoechea Errasti, Vicente (1854–1916). *Vicente Goikoetxea*. Coro Araba, Manu Sagastume, dir., Sabin Salaberri, órg. CD. [Hernani]: Egin, 1997.

Iradier Salaverri, Sebastián (1809–1865). *Iradier*. José Luis Turina, dir., orq., Josefina Cubeiro, sop. LP. [Donostia]: Kea, 1991.

Ledesma Garcia, Nicolás (1791–1883). *Stabat Mater*. Elena Alkiza, Esther Horas, Raquel Urquijo, sop., Eduardo Iturarte, Ramón Uriarte, ten., José Antonio Fernández "Zurdo", bar., José Ramón Rebate, recit., Alfonso Rodríguez, Ainara Rúa, vl., Onintza Azkarate, vla, María Zubikarai,

vcl., Pilar Arana, p., Coral Ondarreta, Cuarteto de Cámara Ondarreta, Manuel Torré Lledó, dir. CD. [Getxo]: Coral Ondarreta, 2005.

―――. *Obras de Nicolás Ledesma/Nicolás Ledesmaren lanak*. Coral Cum Jubilo Abesbatza; Carmen de las Cuevas, dir. CD. Donostia-San Sebastián: Coral Cum Jubilo Abesbatza, 2012.

Gorriti Osambela, Felipe (1839–1896). *Felipe Gorritiren Omenez (1839–1896)*. Xaramela Abesbatza, L'Ensemble Instrumental des Landes, Didier Deblonde, dir. CD. Donostia: Elkar, 1996.

―――. *Lamentaciones/Erostak*. Victoria Canale, sop., P. Langridge, D. Johnston, ten., Roger Stalman, bass, Javier Bello-Portu, org., dir. CD. Orio: ausArt records, 2009.

―――. *Misa en Do menor*. Coro y Orquesta de la Capilla de Santa María de Tolosa, Agrupación Coral Tafallesa, Coral Tubala Uxoa, José Arzelus, org., Ander Letamendia Loinaz, dir. CD. Tolosa: Santamariako Kapera, [2007].

―――. *Organ works. Vol. 1: La transición del órgano barroco al romántico en España*. Esteban Elizondo Iriarte, org. CD. Korschenbroich: Aeolus, 2005.

―――. *Organ works. Vol. 2: La transición del órgano barroco al romántico en España*. Esteban Elizondo Iriarte, org., Arantza Ezenarro, sop. CD. Korschenbroich: Aeolus, 2005.

―――. *Felipe Gorriti: Compositor, maestro de capilla y organista*. CD. Pamplona: Gobierno de Navarra, Fondo de Publicaciones, 2011.

Sarasate, Pablo (1844–1908). *Integral de violí i orquesta*. Gabriel Croitoru, vl, Orquesta Ciudad de Málaga, Jacques Bodmer, dir. 3 CDs. Andorra la Vella: Limit, 1994.

―――. *Pablo Sarasate. Obra completa*. Angel Jesús García, vl., Orquesta Pablo Sarasate, Miguel Ortega, dir. 6 CDs. Madrid: Radiotelevisión Española, 1994.

Santesteban, José Juan (1809–1884). *El legado de Santesteban/Santestebanen ondarea.* Donosti Ereski. Schola Gregorianista, Gerardo Rifón, órg. CD. [Donostia: Donosti Ereski], D.L. 2009.

Zubiaurre, Valentín María de (1837–1914). *Himno Kantata Astarloa.* Durangaldeko Korua, "Bartolome Ertzilla" Musika Eskolako Orkestra, Jesús Egiguren, dir. CD. Durango: Gerediaga Elkartea, L. G. 2002.

———. *Valentín Mª Zubiaurre.* Orquesta Sinfónica de Euskadi, Juan José Ocón, dir. CD. Pully (Switzerland): Claves Records, 2010.

## A Study of Basque Music: 1876–1936

Azkue, Resurrección María de (1864–1951). *Euskal musika herrikoia.* Agurtzane Mentxaka, sop., Angel Piñero, ten., Luis Mari Uriarte, bajo, Aitor Olea Juaristi, p. CD. Orio: ausArt records, [2007].

José Antonio de Donostia (OFM Cap) (1886–1956). *Missa pro defunctis; Poema de la Pasión.* Lola Elorza y Eugenia Echarren, sop., Eduardo Olloqui, English horn, Daniel Oyarzábal, org., Coral de Cámara de Pamplona, David Guindano Igarreta, dir. CD. Madrid: Radiotelevisión Española, 2004.

———. *Integral de la obra para voz y piano.* Almudena Ortega, voz, Josu Okiñena, p. 4 CDs. Madrid: Warner Music Spain, 2012.

———. *Piano music.* Josu Okiñena, p. CD. Madrid: Sony Music Entertainment España, 2013.

Guridi, Jesús (1886–1961). *Amaya.* Rebecca Copley, sop. (Amaya); Marianne Cornetti, mezz. (Amagoya); Itxaro Mentxaka. mezz. (Paula/Olalla), César Fernández, ten. (Teodosio), Rosendo Flores, b. (Asier), Carlos Conde, bar.

(Miguel/Un mensajero/Escudero 2/Pastor 2), Sociedad Coral de Bilbao, Orquesta Sinfónica de Bilbao, Theo Alcántara, dir. 2 CDs. [N.p.]: HNH International Ltd.; Munich: MVD Music and Video distribution, 2000.

———. *El Caserío.* Vicente Sardinero, bar., Ana Rogrigo, María José Suarez, sop., Emilio Sánchez, Felipe Nieto, Fernando Latorre, ten., Sociedad Coral de Bilbao, Orquesta Sinfónica de Bilbao, Juan José Mena, dir. CD. Barcelona: Marco Polo & Naxos Hispánica, D.L. 2003.

———. *Complete organ works.* Esteban Elizondo Iriarte. 2 CDs. Korschenbroich: Aeolus, 2003, 2007.

———. *Piano Works.* Victoria Aja, p. CD. [N.p.]: Marco Polo & Naxos Hispánica, 2005.

———. *Sinfonía Pirenaica.* Bilbao Symphony Orchestra, Juan José Mena, dir., Theo Alcántara, dir., Bilbao Choral Society, Gorka Sierra, dir.. CD. [Barcelona]: Marco Polo & Naxos Hispánica, 2005.

———. *String Quartets.* Bretón String Quartet. CD. [Nevada]: Naxos Rights US, Inc, 2013.

Usandizaga, José María (1887–1915). *Jose Maria Usandizaga.* Euskadiko Orkestra Sinfonikoa, Asier Polo, vcl., Gabriel Chmura, dir. CD. Thun (Switzerland): Claves, 1998.

———. *Las golondrinas.* Josefina Cubeiro (Lina), Isabel Rivas (Cecilia), Vicente Sardinero (Puck), Ramón Alonso (Roberto), Coro Cantores de Madrid, Orquesta Lírica Española, Federico Moreno Torroba, dir. CD. Madrid: EMI-Odeon, 2000.

———. *Mendi mendiyan.* Tatiana Davidova, sop. (Andrea), Juan Lomba, ten. (Joshe Mari), Marta Urbieta, sop. (Txiki); Santos Ariño, bar. (Juan Cruz), Coral Andra Mari, Oquesta Sinfónica de Bilbao, Juan José Mena, dir. 2 CDs. [Barcelona]: Marco Polo & Naxos Hispánica, 2002.

————. *La llama*. Sabina Puértolas (Tamar), sop., Mikeldi Atxalandabaso (Adrián), ten., Damián del Castillo (El Sultán), bar., Coral Andra Mari Abesbatza, Orquesta Sinfónica de Euskadi, Juan José Ocón, dir. 2 CDs. [Madrid]: Universal Music Spain, 2015.

## The Spanish Civil War and the Franco Dictatorship (1936–1975)

Arámbarri, Jesús. *Jesús Arámbarri*. Maria Bayo, soprano; Euskadiko Orkestra Sinfonikoa; dir. Cristian Mandeal. CD. Thun (Switzerland): Claves, 1999.

*Centenario de la Provincia Capuchina: Concierto Sinfónico Multicoral*. Coral Santa María de la Redonda (Logroño), dir. Miguel de Miguel; Coral de Echarri-Aranaz (Navarra), dir. Igor Ijurra; Coral Andra Mari de Errenteria (Gipuzkoa), dir. José Manuel Tife; Coral Delicias (Zaragoza), dir. Fernando Salvador; Orquesta Sinfónica de La Rioja; dir. José Luis de Salbide. CD. Zaragoza: Kikos, D.L. 2000.

Donostia, José Antonio de (OFM Cap) (1886–1956). *Priez pour paix*. Kup Taldea, Gabriel Baltés, dir. CD. [Donostia]: NB, 2007.

Eresoinka. *Bakearen ikurra*. Chorale Eresoinka/Coral Eresoinka/Eresoinka abesbatza.CD. Bayonne: Agorila, 2008.

Escudero, Francisco. *Francisco Escudero*. Euskadiko Orkestra Sinfonikoa; dir. Arturo Tamayo Mandeal. CD. Thun (Switzerland): Claves Records, 2001.

————. *Concierto para clave; Poema al entierro de Cristo; Cuarteto en sol*. LIM (Laboratorio de Interpretación Musical). CD. [Bilbao]: Fundación Bilbao Bizkaia Kutxa/Bilbao Bizkaia Kutxa Fundazioa, D. L. 2002.

Garbizu, Tomás. *Gure Meza*. LP. San Sebastián: Columbia, 1966.

González-Acilu, Agustín. *Arrano Beltza; Libro de los proverbios, cap. VIII; Izena ur izana.* Agrupación Coral de Cámara de Pamplona; dir. Luis Morondo; José Luís Eslava. CD. Madrid: EMEC, D.L. 1996.

Guridi, Jesús. *Jesus Guridi.* Euskadiko Orkestra Sinfonikoa; Orfeón Donostiarra; Ricardo Requejo, piano; dir. Miguel A. Gómez Martínez. CD. Thun: Claves, 1997.

*Himnos y marchas de España.* Banda de la Academia Militar; dir. Capitán López Aguilar; 2 CDs. Banda Regimiento de Montaña; José Antonio Ladreda, dir. CD. Barcelona: OK Records, D.L. 2006.

Madina, Francisco de. *Aita Madina (Francisco de Madina).* Los Romero; Orfeón Donostiarra, Euskadiko Orkestra Sinfonikoa; dir. Cristian Mandeal. 2 CDs. Thun (Switzeland): Claves Records, 2005.

*Nueva antología de la música militar de España.* 4 CDs. Madrid: Polygram Iberica, D.L. 1993.

*Orquesta Sinfónica de Euskadi (II).* Orquesta Sinfónica de Euskadi; dir. Juanjo Mena. CD. Barcelona: Àudiovisuals de Sarrià, D.L. 1999.

Pablo, Luis de. *Luis de Pablo.* LP. Mainz: Wergo Schallplatten Gmbh, [ca. 197-].

Remacha, Fernando. *Música de Cámara.* Brodsky Quartet. CD. Madrid: PolyGram Ibérica, D.L. 1999.

Sorozábal, Pablo. *Victoriana; Paso a cuatro; Capricho español.* LP. [Madrid]: Hispavox, [c. 1957].

## Basque Music from the Transition (1975) to the Present (2018)

Bernaola, Carmelo (1929–2002). *Carmelo A. Bernaola.* LIM (Laboratorio de Interpretación Musical), Jesús Villa Rojo. Dir. CD. Bilbao: BBK Bilbao Bizkaia Kutxa, 2003.

———. *Rondó; Clamores y secuencias; Sinfonía nº3.* Asier Polo, vcl., Orquesta de la Comunidad de Madrid, José Ramón Encinar., dir. CD. [Madrid]: Iberautor Promociones Culturales, 2004.

———. *Carmelo Bernaola.* Euskadiko Orkestra Sinfonikoa, Juanjo Mena, dir., Leticia Moreno, vl. CD. Pully (Switzerland): Claves Records, 2012.

———. *Carmelo Bernaola.* Ensemble Sinkro, Alfonso García de la Torre, dir. CD. [Vitoria-Gasteiz]: Espacio Sinkro records, 2012.

Gonzalez Acilu, Agustin (1929– ). *Arrano Beltza; Libro de los proverbios, cap. VIII; Izena ur izana.* Agrupación Coral de Cámara de Pamplona, Luis Morondo, dir., José Luis Eslava, dir. CD. Madrid: EMEC, 1996.

Ibarrondo Ugarte, Félix (1943– ). *Compositores vascos actuales. Ibarrondo.* Antonio Arias, fl., Gilles Burgos, fl., Juana Guillen, fl., José Sotorres, fl., Noëlle Spieth, cl., Gerardo López Laguna, p., Christophe Bredeloup, per., Pierre Strauch, vcl., Trío a cordes de Paris. CD. Bilbao: Bilbao Bizkaia Kutxa, 1998.

———. *L'oeuvre pour piano.* Alfonso Gómez, p. CD. [Vitoria-Gasteiz]: Espacio Sinkro records, [2010].

———. *Izargui, Fluxus, Diástole, Psaume XII, Aitaren Etxea.* Ensemble Sinkro, Alfonso García de la Torre, dir. CD. Vitoria-Gasteiz]: Sinkro Records, 2015.

Erkoreka, Gabriel (1969– ). *Afrika; Kantak; Jukal; Akorda.* Orquesta de la Comunidad de Madrid, José Ramón Encinar, dir. CD. Cologno Monzese: Milano Dischi, 2008.

———. *Trío del agua.* Trío Arbós. CD. Madrid: Classic World Sound, 2014.

———. *Kaiolan.* Ensemble Recherche. CD. Madrid: Classic World Sound, 2014.

Lazkano, Ramón (1968– ). *Ramon Lazkano*. Ensemble de Musique Contemporaine de Moscou, Alexeï Vinogradov, dir., Youri Kasparov, dir. CD. [Paris]: Le Chant du Monde, 1998.

———. *Ramon Lazkano*. CD. [Paris]: le Chant du monde, 2005.

———. *Hauskor; Ortzi isilak; Ilunkor*. Cello Octet Amsterdam, Ernesto Molinari, cl., Basque National Orchestra, Johannes Kalitzke, dir. CD. [Vienna]: Kairos, 2009.

———. *Laboratorio de tizas*. Ensemble Recherche. CD. Madrid: Classic World Sound, 2012.

———. *Chalk Laboratory I*. Smash ensemble. CD. Lawrence [Kansas]: Odradek, 2015.

Pablo, Luis de (1930– ). *Zurezko olerkia/Poema de la madera*. Artza Anaiak, txalaparta, P'an Ku, perc., Grupo Vocal de Madrid, José Luis Temes, dir. CD. [Madrid]: Iberautor Promociones Culturales, 2003.

———. *Casi un espejo; Passio*. Orchestra Sinfonica Nazionale della RAI, Juanjo Mena, dir., Georg Nigl, bar., Roberto Balconi, contratenor, Coro maschile del Teatro R. di Torino, Orchestra Sinfónica Nazionale della RAI, Gianandrea Noseda, dir. CD. [Madrid]: Diverdi, 2010.

———. *Los novísimos; Vendaval*. Coro de la Comunidad de Madrid, Orquesta de la Comunidad de Madrid, José Ramon Encinar, dir. CD. [Milan]: Stradivarius: Milano dischi [distribuidor], 2010.

———. *Recado*. Óscar Candendo, org., Orquesta Sinfónica de Bilbao, Nacho de Paz, dir. CD. [Bilbao]: Bizkaiko Foru Aldundia/Diputación Foral de Bizkaia, 2012.

———. *Romancero*. Les jeunes artistes, Rachid Safir, dir. CD. [Barcelona]: Columna Música, 2012.

———. *Sombrío; Con alcune licenze*. Miguel Bernat, perc., Proyecto Guerrero, José Luis Temes, dir., The New Julliard

Ensemble, Joel Sachs, dir. CD. [Barcelona]: Columna Música, 2014.

————. *Fiesta I; Vielleicht; Fiesta II.* Grupo de percusión y cuerdas de la Joven Orquesta Nacional de España, José Luis Temes, dir. CD. Madrid: Classic World Sound, 2014.

## Women and Basque Music

Catalan, Teresa (1951– ). *Obra de cámara.* Estrella Estévez, sop., Bartomeu Jaume, p., José Mª Sáez Ferriz, fl. CD. Pamplona: Zeta Soluciones Audiovisuales, 2003.

Gerenabarrena, Zuriñe F. *Despertar a la vida es sueño. Prólogo; Zeihar; Luze; Barne; Orain; Amor fiero.* Ensemble Sinkro; Neue Vocalsolisten. CD. [Vitoria-Gasteiz]: Sinkro Records, D.L. 2017.

Luc, Mª Eugenia (1958– ). *De aire y luz.* Ensemble Kuraia, Sigma Project ("Yun"), Euskadiko Orkestra Sinfonikoa ("Jing"), Andrea Cazzaniga, dir. CD. [Bilbao]: Orpheus, 2015.

Zubeldia, Emiliana de (1888–1987). *El alma nunca se muere: canciones de Emiliana de Zubeldia.* Imelda Moya Camarena, voz, Rito Emilio Salazar, p. CD. Sonora, Mexico: Fondo Estatal para la Cultura y las Artes de Sonora (FECAS)], [2006].

————. *Bocetos y tientos.* José Solórzano, p. CD. [Hermosillo (Mexico)]: Fundación Emiliana de Zubeldia Inda, 2008.

## A Century of Euskal Swing: A Short History of Jazz

Alberto Arteta Group. *Bat.* With Jorge Abadías, Satxa Soriazu, Kike Arza, Juanma Urriza, and Ion Celestino. CD. Moskito Rekords MRi 007, 2014. Recorded March 7 and 8, 2014.

Andueza, Mikel. *BCN.* With Benet Palet, Joan Díaz, Rai Ferrer, and David Gómez. CD. Fresh Sound New Talent FSNT 036, 1997.

Andrzej Olejniczak – Iñaki Salvador Quartet. *Catch.* With Jordi Gaspar and David Xirgu. CD. Elkar KD 382, 1993. Recorded December 4 and 5, 1993.

Arza, Kike. *Curriculum.* With Mikel Andueza, Alberto Arteta, Alejandro Mingot, and Juanma Urriza. CD. Moskito Rekords MRi 006 CD, 2013. Recorded February 2 and 3, 2013.

Askunze, Iñaki. *Cometa Halley.* With Mikel Andueza, Ion Robles, Rogelio Gil, Víctor de Diego, Gorka Benítez, Juan Chamorro, Matthew Simon, Ramón García, José Navarcorena, Víctor Vergés, John de Bude, Tom Johnson, Sergi Vergés, Albert Bover, Javier Colina, Dani Pérez, and Marc Miralta. CD. Marccato Records, 1998. Recorded May 1, 1998.

Bas, Vlady. *Viva Europa!* With Pepe Nieto. LP. Acción AC-30010, 1972.

———. *Free Jazz: Vlady Bas en la Universidad.* With Juan Carlos Calderón, David Thomas, and Pepe Nieto. LP. Acción AC-30016, 1973.

———. *Rompiendo la barrera del sonido.* With Pepe Nieto. LP. Acción AC-30022, 1973.

Benítez, Gorka. *Gorka Benítez Trío.* With Raimón Ferrer, David Xirgu, Dani Pérez, and Ben Monder. CD. Fresh Sound New Talent FSNT 073, 1998.

———. *Sólo la verdad es sexy.* With Albert Bover, Nick Thys, David Xirgu, Carme Canela, Dani Pérez, Juan de Diego, and Víctor de Diego. 2 CDs. Fresh Sound New Talent FSNT 188 DG, 2003. Recorded June 23 and 24, 2003.

————. *Gasteiz.* With Ben Monder and David Xirgu. CD. Fresh Sound New Talent FSNT 441, 2012. Recorded July 16, 2012.

David Xirgu Quartet. *Ugrix.* With Gorka Benítez, Dani Pérez, and Raimón Ferrer. CD (Zirrara; 3). Jazzle ZC-107, 1997. Recorded January 9 and 10, 1997.

De Diego Brothers. *Odola/Sangre.* With Juan de Diego, Víctor de Diego, Pere Loewe, Elisabet Raspall, and Caspar St. Charles. CD. Errabal ER 032, 2010. Recorded December 17–23, 2009.

De Diego, Juan. *Erbestea.* With Trakas: Abel Boquera, Jordi Matas, Caspar St. Charles, and Dani Domínguez. CD. Errabal ER 051, 2012. Recorded January 25 and 26, 2012.

De Diego, Víctor. *Amaia.* With Benet Palet, Albert Bover, Jordi Bonell, Rai Ferrer, and Aldo Caviglia. CD. Fresh Sound New Talent FSNT 012, 1996.

Dúo de pianos Azarola – Aza. *Dulce Sue.* With José Azarola and Joaquín Aza. Compañía Gramófono-Odeon S.A.E. SO. 9316, 1943.

Fernández, Miguel. *Ocean Blood.* With Jason Palmer, Marco Mezquida, Masa Kamaguchi, anfd David Xirgu. CD. Fresh Sound New Talent FSNT 477, 2015.

Garayalde, Javier. *Jazzy Feeling.* With Iñaki Salvador, Gonzalo Tejada, Esteve Pi, Javier and Luis Garayalde Jr. CD. Arion 202 B 149, 2000.

Goia-Aribe, Josetxo. *Los pendientes de la Reina.* With Estitxu Pinatxo, Sorkunde Idigoras, Luisa Brito, Guillermo McGill, and Diana Campóo. CD. Errabal ER 017, 2007. Recorded January 27 and 28, 2007.

Iñaki Salvador Noneto. *Faro.* With Itxaso González, Hasier Oleaga, Gonzalo Tejada, Jonathan Hurtado, Javier Juanco, Jacky Berecoechea, Víctor de Diego, and Mikel Andueza. CD. Errabal ER 012, 2006. Recorded Juny 2006.

Iruña Big Band. *Axuri beltza*. CD. Elkarlanean ZC 022, 1995. Recorded January 5, 1995.

———. *Agur jaunak*. With Mikel Andueza, Mario Fernandino, Ion Robles, Iñaki Askunze, Víctor de Diego, Javier Zazpe, Ramón García, Javier Blázquez, José Navarcorena, Ángel Otxotorena, Benet Palet, Juanjo Arrom, Juan Carlos Aoiz, Albert Bover, Dani Pérez, Javier Colina, Curro Gálvez, Laura Simó, Marc Miralta, and Javi Landa. CD. K Industria Cultural K012 CDs, 1997. Recorded January 1997.

Iturralde, Pedro. *¡Jazz Flamenco!* With Eric Peter, Peer Wyboris, Paco de Algeciras, Paco de Antequera, Paul Grassi, and Nuccio Intrisano. LP. Hispavox HH 11-128, 1967. Recorded Juny 30 and September 14, 1967.

Javier Colina Quartet. *Javier Colina Quartet*. With Ariel Bringuez, Albert Sanz, and Dani García. CD. Moskito Rekords. Jazz on! MR 016, 2015. Recorded December 7, 2013.

José Moro y su Orquesta. "Strutin with Some Barbecue." *Spanish Hot Jazz & Swing, Vol. 3*. CD. Mondotone Records B00IAC59OC, 2014.

Kase, Chris. *My Private Circus*. CD. Errabal ER 054, 2012.

Miren Aranburu Ensemble. *Gorri isila*. With Jean Louis Hargous, Iñaki Salvador, Joseba Loinaz, Gonzalo Tejada, Jean Paul Giles, Víctor Celada, and Edio Pessi. CD. Errabal ER 001, 2002.

Orquestina Betoré. *Las castigadoras. Charleston.* Columbia Graphophone Company RS 549, 1927.

Pedro Iturralde Quintet feat. Paco de Lucía. *Flamenco-Jazz*. With Dino Piana, Paul Grassi, Erich Peter, and Peer Wyboris. LP. Saba SB 15143 ST. Recorded November 3, 1967.

Pirineos Jazz Orchestra, dir. Iñaki Askunze. *Pirineos Jazz Orchestra: la primera orquesta transfronteriza de Europa*. With Pascal Drapeau, Laurent Agnés, Ramón García, Jean Loustalot,

Fidel Fourneyron, Sébastien Arruty, Juan Carlos Aoiz, Guillaume Kuntzel, Ion Robles, Mikel Andueza, Gorka Benítez, Víctor de Diego, Josetxo Silguero, Iñaki Salvador, Dani Pérez, Gonzalo Tejada, Didier Ottaviani, and Laura Ridruejo. CD. Agorila AG CD 352, 2003. Recorded September 9–14, 2003.

Pirineos Jazz Orchestra & Randy Brecker, dir. Iñaki Askunze. *Transatlantic Connection*. With Pascal Drapeau, Laurent Agnés, Jacky Berekoetxea, Ramón García, Fidel Fourneyron, Sébastien Arruty, Juan Carlos Aoiz, Lionel Segui, Ion Robles, Mikel Andueza, Gorka Benítez, Víctor de Diego, Roberto Pacheco, Albert Bover, Dani Pérez, David González, Didier Ottaviani, and Laura Ridruejo. CD. Frank Andrada Music FAM 22037, 2005. Recorded November 2005.

Salvador, Iñaki. *Bi Taupada/LatiDos*. With Zilbor Hestea: Amaia Zubiria, Gonzalo Tejada, Víctor Celada, Josetxo Silguero, Ángel Unzu, Luis Camino, Jesús Artze, and Kirikoketa Taldea. CD. IZ-482-KD, 1997. Recorded May 24–27, 1997.

Sandoval, Iñaki. *Miracielos*. With Eddie Gomez and Billy Hart. CD. Bebyne Records CDB 003, 2011. Recorded November 9, 2009.

San Miguel, Tomás. *Lezao*. With Javier Paxariño, Kepa Junkera, Ibon Coteron, Perdi, and Rubén "Gerla Beti." CD. Nuevos Medios 15641 CD, 1994.

Tejada, Gonzalo. *Ziklo.1*. With Sorkunde Idigoras, Iñaki Salvador, Dani Pérez, and David Xirgu. CD (Zirrara; 1). Jazzle ZC-017, 1994. Recorded July 21 and 22, 1994.

Teresa Zabalza Quintet. *Euria*. With Alejandro Mingot, Miguel "Pintxo" Villar, Iosu Izagirre, and Hasier Oleaga. CD. Errabal ER 004, 2004. Recorded September 13, 14, and 29, 2004.

Unzu, Ángel. *13 solos.* CD (Zirrara; 2). Jazzle ZC-037, 1996. Recorded April 27 and 28, 1996.

Urrutia, Jon. *Home-made.* With Santi Ibarretxe, Toño de Miguel, Borja Barrueta, Itsaso González, Julio Andrade, Diego Álvarez "El Negro," and Mariano Steinberg. CD. Errabal ER 003, 2003. Recorded between July and August, 2003.

Víctor de Diego Group. *Oraindik ametsetan.* With Curro Gálvez, Joan Díaz, and Marc Ayza. CD. Errabal ER 006, 2005. Recorded January 2005.

Zubipeko Swing. *Voilà!* With Adolfo García Gorria, Aingeru Berguices, Gaizka Elosegi, Jon Etxeandia, Pedro Muñoz, and Siegmar Menzel. CD. IZ 399, 1992.

———. *Yan barik.* With Óscar Andollo, Aingeru Berguices, Gaizka Elosegi, Jon Etxeandia, Pedro Muñoz, Siegmar Menzel, and Henryk Zielisni. CD. IZ 448 KD, 1995.

## Popular Music Revisited: A Chronology

195?
Various Artists. Compiler: Ximun Haran. *Kantuz N°1.* Club du Disque Basque.
http://www.eresbil.com/opac/abnetcl.exe/O7030/ID170d3a54 /NT2.

1961
Michel Labéguerie. *Lehen diskoa.* EP. Goiztiri.
http://www.badok.eus/euskal-musika/mixel-labegerie/lehen-diskoa.

1963
Soroak. *N°1.* EP. Goiztiri. http://www.badok.eus/euskal-musika/soroak-laukoa/soroak.

Mikel Laboa. *Bat-Hiru*. LP. Herri Gogoa/Edigsa.
http://www.badok.eus/euskal-musika/mikel-laboa/bat-hiru/.
Antton Valverde, Julen Lekuona, and Xabier Lete. *Bertso zaharrak*.
LP. Herri Gogoa/Edigsa.
http://www.badok.eus/euskal-musika/xabier-lete/bertso-
zaharrak-2.
Various Artists. *Herriko musika*. Cassette. Movieplay.
https://www.soinuenea.eus/es/herriko-musika-alboka-leon-
bilbao-eta-maurizia-txistu-miguel-makuso-dultzaina-juan-bilbao-
trikitrixa-rufino-arrola/er-23576/

1975
Arza Anaiak. *Txalaparta '75 Iraila*. LP. Cramps Records. http://
www.badok.eus/euskal-musika/artze-anaiak/txalaparta-1. *Peio
Ospital eta Pantxoa Carrere*. LP. Elkar.
http://www.badok.eus/euskal-musika/pantxoa-eta-peio/ospital-
carrere.

1977
Haizea. *Haizea*. LP. Herri Gogoa.
http://www.badok.eus/euskal-musika/haizea/haizea.

1978
Itoiz. *Itoiz*. LP. Xoxoa.
http://artxiboa.badok.eus/diskoa.php?id_disko=391&id_artista
=44.

1979
Errobi. *Ametsaren bidea*. LP. Xoxoa.
http://www.badok.eus/euskal-musika/errobi/ametsaren-bidea.

Ruper Ordorika. *Hautsi da anphora*. LP. Xoxoa.
http://www.badok.eus/euskal-musika/ruper-ordorika/hautsi-da-anphora/.

1984
Oskorri. *Alemanian euskaraz*. LP. Elkar.
http://www.badok.eus/euskal-musika/oskorri/alemanian-euskaraz.
Hertzainak. *Hertzainak*. Soñua. http://www.badok.eus/euskal-musika/hertzainak/hertzainak.
La Polla Records. *Salve*. LP. Soñua.
https://www.discogs.com/es/La-Polla-Records-Salve/release/1650804.

1985
Various Artists. Compiler: Juan Mari Beltran. *Euskal Herriko Soinu Tresnak*. Cassette. IZ.
https://www.soinuenea.eus/eu/euskal-herriko-soinu-tresnak/er-22492/.
Kortatu. *Kortatu*. LP. Soñua. http://www.badok.eus/euskal-musika/kortatu/kortatu.

1986
Eskorbuto. *Anti todo*. Discos Suicidas. LP.
https://www.discogs.com/es/Eskorbuto-Anti-Todo/release/2534200.

1987
Imanol. *Joan-etorrian*. LP. Elkar. http://www.badok.eus/euskal-musika/imanol/joan-etorrian/.

R.I.P. *No te muevas!* LP. Basati Diskak.
https://www.discogs.com/es/RIP-No-Te-
Muevas/release/2456669.

1989
Delirium Tremens. *Ikusi eta Ikasi.* LP. Oihuka.
http://www.badok.eus/euskal-musika/delirium-tremens/ikusi-
eta-ikasi.

1991
Su ta Gar. *Jaiotze basatia.* LP. IZ. http://www.badok.eus/euskal-
musika/su-ta-gar/jaiotze-basatia.

1993
Negu Gorriak. *Borreroak baditu milaka aurpegi.* LP. Esan Ozenki.
http://www.badok.eus/euskal-musika/negu-gorriak/borreroak-
baditu-milaka-aurpegi.
Sorotan Bele. *Sorotan Bele.* CD. Elkar.
http://www.badok.eus/euskal-musika/sorotan-bele/sorotan-
bele.

1996
Benito Lertxundi. *Hitaz Oroit.* CD. Elkar.
http://www.badok.eus/euskal-musika/benito-lertxundi/hitaz-
oroit.

1996
Dut. *At.* CD. Esan Ozenki. http://www.badok.eus/euskal-
musika/dut/at.
Kashbad. *Kashbad.* CD. Esan Ozenki.
http://www.badok.eus/euskal-musika/kashbad/kashbad.

Joxe Ripiau. *Karpe Diem*. CD. Esan Ozenki.
http://www.badok.eus/euskal-musika/joxe-ripiau/karpe-diem.
Alaitz eta Maider. *Alaitz eta Maider*. CD. Elkar.
http://www.badok.eus/euskal-musika/alaitz-eta-maider/alaitz-
eta-maider.

1998
King Mafrundi. *Diah!* CD. Esan Ozenki.
http://www.badok.eus/euskal-musika/king-mafrundi/diah.
Various Artists: Maddi Oihenart, Mixel Etxekopar, Mixel Arotze,
et al. *Lürralde zilarra*. CD. Agorila.
http://www.badok.eus/euskal-musika/maddi-oihenart/lurralde-
zilarra/.
Kepa Junkera. *Bilbao 00:00H*. CD. Resistencia.
http://www.badok.eus/euskal-musika/kepa-junkera/bilbao-
0000h.

1999
Hemendik at! *Orain*. CD. GOR. http://www.badok.eus/euskal-
musika/hemendik-at/orain.

2000
Lisabö. *Ezarian*. CD. Esan Ozenki.
http://www.badok.eus/euskal-musika/lisabo/ezarian.

2001
Kuraia. *Kuraia*. CD. Metak. http://www.badok.eus/euskal-
musika/kuraia/kuraia.
Berri Txarrak. *Eskuak/Ukabilak*. CD. Gor.
http://www.badok.eus/euskal-musika/berri-
txarrak/eskuakukabilak/.

2002

Tapia eta Leturia. *Hain zuzen.* CD. Gaztelupeko hotsak. http://www.badok.eus/euskal-musika/tapia-eta-leturia/hain-zuzen.

Gatibu. *Zoramena.* CD. Oihuka. http://www.badok.eus/euskal-musika/gatibu/zoramena.

Betagarri. *Arnasa hartu.* CD. Metak. http://www.badok.eus/euskal-musika/betagarri/arnasa-hartu.

2003

Ken Zazpi. *Bidean.* CD. Gor. http://www.badok.eus/euskal-musika/ken-zazpi/bidean.

Maddi Oihenart, Josetxo Goia-Aribe. CD. Metak. http://www.badok.eus/euskal-musika/maddi-oihenart/ilhargi-min.

2007

Willis Drummond. *Anthology.* CD. Autoekoizpena. http://www.badok.eus/euskal-musika/willis-drummond/anthology.

2008

Esne Beltza. *Made in Euskal Herria.* CD. Gaztelupeko Hotsak. http://www.badok.eus/euskal-musika/esne-beltza/made-in-euskal-herria.

2008

Zura. *Kiribil.* CD. Gor. http://www.badok.eus/euskal-musika/zura/kiribil.

2009

Anari. *Irla izan.* CD. Bidehuts. http://www.badok.eus/euskal-musika/anari/irla-izan.

2013

Neighbor. *Ura patrikan*. CD. Gaztelupeko hotsak.
http://www.badok.eus/euskal-musika/neighbor/ura-patrikan.

2016

WAS. *Gau ama*. LP. Mushroom Pillow.
https://www.discogs.com/es/WAS-Gau-
Ama/release/8242265.
Izaro. *OM*. CD. Autoekoizpena. http://www.badok.eus/
euskal-musika/izaro/com.

2017

Glaukoma. *Kalima*. CD. Bonberenea Ekintzak.
http://www.badok.eus/euskal-musika/glaukoma/kalima.

2018

Broken Brothers Brass Band. *Txertaketa*. CD. Errabal jazz.
http://www.badok.eus/euskal-musika/broken-brothers-brass-
band/txertaketa.
2zio. *Orain eta hemen*. CD. Autoekoizpena.
http://www.badok.eus/euskal-musika/2zio/orain-eta-hemen.

# Index

## A

# B

# H

# K

# O

## Q

## S

# W

CPSIA information can be obtained
at www.ICGtesting.com
Printed in the USA
BVHW070510141220
595601BV00001B/23